THE SALVADOR DALÍ MUSEUM COLLECTION

THE SALVADOR DALÍ MUSEUM COLLECTION

Text by

Robert S. Lubar

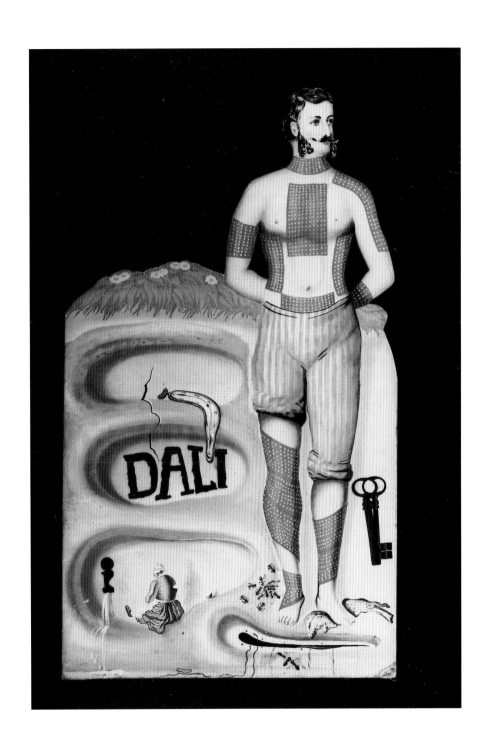

A BULFINCH PRESS BOOK

Boston • New York • London

Acknowledgments

A number of individuals have contributed to this essay and the catalogue notes that follow. First and foremost I am grateful to my editor at Bulfinch Press, Sarah Kirshner, for seeing this project through to completion amid endless delays, and to my copyeditor, Pamela Marshall, for correcting numerous authorial infelicities. I wish to thank the director and staff of the Salvador Dalí Museum for their patience in responding to my queries and for their assistance in researching the exhibition history of the ninety-four oil paintings in the collection: Marshall Rousseau, Joan Kropf, Peter Tush, and William Jeffett. I am deeply indebted to my research assistants, Miriam Basilio, Ellen McBreen, and Juliana Kreinik, for tracking down obscure references in the Dalí literature and for suggesting promising leads. Throughout the research and writing of this catalogue I have also benefited from the counsel of noted Dalí experts Dawn Ades, Fèlix Fanés, and Estrella de Diego.

The Enigma of William Tell (fig. 2 on p. ix) courtesy of the Moderna Museet, Stockholm, Sweden
Salvador Dalí on the cover of *Time* (fig. 4 on p. xi) © 1936 Time Inc.
The Endless Enigma (fig. 6 on p. xii) courtesy of the Museo Nacional Centro de Arte Reina Sofía, Madrid: Dalí bequest 1989
Madonna of Port Lligat (first version) (fig. 9 on p. xv) © 2000 Patrick and Beatrice Haggerty Museum of Art,
Marquette University, Milwaukee, Wis. Gift of Mr. and Mrs. Ira Haupt, 59.9
All art featured on p. iii and in the chronology courtesy of the Salvador Dalí Museum Archives
Photograph on p. 172 © Meli Casals
Photograph on p. 173 © Giacomelli
Photograph on p. 174 © Meli Casals

First Edition

Library of Congress Cataloging-in-Publication Data

Lubar, Robert S.
 Dali : the Salvador Dali Museum collection / Robert S. Lubar.—Rev. and enl. ed.
 p. cm.
 Rev. ed. of: Dali / foreword by A. Reynolds Morse. 1st ed. 1991.
 Includes bibliographical references and index.
 ISBN 0-8212-2480-8 (hc). ISBN 0-8212-2715-7 (museum pb)
 1. Dalí , Salvador, 1904 — Catalogs. 2. Morse, Albert Reynolds, 1914 — Art
collections — Catalogs. 3. Art — Private collections — Florida — Saint Petersburg — Catalogs. 4.
Art — Florida — Saint Petersburg — Catalogs. 5. Salvador Dali Museum — Catalogs. I. Dalí,
Salvador, 1904– II. Dalí, Salvador, 1904– Dali. III. Salvador Dali Museum. IV. Title.

N7113.D3 A4 2000
759.6 — dc21 99-087333

Designed by Peter M. Blaiwas, Vernon Press, Inc.

Bulfinch Press is an imprint and trademark of Little, Brown and Company (Inc.).

PRINTED IN ITALY

Dedication

With great appreciation and gratitude, this book is dedicated to A. Reynolds and Eleanor R. Morse. Over fifty years of collecting the art of Salvador Dalí, as well as their friendship with Gala and Salvador Dalí, have made this valuable collection possible. The Salvador Dalí Museum is the world's most comprehensive collection of the Spanish artist's works.

For the Morses, the Dalí adventure started in 1943 when the newlyweds purchased *Daddy Longlegs of the Evening—Hope!* shortly after they met Salvador Dalí by appointment at the Old King Cole Bar in the St. Regis Hotel in New York. That visit was the start of their long friendship with Dalí. Through the years Mr. and Mrs. Morse collected works by Dalí that they found beguiling and intriguing. Their fascination with the artist's works led Mr. Morse to write many studies of Dalí and his art and Mrs. Morse to translate many books about the artist and his work from French to English. Sharing their knowledge and understanding of Salvador Dalí and his art has been a lifelong mission for this dedicated couple.

From 1971 to 1980, the Morses exhibited their works in a wing of their business in Beachwood, Ohio. During those years, the collection outgrew these quarters and the Morses started a national search for a permanent home. Thanks to the cooperation of many local and state officials, these important works are now housed permanently in St. Petersburg, Florida.

The Museum's Board of Trustees and staff thank the Morses for their profound generosity.

Contents

Introduction: The Martyrdom of Avida Dollars—ix

The Salvador Dalí Museum Collection—1

Biographical Chronology—161

List of Exhibitions—177

Index—181

The Martyrdom of Avida Dollars

Robert S. Lubar

Whatever else Salvador Dalí's paintings may be, they are always news.[1]

In a little-known text published in *Country Beautiful* in November 1961, the eminent American art critic Clement Greenberg made a characteristic pronouncement about taste in painting: "Underneath all apparent differences," he categorically asserted, "a good Mondrian or good Pollock has more in common with a good Vermeer than a bad Dalí has. A bad Dalí has far more in common, not only with a bad Maxfield Parrish, but with a bad abstract painting."[2] In effect, Greenberg was responding to an analogy that Dalí himself had drawn between Vermeer and Mondrian just three years earlier in a diatribe against modernist painting. "I hasten to say," Dalí declared, "that Vermeer is almost everything and Mondrian almost nothing! Completely idiotic critics have for several years used the name of Piet Mondrian as though he represented the *summum* of all spiritual activity. They quote him in every connection. Piet for architecture, Piet for poetry, Piet for mysticism, Piet for philosophy, Piet's whites, Piet's yellows, Piet, Piet, Piet................................Piet, Piet, Piet, Peep, Pity, Piet. Well, I, Salvador, will tell you this, that Piet with one 'i' less would have been nothing but a *pet*, which is the French word for fart."[3] Attacking what he called the "dithyrambic critics" of modern art (one senses Dalí thought of them more as a cartel) at a time when formalist criticism maintained a firm grip on painting in America, Dalí refused to enter the ivory tower of aestheticism.

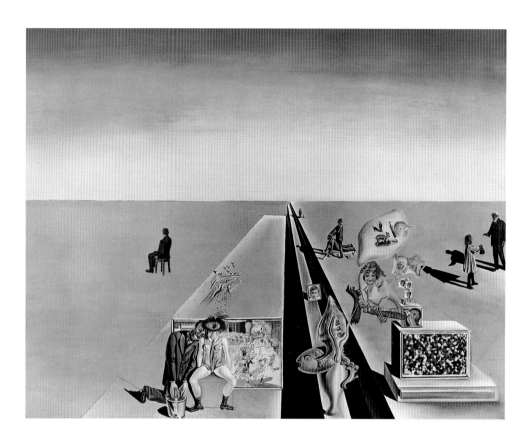

Fig. 1 Salvador Dalí, The First Days of Spring, *1929. Oil and collage on panel, 19 3/4 × 25 5/8 inches. Salvador Dalí Museum, St. Petersburg, Florida.*

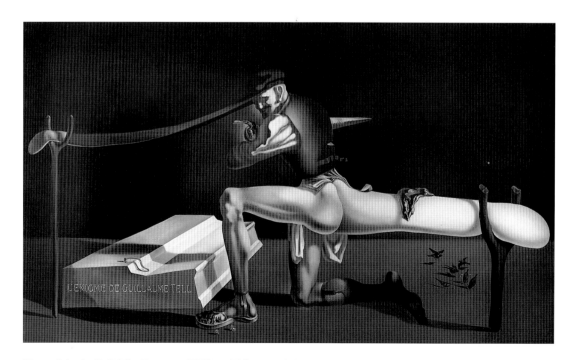

Fig. 2 Salvador Dalí, The Enigma of William Tell, *1933. Oil on canvas, 78 1/2 × 135 inches. Moderna Museet, Stockholm.*

If Greenberg equated Dalí with a debased mass culture and bad abstract painting, the Catalan artist relished the analogy.

Dalí had long flaunted his deliberately retrograde technique and his unapologetic embrace of commercial kitsch and mass culture in the face of the cultural establishment in France and the United States. As early as 1935 he openly challenged the philosophical and aesthetic foundations of modernist painting, insisting that "the illusionism of the most abjectly *arriviste* and irresistible imitative art, the usual paralyzing tricks of *trompe-l'oeil*, the most analytically narrative and discredited academicism can all become sublime hierarchies of thought and the means of approach to new exactitudes of concrete irrationality."[4] At that time the precocious young painter was still a core member of the surrealist group, somewhat suspect in the eyes of André Breton, but a powerful voice within the movement nonetheless. Transgression was to be expected of a surrealist, and Dalí's unrelenting attacks on the "disgraceful lack of philosophic and general culture of the gay propellors of this model mental debility called abstract art," whom he characterized as "sticky and retarded Kantians of scatological *sections d'or*,"[5] reaffirmed Breton's inaugural definition of surrealism as an activity unrestricted by moral and aesthetic preoccupations. Indeed, when Dalí exhibited *The First Days of Spring* (fig. 1) in a groundbreaking exhibition of collage in 1930 (see cat. no. 34), the poet Louis Aragon eschewed formalist categories and insisted

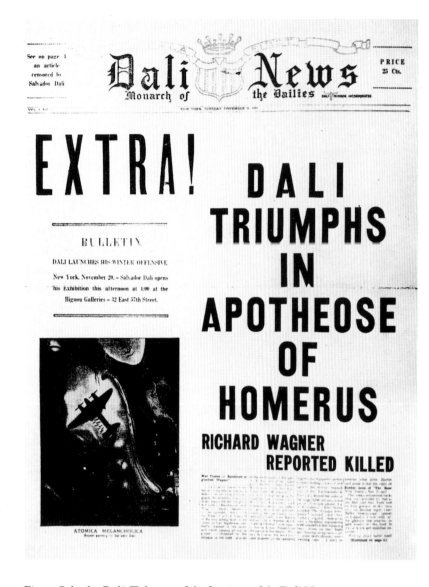

Fig. 3 Salvador Dalí, Title page of the first issue of the Dali News *(November 29, 1945).*

that "the incoherent aspect of a Dalí picture, in its entirety, recalls the particular incoherence of collages. . . . Dalí is . . . associated with the antipictorial spirit that not so long ago made painters, then critics, protest loudly, but that invades painting today."[6]

Thirteen years later, however, Dalí and Aragon were in disgrace. In the "Prologomena to a Third Surrealist Manifesto, or Not," Breton, in exile in New York, lamented the betrayal of surrealist principles, reserving especially harsh words for Dalí and Aragon:

The evils that are always the price of favor, of renown, lie in wait even for Surrealism, though it has been in existence for twenty years. The precautions taken to safeguard the inner integrity of this movement—which generally are regarded as being much too severe—have not precluded the raving false witness of an Aragon, nor the picaresque sort of imposture of the Neo-Falangist bedside-table Avida Dollars.

Surrealism is already far from being able to cover everything that is undertaken in its name, openly or not, from the most unfathomable "teas" of Tokyo to the rain-streaked windows of Fifth Avenue, even though Japan and America are at war. What is being done in any given direction bears little resemblance to what was wanted. Even the most outstanding men must put up with passing away not so much with a halo as with a great cloud of dust trailing behind them.[7]

The story of Dalí's "fall" from surrealist grace and his apotheosis as modernist art's alter ego — the anti-Christ of formalist painting — is a complex affair marked by accusations, recriminations, and, as many would argue, bad faith. As early as February 5, 1934, Breton had summoned Dalí before the General Assembly of the surrealist movement to answer for his refusal to participate in the group's revolutionary activities, his defense of academic painting, family, and paternal authority, and his "anti-humanitarian" behavior. Dalí's exploration of the Hitler phenomenon in his art and writings, and his submission of *The Enigma of William Tell* (fig. 2) to the Salon des Indépendants several days earlier, outraged Breton. With Fascism and the forces of reaction on the rise in Germany, Italy, and France, Dalí's view of Soviet foreign policy as "eminently Nazi, nationalist, Russophile, anti-internationalist, anti-democratic, and anti-liberal"[8] repulsed Breton, who was negotiating a narrow path of rapprochement between the surrealists and the French Communist Party. *The Enigma of William Tell*, whose protagonist is a decrepit father figure

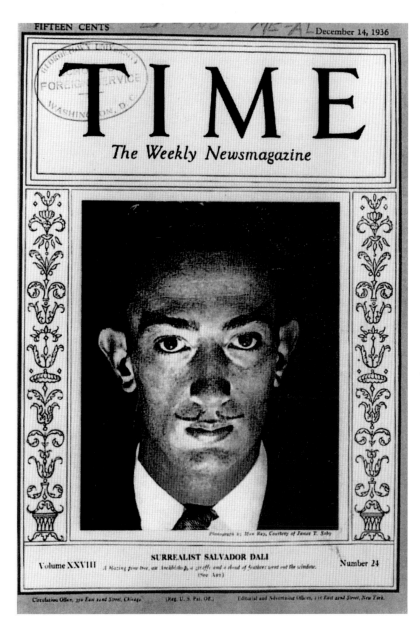

TIME
The Weekly Newsmagazine

Volume XXVIII **SURREALIST SALVADOR DALI** Number 24

Fig. 4 Salvador Dalí on the cover of Time *(December 14,1936): photo by Man Ray.*

remake himself *as* news, as the masthead of his broadsheet *Dali News* (fig. 3) later proclaimed. As early as 1936 Dalí had appeared on the cover of *Time* magazine in a photographic portrait by Man Ray (fig. 4), ensuring that his persona had as much commercial equity as his art. Little more than two years later, Dalí was again the talk of the town when he accidentally crashed through a window at Bonwit Teller in New York while attempting to change a display he designed that the fashionable department store had altered. Never one to avoid publicity, Dalí, the darling of the media, had become inseparable from Dalí the artist, so much so that an article in

Newsweek reporting on the Bonwit Teller incident began, "Salvador Dalí, dapper headline maker of Surrealist painters, has won both notoriety and fortune by depicting his fantastic unconscious on canvas."[11] To be sure, Dalí's *currency* was as much a matter of news as it was a question of money. On April 23, 1939, the *New York Times* reported on Dalí's commission to design an elaborate surrealist pavilion for the New York World's Fair (fig. 5), drawing an explicit link between his art, his public persona, and his commercial interests: "Salvador Dalí, the surrealist painter who recently broke out of a Fifth Avenue store window, has broken

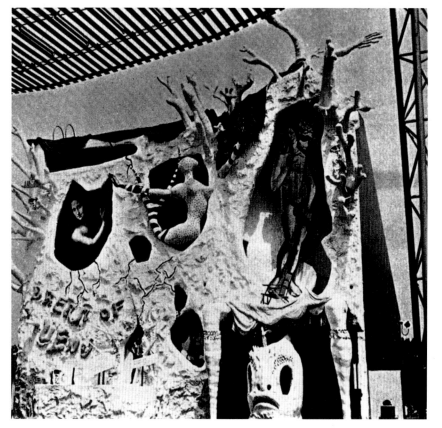

Fig. 5 Salvador Dalí, façade of the "Dream of Venus" pavilion, New York World's Fair, 1939.

with hypertrophied buttocks and a face resembling that of Lenin, was the final insult, and Breton demanded an explanation. Although Dalí narrowly escaped expulsion from the surrealist movement, mocking Breton's Stalinist tactics in his defense, his position within the group was compromised. Five years later Breton publicly denounced Dalí[10] and definitively excommunicated him from the surrealist movement.

As it turned out, 1939 was a key year for Dalí, who could now afford—in all senses of the word—Breton's censure. With the support of Chick Austin of the Wadsworth Atheneum, his New York art dealer Julien Levy, and influential society friends like Caresse Crosby, Dalí launched a massive publicity campaign in America. If he was not the first modern artist to *make* the news, he was surely the first artist to

into the amusement area of the World's Fair, it was announced yesterday. It will cost 25 cents to attend a ten or twelve-minute show of his pictorial conceptions in three dimensions, demonstrated by 'Living Liquid Ladies.' "[12] When authorities attempted to censor the "Dream of Venus" pavilion on the grounds that Dalí's image of a woman with the head of a fish was indecent, Dalí again made news as "the impresario of a side-show in the amusement zone" of the fair.[13]

It is no wonder, then, that Dalí's concurrent exhibition at the Julien Levy Gallery (March 21–April 17, 1939) drew enormous crowds. This time it was Dalí's art that made the news, particularly his complex multi-image painting *The Endless Enigma* of 1938 (fig. 6), which Breton dismissed as a visual crossword puzzle.[14] If *Life* magazine could report that "for general popularity there hasn't been such an exhibit since Whistler's *Mother* was shown in 1934,"[15] Dalí's astounding commercial success also drew sharp criticism. *Time* magazine begrudgingly observed, "In Manhattan last week, having had as much advance publicity as Ringling Bros., Salvador Dalí's new exhibition drew crowds that made the swank Julien Levy Gallery surge and prattle like the *Normandie* at sailing time."[16] More damning was Paul Bird's review for *Art Digest:* "Salvador and his manager, Julien Levy, ride merrily along on the crest of the greatest art publicity campaign of the year. . . . Dalí, of course, cares nothing about the art world. His profits are where the money is: department stores that cater to the chi-chi, café society of the insecure strata, and Hollywood."[17] In Bird's view, Dalí's art was as thin as a one-dollar note.

However much critics registered their shock and contempt, in 1939 Dalí's commercialism was in fact old news. As early as 1936 Dalí had designed a series of extravagant hats for Elsa Schiaparelli based on familiar motifs from his art: cutlets, inkwells, and shoes (fig. 7). In a letter to Breton dated December 28, 1936, he proudly commented on surrealism's impact on the world of fashion and advertising in America: "If you saw it here—the repercussions it's had—you'd be very pleased. . . . The influence of Surrealism is enormous; they're decorating the windows of the most luxurious stores with Surrealism. The creators of animated cartoons are proud to call themselves surrealists. I'm doing my best for our activity."[18] A year later, Dalí went so far as to suggest a redemptive role for surrealism within mass culture. Following a trip to Hollywood in late January 1937, during which time he discussed a collaborative film project with Harpo Marx, Dalí informed the readers of *Harper's Bazaar:*

Reduced to idiocy by the material progress of a mechanical civilization, the public and masses demand urgently the illogical and tumultuous images of their own desires and their own dreams. It is for this reason that today these crowds press hungrily around surrealism's rescue table, digging their nails into the living flesh of morsels of dream which we offer them that we may "save their fantasy" and proclaim "the rights of man's madness." Thus do we try to keep them from sinking forever into that thick leaden sea which is the everyday vulgarity and stupidity of the so-called "realist" world.[19]

Dalí's argument did not convince. The co-opting of surrealism by Madison Avenue left little room to believe the movement would ever serve a redemptive social function. From haute couture fashion for the luxury class to Macy's bargain

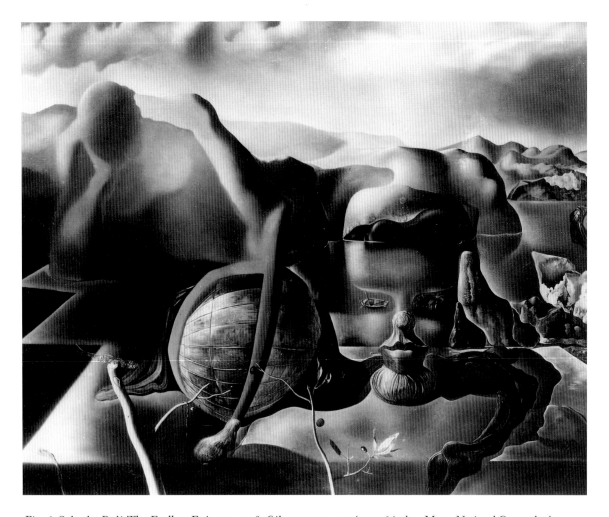

Fig. 6 Salvador Dalí, The Endless Enigma, *1938. Oil on canvas, 44 1/2 × 56 inches. Museo Nacional Centro de Arte Reina Sofía, Madrid.*

basement, from advertisements for Hattie Carnegie beach coats[20] to "mobile jewels,"[21] surrealism had become a hot commodity, and Dalí its most vocal spokesman.[22] Reviewing the groundbreaking "Fantastic Art, Dada, Surrealism" exhibition at the Museum of Modern Art in the winter of 1936–37, social critic Barry Byrne sounded the death knell of surrealism as a revolutionary movement: "The publicity that attended this exhibition and its generally modish character had in it a measure of irony, for surrealism in art had sympathetic social and economic implications to which talented artists dedicated their efforts. The twenty-odd years of its existence have seen it pass from that radicalism to this final stage of modishness."[23] Karl Marx had been replaced by Harpo.

Still, the question remains: If surrealism had fallen from the heights of utopian politics to the depths of the commodity, why was Dalí singled out as Public Enemy No. 1? Surely Dalí cannot be held accountable for single-handedly selling out the lofty ideals of the movement, given the considerable work that core members of the group like Man Ray produced for commercial ventures. What is more, if Dalí designed hats for Schiaparelli in 1936, he also produced a kind of anticommodity for the Exhibition of the Surrealist Object that same year— the extravagant *Aphrodisiac Dinner Jacket* — whose function was precisely to call into question the reified status of mass-produced consumer goods. In fact, Dalí repeatedly transformed mass-cultural materials in his art and writing, from an ad for a medicinal mustard plaster he reworked into a surrealist poster for his exhibition at the Julien Levy Gallery in 1934 (see

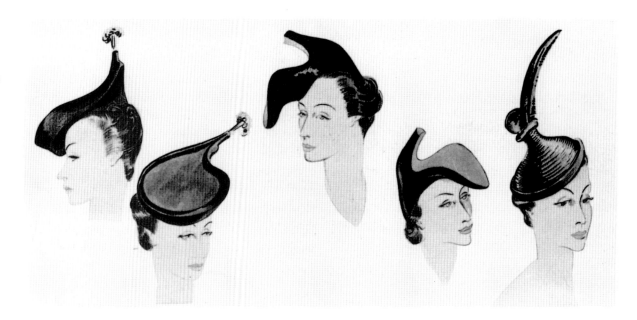

Fig. 7 Salvador Dalí, hat designs for Elsa Schiaparelli, 1936 (Cutlet Hat, Shoe Hat, Inkwell Hat).

cat. no. 57) to the erotic postcards he used to illustrate his great paranoiac-critical tract, *The Tragic Myth of Millet's "Angelus"* (see cat. no. 52). Yet if these works critically engaged commodity culture, by the late 1930s the distinctions between high art and the commodity were less readily apparent in Dalí's work. The critic for *Time* magazine who reviewed Dalí's 1939 exhibition at the Julien Levy Gallery hit the nail on the head: "Persistent association with the smart money is suspect in an artist; so is a highly developed faculty for showmanship. Odd thing about Dalí is that these qualities are apparently all of a piece with his art, yet his art has importance."[24]

In short, Dalí had become a "problem," an embarrassment of sorts for critics who desperately sought to enforce an inherently unstable divide between high art and mass culture, "avant-garde and kitsch," to borrow Clement Greenberg's terminology. As John Canaday described the situation in 1960:

[T]he extremity of the public personality [Dalí] has presented, that of a clamorously ambitious and unabashedly opportunistic man; the absurdity of his pronouncements about himself and his art; his appalling syntheses of mawkish religiosity, sentimental sexuality and abnormal psychology; his maddening way of skidding back and forth across the line that divides slickness from technical brilliance—all of this makes one ready to throw the baby out with the bath water. Yet it is a very curious thing about this painter that the only virtue that he absolutely cannot be denied is, antithetically, the virtue that lies at the basis of all homespun philosophies: he is an awfully hard worker. Publicly a grasshopper who has read Freud, privately he is surely as industrious as an ant.[25]

In the end, however, industriousness did not make up for Dalí's willful transgression of dominant cultural hierarchies. America's "No. 1 public madman,"[26] the "P. T. Barnum of painting,"[27] simply refused to get in

line. For every critic who viewed Dalí's art as the reflection of a world in crisis,[28] an appeal to the "survival of a basic artistic freedom from regimentation in the postwar era,"[29] there were ten ready to accuse him of opportunism, moral cowardice, and even counterrevolutionary behavior.[30] On both the Left and the Right, for both Marxist and formalist critics, Dalí's refusal to declare an unequivocal political position, his wholesale rejection of the modern tradition, his return to academic painting, and his self-absorbed cult of personality raised questions about the seriousness, and even the moral integrity, of his work. Writing in 1942, André Breton stated the problem succinctly:

In spite of an undeniable ingenuity in staging, Dalí's work, hampered by an ultra-retrograde technique (return to Meissonier) and discredited by a cynical indifference to the means he used to put himself forward, has for a long time showed signs of panic, and has only been

able to give the appearance of weathering the storm temporarily through a process of systematic vulgarization. *It is sinking into* Academicism—*an Academicism which calls itself* Classicism *on its own authority alone*—*and since 1936 has had no interest whatsoever for* Surrealism.[31]

Two years later, Greenberg himself responded to Dalí's much-publicized return to academic painting:

Dalí turned on post-cubist painting, praised Meissonier and commercial illustrations, and asserted his contempt for "formal" values by the deliberate but just as often

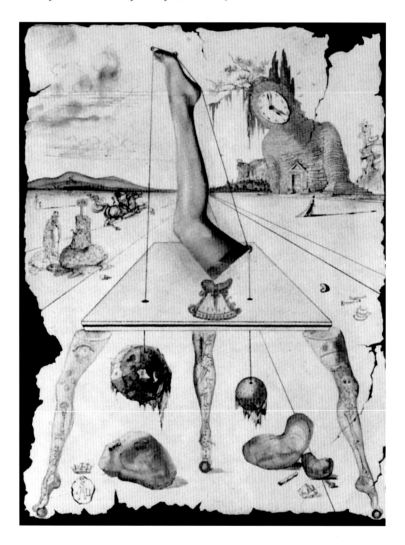

Fig. 8 Salvador Dalí, Leg Composition (*drawing for an advertisement for Bryans Hosiery*), *circa 1944. Watercolor and India ink; dimensions and whereabouts unknown.*

unconscious negligences of his own painting. Thus he made a virtue of his shortcomings. Granted that irreverence has a necessary function in our time, yet irreverence as puerile and widely welcome as Dalí's is no more revolutionary than fascism.[32]

Dalí's critics, of course, were right. The Catalan artist made no bones about his antipathy toward modernist painting, his contempt for ideological politics, and his ability to move freely from the production of surrealist objects in the 1930s to advertisements for hosiery in the mid-1940s (fig. 8). Just as Mark Rothko and Barnett

Newman sought refuge in the metaphysics of form as the space of spiritual absolutes in a materialist age, Dalí returned to tradition and the Catholic Church, investing Gala with the aura of a contemporary Madonna (fig. 9). As for technical brilliance, the one aspect of his work that could not be faulted, Dalí increasingly entrusted the tedious details of his elaborate postwar compositions to his studio assistant, Isador Bea, freeing up his time to pursue a host of extra-artistic activities. Worse still, the "Divine Dalí" shamelessly appropriated individual motifs and entire schemes from his early surrealist paintings, cashing in on his signature style and throwing it in the face of the cultural establishment, all the while laughing, like Liberace, all the way to the bank. Dalí even went so far as to parody his own aesthetic pronouncements, decrying the use of the Golden Section in cubist and postcubist painting in 1935 and then elevating it to the status of a metaphysical absolute in his postwar work (see cat. nos. 85 and 91). Add to this mix Dalí's "invention" of a new genre of paranoiac-critical history painting combined with an eccentric theory of nuclear mysticism and a broad range of technical quotations from Velázquez, neo-impressionism, and *art-informel* and the Dalinian bouillabaisse begins to taste like fast food. As Harold Rosenberg perceptively observed in 1960, "[Dalí's] tendency has always been to overdo and to yield to the intellectually gross, perhaps out of contempt and fear of both his snob and his mass audiences."[33]

To be sure, Dalí hedged his bets. Like a chess player working both sides of the table, he made a series of deliberate and highly publicized

moves and countermoves whose aim was to subvert cultural and aesthetic hierarchies of all sorts. If Dalí's life and work have proved difficult to digest, it is because he flaunted his authentic brand of inauthenticity before a society hungry for metaphysical truth without succumbing to its recuperative mechanisms. On this level Dalí's cultural practice—for it constitutes more than work—is of a piece with Marcel Duchamp and Andy Warhol. Like them, Dalí was a simulator, not an inventor in the orthodox sense. But this is not to say that he acted in bad faith. Dalí was a flamboyant martyr to the culture industry,[34] and his most original act was to hold a distorting mirror to the aesthetic and political ideals of his generation.

Notes

1. "Portraits by Dalí," *New York Times Magazine*, April 11, 1943, 17.

2. Clement Greenberg, "The Identity of Art," *Country Beautiful* (November 1961); reprinted in *Clement Greenberg, The Collected Essays and Criticism*, vol. 4, ed. John O'Brian (Chicago: University of Chicago Press, 1993), 117–120.

3. Salvador Dalí, *Dalí on Modern Art: The Cuckolds of Antiquated Modern Art*, trans. Haakon M. Chevalier (London: Vision Press, 1958), 61.

4. Salvador Dalí, *Conquest of the Irrational* (New York: Julien Levy Gallery, 1935), 12.

5. Dalí, *Conquest*, 19.

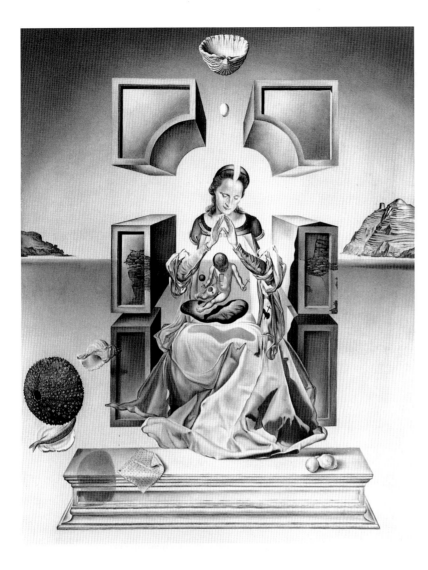

Fig. 9 *Salvador Dalí*, Madonna of Port Lligat *(first version), 1949. Oil on canvas, 19 1/2 × 15 1/16 inches. Patrick and Beatrice Haggerty Museum of Art, Marquette University, Milwaukee, Wisconsin.*

6. Louis Aragon, "La Peinture au défi," preface to the exhibition of collages at Galerie Camille Goemans, Paris, 1930, as translated in *The Autobiography of Surrealism*, ed. Marcel Jean (New York: Viking Press, 1980), 210.

7. André Breton, "Prologomena to a Third Surrealist Manifesto, or Not," *VVV* 1 (June 1942); reprinted in André Breton, *Manifestos of Surrealism*, trans.

Richard Seaver and Helen R. Lane (Ann Arbor: University of Michigan Press, 1972), 281–294. The felicitous phrase "avida dollars" is an anagram for Salvador Dalí and a reference to his commercialism.

8. Salvador Dalí, letter to André Breton of July 29, 1933; reprinted in José Pierre, "Breton et Dalí," in *Salvador Dalí Retrospective, 1920–1980*, exh.

cat., Musée National d'Art Moderne, Centre Georges Pompidou, Paris, December 18, 1979–April 14, 1980, 134–135.

9. For a discussion of the events surrounding Dalí's trial, with related documents, see José Pierre, "Breton and Dalí," and Karin Von Maur, "Breton et Dalí, à la lumière d'une correspondance inédite," in *André Breton: La Beauté convulsive*, exh. cat., Musée National d'Art Moderne, Centre Georges Pompidou, Paris, April 25–August 26, 1991, 196–202.

10. André Breton, "Des Tendances les plus récentes de la peinture surréaliste," *Minotaure* 12–13 (May 1939).

11. "A Dalí Dream Come True," *Newsweek*, March 27, 1939, 27.

12. "Dalí Surrealistic Show to Provide Fun at Fair," *New York Times*, April 23, 1939, 36.

13. "Dalí Manifests," *Art Digest*, August 1, 1939, 9. For a complete account of Dalí's project for the New York World's Fair, see "Salvador Dalí: Dream of Venus," exh. cat., Teatre-Museu Salvador Dalí, Figueres, 1999.

14. In "Des Tendances les plus récentes de la peinture surréaliste" (*Minotaure* 12–13 [May 1939], 17), Breton dismissed Dalí as a showman in his multi-image paintings: "By dint of wishing to over-refine on his paranoiac method, we observe that [Dalí] is beginning to indulge in a game of

amusement akin to the *crossword puzzle*" (as translated in Gibson, *Shameful Life*, 396).

15. "New Yorkers Stand in Line to See His Six-in-One Surrealist Painting," *Life*, April 17, 1939, 44–45.

16. "Art," *Time*, April 3, 1939, 43.

17. Paul Bird, "The Fortnight in New York," *Art Digest*, April 1, 1939.

18. Dalí to Breton (December 26, 1936), in *La Beauté convulsive*.

19. Salvador Dalí, "Surrealism in Hollywood," *Harper's Bazaar*, June 1937, 68. For a discussion of Dalí's commercial endeavors in relation to his work in Hollywood, see Lynda Klich, "*Spellbound* and the Banalization of Surrealism and Psychoanalysis in the United States: A Study in Cultural Trends" (seminar paper, Institute of Fine Arts, New York University, May 1999).

20. A photograph of Man Ray's *Observatory Time—The Lovers* was paired with a chic woman modeling a Hattie Carnegie beach coat in the November 1936 issue of *Harper's*. For an excellent account of the marketing of surrealism as haute couture, see Richard Martin, *Fashion and Surrealism* (New York: Rizzoli, 1987).

21. Gala–Salvador Dalí, "First Prophecy on Jewels," *Vogue*, January 1, 1939, 88.

22. As one commentator astutely predicted, "Right now the use of

surrealism by advertisers and sellers is largely confined to those dealing with the luxury class. Commercial surrealism will probably expand into other income brackets the way it has been expanding into various mediums. Come a few more years, and we may be examining surrealism in Macy's bargain basement." Frank Caspers, "Surrealism in Overalls," *Scribner's*, August 1938, 17–21.

23. Barry Byrne, "Surrealism Passes," *The Commonweal*, July 2, 1937, 262.

24. "Art," *Time*, April 3, 1939, 43.

25. John Canaday, "Nostalgia and the Forward Look: Duchamp Surveys Surrealism and Dalí Forges Ahead in All Directions," *New York Times*, December 4, 1960, section II, 21. The occasion for Canaday's remark was the International Surrealist Exhibition Marcel Duchamp organized for the D'Arcy Galleries in New York, to which Dalí submitted *The Enigma of William Tell* (fig. 2), among other controversial works, much to Breton's consternation.

26. Winthrop Sargeant, "Dalí," *Life*, September 29, 1945, 63–66, 68.

27. "Art: The Reality of Salvador Dalí," unsigned notice, *Life*, December 3, 1945, 114–115.

28. See, for example, Monroe Wheeler's preface to the catalogue of Dalí's first one-man exhibition at the Museum of Modern Art, New York, in 1941.

Wheeler suggested that Dalí's art arose "out of a troubled epoch which neither reports nor comments upon the trouble, but is in itself a significant happening in history. . . . We believe that Dalí is an artist of the greatest interest at the moment, and meaningful in this historic sense. His imagination is not abnormal, at least no more so than that of a number of geniuses of painting in the past; no more so than the tormented psyche of today which is its basic theme. . . . Certainly he offers no solution for the ills of his age. But we believe in lyricism as well as in the more utilitarian functions of the creative spirit. Even excessive feeling in arts is useful to humanity in crisis, in that it forces us to think. One thing we all understand now is that the optimism of the fortunate civilized nations has been of great peril to civilization. Dalí's dream of the present is tragic, and we should not shrink from the shock and pain of it. . . . This is a day of wrath in many ways, and even in his youth Dalí saw it coming."

29. A. Reynolds Morse, "The Dream World of Salvador Dalí," *Art in America* 33, no. 3 (July 1945): 111–126.

30. See, for example, Marxist critic Nicolas Calas's diatribe "Anti-Surrealist Dalí: I Say His Flies Are Ersatz," *View* 1, no. 6 (June 1941): 1,3; and George Orwell's biting critique, "Benefit of Clergy: Some Notes on Salvador Dalí," in *Dickens, Dalí and Others* (New York: Harcourt, Brace,

1946), 170–184.

31. André Breton, "Genesis and Perspective of Surrealism," in *Art of This Century* (New York: Art of This Century Gallery, 1942), 13–27.

32. Clement Greenberg, "Surrealist Painting," *The Nation*, August 12 and 19, 1944; reprinted in *Clement Greenberg, The Collected Essays and Criticism*, vol. 1, ed. John O'Brian (Chicago: University of Chicago Press, 1988), 225–231.

33. Harold Rosenberg, "Midas with a Waxed Moustache" (review of Fleur Cowles, *The Case of Salvador Dalí*), *Saturday Review of Literature*, May 14, 1960, 22–23.

34. Carter Ratcliff, "Swallowing Dalí," *Artforum*, September 1982, 33–39.

THE SALVADOR DALÍ MUSEUM COLLECTION

Catalogue notes by

Robert S. Lubar

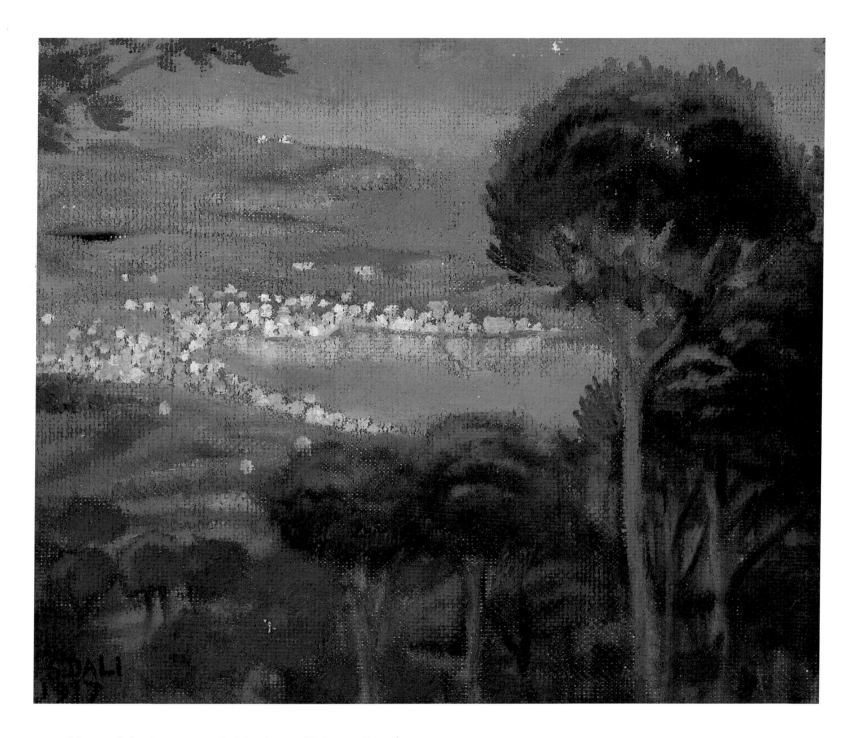

1. *View of Cadaqués with Shadow of Mount Paní*, 1917

Oil on burlap
15 1/2 × 19 inches

The village of Cadaqués occupies a decisive position in Dalí's life and work. Not only did the landscape of Cadaqués and its environs provide

Dalí with specific motifs for his art throughout his career, but the village itself is synonymous with Dalí's formative artistic development. Located on Spain's northeastern coast a few kilometers from the French border, Cadaqués was a remote fishing

community barely touched by the modern world when Dalí's father, Salvador Dalí i Cusí, rented a little summerhouse on the beach from his friends, the Pitchot family, sometime around 1910. Whipped by the maddening winds of the *tramontana* in

the winter and bathed in the warm light of the Mediterranean in the summer, Cadaqués is a landscape of sharp contrasts. The terraced slopes of Mount Paní surrounding the village had been planted with grapevines, which, by the time Dalí's family

arrived, had fallen victim to the great phylloxera epidemic that swept through France and Spain. In the distance, the rocky formations of Cap Creus, sculpted by millennia of fierce winter storms, were a constant reminder of the harsh conditions that supported the summer paradise Dalí encountered as a youth. As the artist explained to André Parinaud in 1977:

Where else does one find so desolate a feeling, such abandoned pathways, such indigent roads, so sparse a vegetation, but

also where an imagination living with more luxury in the excellence of the line of the hills, the design of the bay, the shape of the rocks, the fine and shaded gradation of the espaliers leading down to the sea? Solitude, grace, sterility, elegy— the contrasts come together as in the nature of man, and we live in a perpetual set of miracles. O excellence of those things from which my eyes will never cease to take nourishment.[1]

Painted on coarse burlap (a material readily available in this

fishing community), *View of Cadaqués with Shadow of Mount Paní* is a panoramic landscape of the village surrounded by umbrella pines and Cap Creus in the distance. A warm orange light bathes the village, contrasting sharply with the large aqua planes of the quiet sea and the intense green mass of the pine trees. A small area of foliage in the upper-left corner establishes a sight line for Cap Creus in the background, framing the landscape and transforming the spectacle of nature

into a picturesque view. In the middle ground, the whitewashed houses of Cadaqués sparkle in the intense late afternoon light as the shadow of Mount Paní slowly descends upon the village.

Notes

1. Salvador Dalí, *The Unspeakable Confessions of Salvador Dalí* (as Told to André Parinaud), (London: Quartet Books, 1977), 16.

2. *Punta es Baluard from Riba d'En Pitchot, Cadaqués*, 1918–19

Oil on canvas
8 × 11 inches

Dalí's apprenticeship in modern art began in earnest in June 1916 when the young painter, recovering from the strain of his exams at the Marist Brothers' school in Figueres, vacationed at the Molí de la Torre, Pepito Pitchot's country estate. Pepito's brother Ramón (1871–1925) was a close friend of Picasso's and a member of the *tertúlia* that gathered at Els Quatre Gats café in fin-de-siècle Barcelona; his paintings and prints adorned the walls of Pepito's dining room. Ramón had made a name for himself as a painter of the French school, exporting the latest advances of impressionism and post-impressionism back home. In *The Secret Life* of 1942, Dalí left a vivid record of his introduction through Ramón to advanced French painting while dining with the Pitchots:

These breakfasts were my discovery of French impressionism, the school of painting which has in fact made the deepest impression on me in my life because it represented my first contact with an anti-academic and revolutionary esthetic theory. I did not have eyes enough to see all that I wanted to see in those thick and formless daubs of paint, which seemed to splash the canvas as if by chance, in the most capricious and nonchalant fashion. Yet as one looked at them from a certain distance and squinting one's eyes, suddenly there occurred that incomprehensible miracle of vision by virtue of which this musically colored medley became organized, transformed into pure reality. The air, the distances, the instantaneous luminous moment, the entire world of phenomena sprang from the chaos! R. Pitchot's oldest painting recalled the stylistic and iconographic formulae characteristic of Toulouse-Lautrec. . . .

But the paintings that filled me with the greatest wonder were the most recent

ones, in which deliquescent impressionism ended in certain canvases by frankly adopting in an almost uniform manner the pointilliste *formula. The systematic juxtaposition of orange and violet produced in me a kind of illusion and sentimental joy like that which I had always experienced in looking at objects through a prism, which edged them with the colors of the rainbow. There happened to be in the dining room a crystal carafe stopper, through which everything became "impressionistic." Often I would carry this stopper in my pocket, to observe the scene through the crystal and see it "impressionistically."*[1]

Dalí's encounter with Ramón Pitchot's work was fortuitous, as French impressionist painting made a late showing in Spain. Impressionism (and advanced French painting in general) was first introduced to the Catalan public in 1907 on the occasion of the V Exposición Internacional de Bellas Artes e

Industrias Artísticas. It did not make another significant appearance until 1917, when the French and Spanish governments organized a huge wartime extravaganza in Barcelona, the so-called Exposició d'Art Français, which included works by Cézanne and Renoir. In the interim, the ability to study recent French painting through the eyes of a contemporary presented Dalí with an excellent opportunity, as his understanding of light, color, and technique had been translated by Pitchot into a local idiom. Indeed, many of Dalí's Cadaqués landscapes, where he put his recently acquired knowledge to the test, are patterned on works by Pitchot, although Dalí exhibited a precocious gift for interpretation at an early date.

Punta es Baluard from Riba d'En Pitchot, Cadaqués is a view of Cadaqués from the Pitchot family home on the beach. Directing his angle of vision to the foreground

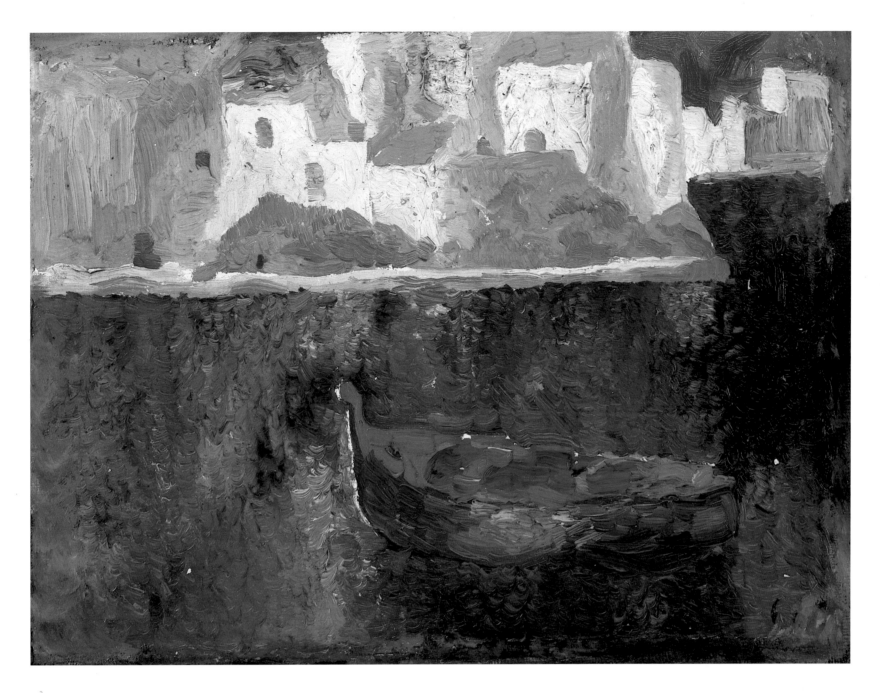

plane and all but dispensing with a horizon, Dalí collapses the space of the painting. In the background several whitewashed buildings stand on low cliffs directly at the water's edge. The intense, vibrant light that falls on the houses, translated into a symphony of oranges and violets, contrasts sharply with the deep green sea, creating a kind of *repoussoir* effect that brings an illusion of depth to this otherwise flattened frontal composition. The brilliant orange and red of the foreground fishing boat in turn creates an anchor for the composition, pulling the eye back into the foreground plane. Dalí's loose brushwork and penchant for flat planes of pure color point to the influence of Toulouse-Lautrec (as translated by Pitchot), while the play of light and contrasting colors suggest that Dalí had also studied the work of Pitchot's contemporaries Joaquim Mir and Hermen Anglada-Camarasa.

Notes

1. Salvador Dalí, *The Secret Life of Salvador Dalí* (New York: Dial Press, 1942), 81.

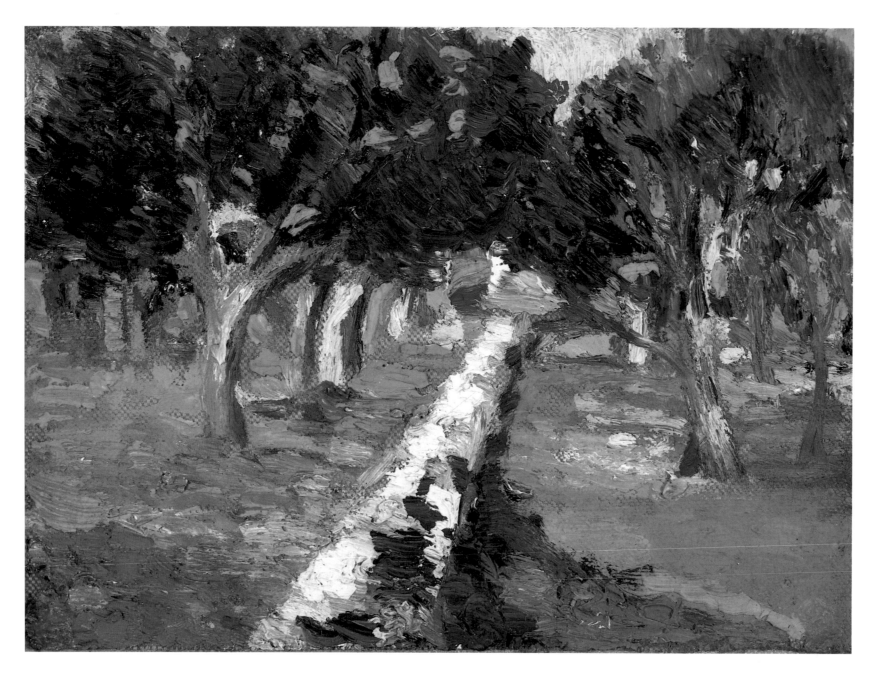

3. *Hort del Llané, Cadaqués*, 1918–19

Oil on canvas
7 7/8 × 10 7/8 inches

Hort del Llané, Cadaqués is one of two nearly identical versions of a familiar motif: the orchards and olive groves behind the Dalí family home on the beach of Es Llané. With the poetic sensibility of an impressionist, Dalí expressed his rapture before the intimate spectacle of nature in his paintings and writings of this period. In a diary entry dated May 24, 1920, he lyrically described an afternoon outing in the countryside with his family:

The fields of wheat stretch out from the edges of the path. . . . The wind rocks the spikes and the fields undulate like golden waves. Everything reverberates with light and the earth shows its fertile power. The poppies embroider the fields with red marks and the orchards extend far into the distance, with their trees brimming with greenish fruits and their staked tomato vines about to ripen. The irrigation channels water the roots of the cabbages and other vegetables, and the spring flowers adorn the railings of the wells with exquisite taste. The sparrows sing and the swallows fly overhead. We continue along a path covered with daisies and yellow flowers along the side of the road.[1]

Notes

1. Salvador Dalí, *Un Diari, 1919–1920: Les Meves impressions i records íntims*, ed. Fèlix Fanés (Barcelona: Edicions 62, 1994), 108–109.

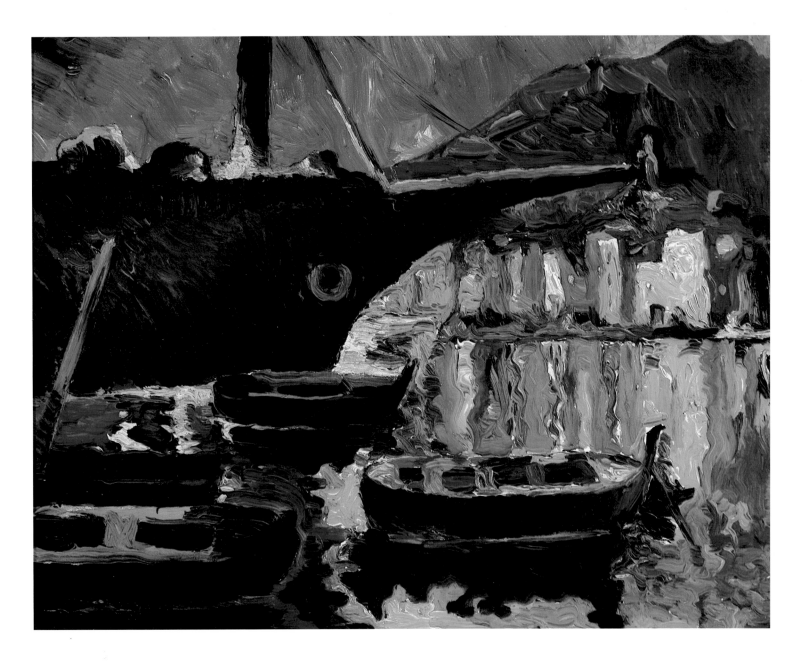

4. *Port of Cadaqués (Night)*, 1918–19

Oil on canvas
7 3/8 × 9 1/2 inches

Exhibition
New York 1965

In the tradition of impressionist *nocturnes* and the nearly monochromatic works of James Abbott McNeill Whistler, *Port of Cadaqués (Night)* might be subtitled "Harmony in Blue." Dalí's view of the port at night is a chromatic fugue; deep ultramarine blues, teals, aquas, and blue-green tones coalesce in the rippled waters, with the silhouette of Mount Paní in the background and a large sailboat in the middle ground. Working with color on the dark end of the value scale Dalí establishes a high degree of luminosity. A few areas of brilliant yellow on the mast of the ship and in the water and touches of red along the fishing boats in the foreground and the coastline and hills behind the village suggest the hour is dusk or dawn. Dalí's sensitivity to the conditions of light and color in nature is underscored by the presence of a second version of the motif in a private collection.

5. *Playa Port Alguer from Riba d'En Pitchot*, 1918–19

Oil on canvas (burlap?)

8 × 9 1/2 inches

Exhibition

New York 1965

Recalling Monet's views of Rouen Cathedral painted at different times of day and under different atmospheric conditions, *Playa Port Alguer from Riba d'En Pitchot*, like a second, identical view of the same year, depicts the church of Cadaqués shrouded in mist. The scene is viewed from a small road on the western edge of Cadaqués known as the Riba d'En Pitchot, which follows the shoreline and passes under a house with an open loggia of three arches (see cat. nos. 6 and 7). Port Alguer (or Portdogué, as it is also known) is located at the foot of the small hill on which stands the church of Cadaqués. The fishing boats that are normally anchored in this picturesque port have all but disappeared beneath the towering silhouette of the church, whose mass is dissolved by the brilliant spectacle of light and color. Using a palette of lilacs, greens, and blues, with touches of white, Dalí captures the effects of morning light refracting off the moist air of the sea.

The degree of formal reduction Dalí achieves in this painting is notable. The surface is given over to a thick application of paint whose materiality belies the apparent dissolution of form. It is possible that Dalí was inspired by the work of Joaquim Mir (1873–1940), whose luminous paintings of Mallorcan caves and lush gardens in the Tarragona countryside were among the most abstract works painted by a contemporary Catalan artist. When Dalí finally had the opportunity to study Mir's work in some depth on the occasion of Barcelona's 1920 Exposició d'Art Municipal, he recorded his impressions in his diary: "Mir! Mir! . . . Still waters with diabolic transparencies, gilded trees, skies scintillating with dreamy colour. . . . But, more than stagnant waters, golden sunsets, shady gardens, colour, colour, colour, colour! . . . Mir is a genius with colour and light, and can stand beside the great French Impressionists, of whom he's a fervent disciple."[1]

Notes

1. Salvador Dalí, *Un Diari, 1919–1920: Les Meves impressions i records íntims*, ed. Fèlix Fanés (Barcelona: Edicions 62, 1994), 121, as translated in Ian Gibson, *The Shameful Life of Salvador Dalí* (London: Faber and Faber, 1997), 79.

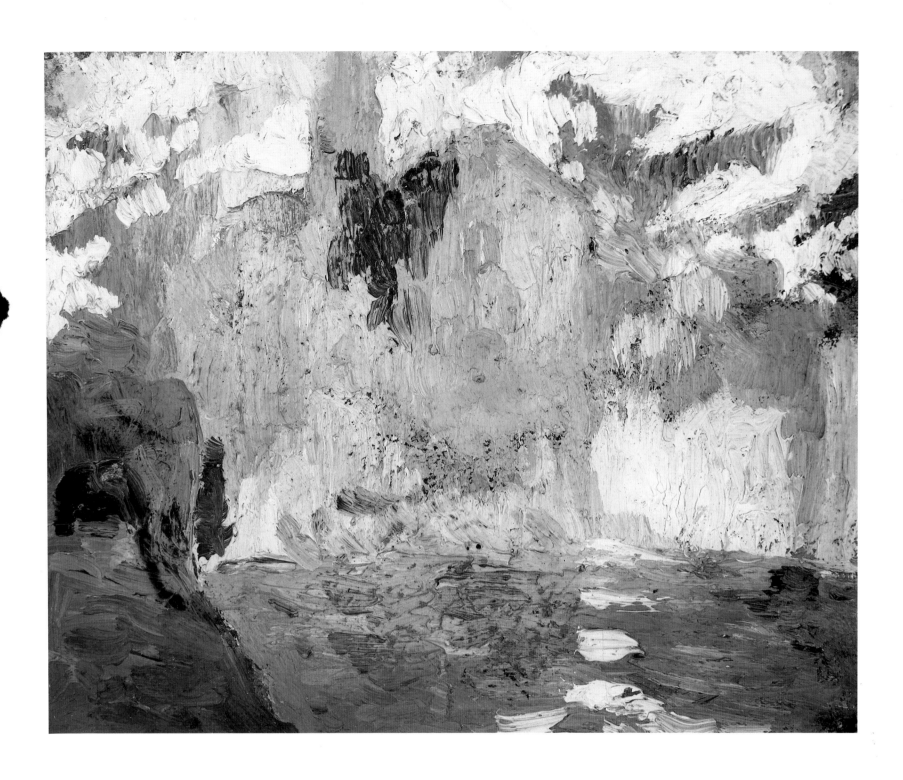

Playa Port Alguer from Riba d'En Pitchot 7

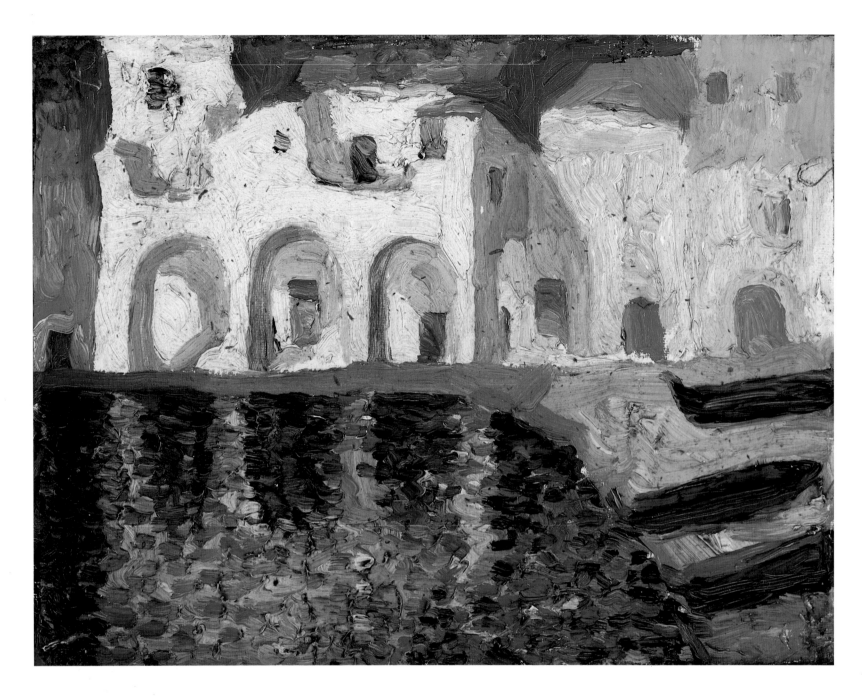

6. *Portdogué, Cadaqués*, 1918–19

Oil on canvas
8 3/8 × 11 inches

Exhibition
New York 1965

Portdogué, Cadaqués and its pendant, *View of Portdogué (Port Alguer), Cadaqués* (cat. no. 7), are closely related views of the Riba d'En Pitchot along the shoreline of the village (see cat. no. 5). Although the perspective is slightly different in each painting, with a less inclusive field of vision in the former canvas, it is likely that the two works were painted at the same time, as was Dalí's practice. The whitewashed surfaces of the buildings form a planar structure whose intense luminosity Dalí establishes by playing off near-complementary color schemes: the lilac shadows of the arches are set off against the slightly yellowed surfaces of the facade, while green and red-orange rectangular areas denote window and door openings. The space of *Portdogué*, *Cadaqués* is more compressed than that of *View of Portdogué*, and the background is treated as a mass of near-abstract color planes that are reflected in the rippled surface of the water. Notable for the absence of figures, both landscapes speak to the calm and solitude Dalí associated with his adopted village.

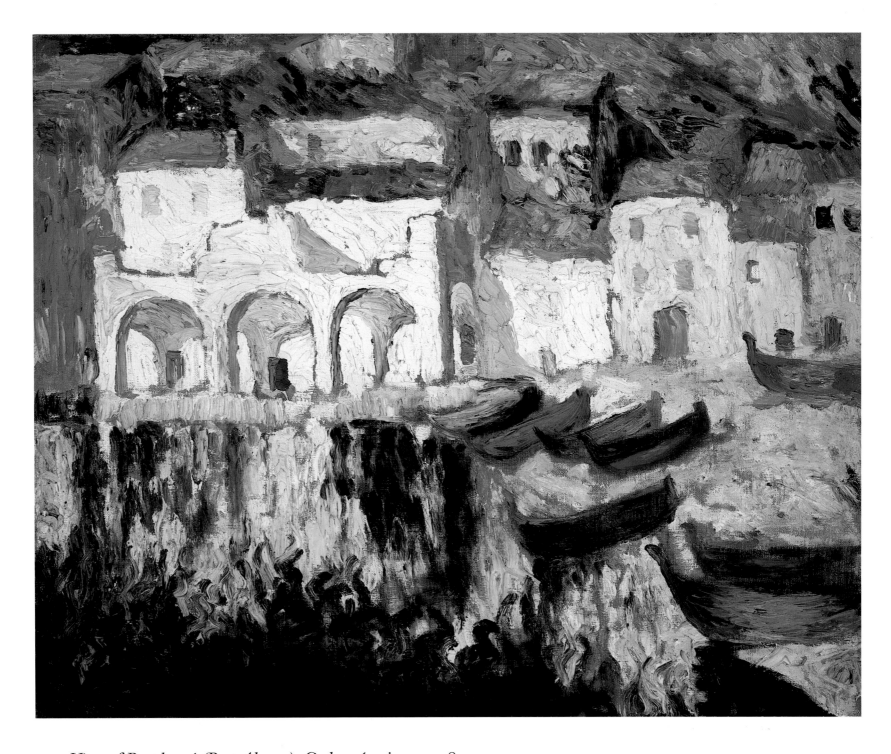

7. *View of Portdogué (Port Alguer), Cadaqués*, circa 1918–19

Oil on canvas
17 3/4 × 20 inches

Exhibitions
New York 1965
Rio de Janeiro 1998

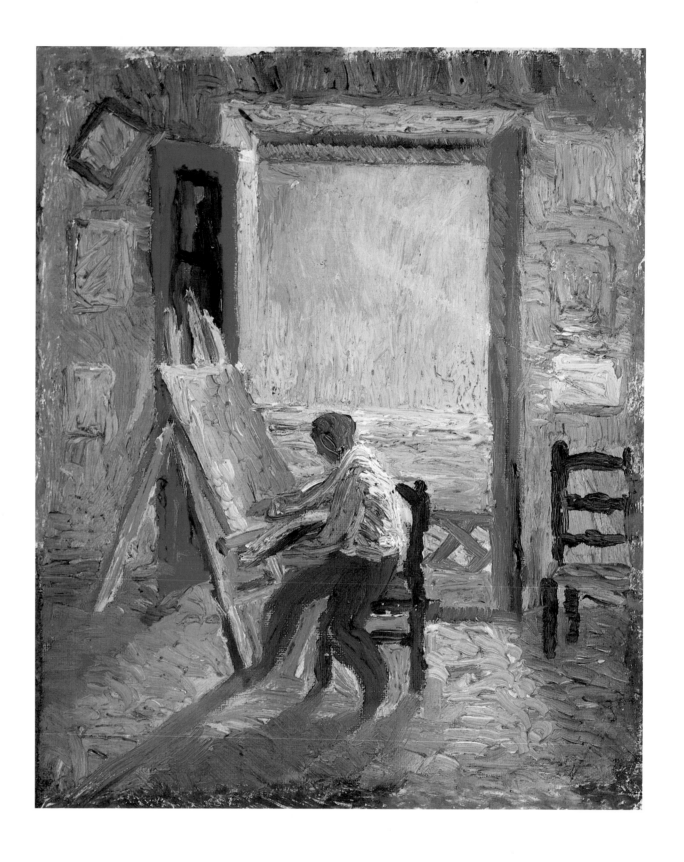

Self-Portrait

8. *Self-Portrait*, 1918–19

Oil on canvas
10 1/2 × 8 1/4 inches

Exhibitions
New York 1965
Fort Lauderdale 1997

To speak of self-portraiture in Dalí's work is, in an important sense, redundant, as Salvador Dalí—the man, the artist, and the person—is the privileged subject and object of his life's work. Not only is Dalí's visual practice matched by his excursions into the realm of literary autobiography, as in the case of the artist's extravagant 1942 text, *The Secret Life of Salvador Dalí*, but the ontological status of self-portraiture in Dalí's work is open to numerous interpretations. From the more generic *Self-Portrait* of 1918–19, in which Dalí presents himself at work before his easel, to the anamorphic self-portrait masks that appear in Dalí's paintings from 1929 on (cat. nos. 34, 35, 45, 70, and 82) and the late, double self-portraits with Gala (cat. no. 91), Dalí explores himself as a social, psychoanalytical, and gendered subject.[1]

In *Self-Portrait* of 1918–19, Dalí appears as an emergent artist working in his first studio in Cadaqués. Signs of Dalí's labors are present in the canvases that hang on the back wall. To capture the intense Mediterranean light, Dalí paints before the open window of his balcony, with a view onto a brilliantly illuminated sea. The deep shadow cast by the figure and the rich golden and red hues that bathe the room in warm light suggest the hour is sunrise or sunset.

The painting is a statement about Dalí's artistic vocation and his corresponding exploration of light and color. Maximum tonal effect is established by the subtle modulation of pure unmixed colors, from the brilliant red of the open window to areas of purple, green, and yellow. More than the influence of Manet, Renoir, Degas, and the neo-impressionists, as transmitted in part through the work of Ramón Pitchot, Dalí seems to be incorporating lessons learned from fauve painting, especially in the choppy brushwork and the heavy application of paint. Recalling Matisse's early fauve paintings of 1904–05, including the motif of the open window, Dalí varies the quality and direction of his brushwork, using a staccato, choppy stroke to describe the waves on the ocean to establish the effect of intense luminosity, and a flatter application of the brush for the open window and pants.

According to the artist's sister, Ana María, Dalí's father secured a studio for his son on the Carrer del Llaner, not far from the converted stable the family had rented from the Pitchot family just outside town.[2] The space, a white room on the upper floor of a fisherman's house overlooking the sea, had been Ramón Pitchot's studio. In his diary of 1920, Dalí painted a vivid portrait of his new working space:

It was a large, whitewashed room on the upper floor of a miserable fisherman's house. The first time I entered it was full of . . . ants, jars of anchovies, stored chairs, barrels of wine, and bundles of dirty, heaped up clothing. The roof was in danger of caving in. Patches of blue sky could be seen through the thatching. It was very picturesque, but very dirty and a bit dangerous. The debris was cleared away and, once inside, I studied the room more closely. At the front end was a balcony from which the sea—a very blue and serene sea—and the sky could be seen. Boats passed by with their sails open, golden from the sun, and the swallows and birds flew around, gaily chirping. On the other side there was a window from which one could see Mount Paní, and an almond tree orchard in the foreground. A baroque, whitewashed altar was on one wall, where I placed a jug filled with rosemary. . . . I organized some books in a worm-eaten cupboard— something by Baroja, Rubén Darío, Erça de Queiróc, and I think a volume by Kant—that I didn't open the entire summer. There were also some other books with reproductions, and the complete Gowans collection. On a table there was a jug with brushes, a paint box, paper, an inkwell, a pencil, a hammer to straighten out the chairs and frames, rolls of Ingres paper and canvas. A large easel was in the middle of the room and a small one hung from a nail. I rubbed my hands with satisfaction and I began to look tenderly upon that studio which, almost without my realizing it, I had already begun to love.[3]

Notes

1. For a discussion of these points, see Robert S. Lubar, "Salvador Dalí: Portrait of the Artist as (An)other," in *Salvador Dalí: A Mythology*, ed. Dawn Ades and Fiona Bradley, exh. cat., Tate Gallery, Liverpool, 1998, 106–116.

2. Ana María Dalí, *Salvador Dalí visto por su hermana* (Barcelona: Parsifal Ediciones, 1993), 24–26.

3. Salvador Dalí, *Un Diari, 1919–1920: Les Meves impressions i records íntims*, ed. Fèlix Fanés (Barcelona: Edicions 62, 1994), 134. The Gowans collection refers to a series of art books that Dalí had studied as a youth.

9. *View of Cadaqués from Playa Poal, 1920*

Oil on canvas
11 1/2 × 19 inches

Exhibitions
New York 1965
Tallahassee 1999

This view of Cadaqués from across the bay is one of Dalí's most impressionistic paintings. Following his departure from Cadaqués in the summer of 1920, Dalí recounted to his uncle Anselm Domènech his current preoccupations:

I spent a delicious summer, as always, in the ideal and dreamy village of Cadaqués. *There, beside the Latin sea, I gorged myself on light and colour. I spend the fiery days of summer painting frenetically and trying to capture the incomparable beauty of the sea and of the sun-drenched beach.*

I'm growing more and more aware all the time of the difficulty of art; but I'm also growing to enjoy it and love it increasingly. I still admire the great French Impressionists, Manet, Degas and Renoir, *the ones who direct my path most firmly. My technique has changed almost completely and my colours are much clearer than before, having abandoned the dark blues and reds which previously contrasted (inharmoniously) with the clarity and luminosity of the others.*

I still hardly pay any attention to preparatory drawing, which I manage to do without almost completely. It's colour and feeling that command my efforts. I don't care at all whether one house is higher or lower than another. It's the colour and the range that give life and harmony.

I believe that drawing is a very secondary part of painting, and is picked up automatically, through habit, and that therefore it doesn't need any detailed study or particular effort.[1]

The artistic lessons Dalí had learned that summer are immediately evident in *View of Cadaqués from Playa Poal.* The triangular mass of the village, crowned by the church in the center, is atomized into a brilliant mosaic of discrete pink, lavender, and white tesserae. The intense light of the Mediterranean is reflected on the whitewashed buildings and explodes in a profoundly luminous sky. The choppy, varied brushwork adds a sense of freshness and immediacy, defining form in relation to texture and color. Despite the apparent absence of preparatory drawing, years of patient observation have conditioned this expressive interpretation of a familiar motif.

Notes

1. Salvador Dalí, *Un Diari, 1919–1920: Les Meves impressions i records íntims,* ed. Fèlix Fanés (Barcelona: Edicions 62, 1994), 57–58, as translated in Ian Gibson, *The Shameful Life of Salvador Dalí* (London: Faber and Faber, 1997), 65

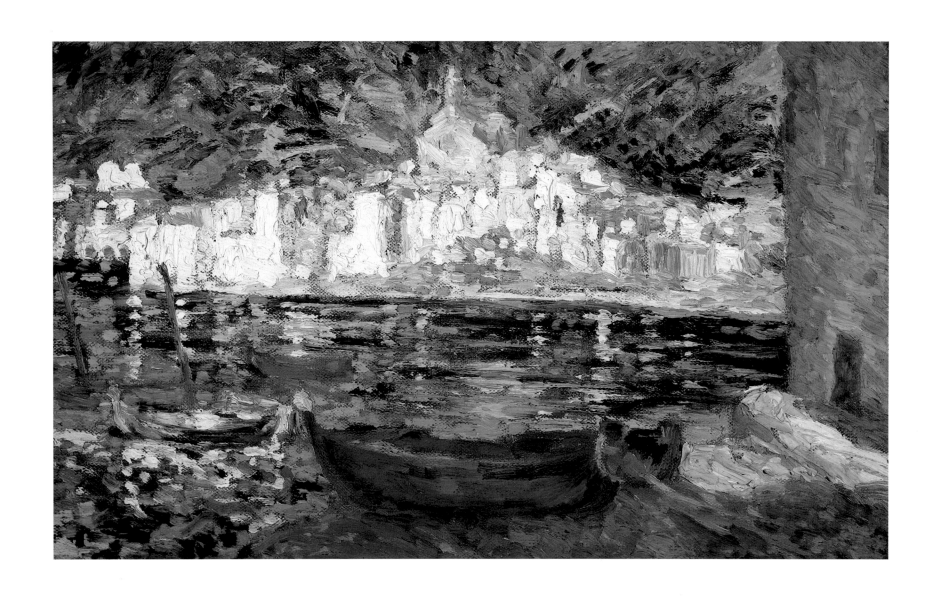

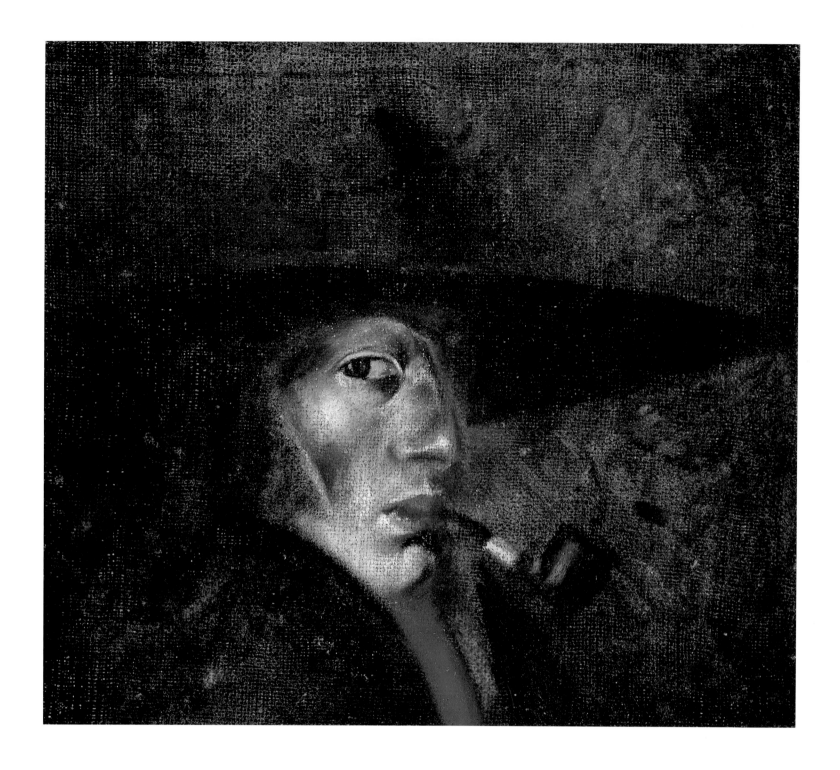

Self-Portrait (Figueres)

10. *Self-Portrait (Figueres)*, 1921

Oil on burlap

14 1/2 × 16 1/2 inches

Exhibitions

New York 1965

London 1994

Atlanta 1996

Shinjuku 1999

From his earliest days Dalí used dress and the outward signs of physical appearance as a means to assert his identity. In *The Secret Life* of 1942, Dalí described a kind of youthful masquerade in which he transformed himself into an eccentric outsider to bourgeois society:

I had let my hair grow as long as a girl's, and looking at myself in the mirror I would often adopt the pose and the melancholy look which so fascinated me in Raphael's self-portrait, and whom I should have liked to resemble as much as possible. I was also waiting impatiently for the down on my face to grow, so that I could shave and have long side-whiskers. As soon as possible I wanted to make myself "look unusual," to compose a masterpiece with my head; often I would run into my mother's room—very fast so as not to be caught by surprise—and hurriedly powder my face, after which I would exaggeratedly darken the area around my eyes with a pencil. Out in the street I would bite my lips very hard to make them as red as possible. These vanities became accentuated after I became aware of the first curious glances directed toward me, glances by which people would attract one another's attention to me, and which said, "that's the son of Dalí the notary." [1]

As he performed his sense of social difference publicly, Dalí's unusual appearance gained him considerable notoriety. Not only did his costume identify him as an "insurgent" within bourgeois society, [2] but Dalí also stood out among his artist peers at the Residencia de Estudiantes in Madrid, where he lived while attending the Real Academia de San Fernando. He later recalled:

I bought a large black felt hat and a pipe which I did not smoke and never lighted, but which I kept constantly hanging from the corner of my mouth. I loathed long trousers, and decided to wear short pants with stockings, and sometimes puttees. On rainy days I wore a waterproof cape which I had brought from Figueres, but which was so long that it almost reached the ground. With this waterproof cape I wore the large black hat, from which my hair stuck out like a mane on each side. I realize today that those who knew me at that time do not at all exaggerate when they say that my appearance "was fantastic." It truly was. [3]

In *Self-Portrait (Figueres)* Dalí sports the eccentric costume for which he became known. Employing the device of a deep Rembrandtesque chiaroscuro set off against areas of intense blue, red, and yellow paint, Dalí establishes the effects of high drama, suggesting that his self-portrayal is also a performance, an exercise in self-display. Like an actor with his stage props, Dalí marshals the full resources of his disguise in order to establish a discrete persona. Forgoing the traditional interpretation of portraiture as a moment of psychological introspection, Dalí locates himself in relation to a visible network of social and cultural signs.

Notes

1. Salvador Dalí, *The Secret Life of Salvador Dalí* (New York: Dial Press, 1942), 124–125.

2. A short chronicle that appeared in a local newspaper (One, "En S. Dalí Domènech," *Alt Emporda* [Figueres], September 17, 1921) described Dalí's appearance as "the only note of insurgency on our streets," a clear reference to the political turmoil of the day.

3. Dalí, *Secret Life*, 160.

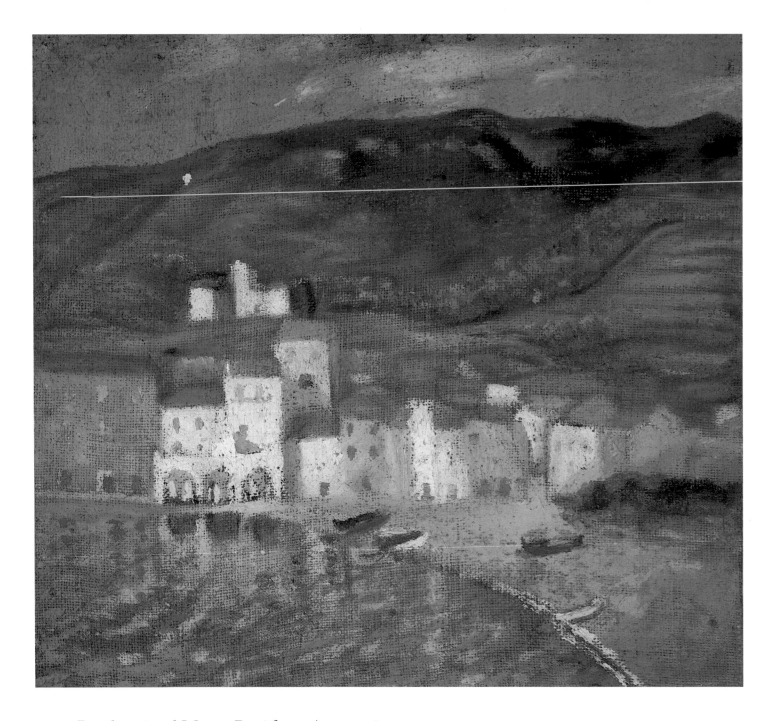

11. *Portdogué and Mount Paní from Ayuntamiento, 1922*

Oil on burlap
17 × 21 inches

Exhibitions
New York 1960A
New York 1965

This oil sketch of the Riba d'En Pitchot and Portdogué captures the more primitive aspects of Cadaqués. Signs of the former wine industry can be detected in the terraces that are carved into the hillside at the center right, while the rocky slopes of Mount Paní, largely stripped of vegetation but for some umbrella pines, shield the village from the outside world, adding to the austere beauty of the site.

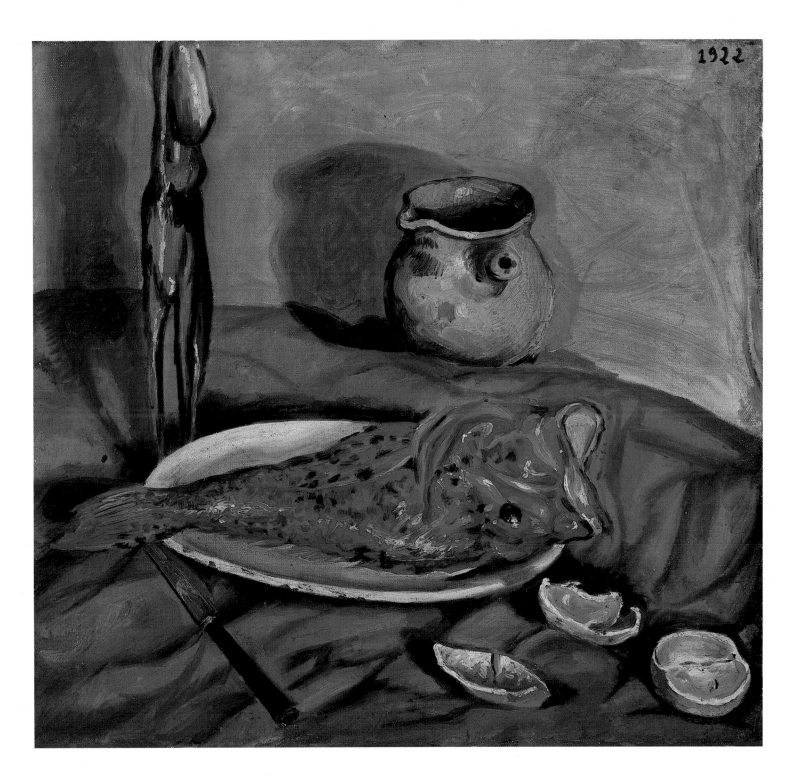

12. *Still Life (Pulpo y Scorpa)*, 1922

Oil on canvas

21 3/8 × 22 1/2 inches

Exhibition

New York 1965

The genre of still life engaged Dalí throughout his long career. One of the artist's earliest extant works is a copy of a Dutch interior by the Spanish painter Manuel Benedito y Vives (1875–1963), which Dalí had seen reproduced in the Catalan journal *Museum* in 1912.[1] The scene, depicting a female servant seated at a kitchen table in a sparse interior, points to Dalí's growing interest in Dutch still life, which the artist would locate at the center of his theory of objectivity in painting (see cat. nos. 24 and 25).

On the surface, *Still Life (Pulpo y Scorpa)* is a sober painting depicting the humble ingredients and rustic earthenware utensils that were staples of the Dalí family kitchen. Undoubtedly executed during a break from his studies in Madrid, where Dalí was able to examine Dutch, Flemish, and Spanish genre painting at the Prado, *Still Life (Pulpo y Scorpa)* demonstrates the artist's early, somewhat tentative mastery of form and the complexities of a multi-object composition. The delight Dalí takes in painting the red fish stretched out on a slightly chipped plate and the exuberance of his brushwork recall his experiments with plein-air painting in Cadaqués, while the solidity of the jug and the foreground wedges of fruit suggest Dalí's concern with compositional form and structure. Most unusual of all is the octopus, which appears to stand beside the plate but is in all probability hanging from a hook located outside the pictorial space. This strange object adds a vertical accent to the composition and contrasts sharply with the horizontal configuration of the red fish.

Notes

1. Dawn Ades, *Dalí* (London: Thames and Hudson, 1982), 12.

13. *The Lane to Port Lligat with View of Cap Creus*, 1922–23

Oil on canvas
22 3/4 × 26 3/4 inches

Exhibitions
Barcelona 1922?
New York 1965
Fort Lauderdale 1997
Rio de Janeiro 1998
Shinjuku 1999

The scene depicts a path lined on both sides by olive orchards leading from Cadaqués to the neighboring fishing village of Port Lligat, where Dalí would later settle. In the distance the lighthouse and rocks of Cap Creus are visible.

It is possible that *The Lane to Port Lligat* is the painting Dalí exhibited as *Olive Trees* with the Associació Catalana d'Estudiants in 1922. Of the 134 works presented at the Galeries Dalmau in Barcelona, Dalí's entries were singled out for special praise. One critic wrote:

This young artist has already been noticed in these pages as an outstandingly talented new Catalan painter. Here in the Empordà we have been watching the development of this precocious artist, who finds his subject-matter in the natural beauty of the landscape surrounding Cadaqués and Cap Creus. His truly personal artistic vision is abundantly clear in the manner in which he has treated these luminous inlets, finding just the right colour for the time of day and allowing it to impregnate the canvas with sensitivity. . . . The young Dalí is following a path which is sure to lead him to great success.[1]

Notes

1. Montserrat Aguer and Fèlix Fanés, "Illustrated Biography," in *Salvador Dalí: The Early Years*, exh. cat., South Bank Centre, London, 1994, 23. The notice appeared in *La Tribuna* (Barcelona) on January 27, 1922. In another review of the exhibition, Octavi Saltor singled out *Olive Trees* as a painting of "imponderable beauty, the best presented by Dalí." "Pintors figuerencs. A propòsit d'una exposició escolar, organitzada per la 'Associació Catalana d'Estudiants,' de Barcelona," *Alt Empordà* (Figueres), February 11, 1922.

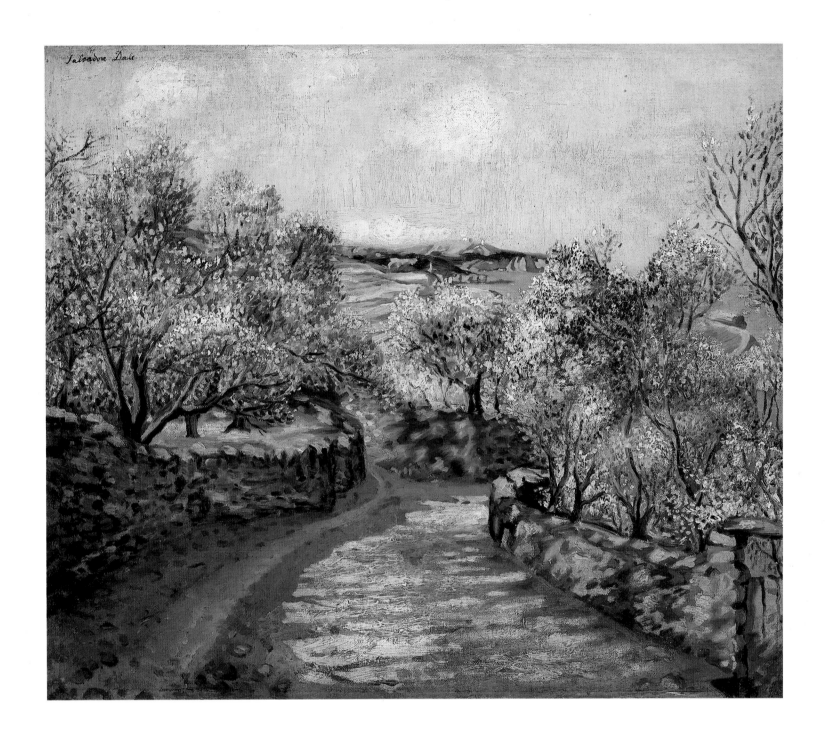

14. *Cadaqués, 1923*

Oil on canvas

38 × 50 inches

Exhibition

New York 1965

This panoramic view of the village of Cadaqués and the Riba d'En Pitchot from a hill overlooking Cadaqués Bay is a pastoral scene of country life. Two groups of women resting from their work in the fields are shown in the foreground, engaged in a range of leisure activities. The site may correspond to the orchard Dalí depicted a year earlier in *The Lane to Port Lligat* (cat. no. 13). The composition is also related to a number of highly finished drawings of olive groves and village scenes and a series of pastoral landscapes Dalí painted in 1923.

In both theme and style, *Cadaqués* marks a turning point in Dalí's artistic career. Not only is this a meticulously finished painting, but Dalí has abandoned the impressionist *facture* and intense palette that were characteristic of his early work. A new sense of order and composure is evident, as Dalí emphasizes the underlying structure of the landscape and treats volume and mass in terms of simplified, geometric shapes. The mosaiclike tesserae of Dalí's earliest experiments with neo-impressionist technique have now given way to the solid forms of houses painted in local color, while the olive trees are defined as a series of regular, curvilinear forms massed one atop the other. An organic rhythm unifies the composition, as Dalí directs the viewer's eye down the path at the lower left, through the terraced hillsides below and up along the sinuous curves of the distant mountains.

There are numerous sources for Dalí's change in style. The young painter closely followed recent developments in international avant-garde art. Dalí's uncle Anselm, a bookseller, provided his nephew with copies of the Italian art journal *Valori plastici* and the French periodical *L'Esprit nouveau*, both of which called for a return to classical principles of order and structure in painting. Closer to home, the classical revival of Catalan *Noucentisme* provided Dalí with the ideological and formal tools to imagine a contemporary arcadia in which man and nature exist in perfect harmony. With the exception of the hot-air balloon in the sky and the generic, albeit contemporary, costumes of the figures, Dalí presents Cadaqués as a self-sufficient, productive community frozen in time.

Although Dalí had clearly abandoned impressionism by 1923, it was not until 1926 that his friend the art critic Sebastià Gasch championed his cause and launched a systematic, highly public campaign against the persistence of impressionist painting in Catalonia. In an early article on Picasso, Gasch insisted that, "Impressionism forgot the fundamental laws that have governed the painted surface through all great periods of art. Impressionism converted painting into an amorphous art."[1] Two years later, in a lecture on recent Catalan painting, Dalí followed suit, lamenting the anachronistic survival of a home-grown, sentimental naturalism in the style of the nineteenth-century painter Martí i Alsina and dismissing contemporary landscape artists as "painters of twisted trees."[2]

———

Notes

1. Sebastià Gasch, "Picasso i l'impressionisme," *Gaseta de les arts* (Sitges) 44 (March 1, 1926).

2. Salvador Dalí, "Art català relacionat amb el més recent de la jove intel.ligència," *La Publicitat* (Barcelona), October 17, 1928; reprinted in Salvador Dalí, *L'Alliberament dels dits. Obra catalana completa*, ed. Fèlix Fanés (Barcelona: Quaderns Crema, 1995), 133–146.

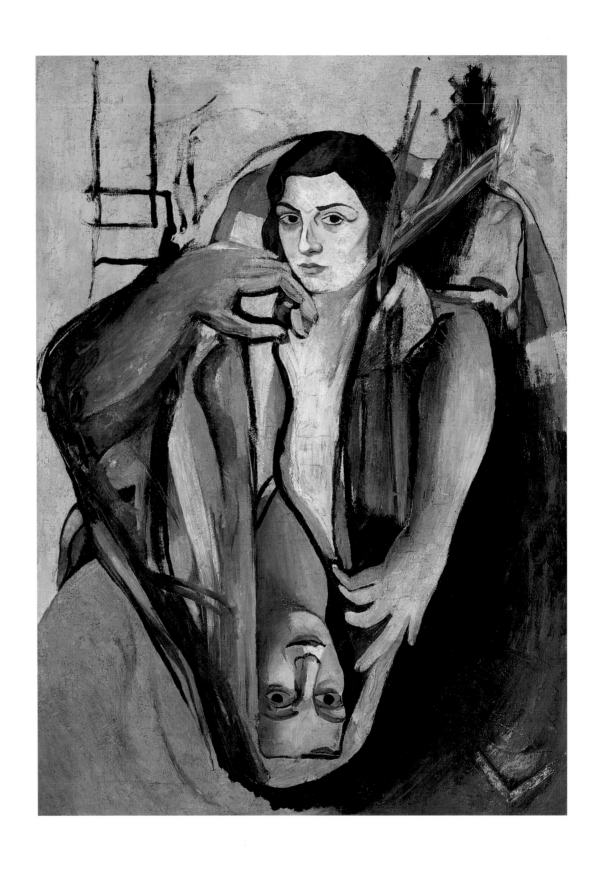

15. *Portrait of My Sister,* 1923

Oil on canvas
41 × 29 3/4 inches

Exhibitions
Barcelona 1925?
New York 1965

Dalí's younger sister, Ana María (1908–90), occupies a prominent position in his early work. Between 1923 and 1926 Dalí portrayed his sister at least twelve times, in states ranging from passive contemplation to symbolic crucifixion (see cat. no. 26). On the occasion of his first one-man exhibition in 1925, at the Galeries Dalmau in Barcelona, Dalí exhibited eight of these portraits, one of which is probably this image.

Period photographs reveal that *Portrait of My Sister* was originally a straightforward representation of Ana María dressed in a casual robe, her hands crossed in her lap, seated in an armchair beside a table laden with books and a piece of fruit. The stylized counterimage in the finished work, with its masklike features and horribly distorted arms, was a later addition that effectively transformed the painting into a bizarre and monstrous caricature. There is some question concerning the precise significance of the overpainting, and whether it is by Dalí's hand. Were the stylized features of Ana María's counterimage conceived in response to Picasso's atavistic classicism, which Dalí had ample opportunity to consider firsthand when he visited the artist's studio on the occasion of a trip to Paris and Brussels with his aunt and sister in April 1926? Or do the grotesque aspects of the double portrait reflect Dalí's alienation from his sister following his union with Gala in 1929? Whatever the motivation for this change, *Portrait of My Sister* is an arresting image of psychic division, an apprehensive encounter with the self as a monstrous other.

Dalí's relationship with Ana María was fraught with love and aggression. In *The Secret Life* Dalí recounts an incident in which he kicked his younger sister in the head when she was two years old. Although the story is probably apocryphal, it underscores the artist's rage that his position as the supreme love object of his parents had been compromised by the birth of his sister. Years later, when Ana María sided with her father over an incident in which Dalí was expelled from the family home for inscribing a canvas of 1929 with the words "Sometimes I spit for PLEASURE on the portrait of my mother," the Oedipal drama assumed a new sense of urgency for the painter. Despite a reconciliation with his father in 1935, in which Salvador Dalí i Cusí reinstated his son in his will, Dalí's relationship with Ana María remained difficult. When Ana María in her 1949 book *Salvador Dalí Seen by His Sister* contradicted Dalí's autobiographical narrative in *The Secret Life* and blamed Gala and surrealism for the downfall of her brother, Dalí's quarrel with his sister resumed with an intensity that was to last until his death.

16. *Still Life (Fish with Red Bowl),* 1923–24

Oil on canvas
19 3/4 × 21 3/4 inches

Exhibitions
New York 1965
Fort Lauderdale 1997

The formal solidity of *Still Life (Fish with Red Bowl)* suggests that Dalí had become increasingly adept at mastering multi-object compositions. The fish in the earthenware pot (known in Catalan as a *casola*) occupies the center of the visual field, counterbalanced to the right and left by a dark bottle and a brilliant red-and-green tomato. A second fish in the center foreground establishes a counterrhythm and serves to anchor the precariously balanced *casola*. The sculptural treatment of the linen and the liberties Dalí has taken with the spatial disposition of the table itself suggest the influence of Cézanne, while the formal reduction of the composition and the extreme individuation of the still-life objects point to the influence of Italian metaphysical painting, particularly the art of Giorgio Morandi and Carlo Carrà. In thus constructing an aesthetic bridge between traditional still-life painting and international modern art, Dalí followed the example of other young artists in Madrid who translated advanced avant-garde painting into a local idiom that could be more easily assimilated.

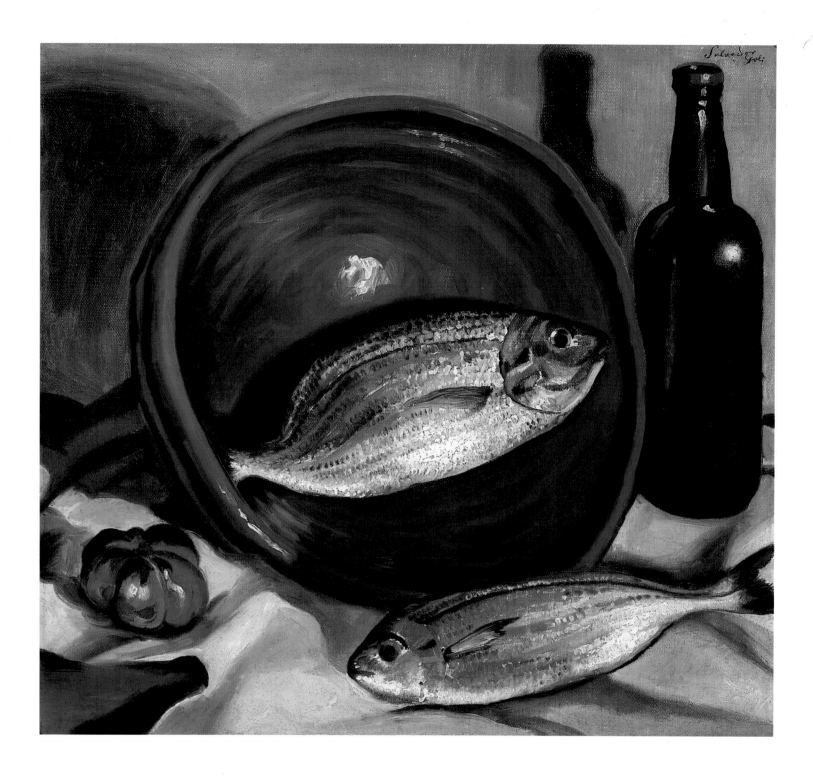

Still Life (Fish with Red Bowl)

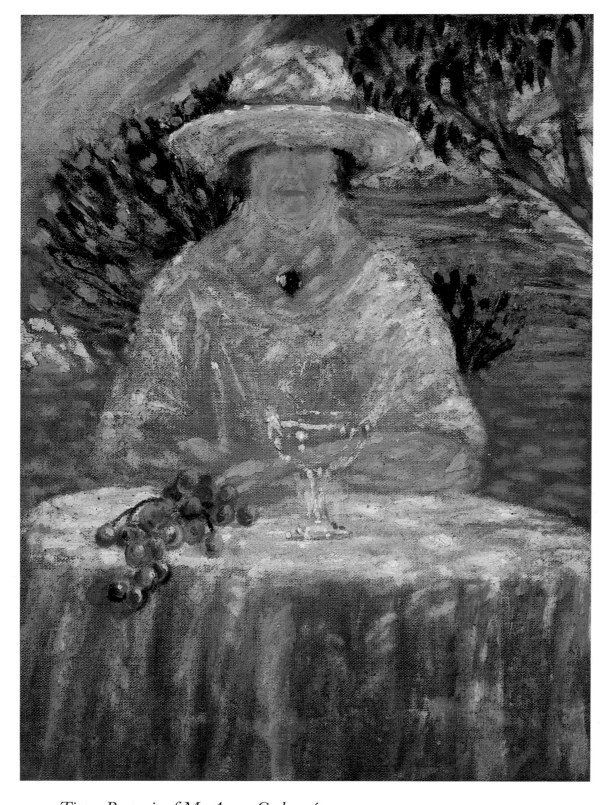

17. *Tieta, Portrait of My Aunt, Cadaqués,* 1923–24

Oil on canvas
20 3/4 × 16 1/4 inches

Exhibitions
New York 1965

Shinjuku 1999

On February 6, 1921, Felipa Domènech i Ferrés (1874–1921), Dalí's mother, succumbed to a long battle with cancer of the uterus at the age of forty-seven. The tragedy came as a particularly harsh blow to Felipa's sister Catalina (1873– ?), who had lived with the Dalí family since 1910. Following a nervous breakdown and a period of convalescence in Barcelona, Catalina returned to Figueres and assumed a new role as a surrogate mother to Salvador and Ana María Dalí, a practice that was not unusual in Catalonia. On December 22, 1922, having received a papal dispensation and the approval of his family, Salvador Dalí i Cusí formalized his relationship with Catalina, taking her hand in marriage in a ceremony celebrated in Barcelona.

As Dalí's *tieta* (auntie) and second mother, Catalina had long occupied an important place in the family if not in Dalí's art. Seated before the Bay of Cadaqués on the terrace of the family's summer home, she is bathed in the brilliant white light of the Mediterranean. The oleander bush behind her explodes in a profusion of pink and mauve that is strategically picked up in the tones of Catalina's flesh, the terrace, the distant hills, and the grapes on the table before her. Indeed, the entire painting is a symphony of blues and pinks, with areas of white suggesting the effects of light and shadow on local color. Remarkable more for Dalí's sustained interest in impressionist painting at this late date — particularly the work of Renoir — than for its physiognomic accuracy, *Tieta, Portrait of My Aunt, Cadaqués* is a study in light and color.

18. *Bouquet (L'Important c'est la rose)*, 1924

Oil on cardboard
19 3/4 × 20 1/2 inches

Exhibition
New York 1965

While a student at the Real Academia de San Fernando in Madrid, Dalí lived at the famed Residencia de Estudiantes, where he met Luís Buñuel, José (Pepín) Bello, and the poets Federico García Lorca, Pedro Garfias, and Eugenio Montes. Years later Dalí described these men collectively as the "artistic-literary advance guard, the non-conformist group, strident and revolutionary, from which the catastrophic miasmas of the post-war period were already emanating. This group had recently inherited a narrow negativistic and paradoxical tradition deriving from a group of 'ultra' *littérateurs* and painters—one of those indigenous 'isms' born of the confused impulses created by European advance guard movements, and more or less related to the Dadaists."[1]

Dalí's friends inducted him into a small but militant coterie of advanced painters and poets who actively promoted international avant-garde art and letters in the Spanish capital. Although Dalí had come into contact with advanced Italian and French painting through art magazines and newspaper articles, executing several cubo-futurist drawings in his own copy of Umberto Boccioni's *Pittura scultura futuriste (Dinamismo plastico)* sometime around 1922, it was not until 1923–24 that he participated in the activities of the Spanish avant-garde as a full member.

Between 1923 and 1925 Dalí executed a series of paintings that show the influence of Cézanne and cubism to varying degrees. *Bouquet (L'Important c'est la rose)* of 1924 belongs to this group. Recalling the *non-finito* of Cézanne's late paintings, Dalí draws a formal analogy between the petals of the roses, the faceted planes of the window blinds, and the reflections in the water of the vase. At the same time, Dalí's precise line demonstrates his commitment to traditional drawing practices, as the young painter enthusiastically responded to the work of Jean-Auguste-Dominique Ingres and the postwar classicism of Juan Gris, whose move from cubism to a more traditional figuration was discussed in the avant-garde journal *Alfar,* which Dalí read. The result in *Bouquet (L'Important c'est la rose)* is a kind of hybrid, home-grown modernism that effectively demonstrates an original, if somewhat conflicted, interpretation of foreign avant-garde currents in contemporary Spanish painting.

Notes
1. Salvador Dalí, *The Secret Life of Salvador Dalí* (New York: Dial Press, 1942), 174–175. The phrase " 'ultra' *littérateurs* and painters" refers to the movement known as *ultraísmo* in Spain, which assimilated a range of influences from Dada and cubist poetry to advanced French and Italian painting.

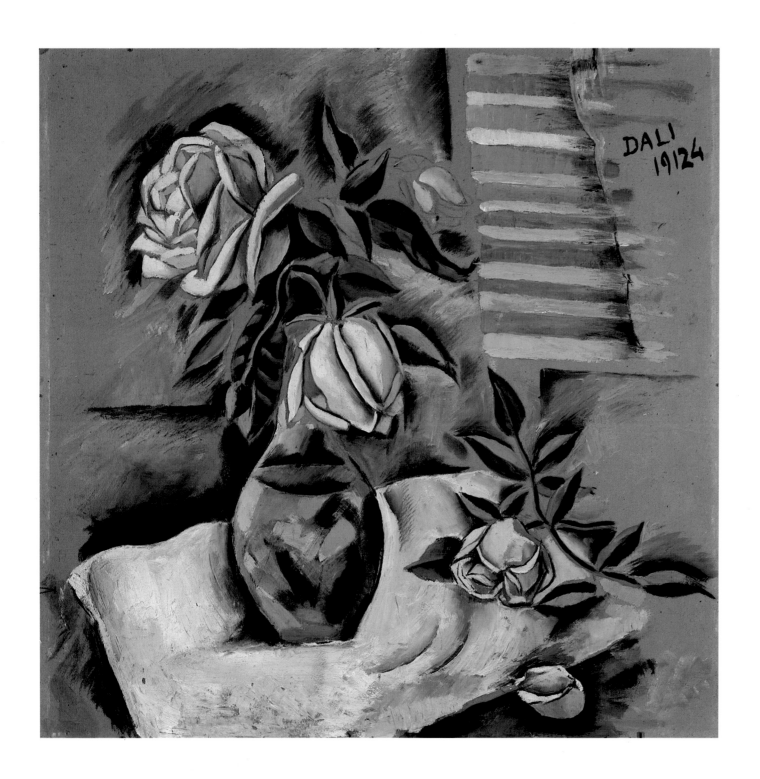

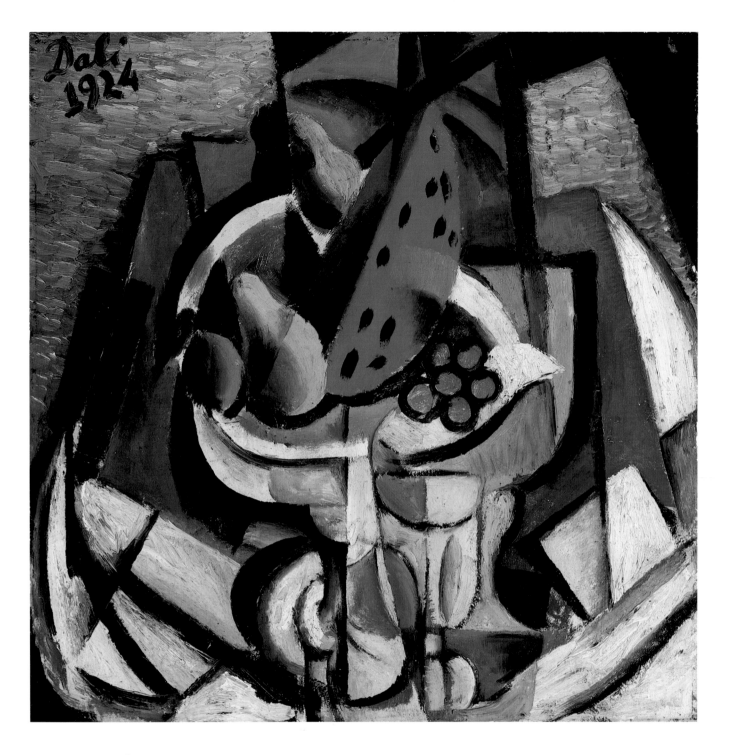

19. *Still Life (Sandia)*, 1924

Oil on canvas
19 1/2 × 19 1/2 inches

Exhibitions
Madrid 1925
New York 1965
Madrid 1995
Fort Lauderdale 1997

Dalí's experiments with cubism carried him simultaneously in several aesthetic directions. Alongside the canvases he executed in a classicizing idiom, Dalí adapted a range of formal devices from the work of Picasso, Braque, Gris, Morandi, Carrà, Ozenfant, and Jeanneret (Le Corbusier). In 1925, on the occasion of the Exposición de la Sociedad de Artistas Ibéricos (ESAI) at the Palacio de Exposiciones del Retiro in Madrid, the Spanish public had the opportunity to gauge Dalí's complex artistic personality. *Still Life (Sandia)* of 1924 was included in the show, along with nine other recent works by the Catalan painter.

The ESAI represented a watershed event in Spanish cultural life. The Sociedad established a forum in which modern Spanish and Portuguese artists of diverse stylistic tendencies could exhibit their work and thereby build a bridge of understanding between themselves and a largely uneducated and hostile public. Aside from private literary organizations like the Ateneo in Madrid and a handful of galleries, an institutional network for the exhibition and promotion of modern art did not yet exist in the Spanish capital; the Sociedad sought to fill that void and provide a "platform necessary for the struggle to remodel the current situation" and, in the process, "reestablish a balance that would allow the public to develop its own judgements" about modern art.[1]

Of the nearly five hundred works by forty-eight artists in the exhibition, which opened on May 28, 1925, Dalí's entries attracted particular attention. Not surprisingly, reviewers were put off by the artist's cubist paintings, although the presence of neoclassical works by Dalí tended to temper their criticism. Thus Juan de la Encina wrote in the pages of *La Voz*:

Cubism doesn't seduce me at all. . . . As a leavening it has been most useful. But as a concrete goal for painting I don't believe it has thus far constructed anything durable. . . . But I won't censor Dalí for his cubist undertakings, taking into account—as demonstrated by his nudes—that he doesn't take refuge in them in order to undo the great discipline of the study of form. To some extent these exercises have enabled him to study with some precision the relation of volumes and proportions. . . . A geometric exercise of this sort can be useful when it comes to composition. Dalí is a good draftsman and a good constructor.[2]

In contrast, the poet and critic José Moreno Villa observed that his friend was equally attracted to Amédée Ozenfant and André Derain, sympathetically commenting that for a painter like Dalí there was no essential difference between the human figure and a siphon insofar as these forms relate to the "serene architecture of the canvas."[3]

In many respects *Still Life (Sandia)* was the least austere of the cubist paintings Dalí exhibited at the ESAI. His other entries employed either a mechanical formal vocabulary derived from French purist painting or looked to the Italian metaphysical school for a poetics of everyday objects suspended and isolated in airless spaces. In contrast, *Still Life (Sandia)* represented a throwback to an earlier moment in the history of cubist and postcubist painting. Despite the treatment of the glass in the foreground, which employs architectural analogies familiar from contemporary works by Ozenfant and Jeanneret, Dalí's formal vocabulary recalls the works Picasso executed on the occasion of his 1917 sojourn in Barcelona. These much discussed paintings, which included cubist *and* neoclassical works, were reproduced in the Catalan journal *Vell i Nou*, which Dalí may have read.[4] Picasso's stylistic facility in moving between cubism and a more traditional figuration suggested a new direction in modern art to the young Dalí, who followed the older artist's example in the works he produced and executed in the years 1923–25.

———

Notes

1. For a discussion of the founding manifesto of the Sociedad de Artistas Ibéricos and a reconstruction of its first exhibition, see Jaime Brihuega and Concha Lomba Serrano, *La Sociedad de Artistas Ibéricos y el Arte Español de 1925*, exh. cat., Museo Nacional Centro de Arte Reina Sofía, Madrid, 1995.

2. Juan de la Encina, "Salvador Dalí," *La Voz* (Madrid), June 25, 1925.

3. José Moreno Villa, "Nuevos artistas: Peimero Exposición de la Sociedad de Artistas Ibéricos," *Revista de occidente* (Madrid) 9, no. 25 (July–August–September 1925): 80–91.

4. Joan Sacs, "La Pintura d'En Picasso, I," *Vell i Nou* (Barcelona) 4 no. 72 (August 1, 1918): 287–293; and Joan Sacs, "La Pintura d'En Picasso, II," *Vell i Nou* (Barcelona), 4, no. 73 (August 15, 1918): 307–310.

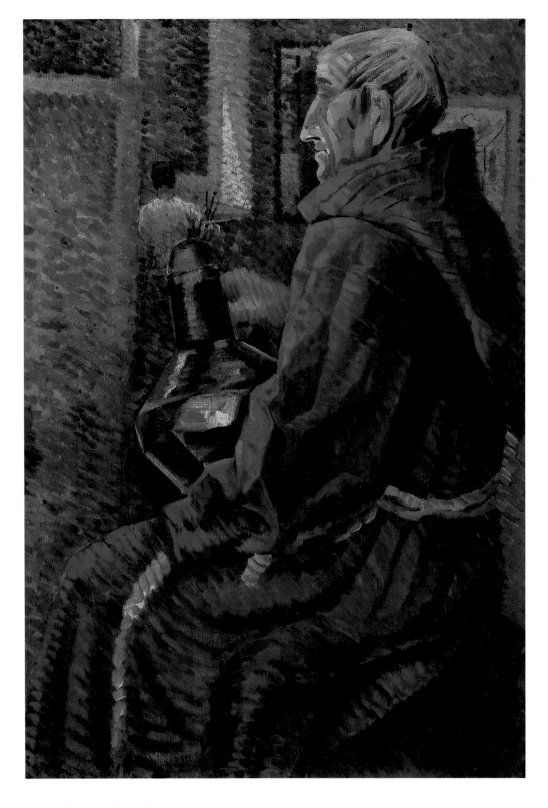

20. *Seated Monk*, 1925

Oil on canvas
39 1/2 × 27 inches

Exhibition
New York 1965

Dalí painted *Seated Monk* and *Studio Scene* (cat. no. 21) on the recto and verso of a single canvas. Along with *Study of a Nude* of the same year (cat. no. 22), the paintings reflect Dalí's training at the Real Academia de San Fernando in Madrid, which he entered in September 1922. Dalí had already been exposed to academic instruction at the Figueres Instituto, where he received drawing lessons from an Andalusian engraver named Juan Núñez Fernández, who was a graduate of the Royal Academy in the Spanish capital. But the celebrity and fortune that Dalí's precocious talent promised necessitated that he continue his studies in Madrid, where he hoped to seal his reputation as a great painter.

The course of Dalí's studies, however, proceeded differently. In the autumn of 1923 Dalí was implicated in a student protest against the jury responsible for choosing Joaquín Sorolla's successor to the Chair in Open-Air Painting. When the conservative jury refused to appoint Daniel Vázquez-Díaz, a reformist candidate overwhelmingly supported by the students, an uproar broke out that was reported in local newspapers and considerably embarrassed the administration of the Academy. The Chair remained vacant, and Dalí was expelled from the Academy on October 22, 1923, for the 1923–24 academic year. He resumed his studies in Madrid in September 1924.

The incident is an early indication of Dalí's role as a cultural provocateur and provides considerable insight into his increasing alignment with the cause of international modern art. The three academic studies he painted in 1925 lack conviction when compared with Dalí's experiments in cubist and metaphysical painting at this time. Indeed, Dalí's submissions to the Exposición de la Sociedad de Artistas Ibéricos that spring (see cat. no. 19) publicly confirmed his identity as a modernist painter whose style was far removed in form and content from the traditional practices advanced by the San Fernando Academy. Even Dalí's most overtly "traditionalist" paintings of this period, including *Study of a Nude*, take considerable license with academic conventions, as Dalí began to explore the erotic potential of the female nude. Moreover, Dalí's technique in *Seated Monk* and *Studio Scene* recalls that of the great Catalan painter Isidre Nonell, whose agitated brushwork had likewise challenged academic conventions in turn-of-the-century Barcelona.

21. *Studio Scene*, 1925

Oil on canvas

39 1/2 × 27 inches

22. *Study of a Nude, 1925*

Oil on canvas

39 × 28 inches

Exhibitions

New York 1965

Fort Lauderdale 1997

Shinjuku 1999

Oil on panel
20 × 15 3/4 inches

Exhibitions
Barcelona 1926B
Madrid 1962
New York 1965
Liverpool 1998

An incipient eroticism entered Dalí's work in 1926, in effect positioning *Girl with Curls* in a class apart from the artist's previous studies of the female figure. On the one hand, Dalí's academic nudes of 1925 and 1926 are paragons of controlled drawing and restrained sensuality; on the other, his close-ups of Ana María seen from the back (cat. no. 24) encourage a dialogue between the viewer and the object viewed that transforms the act of looking more into an identificatory relation of proximity than an erotic exchange. In *Girl with Curls*, however, Dalí transforms a scene of earthy sexuality into a spectacle of erotic projection, as a young peasant girl standing amid the verdant green fields of the Empurdà momentarily pauses on her journey to gather her windswept blond curls behind her ear. As her right foot emerges from its slipper in an apparent reflex of innocent abandon, her scanty dress falls suggestively off her left shoulder and drapes around her buttocks to reveal an ample pair of fleshy cheeks, thereby charging the scene with erotic energy. That Dalí later adapted the pose of the young woman to

23. *Girl with Curls*, 1926

represent the surrealist/Freudian muse Gradiva in a series of drawings executed over the course of the 1930s suggests that he recognized and fully exploited the erotic appeal of the figure in *Girl with Curls*.[1] Indeed, the monumental, almost phallic presence of the standing female figure is a visual topos in Dalí's paintings of the 1920s and '30s, from *Apparatus and Hand* of 1927 (cat. no. 27), where a mecanomorphic armature sprouting a fantastic hand stands in for the figure, to *Portrait of Gala* 1932–33 (cat. no. 47), where the artist imagines his beloved Galuchka as the omnipotent phallic mother, who rises, like an apparition, from the foreground plane.

Notes

1. On Dalí, Freud, and the myth of Gradiva, see Fiona Bradley, "Gala Dalí: The Eternal Feminine," in *Salvador Dali: A Mythology*, ed. Dawn Ades and Fiona Bradley, exh. cat., Tate Gallery, Liverpool, 1998, 54–76.

24. *Girl's Back*, 1926

Oil on panel
12 1/2 × 10 3/4 inches

Exhibition
New York 1965

Concurrent with his work at the Real Academia de San Fernando and his interest in the neoclassicism of both Picasso and Ingres, a growing sense of realism had begun to enter Dalí's painting in 1925. In an undated letter to Federico García Lorca of the following year, Dalí discussed his latest experiments in the context of his new passion for Dutch art: "I dream of going to Brussels to copy Dutch painting in the museum. You have no idea how much of myself I have put into my painting, how much affection I feel as I paint my windows open to the rocky sea, my baskets of bread, my girls sewing, my fish, my skies resembling sculptures."[1] Two years later, in an important theoretical text entitled "The New Limits of Painting," Dalí defined his interest in Dutch art with greater clarity, emphasizing the viewer's relation to the scene of representation as a subject in the world who actively scans the visual field, mapping and cataloguing its manifold incidents. Singling out Vermeer's art as "a case of the highest, most humble, and most dramatic probity" in the history of the "proper way of looking," Dalí adapted the descriptive impulse in Dutch art to his own painting.[2]

Even before Dalí's first trip to Paris and Brussels in April 1926, during which time he had the opportunity to study Dutch and Flemish painting in some detail, he demonstrated a keen interest in the work of Vermeer and his contemporaries. In early 1926 Dalí's uncle Anselm provided his nephew with a book on Vermeer, which supplemented the little monograph on the Dutch painter from the Gowans Art Books series that the artist had treasured since his youth.[3] At the same time, Dalí's technique acquired greater precision, and his decision to paint on panel in a quasi-miniaturist scale suggests that he consciously sought to imitate the effects of the Dutch and Flemish masters he so admired. Indeed, in *Girl's Back* Dalí lavishes particular attention on his sister's hair, which, gathered by a clasp just above the nape of her neck, extends in three tight coils that slither down her back, perhaps recalling the tuft of hair that escapes from the braided coiffure of Vermeer's *Lacemaker* (Museé du Louvre, Paris). The heightened realism of Dalí's depiction of the hair in turn contrasts with the more summary treatment of Ana María's dress and the exposed surfaces of her face and back, pointing to the range of stylistic idioms with which Dalí worked at this time.

If, as Dalí suggested in his 1928 text, Vermeer's art is the expression of a particularly acute visual probity, in Dalí's own painting this descriptive realism is joined to the theme of looking. *Girl's Back* belongs to a series of paintings of female subjects situated with their backs to the spectator, such that the viewer assumes the position of a figure *at* the threshold of the scene, as in the canonical Renaissance conception of the painting-as-window, and that of the figure *within* the scene of representation itself. Doubling as spectator *and* the object of the gaze, the viewer's mastery of the scene is simultaneously affirmed and undermined, as Dalí begins to explore the perceptual and semiological operations of visuality as a structural code.

Notes

1. Salvador Dalí, letter to Federico García Lorca; transcribed in Rafael Santos i Torroella, "Dalí escribe a García Lorca," *Poesia* (Madrid) 27–28 (1986): 44–45. Santos dates the letter to September 1926, although the artist's desire to travel to Brussels, a trip he did not make until April of that year, suggests that the letter was written in February or March 1926.

2. Salvador Dalí, "Nous límits de la pintura," *L'Amic de les arts* (Sitges) 22 (February 29, 1928): 167–169; 24 (April 30, 1928): 185–186; and 25 (May 31, 1928): 195–196, translated in *The Collected Writings of Salvador Dalí*, ed. Haim Finkelstein (Cambridge: Cambridge University Press, 1998), 81.

3. Fèlix Fanés, *Salvador Dalí: La Construcción de la imagen, 1925–1930* (Barcelona: Electa, 1999), 47, cites a letter in which Dalí thanks his uncle for sending him the Vermeer volume.

Oil on panel
12 1/2 × 12 1/2 inches

Exhibitions
Barcelona 1926B
Pittsburgh 1928
New York 1941A
New York 1945B
Boston 1946
New York 1947
New York 1965
Figueres 1993
Fort Lauderdale 1997
New York 1997A
Pittsburgh 1998
Bilbao 1999
Shinjuku 1999

The Basket of Bread marks a watershed in Dalí's early career as a painter. In a circa 1926 letter to his friend the art critic Sebastià Gasch, Dalí explained his current aesthetic objectives:

For me, the interior of things is still a superficial reality; the deepest areas are still only a skin. . . . I do not see any questions that need an answer in the world around us; I only see the record of objective facts.

Subjectivism? . . . Can a scholar who discovers a cell, a never before seen microbe, be accused of being subjective? Can a painter who discovers an unusual association among forms, who finds a kind of cell or microbe, be accused of being subjective?

The discovery, of course, depends on them; it depends on the subject. Another scholar or another painter would not have discovered the same thing, but I don't believe this detracts from the objective character of the discoveries.[1]

Suggesting that one's vision of the objective world is fundamentally a question of individual perspective, Dalí nonetheless rejected the postsymbolist conception of painting as the expression of the artist's state of mind. In an article of the following year, Dalí championed the cause of photography as a technology capable of mapping the minute details of the physical world with the utmost objectivity, privileging the function of the eye as a precise recording mechanism: "Let's be content with the immediate miracle of opening our eyes and being dextrous in the apprenticeship of proper looking. Shutting the eyes is an antipoetic method of perceiving resonances. . . . In the history of looking, [Vermeer of Delft's] eyes are the case of the highest probity."[2]

A series of interrelated issues join these two texts in Dalí's aesthetic theory: the artist's disdain for sentimentalism of any kind; his abiding belief that the visible conditions of the physical world are in themselves the objects of poetic inspiration; his open embrace of new technologies that might make those conditions manifest; and his position as a modernist artist in a historical lineage that begins not with Manet and Cézanne but with Vermeer and Dutch painting.

Indeed, *The Basket of Bread* represents an aesthetic manifesto of Dalí's new interests in the period extending from his first exhibition at the Galeries Dalmau in November 1925 to the early months of 1926. The jewel-like painting on panel, which measures only 12 1/2 inches square, is packed with visual incident. Against a flat black background that calls to mind the Spanish tradition of *bodegones* in the work of Francisco de Zurbarán and Juan van der Hamen y León as much as its luminous surface and precise detailing bear affinities with the panels of Jan van Eyck, Dalí has poised the elements of his still life: a common straw basket filled with four pieces of hearty peasant bread set on a simple white table linen. The extreme reduction of still life elements and the apparent solidity of the composition—the table linen in particular has a marblelike countenance however much it appears to float in an undefined space—belie the artist's intricate rendering of surfaces and textures, from the tight latticework of the basket to the minute gouges in the crust of the bread. An eery quietude permeates the still life, with a glow that seems to emanate from within the objects themselves. In part the result of Dalí's unorthodox technique (the artist used a varnish known as dammar rather than oil as a binding medium for his pigments), this effect serves to transform the banal objects into the protagonists of an almost ritual drama. Indeed, the liturgical associations of the bread and its iconic presence and central position in the composition suggest that Dalí's "realism" is anything but prosaic. Suffused with a mysterious aura of the kind that often surrounds the most ordinary things, Dalí's *Basket of Bread* speaks to the artist's intimate encounter with the "objective facts" of the visible world. With Dutch painting as a historical reference and a technical armature, Dalí's "realism" has a metaphysical quality.

As a common motif and symbolic theme, bread occupies a privileged position in Dalí's art and writings. The mundane object appears in numerous guises with increasingly extravagant associations, ranging from religious connotations in *Eucharistic Still Life*, 1952 (cat. no. 81), and *The Last Supper*, 1955 (National Gallery of Art, Washington, D.C.), to its role as a phallic surrogate in *Catalan Bread* and *The Invisible Man* of 1932 (cat. nos. 44 and 45). Closest to the 1926 version is a 1945 oil painting by the same name, which Dalí exhibited side by side with the earlier work at the Bignou Gallery, New York, from November 25, 1947, to January 3, 1948. On the occasion of an earlier one-man show at the same gallery, where the 1945 version of *The Basket of Bread* was first exhibited, Dalí explained in a catalogue note:

Bread has always been one of the oldest fetishistic and obsessive subjects in my work, the one to which I have remained the most faithful. I painted this same subject nineteen years ago. In making an accurate comparison of the two pictures, one can study the entire history of painting, from the linear charm of primitivism to the stereoscopical hyper-aestheticism.

This typically realistic picture is the one which has satisfied my imagination the most. Here is a painting about which there is nothing to explain: The total enigma![3]

The 1926 *Basket of Bread* was one of the first works by Dalí to be exhibited in the United States, at the 27th International Exhibition of Paintings held at the Carnegie Institute, Pittsburgh (October–December 1928). The painting has been restored on two, possibly three, occasions: sometime around 1941; in 1966, after it was damaged on the occasion of an exhibition at the Gallery of Modern Art, New York; and again in 1993, under the auspices of the Departament de Restauració de la Fundació Gala–Salvador Dalí, Figueres.

Notes

1. Salvador Dalí, undated letter to Sebastià Gasch (circa 1926); reprinted in Rafael Santos i Torroella, *"La Miel es más dulce que la sangre." Las Epocas lorquiana y freudiana de Salvador Dalí* (Barcelona: Seix Barral, 1984), 236–239.

2. Salvador Dalí, "La Fotografia, pura creació de l'esperit" (Photography: pure creation of the spirit), *L'Amic de les arts* (Sitges) 18 (November 30, 1927): 90–91, translated in *The Collected Writings of Salvador Dalí*, ed. Haim Finkelstein (Cambridge: Cambridge University Press, 1998), 46. Dalí asserted his views on Dutch art and the question of romantic sentimentalism in painting as early as circa 1925 in a letter to the poet José Moreno Villa: "Every day I marvel more at the Dutch. . . . Vermeer of Delft. . . . That is the height of painting, because in his work the pictorial problem as a drama disappears." (J. Moreno Villa, "Notas de Arte: El Oficio," *El Dia gráfico* [Barcelona]), December 23, 1925.

3. Salvador Dalí, artist's statement in *Recent Paintings by Salvador Dalí*, exh. cat., The Bignou Gallery, New York, November 20–December 29, 1945.

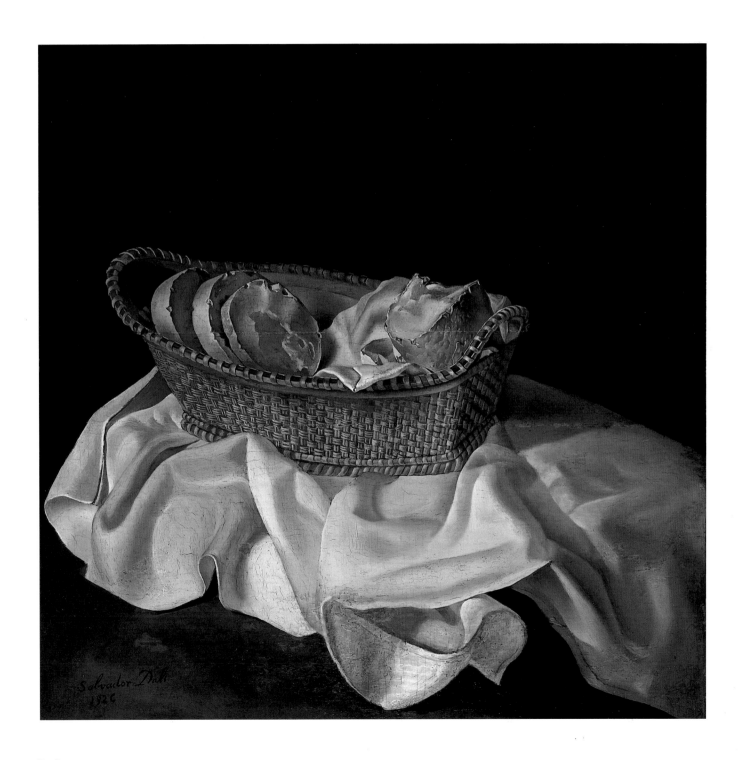

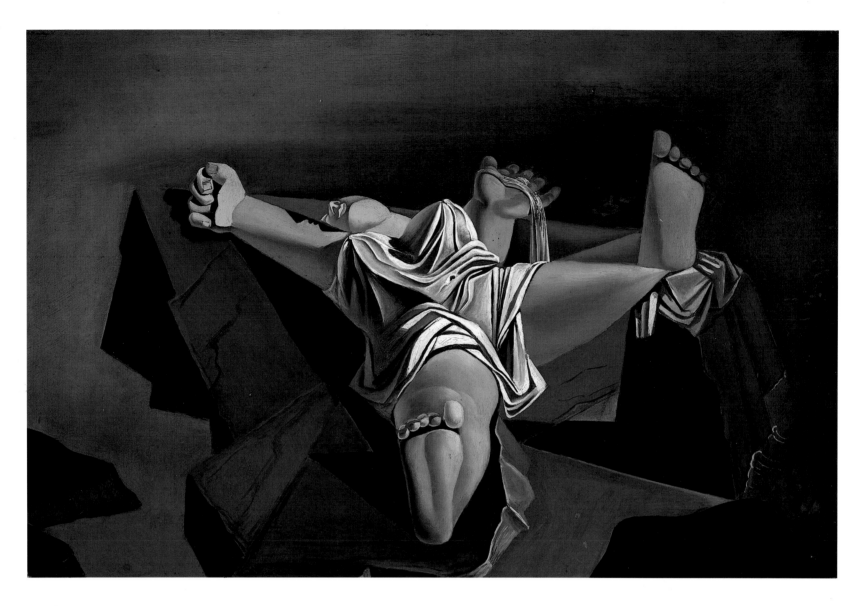

26. *Femme Couchée*, 1926

Oil on panel
10 3/4 × 16 inches

Exhibitions
Barcelona 1926A
Barcelona 1926B
New York 1965
London 1994
Fort Lauderdale 1997
Hartford 2000

On December 31, 1926, Dalí's second solo exhibition opened at the Galeries Dalmau in Barcelona. Since the time of his first show at the same establishment in 1925, Dalí's work had been featured in a number of articles in the Catalan and Castilian press, focusing on his myriad sources in impressionist and modern art. Dalí's second one-man exhibition at the Galeries Dalmau confirmed his public reputation as an innovative painter with a complex and multifaceted stylistic personality. Writing in *L'Amic de les arts*, an advanced artistic and literary journal published in Sitges, art critic Sebastià Gasch singled out three works for commentary:

We believe . . . that the genuine, characteristic, sincere Dalí is the Dalí of Venus and the Sailor, *and the Dalí of* NeoCubist Academy *and the Dalí of* Figure on the Rocks. *Within the confines of this style Dalí has realized works that are almost perfect. However, we believe that Dalí does not have to force his character, that this character does not have to force itself unnecessarily, and that he has to make an effort, within this intelligent neoclassicism, to surpass the victories he has won and to temper his logic with a breath of humanity. Recently, however, Dalí, who has his modish side, has allowed himself to be led by fashion and has plunged wildly into the painting of canvases in the style of Picasso's most recent works.*[1]

Commenting on Dalí's tendency to work simultaneously in a neoclassical and a cubist idiom, Gasch feared that his friend would fall victim to a derivative and faddish modernism, thereby betraying his natural talents as a painter of the human figure.

The three canvases Gasch singled out for praise were works in which Dalí's neoclassicism was in fact tempered by his experience of cubism and the Italian metaphysical school. *Femme Couchée*, the work referred to as *Figure on the Rocks*, is a case in point. The painting is a radically foreshortened portrait of Ana María Dalí, whose profile is cast in shadow on her right arm. The outstretched arms of the figure establish the orthogonal axes of a composition that is defined by repeating triangular and trapezoidal relationships. The tilted perspective and the precise geometric divisions of the body, the facets of the rocks, and the shadows establish the disquieting effect of an airless, distorted space, one that bears affinities with the work of Carlo Carrà and Giorgio de Chirico.

The classical references in *Femme Couchée* are decidedly ironic. Ana María is clad only in a generic toga that clings to her ample body, and her navel and erect nipples are suggestively emphasized. The erotic appeal of the figure, however, is kept in check by the sobriety of Dalí's line and the unsparing precision of his geometry. As we look down upon the vulnerable figure, her legs spread in a position of sexual availability, Ana María's pose conjures associations with the crucified Christ and the bound Prometheus, paragons of suffering and stoical resignation. The water that flows from Ana María's left hand, however, suggests a dual allusion to sexual climax and Christ's sacrifice, pointing us toward a narrative of guilt and repressed desire as the latent subject of the painting. Indeed, Dalí would explore this theme more overtly in his scandalous bather compositions of 1928 (cat. nos. 28 and 29).

A prominent source for the veiled eroticism of *Femme Couchée* can be found in Picasso's neoclassical paintings of 1920–22, in which grossly distorted atavistic bathers make a notable appearance. On the occasion of his first trip to Paris in April 1926, Dalí visited Picasso's studio, where he would have seen several of these canvases along with the artist's most recent cubist paintings. The liberties Dalí took with the classical subject matter of *Femme Couchée* suggest that he tried to achieve a synthesis of these two tendencies in a single work while exploring the theme of an archaic sexuality that Picasso had masterfully represented. The precision of Dalí's line in turn points to the artist's dialogue with the nineteenth-century painter Jean-Auguste-Dominique Ingres, as transmitted through Picasso. Three quotations from Ingres's *Pensées*, which Dalí read at this time, were prominently transcribed in the catalogue of his first exhibition at the Galeries Dalmau the previous year, including: "Drawing is the probity of art," and "Beautiful forms are flat planes with curves. Beautiful forms are those which have firmness and plenitude, where small detail does not conflict with large masses." [2] That Dalí paid careful attention to Ingres's advice is demonstrated by the presence of preparatory sketches for *Femme Couchée*.

Notes

1. Sebastià Gasch, "Salvador Dalí," *L'Amic de les arts* (Sitges) 11 (February 28, 1927): 16–17; as translated in Montserrat Aguer and Fèlix Fanés, "Illustrated Biography," in *Salvador Dali: The Early Years*, exh. cat., South Bank Centre, London, 1994, 29.

2. Ian Gibson, *The Shameful Life of Salvador Dalí* (London: Faber and Faber, 1997), 127.

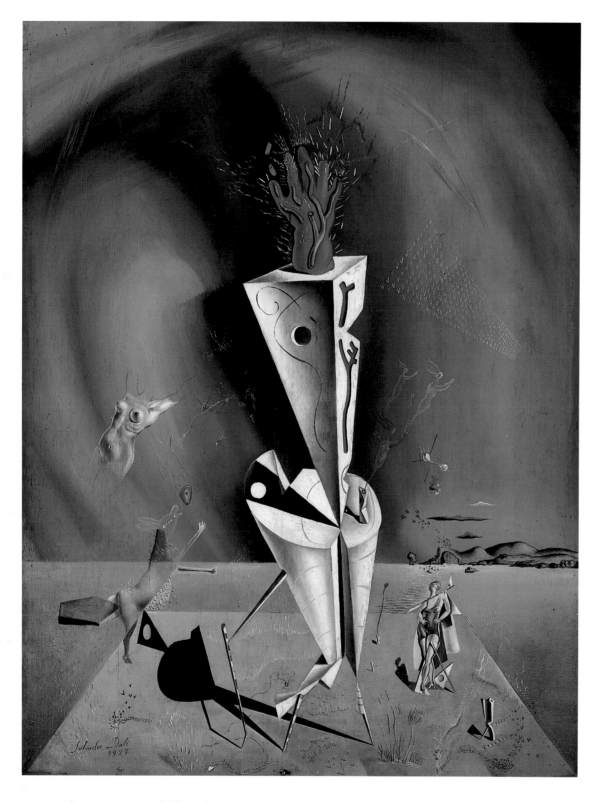

27. *Apparatus and Hand*, 1927

Oil on panel

24 1/2 × 18 3/4 inches

Exhibitions
Barcelona 1928
Figueres 1928
Madrid 1929
Paris 1929
New York 1965
London 1994
Shinjuku 1999
Hartford 2000

While performing military service in Figueres over the summer of 1927, Dalí managed to complete two paintings that marked yet another departure in his work: *Apparatus and Hand* (formerly titled *The Wood of Gadgets*) and the lost work *Honey Is Sweeter Than Blood (The Birth of Venus)*. Together with *Cenecitas/Little Ashes* (Museo Nacional Centro de Arte Reina Sofía, Madrid), which Dalí completed sometime in January or February of 1928,[1] the paintings inaugurate an elaborate figuration of part-objects, decapitated and dismembered bodies, flying fish, rotting donkeys, ectoplasmic traces, and strange mechanical apparatuses casting black shadows in deep, open spaces. However much Dalí insisted at the time that a considerable distance separated him from French surrealist thought, there is no question that his new style owed a heavy debt to Yves Tanguy, Giorgio de Chirico, and Max Ernst, whose work Dalí would certainly have known through reproductions in advanced literary journals like *Valori plastici*, *Littérature*, and *La Révolution surréaliste*.[2] The form of the apparatus in *Apparatus and Hand* surely derives from de Chirico's paintings of mannequins and metaphysical armatures, while Dalí's interest in precise geometries and

objects of the modern, industrialized world reveals his affinities with the project Amédée Ozenfant and Charles-Edouard Jeanneret advanced in the pages of *L'Esprit nouveau* (1920–24), which Dalí is known to have read. Indeed, the apparatus made its first appearance in Dalí's work of the previous year *(Departure: Homage to the Fox Newsreel* [private collection], *Naturaleza Muerta, Invitación al Sueno* [private collection], and *naturaleza muerta al claro de luna* [Museo Nacional Centro de Arte Reina Sofía, Madrid]), assuming its place among imagery derived from the worlds of aviation and film.

Dalí's apparatus, however, serves no mechanical function; rather, it is a "precise instrument of an unknown physics," as he described a related device in his first published prose poem, "Sant Sebastià," which appeared in the July 1927 issue of the journal *L'Amic de les arts.* In this poem, Dalí describes his vision of the martyred Italian saint, who suffers his passion with stoical resignation as arrows pierce his exposed flesh. "In certain parts of [the saint's] body," Dalí writes, "the veins appeared on the surface with their intense blue of a Patiner storm, and traced curves of painful voluptuousness on the pink coral of the skin."[3] The venal imagery reappears in *Apparatus and Hand* on the side of the gadget, and as a network of branchlike lines that extend from the wrist to the fingers of the throbbing red hand. In this way, Dalí identifies the saint's body with physical passion, and his martyrdom with the "slings and arrows" of an erotic exchange. To be sure, the presence of a flying fish, the torso of a woman, and a pair of floating breasts immediately establishes a sexual narrative, as Dalí transforms his

agonistic bathers of 1926 into machines for self-pleasure.

Ian Gibson, building on a psychoanalytic interpretation first advanced by Rafael Santos i Torroella, relates the onanistic theme of *Apparatus and Hand* to Dalí's "sexual problems at the time."[4] "Incapacitated by shame from experiencing sexual satisfaction in the external world," he asserts, and "anxious about his indulgence in what English dictionaries were calling 'self-abuse' up to the 1960s, Dalí was in a painful quandary."[5] Indeed, for both authors Dalí's onanistic fantasies and his presumed incapacity to achieve sexual gratification with women (until, we are told, Gala emerges on the scene and "rescues" Dalí from his perversions) are related to repressed homosexual desire; to this end, the poem "Sant Sebastià" is read as a coded reference to García Lorca's amorous interest in the young Catalan painter. This emphasis on psychological transparency, however, fails to acknowledge the full extent to which Dalí consciously constructed a mythic persona through the practice of biographical narrative, interpreting his own experience through the established grid of psychoanalysis. If Dalí's Freudian critics find guilt, repression, and castration anxiety in his work, it is because Dalí *put it there* as a subject of representation.

What is more, psychoanalytic readings of *Apparatus and Hand* and "Sant Sebastià" tend to underplay the ways in which Dalí sought to represent his sustained interest in visuality as a social and cultural code. In a letter to his friend José (Pepín) Bello of mid-December 1925, Dalí referred to the "Book of Putrefaction" he and Lorca had planned to publish. Lorca was to supply the text and Dalí

the illustrations. "In a short while my Book of Putrefaction will appear, with Federico's preface," Dalí wrote. "In the final analysis putrefaction is all SENTIMENT (with capital letters), and, in that way, something that cannot be separated from human nature. As long as there is a terrestrial atmosphere there will be putrefaction. The only thing that escapes this atmosphere is 'astronomy.' We therefore oppose Astronomy to Putrefaction."[6] In the "Sant Sebastià" text Dalí reprises this subject, describing the presence of a heliometer next to the saint that allows him to view the world with Holy Objectivity, devoid of emotional associations. "In St. Sebastian's heliometer," Dalí imagines, "there was not any music or voice and, in certain fragments, it was blind. These blind spots of the gadget were the ones corresponding to its sensitive algebra, and the ones designed to pinpoint what was most insubstantial and miraculous." Looking through the glass, Dalí is able to view the objective facts of the modern, industrialized world with greater clarity: "the anti-artistic and astronomical orbit of the *Fox Newsreel*," the world of modern dance and music, gin cocktails, and sports competitions. Indeed, the poem serves as a corrective to the romantic cult of sentimentality and as a challenge to traditionalism in painting. Dalí, in effect, asks his contemporaries to open their eyes wide before the spectacle of modern society, to embrace a new kind of looking at a time when the camera had come to replace the sentimental eye of the painter/observer. As Dalí explained, "The opposite side of St. Sebastian's magnifying glass corresponded to putrefaction. Everything, seen through it, was anguish, darkness and,

even, tenderness; tenderness, even, because of the exquisite absence of mind and naturalness."

In *Apparatus and Hand*, of course, there is little that actually corresponds to the objective precision of the photographic lens as Dalí conceived it. Nonetheless, the strange dislocations in scale between objects and the way forms appear to fade in and out suggest certain affinities with film and photographic technologies. More important, the imagery itself functions as an idiosyncratic manifesto of Dalí's embrace of mass culture. As Haim Finkelstein observes:

[Apparatus and Hand] represents all that Dalí found alluring in the modern woman, or, rather, in her stereotyped image as it appeared to him in advertisements, billboards, or in the movies. It is the woman with the slickly coiffed head seen from behind in an advertisement for Isotta Fraschini that Dalí drew for the Revista Residencia *in 1926. She is verbally echoed in "Sant Sebastià" in the reference to a "girl playing polo reflected in the nickeled headlight of an Isotta Fraschini," or the "girl without breasts" on the bridge of a steamer, who teachers "sailors saturated with the southern wind how to dance the black-bottom," or even the "girl in the bar [who] plays 'Dinah' on her little gramophone, while she prepares gin for the motorists."[7]*

Clearly, Dalí's painting and the "Sant Sebastià" text were intended to be polemical. When Dalí exhibited *Apparatus and Hand* at the Autumn Salon in Barcelona (October 8–21, 1927), it caused a public scandal. In an article he published in the October 31, 1927, issue of *L'Amic de les arts*, Dalí explained his position, insisting

that he conceived his art without aesthetic a prioris, and on the margins of institutional culture: "My things . . . are anti-artistic and direct, they move and are understood instantaneously, without the slightest technical training. (Artistic training is what prevents people from understanding them.) Preliminary explanations, *preliminary ideas* and *prejudices* are not necessary, as in the other form of painting. They have only to be looked at with pure eyes."[8] Rejecting the idea of stereotypical "invented" images, and likening his vision to the anonymous products of the mechanical world and the objective transpositions wrought by the camera, he concluded: "All this seems to me more than enough to show the distance which separates me from Surrealism, in spite of the intervention of what we might call the poetic transposition of the purest subconscious and freest instinct." Despite Dalí's disavowal of French surrealism, however, the poet Paul Eluard clearly perceived an affinity, acquiring the painting by November 1929.[9]

Notes

1. Haim Finkelstein, *Salvador Dalí's Art and Writing, 1927–1942: The Metamorphoses of Narcissus* (New York: Cambridge University Press, 1996), 42.

2. Dawn Ades, *Dalí* (London: Thames and Hudson, 1982), 45, proposes specific sources in Tanguy's painting, suggesting that Dalí may have acquired a copy of the catalogue of Tanguy's exhibition at the Galerie Surréaliste, Paris (May 27–June 15, 1927), a supposition Finkelstein, *Art and Writing*, 33, has questioned.

3. Salvador Dalí, "Sant Sebastià," *L'Amic de les arts* (Sitges) 16 (July 31, 1927): 52–54, in *Salvador Dalí: The Early Years*, trans. John London, exh. cat., South Bank Centre, London, 1994, 214–216.

4. Rafael Santos i Torroella, "*La Miel es más dulce que la sangre.*" *Las Epocas lorquiana y freudiana de Salvador Dalí* (Barcelona: Seix Barral, 1984) and "*Los Putrefactos*" *de Dalí y Lorca. Historia y antología de un libro que no pudo ser* (Madrid: Residencia de Estudiantes, 1995).

5. Ian Gibson, *The Shameful Life of Salvador Dalí* (London: Faber and Faber, 1997), 166–167.

6. For a full account of the project, see Rafael Santos i Torroella, "*Los Putrefactos*"; and *Los Putrefactos por Salvador Dalí y Federico García Lorca: Dibujos y documentos*, exh. cat., Fundació Caixa Catalunya, Barcelona, 1998.

7. Finkelstein, *Art and Writing*, 53.

8. Salvador Dalí, "Els Meus quadros del Saló de Tardor," *L'Amic de les arts* (Sitges) 19 (October 31, 1927), in *Dalí: Early Years*, 217.

9. The catalogue of Dalí's first exhibition at the Camille Goemans Gallery in Paris (November 20–December 5, 1929) lists Paul Eluard as the owner of the painting.

28. *The Bather,* 1928

Oil on panel
20 1/2 × 28 1/4 inches

Exhibitions
Zürich 1929
Cleveland 1947
New York 1965
Rio de Janeiro 1998
Hartford 2000

Building upon the extravagant figuration of acephalic women, flying breasts, and grossly distorted anatomies that entered his work in 1927, Dalí executed a series of bather paintings in early 1928 in which he radically reconfigured the contours of the human body. Returning to a theme that had long captured his imagination, Dalí now interpreted the venerable art-historical tradition of the erotic reclining nude in explicitly sexual terms.

Splayed out on a sandy beach for all to see, the body of Dalí's bather has been reduced to a hairy, tumescent big toe whose linear markings suggestively coalesce into a series of labialike folds around the nail. A red arabesque extends from the joint of the toe to the breast of a phantomlike creature in the upper left whose body has exploded into pieces that appear to float across the horizon. The erect female figure, a counterpart to the phallic toe, touches her thumb with her index finger, forming an open cavity in her swollen hand. Despite an obvious allusion to intercourse, however, the "male" and "female" protagonists of this sexual drama are only indirectly joined by the veinlike coil that extends from the toe. Graphically mapping an erotic exchange, the red arabesque, the phallic toe, and the enlarged hand tell a story of unfulfilled desire expressed through onanism.

In a text of the following year entitled ". . . The Liberation of the Fingers . . . ,"[1] Dalí more explicitly pursued the associations of the phallus/finger/toe. Discussing his friendship with a largely uncultured character named Eugenio Sánchez, whom he met during his military service the preceding year, Dalí describes how upon introducing his friend to certain surrealist texts in order to encourage his faculties of free association, he was astounded to hear him utter the phrase, "there is a flying phallus." Recognizing that his friend could not have had prior knowledge of Freud's discussion of the winged phallus in ancient art, as explored in his 1910 essay "Leonardo da Vinci and a Memory of His Childhood," Dalí muses on the collective pychoanalytic meaning of hypnagogic images — in this case, the detached finger/flying phallus —

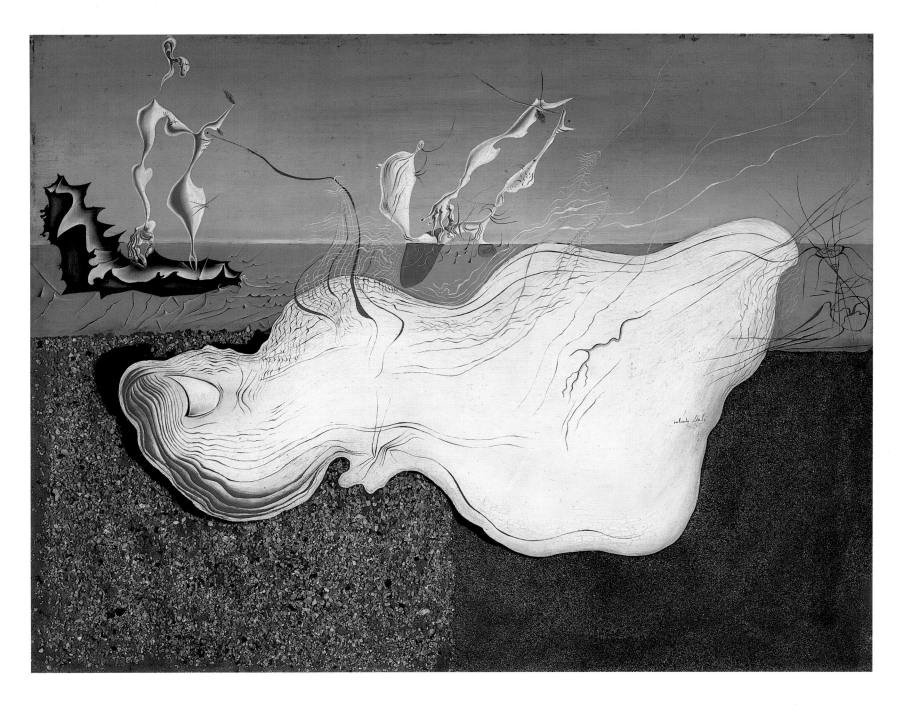

derived just before falling asleep. To be sure, Dalí's bather paintings of 1928 testify to the presence of unconscious desire as an agent of transformation for the subject both in dreams and in the physical world. In the highly suggestive, albeit deadpan, photographs of phallic "erect" fingers that illustrate "... The Liberation of the Fingers ... ," that presence is rendered explicit.

Numerous sources have been proposed for Dalí's change in style at this time. On the one hand, the grossly distorted anatomy of the big toe (which looks ahead to Dalí's anamorphic self-portraits in such paintings as *The Persistence of Memory* of 1931 [Museum of Modern Art, New York]) owes a clear debt to Picasso's gargantuan bathers of the early to mid-1920s. Closer to the spirit of the painting, however, is the

work of André Masson, Yves Tanguy, Jean Arp, and Joan Miró, in whom Dalí expressed a keen interest at this time. Masson's sand paintings of 1926–27 establish an immediate precedent for Dalí's unorthodox use of new media, as do Picasso's series of "guitars" of 1926, in which lowly, debased materials are attached to soiled, cardboard grounds. Dalí's penchant for organic, biomorphic shapes, in contrast, points to the

influence of Tanguy, Arp, and especially Miró, whom Dalí had met at that time.[2] In a short text on his Catalan colleague, published in June 1928, Dalí waxed poetic about Miró's elemental figuration and economy of means: "Joan Miró knows how to clearly divide up an egg yolk, in order to make possible the appraising of the astronomical course of a head of hair. Joan Miró brings the line, the point, the slight stretching out of shape, the

figurative meaning, the colors, back to their purest elemental magical possibilities."[3] Indeed, *Bather* immediately reveals Dalí's intuitive understanding of Miró's tight, crisp line and his use of a simplified vocabulary of signs: the wispy creature that hovers above the sea to the right of the big toe bears striking affinities with the figuration Miró employed in works of 1924–27 with a patently sexual character.[4]

Notes

1. Salvador Dalí, " . . . L'Alliberament dels dits. . . ," *L'Amic de les arts* (Sitges) 31 (March 31, 1929): 6–7.

2. Miró took a keen interest in his young Catalan colleague, bringing his dealer Pierre Loeb with him to Figueres to visit Dalí in mid-September 1927. On Dalí's meeting with Miró, see Ian Gibson, *The Shameful Life of Salvador Dalí* (London: Faber and Faber, 1997), 169–170; and Fèlix Fanés, *Salvador Dalí: La Construcción de la imagen, 1925–1930* (Barcelona: Electa, 1999), 116–117.

3. Salvador Dalí, "Joan Miró," *L'Amic de les arts* (Sitges) 26 (June 30, 1928): 202, translated in *The Collected Writings of Salvador Dalí*, ed. Haim Finkelstein (Cambridge: Cambridge University Press, 1998), 93–94.

4. Following his visit with Miró, Dalí wrote to García Lorca of Miró's "enormous Purity," adding the important disclaimer, however, that "Miró paints chickens with hairs and pricks, etc." Cited by Gibson, *Shameful Life*, 170.

29. *Beigneuse*, 1928

Oil on panel
25 × 29 1/2 inches

Exhibitions
Zürich 1929
New York 1965
London 1994
Fort Lauderdale 1997
Shinjuku 1999
Hartford 2000

Beigneuse is a thematic pendant to *Bather* of 1928 (cat. no. 28).[1] Although slightly larger, it reprises the subject matter of the other painting and of the bather series in general: an enormous hand with an extended phallic pinky finger has replaced the tumescent big toe of *Bather*, while the feet in *Beigneuse*, however exaggerated, are significantly reduced in size and scale. In contrast to the other painting, however, the predatory sexuality of the bather is fully manifest. The diminutive face is reduced to two stylized black circles for eyes, while the serrated open mouth suggests a *vagina dentata*, an obvious allusion to the threat of castration. With a hideously deformed, sagging left breast and sickening flesh the color of Pepto-Bismol, *Beigneuse* is an image of decay, putrefaction, and death.

Dalí conceived the painting as a frontal attack on the Catalan art establishment and its adherence to age-old canons of ideal feminine beauty. The sandy beach on which the figure reclines at once establishes a concrete, material setting for the nude, in that it consists of actual sand embedded in the paint, and acts as an exhortation to touch, its coarse texture existing in marked contrast to the smooth surface of the figure's flesh. The friction that is established between these dissonant textures appears to have both a sexual and an art-historical meaning, calling to mind Max Ernst's *frottage* technique, in which pigment is rubbed onto canvas or paper that has been laid on a rough surface, revealing the underlying texture. In French slang, however, the verb *frottager*—"to rub" —also refers to the grinding of bodies in an erotic encounter, a meaning that cannot have escaped Ernst or Dalí.

The theme of the overtly sexual bather in Dalí's work in turn bears striking affinities with a contemporaneous series of equally lewd "Spanish Dancers" produced by Miró in the late winter/early spring of 1928. Although it is unlikely that Dalí knew of this series (Miró executed the "Spanish Dancers" in Paris), he was familiar with his colleague's much publicized desire to "assassinate" painting. (The "Spanish Dancers" incorporates unorthodox materials, such as sandpaper, feathers, cork, hat pins, and illustrations from retail catalogues, in a calculated assault on the tradition of *belle peinture*.) In the final section of his essay "The New Limits of Painting," which Dalí published in three installments in February, April, and May 1928, as he worked on the "Bather" series, he championed surrealism's attack on the cultural norms of bourgeois society, especially the investment in high art as a moral and spiritual absolute: "The assassination of art, what a beautiful tribute!! The Surrealists are people who honestly devote themselves to this. My thought is quite far from identifying with theirs, but can you still doubt that only those who risk all for everything in this endeavor will know all the joy of the imminent intelligence. Surrealism risks its neck, while others continue to flirt, and, while many put something aside for a rainy day."[2]

Notes

1. This hypothesis is sustained not only by the visual evidence but also by the fact that dissident surrealist author Georges Bataille included both paintings in an exhibition he organized in Zürich of abstract and surrealist art ("Abstrakte und Surrealistiche Malerei und Plastik," Kunsthaus,

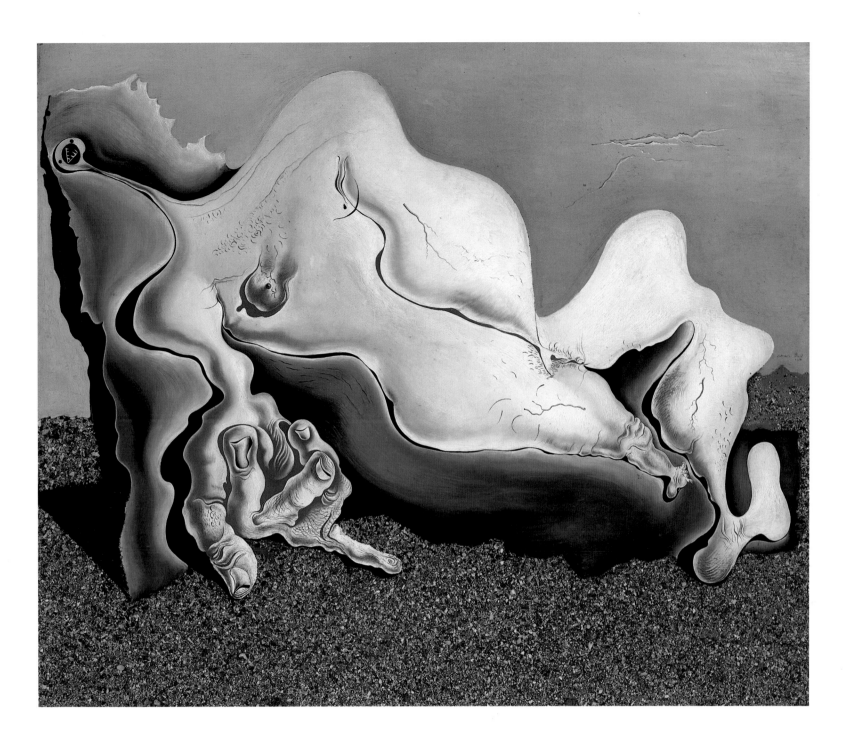

Zürich, October 6–November 3, 1929), subsequently publishing the two works side by side in his journal *Documents*. Given that Dalí refused Bataille permission to publish his *Lugubrious Game* in the December 1929 issue of the magazine, he must have granted his explicit authorization on this occasion.

2. Salvador Dalí, "Nous límits de la pintura" (part 3), *L'Amic de les arts* (Sitges) 25 (May 31, 1928): 195–196, translated in *The Collected Writings of Salvador Dalí*, ed. Haim Finkelstein (Cambridge: Cambridge University Press, 1998), 92.

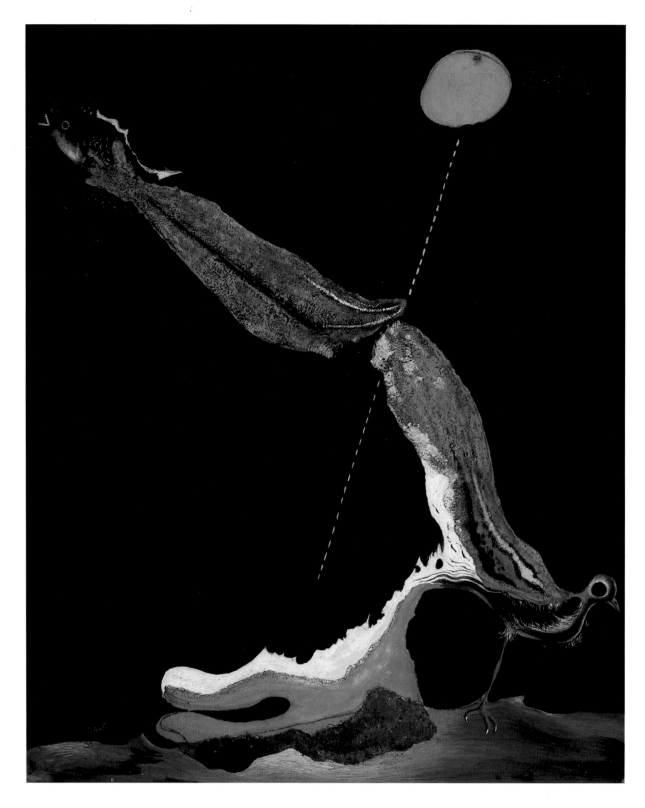

30. *Ocell . . . Peix*, 1928

Oil on panel

24 × 19 1/2 inches

Exhibitions

New York 1965

London 1994

Pittsburgh 1998

Ever since he had begun collaborating in earnest with Federico García Lorca on illustrations for *El Libro de los putrefactos* (see cat. no. 27), the subject of putrescence occupied an important position in Dalí's art and writings. Over the course of 1928, Dalí executed a series of paintings of rotting fish, birds, and donkeys in which the idea of the "putrefacto" took on new and more complex meanings. From its original conception as a term of harmless derision designating cultural provincialism, staid bourgeois manners, and excessive sentimentality, it came increasingly to signify an almost exalted state of abjection, decay, and perversion in direct opposition to the bourgeois social order. By July 1930, under the full impact of surrealism, Dalí went so far as to include putrefaction among the three great simulacra (in addition to excrement and blood) as agents of systematic demoralization.[1]

The iconography of *Ocell . . . Peix* (Bird . . . fish) may be located midway between these two positions. On the one hand, the image of the lifeless bird suggests an act of lowering (an Icarian descent) from the romantic heights symbolized by the moon in the upper right. On the other hand, the diagonal armature whose terminal points end in the body of a fish and that of the bird suggests metamorphosis, the loss of identity, and formlessness, as one thing slides into another. Indeed, the armature itself resembles a distorted human (female?) leg, with the bird's clawed foot suggesting the spiked heel of a shoe that is firmly planted on the foreground plane. Exaggerated as this claim may appear, it should be kept in mind that Dalí maintained the association of fish head/woman/phallus in *The First Days of Spring* of 1929 (cat. no. 34), where the fish alludes to both male and female genitalia, and constructed one of his first "Objects of Symbolic Functioning" in 1931 using a woman's high-heeled shoe. In all three works, the fetishistic implications of the leg, shoe, fish, and bird (traditionally a surrogate for female genitalia) locate meaning within the arena of abjection and sexual perversion pathologized by Freud and Krafft-Ebing but championed by Dalí and the French surrealists.

That Dalí was increasingly responding to surrealist art and ideas at this time, despite his professed distance from the movement (see cat. no. 29), is immediately evident in the formal language he employed in *Ocell . . . Peix*. The image of the rotting bird is clearly indebted to Max Ernst, particularly his paintings of LopLop, Superior of Birds (Ernst's totem animal), while the rough surface textures of the leglike extension suggest that Dalí had been interested in Ernst's *frottage* technique. However, the overall structure of the painting, with its flat background and figuration organized along a double diagonal axis, more closely replicates that of Miró's dreamscapes of the mid-1920s, particularly a work like *Person Throwing a Stone at a Bird* of 1926 (Museum of Modern Art, New York).

Notes

1. Salvador Dalí, "L'Ane pourri," in *La Femme visible* (Paris: Editions surréalistes, 1930).

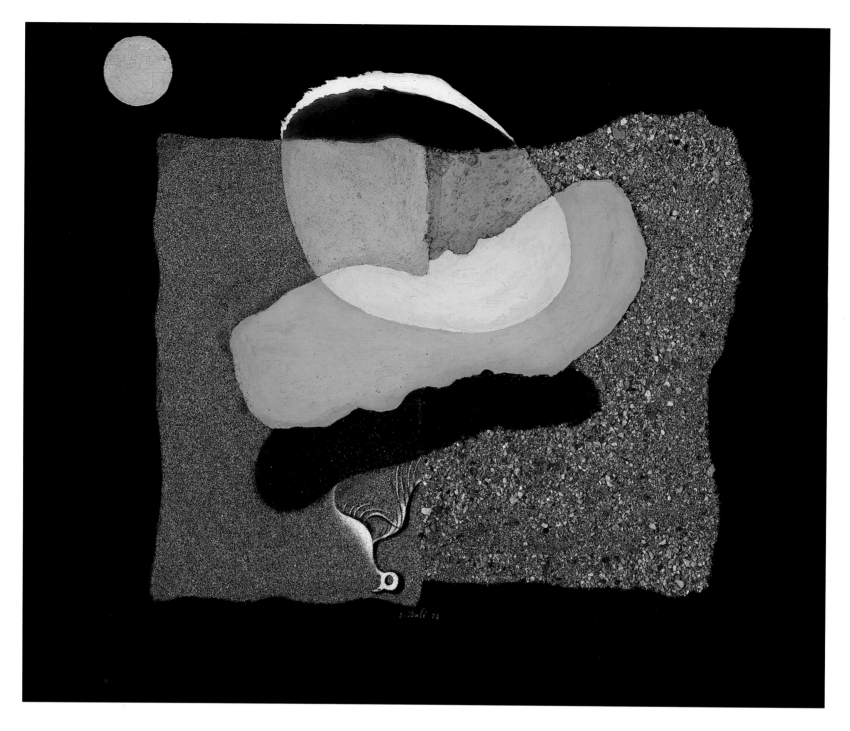

31. *Dit Gros etc. (Big Thumb, Beach, Moon and Decaying Bird)*, 1928

Oil on panel
19 3/4 × 24 inches

Exhibitions
Barcelona 1928
New York 1965
Fort Lauderdale 1997

48 Catalogue 31

Dit Gros etc. (Big Thumb, Beach, Moon and Decaying Bird)

Dalí painted two versions of *Big Thumb, Beach, Moon and Decaying Bird* in 1928. In the second, nearly identical version, the form of the thumb is more explicitly defined, while a cloud bisects the moon in the upper left. Looking ahead to the opening sequence in Dalí and Luís Buñuel's film of the following year, *Un Chien andalou* (see cat. no. 33 for a discussion), the moon/cloud imagery refers to the romantic cult of sentimentality Dalí opposed to the objective vision of astronomy in the 1927 text "Sant Sebastià" (see cat. no. 27). Part of an extended series of paintings in which the image of a big toe or phallic finger figures prominently (see cat. nos. 28, 29, and 32), *Dit Gros . . .* restates the theme of abjection and sexual perversion with great economy of means.

Dalí submitted *Dit Gros . . .* along with another work entitled *Dialogue on the Beach/Unsatisfied Desires* (private collection) to Barcelona's 1928 Autumn Salon at the Sala Parés. The overt sexual content of *Dialogue* (a hand with an outrageous phallic finger pointing upward engages in a frustrated and impossible "dialogue" across an expanse of open space with a feminine mass to its right; the desire for union is graphically written across the space of the painting in a delicate, meandering line) so concerned the director of the gallery, Joan Maragall, that he asked Dalí to withdraw it from the exhibition.[1] Outraged, Dalí rejected Maragall's proposal out of hand and decided to show the two pictures elsewhere. Dalí then approached his dealer Josep Dalmau with the possibility of exhibiting the two paintings in a group show, insisting, in a savvy publicity ploy, that the corresponding

catalogue indicate they had been rejected from the Sala Parés show. Awaiting Dalmau's response, Dalí threatened Maragall that, under the circumstances, he would not deliver a much publicized lecture on the occasion of the Autumn Salon. Maragall's response was an offer to buy the two paintings on the condition that only the less contentious one be exhibited.

Not one to remain complacent, on the day of the inauguration of the Sala Parés show Dalí published a disingenuous statement in a local newspaper, *La Publicitat*, stating that he had declined to exhibit voluntarily at the Autumn Salon because one of his paintings had been rejected; if the other was on exhibit, he insisted, it was because the work now belonged to Maragall. Meanwhile, Dalmau agreed to show *Unsatisfied Desires* after the Autumn Salon closed, but Dalí's father, fearing a public scandal, implored Dalmau to reconsider. Torn between his duty to Dalí and his sense of propriety, Dalmau finally exhibited the painting with a piece of cork covering the objectionable phallic finger.[2]

Dalí took full advantage of this unhappy course of events, delivering a lecture at the Sala Parés that attacked the foundations of the Catalan cultural establishment by systematically negating the idea of a racial essence in Catalan art, the much championed revival of Catalan decorative arts and métiers, and the preeminence of regional landscape painting (one of the Catalan bourgeoisie's sacred cows). Championing the machine aesthetic and the work of Miró, Arp, Brancusi, and Picasso, Dalí boldly proclaimed, "Only an art generated on the

margins of the intelligence—on the margins of all culture, of any system of culture, [an art of] pure consequence, a pure product of inspiration and instinct—arrives at intuitive truths of an absolute value and exactitude."[3] From this point onward, there would be no turning back for Dalí; the Catalan public came to expect scandal from the young artist, and Dalí gladly delivered in kind.

Notes

1. On October 3, 1928, Maragall wrote to Dalí: "Distinguished friend, I have just received your two canvases. I am not writing now to tell you how much I value the very many qualities that I find in both of them. But I have to write from a point of view completely removed from my personal opinion. It is very difficult to exhibit one of your paintings, if I am to prevent my Gallery becoming involved in a series of arguments which would damage a success that I believe everyone has to support. I very much wish that you were in my place and that you would imagine what it means for the Barcelona public to be invited to an exhibition in which they would find a picture that would disgust them to the core of their being. I wish you were in my place and were able to understand how very difficult it is to write this to you, how much I would like to say nothing to you and exhibit the picture. I would be very grateful if you would release me from this predicament by allowing me not to exhibit this work of yours,

much as I would regret this. I am sure of this and look forward to your telephoning me or leaving a message. I remain always your firm friend. Joan Maragall." Montserrat Aguer and Fèlix Fanés, "Illustrated Biography," in *Salvador Dalí: The Early Years*, exh. cat., South Bank Centre, London, 1994, 39.

2. A full account of the events with corroborating documents is provided by Rafael Santos i Torroella, "Salvador Dalí i el Saló de Tardor: Un Episodi de la vida artística barcelonina el 1928," *Discurs d'ingrés de l'Acadèmic Electe llegit a la sala d'Actes de l'Acadèmia el dia 27 de febrer de 1985* (Barcelona: Reial Acadèmia Catalana de Belles Arts de Sant Jordi, 1985), 5–34.

3. Salvador Dalí, "Art català relacionat amb el més recent de la jove intel.ligència," *La Publicitat* (Barcelona), October 17, 1928; reprinted in Salvador Dalí, *L'Alliberament dels dits. Obra catalana completa*, ed. Fèlix Fanés (Barcelona: Quaderns Crema, 1995), 133–146.

Catalogue 31

Dit Gros etc. (Big Thumb, Beach, Moon and Decaying Bird) 49

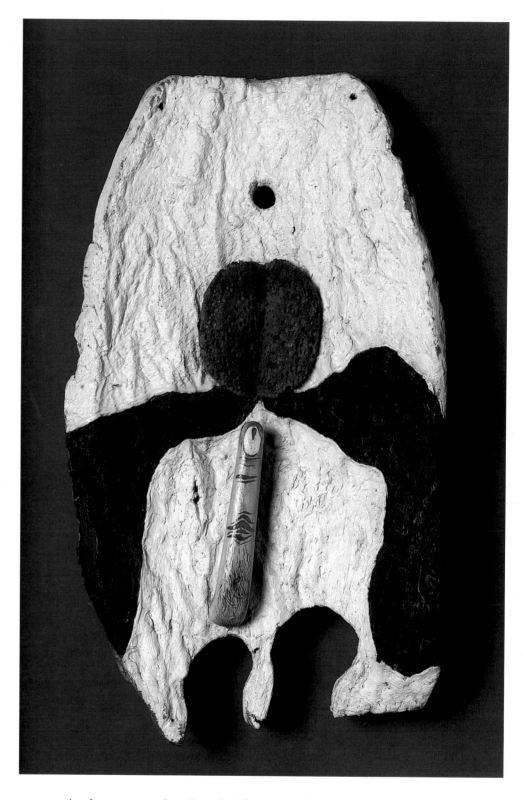

32. *Anthropomorphic Beach (fragment)*, 1928

Anthropomorphic Beach (fragment)

Painted cork, wood, and sponge
19 × 11 inches

Exhibitions
New York 1965
London 1994
Paris 1995

In keeping with the theme of erotic abandon (luxuriating, albeit grotesque, figures reclining on the beach) that had entered his work in 1928, that same year Dalí executed a series of more abstract beachscapes with collage elements in which form is reduced to organic, biomorphic shapes inspired by the relief sculptures of Jean Arp. *Anthropomorphic Beach*, a fragment from a larger, now destroyed painting, belongs to this series. A. Reynolds Morse relates how he acquired the piece:

It was quite by chance that while strolling near Dalí's house in 1956 I passed the rubbish heap and noticed a broken stretcher and a defaced canvas with a piece of cork attached. Late that night I woke with a start and realized that the discarded object was from Playa Antropomórfica. *So with knife and flashlight under a gibbous moon I left the Hotel Port Lligat and rescued it just as the flames from the burning refuse were about to reach it. . . . Today it is one of the few surviving object-symbols that Dalí relates he fastened to his canvases at one stage of his career.*[1]

The immediate precedent for the kind of formal *bricolage* Dalí employed in this series can be traced to the working practices of Joan Miró and Max Ernst, who both employed found materials from illustrated catalogues as points of departure for their imagery, and Picasso's "guitar" collages of 1926, which Dalí is likely to have seen on the occasion of his first trip to Paris that year.

Anthropomorphic Beach renders explicit the subject of Dalí's *Bather* and *Beigneuse* (cat. nos. 28 and 29). The hairy finger pointing upward toward a soft, blood-red piece of sponge leaves little room for the imagination, as the finger/phallus association achieves its most concrete form to date in Dalí's work. The obscene gesture may also have been intended as a reference to a familiar expletive—giving one the finger to register anger or displeasure—which Dalí is likely to have directed at the conservative Catalan public and the Barcelona art establishment. Indeed, in March 1928 Dalí, Sebastià Gasch, and Lluís Montanyà published the infamous *Manifest Groc* (Yellow manifesto), a tract that violently denounced the anachronistic state of Catalan culture and promoted machine-age aesthetics and modern technology. Giving the finger, as it were, to the Catalan bourgeoisie, the manifesto launched an all-out offensive using rhetoric that closely approximated the language of the Italian futurists:

All courtesy in our attitude has been eliminated from this manifesto. *There is no point in any discussion with the representatives of present-day Catalan culture, which is artistically negative, even though efficient in other regards. Compromise or correctness lead to deliquescent and lamentable confusing of all values, to the most unbreathable spiritual atmospheres, and to the most pernicious of influences. . . . Violent hostility, on the other hand, sets neatly all values and attitudes and creates a hygienic state of mind.*[2]

Notes

1. A. Reynolds Morse, *Salvador Dalí: A Panorama of His Art* (Cleveland: The Salvador Dalí Museum, 1972), 147.

2. *Manifest Groc* (Yellow manifesto [Catalan anti-artistic manifesto]), translated in *The Collected Writings of Salvador Dalí*, ed. Haim Finkelstein (Cambridge: Cambridge University Press, 1998), 59.

Oil on panel
19 3/4 × 25 inches

Exhibitions
New York 1965
London 1994
Shinjuku 1999

The Ram belongs to a series of paintings from 1928 in which a constellation of images (bird/moon/donkey/landscape/fish/female body) are organized along a symbolic axis. Of these, *The Spectral Cow* (Musée National d'Art Moderne, Centre Georges Pompidou, Paris) and *The Stinking Ass* (private collection, Paris) are closest in spirit to *The Ram (Vache Spectrale)*. The precise meaning of the hapless creature in the painting is unclear, but its partially decomposed body relates it to the themes of putrescence, sentimentality, and the decadence of high culture that Dalí associated with the image of the rotting donkey. In a letter to his friend José (Pepín) Bello dated October 24, 1927, the artist commented on a recent prose poem published by the well-known writer Juan Ramón Jiménez.[1] *Platero y Yo* is the poet's sentimental story of pastoral life in the company of his companion, a donkey named Platero, who later dies of poisoning. Describing Jiménez unsparingly as "a big, hairy *putrefacto*," Dalí contrasts his lyric poetry with the objective and "anti-artistic" image of a rotting donkey, the antithesis of romantic idealization. A year and a half later, Dalí and Luís Buñuel wrote a joint letter to Pepín Bello in which they included a passage from a letter that they were planning to send to Jiménez: "¡¡MERDE!! Para su *Platero y Yo*, para su fácil y mal intencionado *Platero y Yo*" (SHIT on your *Platero y Yo*, on your facile and ill-intentioned *Platero y Yo*).[2] Several months later, the image of the rotting donkey appeared again in Dalí and Buñuel's notorious film, *Un Chien andalou*.

The Ram foreshadows the inaugural filmic metaphor in *Un Chien andalou*, in which a man on a balcony looks out at the moon as a thin cloud cuts across its path. Symbolizing romantic love, the moon/cloud metaphor is then transformed in a horrific sequence in which the camera zooms in on a woman's eye as it is sliced by a razor blade. Indeed, a similar contrast of sentimentality with horror and abjection is suggested in *The Ram*, in which the profile of a face is transposed over a full moon beside the emaciated ram and the carcass of a rotting bird in the center foreground.

The Ram also attests to Dalí's increasing formal debts to surrealist painting. The organic figuration of the face and bird are borrowed from the relief sculptures of Jean Arp (Picasso's dual frontal/three-quarter portraits are also in evidence), while the image of the ram is likely to have been inspired by Max Ernst's *Belle Saison* of 1925 (private collection). Characteristically, Dalí transforms his surrealist sources by developing an entirely personal and idiosyncratic iconography that would significantly inject new life into the surrealist movement by 1930.

Notes

1. The letter is reproduced in Rafael Santos i Torroella, *Dalí residente* (Madrid: Residencia de Estudiantes, 1992), 193–195.

2. Letter of February 10, 1929, in Santos i Torroella, *Dalí residente*, 218–221.

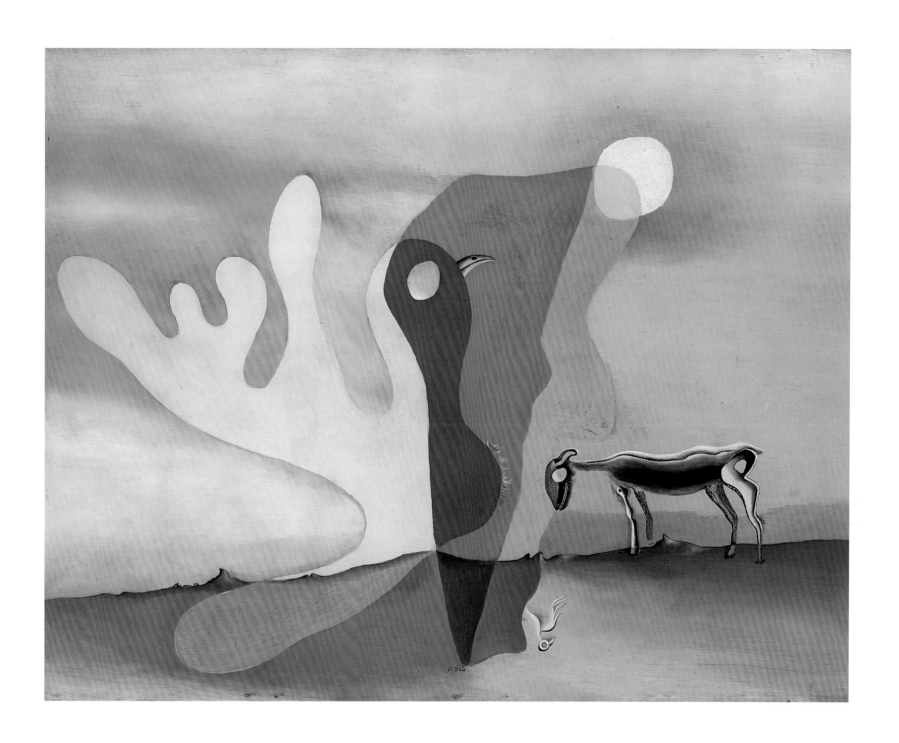

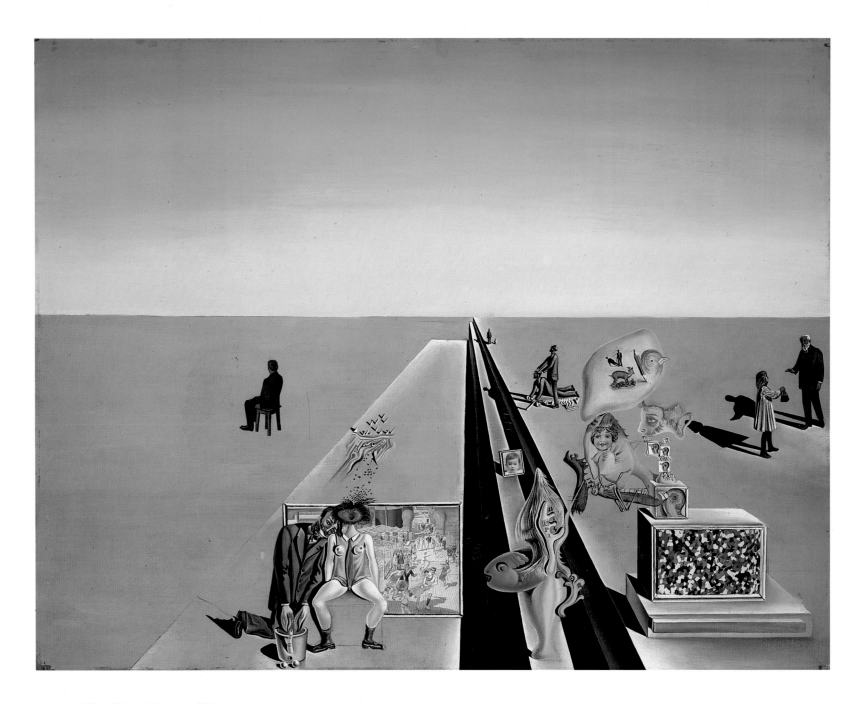

34. *The First Days of Spring*, 1929

Oil and collage on panel
19 3/4 × 25 5/8 inches

Exhibitions
Paris 1929
Paris 1930
New York 1965
London 1994

Liverpool 1998
Shinjuku 1999

In the months following his
scandalous lecture at the Sala Parés
on the occasion of Barcelona's third
Autumn Salon (see cat. no. 31), Dalí
set out to capitalize on his newly

found notoriety. His writings
maintained a decidedly polemical
tone, and his work continued to
violate established aesthetic
conventions. In a move to extend his
visual practice, Dalí met with Luís
Buñuel in Figueres in January 1929
to work on the script for a

collaborative film project
provisionally titled *Dangereux de se
pencher en dedans* (Dangerous to lean
inside). Premiering in Paris on June 6
of that year as *Un Chien andalou*, the
film waged war on the tradition of
classic cinema and announced the
adherence of the two young

Spaniards to the principles of the surrealist movement. Indeed, Dalí had already edited the final—"surrealist"—issue of *L'Amic de les arts* in March 1929, dissuading his readers of any doubts they may have had about his allegiance to the French movement. When he arrived in Paris in early April to assist Buñuel with the filming of *Un Chien andalou*, he was poised to participate in the intellectual, cultural, and philosophical activities of the group.

Before arriving in Paris, Dalí executed *The First Days of Spring*, a painting that might well be considered his *carte de visite* for the surrealists. Through the efforts of Miró, Dalí was introduced to advanced literary and artistic circles in Paris, befriending René Magritte, Jean Arp, Paul Eluard, and the man who would shortly become his dealer in Paris, Camille Goemans. By the time he returned to Cadaqués in the summer of 1929, Dalí had made a strong impression on André Breton, and it was Breton himself who wrote the introduction to the catalogue of Dalí's first exhibition in Paris the following November. "Dalí's art," Breton announced, "the most hallucinatory that has been produced up to now, constitutes a veritable threat. Absolutely new creatures, visibly mal-intentioned, are suddenly on the move."[1]

The First Days of Spring was included in the Goemans exhibition, along with *The Lugubrious Game* (private collection), *Illumined Pleasures* (Museum of Modern Art, New York), *The Great Masturbator* (Museo Nacional Centro de Arte Reina Sofía, Madrid), and *Accommodations of Desire* (private collection), all four recognized as classic works in Dalí's development of a Freudian lexicon of symbols organized around psychoanalytic themes. In *The Secret Life*, Dalí commented that "libidinous pleasure was described in symbols of a surprising objectivity" in *The First Days of Spring*, as the young artist constructed a semiautobiographical narrative that indulged his most perverse—albeit highly overdetermined—fantasies.[2] Dalí's portrait appears twice in the painting: in the form of an actual photograph of the artist as a baby, located along the stairs in the center of the composition; and in an anamorphic self-portrait immediately to its right, in which a grasshopper appears to mount Dalí's face (for a discussion of the extended meaning of the grasshopper in Dalí's art, see cat. no. 51).

The psychoanalytic content of Dalí's narrative concerns the anxiety of sexual awakening. It is inscribed in *The First Days of Spring* by means of sexual symbols that are drawn from Freud's writings: the phallic form of a fish whose head protrudes from a fantastic jug with female attributes; the image of a putrescent goat whose analogue is to be found in the swarm of flies that emerges from a woman's head in the form of a hairy anus or genitals; the visual pun of a tie that hangs between the same figure's breasts, configuring the sign for a displaced phallus and/or the labial folds of a vagina (the hands of her male partner in turn form the double image of a vagina that is penetrated by an erect phallic finger); the suggestive coupling of two men engaged in an act of (sexual) aggression that is fraught with Oedipal tension; the scene of a young girl who offers her "purse" to an elderly bearded man; and the presence of steps in deep shadow, a classic Freudian reference to sexual intercourse. In this light, *The First Days of Spring* may be thought of as a kind of visual primer to Freud's *Interpretation of Dreams*, which Dalí had read in Spanish translation.[3] As Dawn Ades has observed, "what makes [Dalí's] paintings of 1929–30 so extraordinary is the way they hold in balance a real neurotic fear which is clearly very powerful, and a knowing use of psychology textbooks."[4]

Everything about *The First Days of Spring* is calculated to shock, even to repulse, the viewer. Not only does Dalí's imagery engage themes of aggression, cruelty, dismemberment, and sado-masochistic eroticism, but the intensity with which he delights in the most abject and base aspects of human nature relates his project to that of dissident surrealist Georges Bataille, with whom he was in contact at this time.[5] What is more, Dalí assaulted the sensibility of the viewer in the way he actually painted his pictures, using the tradition of academic illusionism to insist on a high level of verisimilitude. Not only is the imagery disturbing in its own right, but Dalí adopted specific strategies employed by Giorgio de Chirico, René Magritte, and Max Ernst—vertiginous perspectival projection, deep shadows, and the juxtaposition of incongruous objects —to subvert the familiar reality of appearances. The literal presence of ready-made collage elements—a chromolithograph in the shadow box behind the couple and the little photograph of Dalí as a baby—in turn underscores the idea of visual and thematic disjunction, as a seemingly innocuous scene of leisure on a luxury cruise ship is directly implicated in Dalí's horrific dream narrative.[6] As the artist would declare in a polemical text of 1935, *Conquest of the Irrational*:

My whole ambition in the pictorial domain is to materialize the images of concrete irrationality. . . . The important thing is what one wishes to communicate: the concrete irrational subject. The means of pictorial expression are placed at the service of this subject. The illusionism of the most despicably go-getting and irresistible imitative art, the skillful tricks of paralyzing trompe-l'oeil, the most analytically narrative and discredited academicism, all these can become sublime hierarchies of thought at the approach of the new exactitudes of concrete irrationality, as the images of concrete irrationality draw nearer to the phenomenally real. . . . Instantaneous color photography done by hand of the superfine, extravagant, extraplastic, extrapictorial, unexplored, superpictorial, superplastic, deceptive, hypernormal, feeble images of concrete irrationality—images that are provisionally unexplainable and irreducible by systems of logical intuition or by rational mechanisms.[7]

Dalí's double-edged transgression at the level of form and content was not lost on his contemporaries. Reviewing his recent work in an article published just prior to the opening of the Goemans exhibition, Sebastià Gasch described Dalí's challenge to the tradition of *belle peinture* and aesthetic modernism, in line with surrealist principles of moral and aesthetic subversion:

In these paintings this technical indifference borders on disdain." This indifference that a number of today's artists—the best ones?—feel for plastic problems is curious. After a period of art for art's sake, a period in which the canvas was considered an end in itself and in which the problem of form and color was exclusively extolled to the exclusion of any moralizing or simply literary intention, it is curious to note that art returns to the service of a moral, a very special moral. We are witnessing the total liquidation of numerous centuries of painting and the most absolute failure of aesthetic research which insistently proceeded from impressionism to cubism. . . . For the surrealists, painting is the manifestation—surely the most insignificant one—of a general spiritual state. Man is much more important than his work. And when this man grabs his brushes, he does it in the service of his morality, the morality of the surrealists: a terribly amoral, pessimistic, skeptical, dirty, and lowly sexual morality.[8]

Although Gasch insisted that "there is a chasm between this very particular conception of art and my own," he admitted that the emotional force of Dalí's recent work demanded serious attention.

A few months later, *The First Days of Spring* was again exhibited at the Galerie Goemans in a ground-breaking show featuring recent work in collage by Max Ernst, René Magritte, Joan Miró, Francis Picabia, and Jean Arp, among others. Turning to Dalí toward the end of his essay, surrealist poet Louis Aragon considered his approach to the collage medium as an act of aesthetic terrorism:

What defies interpretation best is probably the use of collage by Salvador Dalí. He paints with a magnifying glass; he knows so well how to imitate a chromo, that the result is inevitable: the pasted parts of the chromo are thought to be painted while the painted parts are thought to be pasted. Does he aim thus at confusing the eye and does he enjoy causing a mistake on purpose? This may be admitted but it does not explain a double game that cannot be ascribed either to the artist's despair before the inimitable, or to his laziness before a ready-made expression. It is certain too that the incoherent aspect of a Dalí picture, in its entirety, recalls the particular incoherence of collages. An attempt has been made to reduce Max Ernst's collages to plastic poems. If one should try on psychological grounds to handle Dalí's paintings in the same way, he could claim that every one of his pictures is a novel. Thus Dalí is also associated with the antipictorial spirit that not so long ago made painters, then critics, protest loudly, but that invades painting today. This is what may be retained from a sequence of facts that we are witnessing that might seem chaotic only to those who did not see their essential link.[9]

As Breton had recognized a few months earlier, Dalí's "Challenge to Painting" (the title of Aragon's essay) did, indeed, constitute a "veritable threat."

Notes
1. André Breton, "Stériliser Dalí," in *Salvador Dalí*, exh. cat., Camille Goemans Gallery, Paris, November 20–December 5, 1929, as translated in Ian Gibson, *The Shameful Life of Salvador Dalí* (London: Faber and Faber, 1997), 237.

2. Salvador Dalí, *The Secret Life of Salvador Dalí* (New York: Dial Press, 1942), 213.

3. In Dalí, *Secret Life*, (167), the artist stated, "[Freud's *Interpretation of Dreams*] presented itself to me as one of the capital discoveries in my life, and I was seized with a real vice of self-interpretation, not only of my dreams but of everything that happened to me, however accidental it might seem at first glance." The Spanish translation appeared in 1924. According to Gibson (*Shameful Life*, 116–117), the first two volumes of Freud's complete works (Biblioteca Nueva, Madrid) were published just prior to Dalí's arrival in the Spanish capital in September 1922, and contained *The Psychopathology of Everyday Life, Three Essays on the Theory of Sexuality, Five Lectures on Psycho-Analysis*, and the essays "On Dreams" and "Beyond the Pleasure Principle." A year later, *Jokes and Their Relation to the Unconscious* and *Introductory Lectures on Psycho-Analysis* appeared in translation in the same series. Gibson suggests that Dalí may have read or at least perused these seminal texts by 1924.

4. Dawn Ades, *Dalí* (London: Thames and Hudson, 1982), 75.

5. For a discussion of Dalí's position in the surrealist movement at a time of internal divisions between André Breton and dissident members of the group, including Georges Bataille and Robert Desnos, see Ades, *Dalí*, 66–70. As the author astutely observes (68), "What becomes apparent is that Bataille saw in Dalí a possible accomplice in his attack on what he considered the anti-materialist idealism of the Surrealists. It is also true that Bataille probably understood Dalí better than Breton did, and could sympathize precisely with those aspects of Dalí's interest in the materiality of objects, and in the grotesque and the shocking, which Dalí himself felt were out of line with the Surrealists."

6. Dalí's model for the use of collage elements within the context of an extended dream narrative is clearly Max Ernst, whose first collage novel, *La Femme 100 têtes*, appeared in 1929. Peter Tush of the Salvador Dalí Museum has convincingly proposed a direct source for the figure of the man seated in a chair in *The First Days of Spring* in an untitled collage of 1920 by Max Ernst (see Werner Spies, ed., *Max Ernst: A Retrospective*, exh. cat., Tate Gallery, London, 1991, no. 38).

7. Salvador Dalí, *Conquest of the Irrational* (New York: Julian Levy Gallery, 1935).

8. Sebastia Gasch, "Les Obres recents de Salvador Dalí," *La Publicitat* (Barcelona), December 16, 1929.

9. Louis Aragon, "La Peinture au défi," preface to an exhibition of collages at Galerie Goemans, Paris, 1930; in Marcel Jean, ed., *The Autobiography of Surrealism* (New York: Viking Press, 1980), 210.

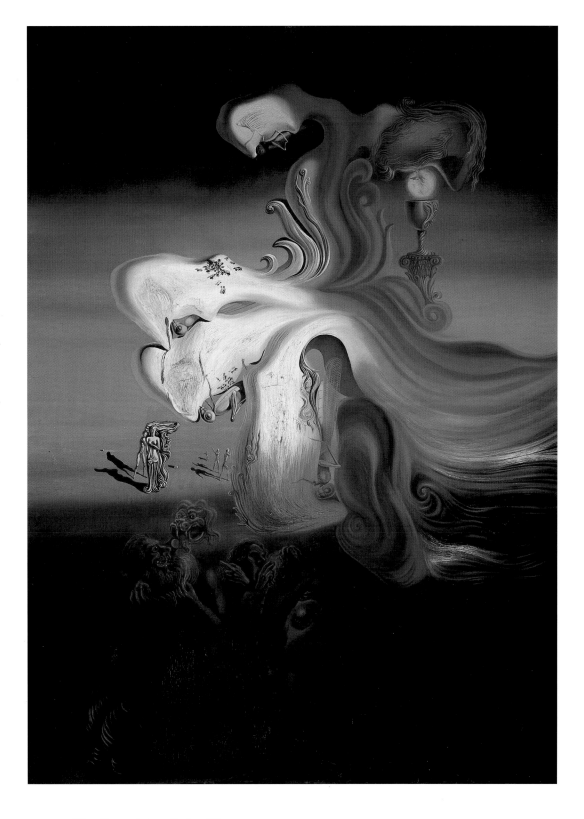

Oil on canvas
39 3/8 × 28 3/4 inches

Exhibitions
Paris 1931
New York 1944?
New York 1965
Fort Lauderdale 1997

Profanation of the Host belongs to a series of paintings executed in 1929–30 in which Dalí explores the theme of onanism, guilt, and paternal retribution (see also cat. nos. 36 and 37). The self-portrait head of The Great Masturbator, which first appeared in an eponymous work of 1929 (Museo Nacional Centro de Arte Reina Sofía, Madrid), is repeated four times in the painting in the form of organic extremities that appear to burst forth from the extravagant object/monument in the center of the composition. Grasshoppers, which Dalí associated with abjection and horror (see cat. no. 51), are strategically appended to the central structure and to the faces of three of the masturbators. The fourth masturbator, distinguished by flowing locks of blond hair and a copious beard that repeats the organic rhythm of the swirling forms below, ironically bows its head before the image of a luminous host rising from a chalice. Blood-stained semen drips from the mouth of the masturbator into the chalice. To the left of the central monument are several nude figures of both sexes and a semiclothed woman with flowing blond hair and a long robe. Beneath her, an entangled mass of five virtually indistinguishable male and female bodies dissolves into the shadows. Crowning the scene is a lion's head that bears a certain resemblance to the grotesque, bearded figure at the far left of the group.

35. *Profanation of the Host*, 1929–30

Critics have long associated the organic profusion of form in *Profanation of the Host* and related works (see cat. no. 36) with Dalí's interest in art nouveau—what he called modern style—architecture. At a time when the rationalist aesthetic of Walter Gropius, Mies van der Rohe, and Le Corbusier had achieved international recognition, Dalí characteristically looked elsewhere, turning his attention to the considerably undervalued work of Hector Guimard and Antoni Gaudí. In an important text of 1930, *"L'Ane Pourri"* (The stinking ass), in which he began to elaborate his theory of paranoia in relation to concrete simulacra (material, at times delirious, images that are ideal expressions of the desiring subject), Dalí insisted:

The acceptance of simulacra, whose appearances reality strives with great difficulty to imitate, leads us to desire ideal things.

Perhaps no simulacrum has created ensembles to which the word ideal could apply so well as the great simulacrum constituted by the astounding Art Nouveau ornamental architecture. No collective effort has managed to create a dream world so pure and so disturbing as the Art Nouveau buildings, which, existing on the fringes of architecture, constitute in themselves a true realization of solidified desires, and where the most violent and cruel automatism terribly betrays a hatred of reality and the need to find refuge in an ideal world, in a manner akin to the way this happens in infantile neurosis.[1]

Suggesting that the extravagant, organic forms of art nouveau architecture have a violent character

in which boundaries between the internal and the external, the soft and the hard, dream and reality, are dissolved (as in the case of the double image), Dalí champions Breton's axiom "Beauty will be CONVULSIVE or it will not be at all."[2] The new images of surrealism, he concludes, "may . . . contribute to the collapse of reality, to the benefit of everything which, through and beyond the base and abominable ideals of any kind, aesthetic, humanitarian, philosophical, and so on, brings us back to the clear sources of masturbation, of exhibitionism, of crime, and of love."

Thus Dalí's definition of the three great simulacra—"blood, excrement, and putrefaction"—represents an effort to pry open social taboos and to expose the repression they enforce. In *Profanation of the Host*, Dalí the iconoclast goes so far as to invert sacred dogma—the mystery of Christ's transubstantiation—in order to challenge specific agents of repression, as he defines them. But Dalí's attack on the host should not be confused with a direct institutional critique of the Catholic Church.[3] In effect, the idea of transubstantiation is a metaphor for the dissolution of the self—for the idea of consumption (the desire for love) and abnegation (the death drive) as the two great instincts that mediate corporeal and psychic boundaries. Returning to the metaphor of consumption in an analysis of the "Terrifying and Edible Beauty of Art Nouveau Architecture" in a 1933 essay, Dalí translates Breton's ideal of "mad love" into a new language of abjection and "cannibal

imperialism": "Beauty will be edible or will cease to be," he declares.[4]

———

Notes

1. "L'Ane pourri," in Salvador Dalí, *La Femme visible* (Paris: Editions surréalistes, 1930), 11–20; also printed in *Le Surréalisme au service de la révolution* (Paris) 1 (July 1930): 9–12; translated in *The Collected Writings of Salvador Dalí*, ed. Haim Finkelstein (Cambridge: Cambridge University Press, 1998): 223–226. The date of Dalí's text and the clear influence of art nouveau architecture in *Profanation of the Host* in turn support Ian Gibson's assertion that the painting was probably not completed until 1930 (*The Shameful Life of Salvador Dalí* [London: Faber and Faber, 1997], 282).

2. André Breton, *Nadja* (Paris: Editions surréalistes, 1928), 160.

3. Citing the work of Rafael Santos i Torroella ("Giménez Caballero y Dalí: influencias recíprocas y un tema compartido," *Anthropos. Revista de documentación científica de la cultura* [Barcelona] 84 [1988]; 53–56), Gibson, *Shameful Life* (282), points to another possible source for the motif of blood/semen dripping into a chalice in Ernesto Giménez Caballero, *I, Inspector of Drains* (1928), in which "an old Jesuit recalls how a schoolfriend of his used to boast that he had ejaculated into the Chalice, exclaiming: 'I sully myself over God and the Virgin, His Mother, and in the Holy Cup.' " Dalí was

on good terms with Giménez Caballero, publishing several essays in his review, *La Gaceta Literaria*, in 1928 and 1929.

4. Salvador Dalí, "De la Beauté terrifiante et comestible de l'architecture modernstyle," *Minotaure* (Paris) 3–4 (December 12, 1933): 69–76.

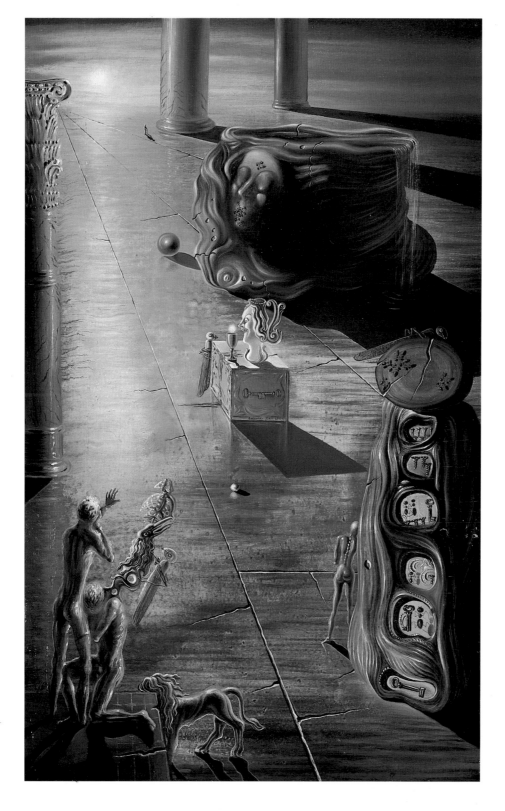

36. *The Font,* 1930

Oil and collage on panel
26 × 16 1/4 inches

Exhibitions
New York 1933B
New York 1936A
New York 1941A
Cleveland 1947
New York 1965
London 1994
Liverpool 1998
Rio de Janeiro 1998
Shinjuku 1999

The theme of abject desire that Dalí explored in *Profanation of the Host* (cat. no. 35) is tied to a psychoanalytic narrative of guilt and paternal retribution in *The Font.* The title refers to a large (baptismal?) fountain in the background in the shape of a woman's head from which water overflows. The undulating rhythms of the structure reveal Dalí's fixation on the "edible beauty" of art nouveau architecture, while the serpentine coils of the figure's hair, in conjunction with her stony, petrified countenance, allude to the myth of Medusa, which Freud interpreted in relation to the male child's recognition and disavowal of the mother's absence of a penis and the corresponding threat of his own emasculation. The closed eyes of the figure signify Medusa's blinding stare, while the substitution of a horde of ants for the mouth, which resembles a pubis, simultaneously serves to represent and conceal the object of the child's anxiety.[1] Immediately below the baptismal font is a chalice and host. A pitcher in the form of a woman's head stands to the side of the cup, on a small bloodstained

platform to which a grasshopper and a key are attached. A sign of abject terror, the grasshopper has phallic associations for Dalí and, like the fish, is a bisexual creature (see cat. no. 51). The key is in turn a conventional symbol of the Freudian unconscious (note the presence of keys, screws, ants, and a woman's head painted in the curious object on the lower right in conjunction with an image of ideal feminine beauty in the form of a French postage stamp representing Marianne).

Dalí's conflation of Christian imagery with the theme of Oedipal guilt and castration anxiety serves to narrate specific events in his life. According to Ian Gibson, Dalí made a brief trip to Paris in late October 1929 to set up his Goemans exhibition, returning to Spain with Gala Eluard just prior to the opening.[2] During his brief stay in the French capital Dalí painted *The Sacred Heart*, subtitled *Sometimes I spit for PLEASURE on the portrait of my mother* (Musée National d'Art Moderne, Centre Georges Pompidou,

Paris), a painting that was intended to scandalize the public in the spirit of Francis Picabia's *Sainte Vièrge* of 1920. When Dalí's father learned of the existence of the painting, which was exhibited in the Goemans show, he viewed it as a direct attack on the good name of his late wife and Dalí's beloved mother. Dalí's open relationship with Gala Eluard, a married woman, had already scandalized his family and the residents of Cadaqués the previous summer, straining Dalí's relationship with his father. Disgusted by his son's behavior and refusal to submit to his authority, Dalí senior informed his son in a letter dated December 6, 1929, that he was banished from the family home. The two men did not speak for another five years.

Thus viewing his immediate past through the lens of Freudian psychoanalysis, Dalí constructs a kind of mythic autobiography in *The Font*. In the lower left-hand corner two male figures appear to engage in oral sex, a symbolic act with numerous moral proscriptions in relation to the

paternal interdiction of the Oedipal drama. A fantastic bird (a vulture?) with a grasshopper attached emerges from the back of the kneeling figure, while the standing figure covers his face in shame and raises his left arm in a gesture of terror and/or self-defense.[3] The stylized lion to the right of the couple represents the father, the sign of paternal authority under which this nightmarish scene of desire, guilt, and retribution is enacted. The three columns, which may allude to the ancient Greek settlement of Empúries near Dalí's home, establish an archaeological metaphor for the scene, as Dalí the artist and myth-maker sifts through layers of the Freudian unconscious to construct his own narrative of personal loss in the historical present.

———
Notes

1. Dalí used a similar conceit in *The First Days of Spring* (cat. no. 34), where the head of the woman in the foreground is painted so as to suggest the form of a vagina from

which flies emerge. The image of the head/fountain in *The Font* reappears in a painting of 1931 entitled *The Dream* (private collection, New York).

2. Ian Gibson, *The Shameful Life of Salvador Dalí* (London: Faber and Faber, 1997), 234–236.

3. The vulture may be an oblique reference to Freud's psychoanalytic biography of Leonardo da Vinci, in which the Viennese doctor considers the psychoanalytic implications of the artist's memory of a vulture that visited him in his cradle, opening his mouth with its tail. The case history was published in May 1910. Sigmund Freud, "Leonardo da Vinci and a Memory of His Childhood," reprinted in Peter Gay, ed., *The Freud Reader* (New York: W. W. Norton, 1989), 443–481.

37. *La Main (Les Remords de conscience)*, 1930

Oil and collage on canvas
16 1/4 × 26 inches

Exhibitions
New York 1965
New York 1972
Barcelona 1996
Pittsburgh 1998
Shinjuku 1999

Reminiscing about his sexual coming of age in his confessional

autobiography, Dalí described his first experiences of masturbation:

I was growing, and so was my hand. "It" finally happened to me one evening in the outhouse of the institute; I was disappointed, and a violent guilt-feeling immediately followed. I had thought "it" was something else! But in spite of my disappointment, overshadowed by the delights of remorse, I always went back to doing "it," saying to myself, this is the

last, last, last time! After three days the temptation to do "it" once more took hold of me again, and I could never struggle more than one day and one night against my desire to do it again, and I did "it," "it," "it," "it" again all the time.[1]

By 1927, Dalí had begun to explore the theme of autoeroticism as a subject in visual representation, executing a series of paintings over

the next two years in which onanism is associated with putrefaction and the mortification of the flesh (cat. nos. 27, 28, 29, 32, and 35). With *La Main*, Dalí joined the subject of masturbation to an ever more complex narrative of sexual anxiety and Oedipal guilt, using the broad themes of psychoanalytic theory to bracket his perverse fantasies.

La Main is a dark and disturbing vision of guilt and repression. The

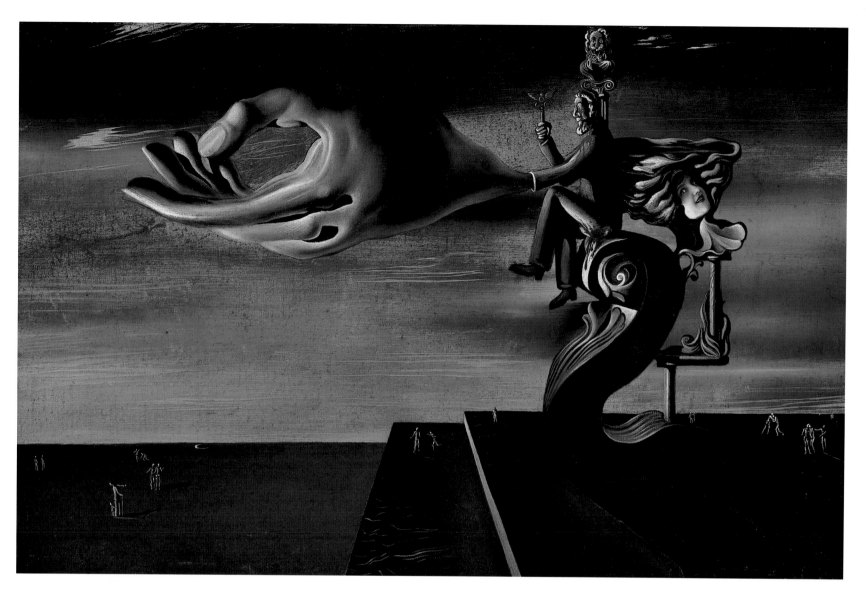

protagonist, a male figure with an enormous hand (the sign of, and catalyst for, his guilt) is precariously perched on an elaborate plinth that rests atop two steps, a classic Freudian allusion to sexual intercourse.[2] Presiding over the scene with hierarchical authority is the bust of an old man whose full, wavy hair and sinuous beard figuratively "lionize" him. His role, in Haim Finkelstein's words, is that of a "punishing super-ego and a castrating agent," the father figure whose symbolic presence serves to check the son's incestuous desires, which must

be sublimated as erotic fantasies.[3] Yet the physical appearance of the bearded masturbator also suggests that he identifies with the father, whose power he must overcome if he is to achieve union with the idealized female figure behind him, a Medusa-like creature who threatens the masturbator with castration and death (see cat. no. 36 for a discussion of a related image).[4] The "son's" guilt and ignominy are in turn graphically represented by the presence of fecal matter that pours from the seat of his pants, just as blood drips from the hollow sockets of his eyes—a clear

reference to the eyes of Oedipus. Dwarfed by the presence of the enormous hand, tiny figures of indeterminate sex engage in activities of play and/or combat on the stairs, platform, and distant plain. Several carry the stigma of Oedipal guilt on their bloodstained bodies.

However much Dalí's psychoanalytic scenario may appear predictable to some, the perverse delight he takes in painting the three great simulacra—blood, putrescence, and excrement—is disturbing. If Dalí's sand and cork paintings of 1928 (cat. nos. 28, 29, 31, and 32) were

intended to shock, images of bloody bodies and a man soiling his pants surely aimed to repulse. In *The Lugubrious Game* (private collection), Dalí's "reception piece" for the surrealists and the centerpiece of his exhibition at the Galerie Goemans in November 1929,[5] the presence of fecal imagery had elicited concern on the part of André Breton and Gala Eluard that the young artist was coprophilic. Dalí worked on the painting throughout the summer of 1929 in an acute state of mental exacerbation, in which spontaneous memories of childhood fantasies appeared with the

force of voluntary hallucinations. By his own account Dalí attempted to capture these associations in the painting, although the visual evidence (specific quotations from works by Giorgio de Chirico and the existence of an elaborate preparatory sketch for one of the main figural groups) suggests that Dalí worked within the framework of an established dream narrative, relying on the process of free association to encourage his visionary faculties. In his catalogue preface to Dalí's exhibition at the Galerie Goemans, André Breton cautioned the young painter not to fall victim to the Freudian text, although the sheer violence and brutal force of Dalí's recent work appears to have tempered his criticism. If a similar objection can be leveled at *La Main*, whose imagery and interpretation are in significant ways predetermined, the perverse pleasure Dalí takes in exploring the world of abject desire gives one pause to reconsider.

Notes

1. Salvador Dalí, *The Secret Life of Salvador Dalí* (New York: Dial Press, 1942), 139.

2. According to A. Reynolds Morse (*Salvador Dalí: A Panorama of His Art* [Cleveland: The Salvador Dalí Museum, 1972], 151), the platform on which the figure sits is directly based on a memorial on the Ramblas de Barcelona that is dedicated to the Catalan poet and dramatist Frederick Soler (1838–95). In a characteristic act of inversion and cultural subterfuge, Dalí undermines the tradition of the commemorative public moment by transforming the heroic figure into a masturbator. The base of the Soler monument also appears in *The Dream* of 1931 (private collection, New York), where it supports a seated male figure who buries his head in shame. A Medusa-like creature in the form of the fountain from *The Font* (cat. no. 36) appears in the foreground.

3. Haim Finkelstein, *Salvador Dalí's Art and Writing, 1927–1942: The Metamorphoses of Narcissus* (Cambridge: Cambridge University Press, 1996), 97.

4. The woman's face is actually a bit of photographic collage. This image of the slightly seductive, slightly disturbed and disturbing figure looks ahead to a photocollage Dalí executed in 1933, *The Phenomenon of Ecstasy*. The collage appeared in the December 1933 issue of *Minotaure* (Paris): 3–4.

5. Dawn Ades, *Dalí* (London: Thames and Hudson, 1982), 65.

38. *The Average Bureaucrat*, 1930

Oil on canvas
31 7/8 × 25 3/4 inches

Exhibitions
Amsterdam 1938
Fort Lauderdale 1997
Liverpool 1998

Upon receiving word on December 6, 1929, of his expulsion from the family home (see cat. no. 36), Dalí shaved his head in an act of defiance against the threat of symbolic castration. Over the next four years he produced a series of paintings in which the image of the father obsessively dominated his subject matter in the form of mythical and historical figures (William Tell, Lenin, civil servants, the grasshopper child, members of the family group from Jean-François Millet's *Angelus*, and, later, Sigmund Freud) with grotesquely enlarged, often distorted, bald heads (see cat. nos. 48, 51, 52, and 56), or hydrocephalic, anamorphic skulls (cat. no. 50). Referring at once to the threat of emasculation by a ruthless father and the sublimation of unresolved Oedipal desires, these disturbing paintings collectively explore the theme of masochism: the desire for and resistance to symbolic incorporation and authoritarian control.

The image of the bureaucrat—a clear reference to Dalí's father, who was a notary—first appears in *The Average Bureaucrat* of 1930. The enormous, somewhat ridiculous figure looms large over the twilight landscape of the Empordà, dwarfing the couple (Dalí and his father, or, more generally, an Oedipal group) in the middle ground. The convoluted nature of the bureaucrat's thought is suggested by the presence of snail shells in craterlike openings in his head.[1] The shells, in Freudian symbolism, allude to female genitalia, while the openings transform this representative of bourgeois law and order into an elaborate, soft Swiss cheese of sorts.

In Dalí's thinking, specific foods have extended psychic and sexual associations. As he explained in *The Secret Life*:

I like to eat only things with well-defined shapes that the intelligence can grasp. I detest spinach because of its utterly amorphous character, so much so that I am firmly convinced, and do not hesitate for a moment to maintain, that the only good, noble and edible thing to be found in that sordid nourishment is the sand.

The very opposite of spinach is armor. That is why I like to eat armor so much, and especially the small varieties, namely, all shell-fish. By virtue of their armor, which is what their exoskeleton actually is, these are a material realization of the highly original and intelligent idea of wearing one's bones outside rather than inside, as is the usual practice.[2]

In this dialectic of the soft and the hard, shellfish represent the protective armor of the ego, the very structure of self-preservation. The formlessness of spinach, in contrast, suggests vulnerability, detumescence, and the unfathomable depths of desire itself—something that is elusive, just beyond reach, impossible to contain. For this reason, soft forms can be both a source of fascination *and* repulsion. Dalí continues: "Having once overcome the obstacle by virtue of which all self-respecting food 'preserves its form,' nothing can be regarded as too slimy,

gelatinous, quivering, indeterminate or ignominious to be desired, whether it be the sublime viscosities of the fish-eye, the slithery cerebellum of a bird, the spermatozoal marrow of a bone or the soft and swampy opulence of an oyster."[3]

Dalí plays on the dualistic symbolism of food in relation to the dialectic of soft and hard in *The Average Bureaucrat*. If the snails allude to the ego's task of self-preservation, the open cavities suggest a corresponding loss of self. In this light, the ghostly bureaucrat can be interpreted as a magnificent, albeit detumescent, phallus, a dual sign of impotence and dissolution as the figure's enormous head collapses into his body. As he exacts his revenge on the figure of paternal authority, Dalí, in effect, transforms the Oedipal scenario into a fantasy of libidinal appropriation, domination, and control over the father figure.

———

Notes

1. In *The Secret Life*, Dalí relates events surrounding his momentous meeting with Sigmund Freud on July 19, 1938, to a gastronomic excursion to Sens, France: "We started the dinner with snails, one of my favorite dishes. . . . All of a sudden I saw a photograph of Professor Freud on the front page of a newspaper which someone beside me was reading. I immediately had one brought to me and read that the exiled Freud had just arrived in Paris. We had not yet recovered from the effect of this news when I uttered a loud cry. I had just that instant discovered the morphological secret of Freud! Freud's cranium is a snail! His brain is in the form of a spiral— to be extracted with a needle!" Salvador Dalí, *The Secret Life of Salvador Dalí* (New York: Dial Press, 1942), 23. In this account, the structure of the snail's exoskeleton is analogized with the complexity of Freud's mind, while in the story of Dalí's actual meeting with the German doctor effects of transference and countertransference are described that underscore the symbolic valence of the snail's shell as a kind of ego-armor.

2. Dalí, *Secret Life*, 9.

3. Dalí, *Secret Life*, 10.

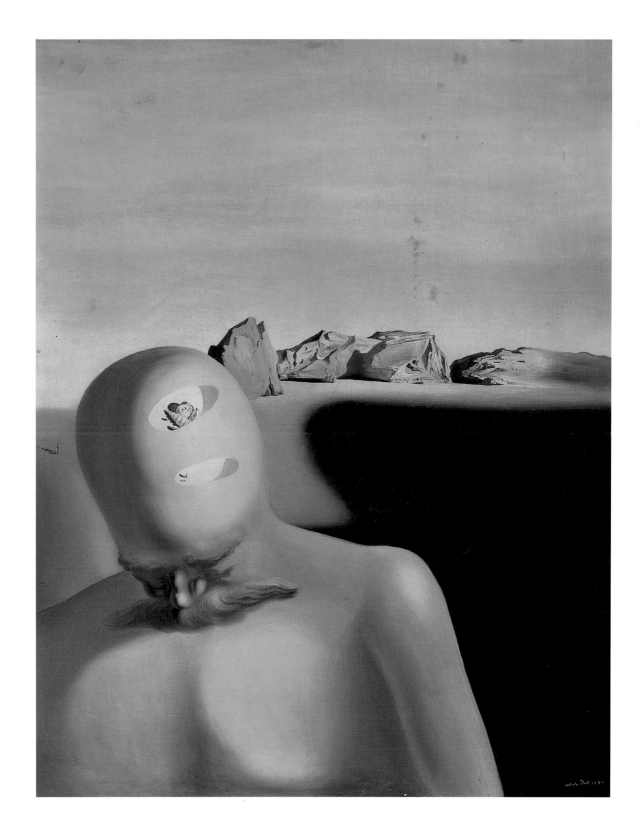

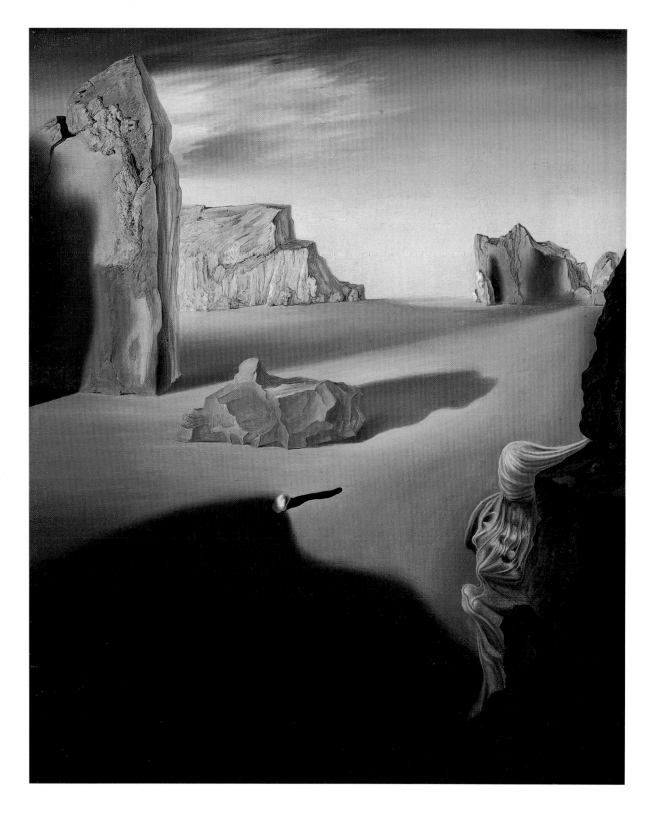

39. *Shades of Night Descending*, 1931

Oil on canvas

13 1/4 × 10 3/8 inches

Exhibitions
Chicago 1933
Paris 1934?
New York 1941A
Cleveland 1947
New York 1965
Fort Lauderdale 1997
Rio de Janeiro 1998
Shinjuku 1999

Shades of Night Descending and *Au Bord de la Mer* (cat. no. 40) belong to a series of "nostalgic landscapes" Dalí painted in 1931. In both, the flat plain of the Empordà is clearly visible, broken by the rocks of Cap Norfeu, near Cadaqués, in the former, and the jagged cliffs of Cap Creus in the latter. The hour is dusk and a crisp half-light permeates the air. The contours of the landscape are in sharp focus, while deep, somewhat mysterious, shadows spread across the open plain. The monotony of the landscape is broken only by an occasional stone or geological formation, while a mood of presentiment and foreboding is suggested by the presence of anthropomorphic, phantomlike objects that cling to the rocks and/or insinuate themselves into the landscape in the form of ghostly apparitions. Tipping his painter's brush to Giorgio de Chirico, Yves Tanguy, and René Magritte, Dalí establishes a visual poetics of melancholy and loss organized around memories of the landscape of his youth.

　　Shades of Night Descending states the theme of loss more explicitly than *Au Bord de la Mer*, where the phallic form

of the white object is a generalized cipher for the indeterminate contours of desire. The shadow of a grand piano invades the foreground space of *Shades of Night Descending,* an ominous form with patently sexual overtones that is ostensibly based on Dalí's fond memories of musical evenings spent with the Pitchot family on the beach at Cadaqués.[1] Immediately to its right a shrouded figure emerges from the silhouette of a cliff.[2] Although the sex of the figure is indeterminate, the contours of a glass and a high-heeled shoe beneath the surface of the clinging garment point to a female presence.[3] Together, the piano and the figure—whose form is also phallic—suggest that Dalí's melancholy is tied to a fantasy of separation from the mother, the quintessential object of desire. The phantom form of the veiled figure and the white monolith, then, both represent the mark of desire.

Three years after painting *Shades of Night Descending* and *Au Bord de la Mer,* Dalí somewhat obliquely discussed the meaning of phantom forms in his work in a difficult text entitled "The New Colors of Spectral Sex-Appeal." Here, Dalí imagines the phantom as the external projection of libidinous energies, a kind of gelatinous excess, like fat, that conceals an inner "volume" of unconscious drives that are converted into traces of something to be desired. Using the metaphor of the envelope, he writes:

The phantom is materialized in the "simulacrum of volume."—The simulacrum of volume is the envelope.— The envelope hides, protects, transfigures, stirs up, tempts, gives a misleading notion of volume. It causes ambivalence with regard to volume and makes the

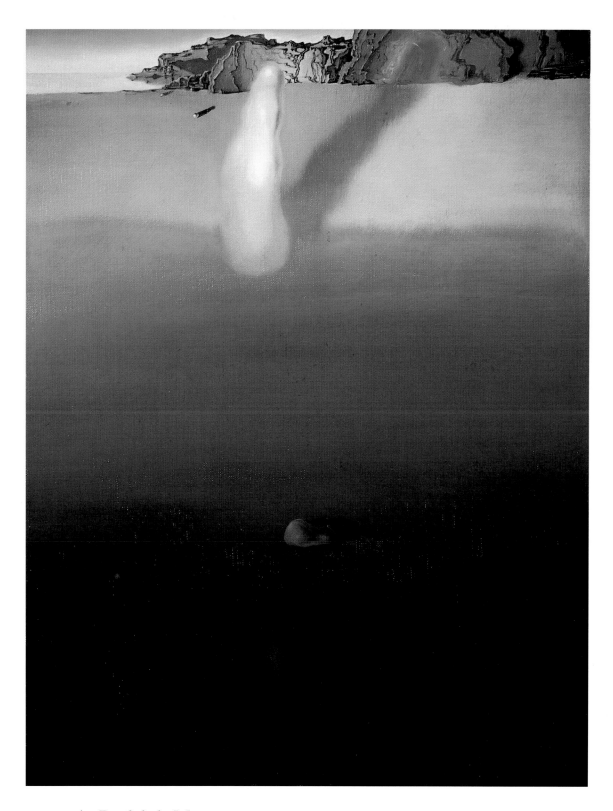

40. *Au Bord de la Mer,* 1931

Oil on canvas
13 1/4 × 10 3/8 inches

Exhibitions
Hartford 1931
New York 1933A

Cleveland 1947
New York 1965

volume become suspect.—It promotes the birth of delirious theories regarding volume.—It provokes the giddiness of an ideal knowledge of volume, of an inconsistent knowledge of volume.—The envelope dematerializes the contents, the volume, debilitates the objectivity of volume, turns the volume virtual and agonizing.[4]

In this sense, the phantom is the external trace of repression, the mark of desire that conceals the "flesh" of the concrete, irrational subject, as Dalí imagines it. In contrast to the specter, which threatens to unhinge the subject, the phantom is more of an armor, a structure of occlusion and repression that defines the contours of the unconscious and fills the real with the luminous, iridescent light of desire.

————

Notes

1. The image of the grand piano made an early appearance in Dalí's work in drawings for the *Libro de los putrefactos*, where it represented bourgeois cultural pretenses. In *Un Chien andalou* the piano was connected to the theme of putrefaction and anticlericalism. Dalí returned to the image of the piano repeatedly throughout the 1930s and 1940s, interweaving personal reminiscences with Freudian symbolism (see cat. nos. 38, 51, and 75).

2. Veiled figures first appeared in Dalí's frontispiece drawing for André Breton and Paul Eluard's *L'Immaculée conception* (November 1931). The conceit of the veiled figure is derived from works by Dalí's friend René Magritte (e.g., *The Lovers* [1928], Australian National Gallery, Canberra).

3. The shoe and glass reappear in *Diurnal Illusion: The Shadow of a Grand Piano Approaches* (private collection) of 1931. That same year Dalí incorporated a woman's shoe into his first "Surrealist Object Functioning Symbolically."

4. Salvador Dalí, "The New Colors of Spectral Sex-Appeal," translated in *The Collected Writings of Salvador Dalí*, ed. Haim Finkelstein (Cambridge: Cambridge University Press, 1998), 201–207. The text original appeared as "Les Nouvelles couleurs du sex appeal spectral," *Minotaure* (Paris) 5 (February 1934): 20–22.

41. *Memory of the Child-Woman*, 1931

Oil on canvas with collage
39 × 47 1/4 inches

Exhibitions
Paris 1931
New York 1950B
New York 1965
Fort Lauderdale 1997
Liverpool 1998
Shinjuku 1999

This important painting of 1931, replete with Freudian symbolism, belongs to a series of works in which Dalí interprets his estranged relations with his father through the myth of William Tell. Dalí's adulterous affair in 1929 with Helena Diakanoff Devulina (Gala) and his blasphemous inscription on *The Sacred Heart* deeply offended Dalí's father, who promptly expelled his son from the family home (see cat. no. 36). In protest, Dalí shaved his head and buried his hair in the sand, a gesture that at once signaled paternal defiance and his recognition of the symbolic threat of castration that his exile represented. Over the next three years, Dalí executed a series of paintings in which he attempted to exorcize his guilt and fear of paternal retribution by transferring his libidinal fantasies to Gala, the "child-woman," who subsumed Dalí's desire to regress to a state of infantile sexuality and, in the process, symbolically freed him from Oedipal repression and moral censorship. Indeed, in a poetic text of 1931 entitled *L'Amour et la mémoire*, Dalí imagined his muse, Gala, as the personification of the polymorphous perverse:

Gala
her eyes resembling her anus
her anus resembling her knees
her knees resembling her ears
her breasts resembling the big lips of her genitals
the big lips of her genitals resembling her belly-button
her belly-button resembling the finger of her hand
the finger of her hand resembling her voice
her voice resembling the toe of her foot
the toe of her foot resembling the hair of her armpits
the hair of her armpits resembling her forehead
her forehead resembling her thighs
her thighs resembling her gums
her gums resembling her hair
her hair resembling her legs
her legs resembling her clitoris
her clitoris resembling her mirror
her mirror resembling her walk
her walk resembling her cedars.[1]

Signs of the Oedipal drama abound in Dalí's great painting. The hermaphroditic bust that emerges from the biomorphic structure in the center recalls the mythical phallic mother, in whose omnipotence, Freud argued, the male child believes until the anxious moment of sexual identity formation, when he discovers the mother lacks a penis. According to Freud, the primal scene sets into motion a complex fantasy of castration for the young male child, who attempts to allay his fears through a process of recognition and disavowal of maternal difference. What is suggested here is that the

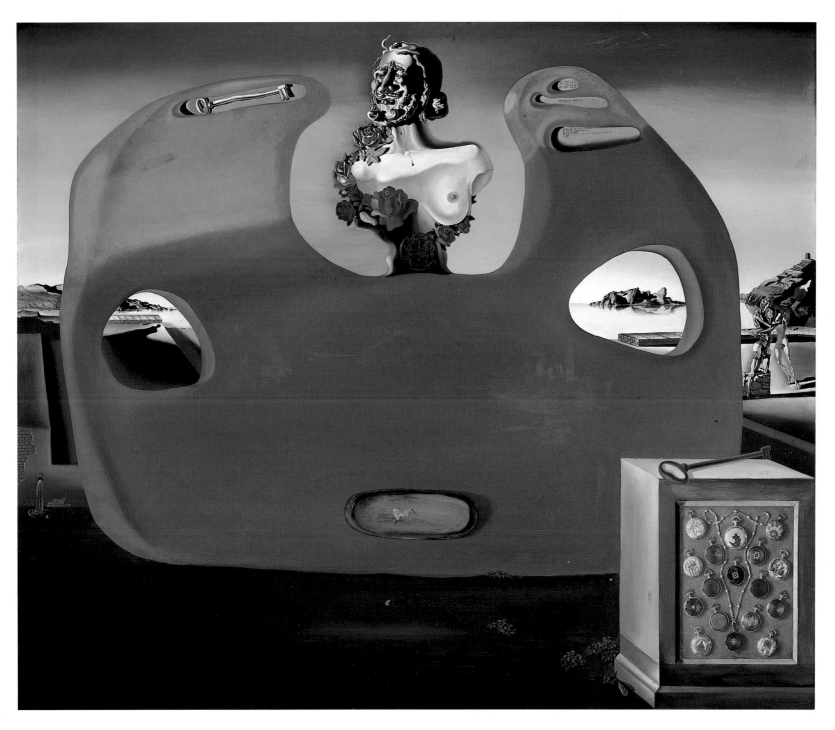

threat of emasculation and loss results in compensatory mechanisms through which gendered difference is not so much given as produced and reproduced over the course of a lifetime through language and social behavior, belying the fantasy that a secure representation of the male position can ever be internally assured.[2] Indeed, Dalí seems to engage in a process of libidinal transference in *Memory of the Child-Woman*, from the phallic mother, whose name—"ma mère"—is inscribed ten times in the upper-right cavity of the biomorphic structure, to Gala, the artist's muse/mistress, whose pet name—"olivette"—is inscribed three times just below.[3] The threat of paternal retribution is graphically represented by the two struggling figures—an older and a younger male—to the far right center of the composition, and in the bleeding eyes of the statue (an obvious allusion to the eyes of Oedipus and the castration complex). The hermaphroditic bust of William Tell, recognizable from other paintings in the series—*William Tell*, 1930 (private collection), and *William Tell and Gradiva*, 1930 (Fundació Gala–Salvador Dalí, Figueres)—presides over the scene, with a lionlike beard alluding to paternal authority and retribution.[4]

Dalí interprets the story of the Swiss hero in relation to the castration complex. Other sexual symbols scattered throughout the painting allude to the source of the Oedipal drama: the roses refer to female genitalia; two large keys—phallic symbols in Freud's lexicon—and a fountain spouting water from a partially exposed plaster wall suggest the act of coitus; while a lithographic print of stop watches in the lower right indicates the contrary, arrested sexual activity and/or the persistence of amorous memories. Perhaps most significant of all is a tiny detail painted on the blue gemstone beneath the bust of Tell. Here, Dalí includes an anamorphic self-portrait in the guise of the "Great Masturbator" (see cat. no. 35). That Dalí's narrative is connected to specific experiences in his life is suggested by the geographical specificity of the landscape, with the rocks of Cap Creus and the windswept hills of Port Lligat in the distance.

Notes

1. Salvador Dalí, *L'Amour et la mémoire* (Paris: Editions surréalistes, 1931), as excerpted and translated in Ian Gibson, *The Shameful Life of Salvador Dalí* (London: Faber and Faber, 1997), 294. As Haim Finkelstein, *Salvador Dalí's Art and Writing, 1927–1942: The Metamorphoses of Narcissis* (New York: Cambridge University Press, 1996), astutely observes (134): "Gala . . . appears to satisfy Dalí's vision of infantile sexuality, a kind of olymorphously perverse day-dream, which appears to be completely free of the repressive aspects of the super-ego. Not that she had necessarily helped actualize Dalí's perverse fantasies. . . . Rather, he needed her as an anchor for his perverse 'representations' and fantasies; she could fulfill his needs precisely because she subsumed for him a promise of voyeuristic, incestuous, and shameful pleasure."

2. Citing Freud's 1923 text *A Seventeenth-Century Demonological Neurosis*, Dawn Ades ("Dalí and the Myth of William Tell," in *Salvador Dalí: A Mythology*, ed. Dawn Ades and Fiona Bradley, exh. cat., Tate Gallery, Liverpool, 1998, 46) advances a more canonical reading of the hermaphroditic imagery in *Memory of the Child-Woman*: "'A boy's feminine attitude to his father,'" Freud writes, "'undergoes repression as soon as he understands that his rivalry with a woman for his father's love has as a precondition the loss of his own male genitals—in other words, castration. Repudiation of the feminine attitude is thus the result of a revolt against castration. It regularly finds its strongest expression in the converse fantasy of castrating the father, of turning him into a woman.'" My intent is not to argue with this reading, which Dalí would surely have authorized, but to provide an alternative interpretation of the castration complex in which the concept of gender is more fluid. For a groundbreaking rereading of Freudian and Lacanian theories of gender development, see Judith Butler, *Gender Trouble* (London: Routledge, 1990).

3. The number of times the inscriptions are repeated is significant, alluding to the anniversary of Dalí's mother's death and the duration of his relationship with Gala.

4. The identification is confirmed by the presence of a small bronze medallion beneath the bust in which the sexual iconography of the scene as a whole is condensed and the name "Guillaume Tell" is clearly spelled out.

42. *Suez*, 1932

Oil on canvas
18 1/2 × 18 1/2 inches

Exhibitions
New York 1965
Pittsburgh 1998
Shinjuku 1999

Over the course of 1932 Dalí explored what he later called the "morphological aesthetics of the soft and hard" through an elaborate alimentary symbolism.[1] *Suez* is related to a series of landscapes and still lifes in which a limited variety of foods, typically fried eggs and tumescent loaves of bread, assume center stage (see cat. nos. 44 and 45). Although neither of these elements is present in *Suez*, the image of an elongated spoon, stretching like a tightrope across an enormous canal or trench, is clearly implicated in Dalí's theories of psychic cannibalism and "edible beauty" (see cat. no. 35).

The curiously "bisexual" form of the soft spoon in *Suez* has scatological associations. A phallic container of sorts, the spoon is the object through which Dalí links ideas about sexual regression and the symbolic death of the gendered (social) subject to acts of physical ingestion and the loss of boundaries between the interior and exterior worlds.[2] In Dalí's system, soft matter is both abject—in its suggestion of corporeal dissolution—and ideal, marking the subject's desire to return to an "intrauterine" state of jubilant polymorphous perversity. With more than a nod to Freud's *Beyond the Pleasure Principle* of 1920, in which the Austrian doctor theorized the existence of a death drive, Dalí imagined love and the dream to be states of extreme self-abnegation through which the subject's desire for regression manifests itself.[3] As he explained in an early surrealist text, *La Femme visible*:

The relationships between dream, love, and the sense of annihilation that is peculiar to each of these have always been obvious. Sleeping is a form of dying, or, at least, dying to reality; better still, this is the death of reality. But reality dies in love as it does in the dream. . . .

If love embodies dreams, let us not forget that one often dreams of one's

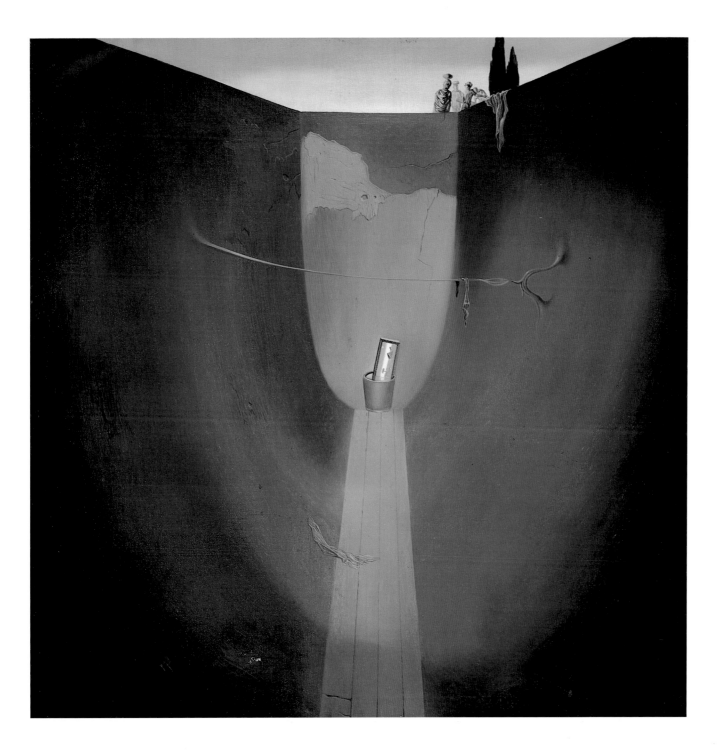

own annihilation and that this, to judge by our oneiric life, would be one of man's most violent and most turbulent unconscious desires. The intrauterine signification occupies each day a more important place in the study of dreams. . . . I am beginning to suspect that, when we have described someone under the power of love as having his face "lit up and transformed like the face of a child," it is not quite childhood or the child's face that we have in mind, but, more cruelly, the more remote face of the foetus. . . . [A]ll that psychophysiology has taught us about the phenomenology of repugnance leads us to believe that desire could easily overcome unconscious symbolic representations. Repugnance would be a symbolic defense against the intoxication of the death wish. One experiences repugnance and disgust for what deep inside one wishes to get closer to, and from this comes the irresistible "morbid" attraction, conveyed often by incomprehensible curiosity, of what appears to us repugnant. In love we reign over the floods of images of self-annihilation. The scatological simulacra, the simulacra of desire, and the simulacra of terror acquire a confusion of the clearest and most dazzling kind.[4]

In *Suez*, Dalí imagines the death of the subject and the return to an anterior state of polymorphous pleasure as a kind of symbolic burial presided over by four mysterious figures. The cypress trees in the background, a motif Dalí borrowed

from the German artist Arnold Boecklin, signify death, while three limp pieces of cloth allude to formlessness and dissolution. Although the exact meaning of the little Egyptian desert scene immersed in a bucket in the center of the womblike canal is not clear, it may signify the desire for regression itself through allusion to the most famous of ancient funerary monuments.

Notes

1. Salvador Dalí, *The Secret Life of Salvador Dalí* (New York: Dial Press), 304.

2. Spoon imagery appears in several paintings of 1932, usually in association with two fried eggs. In *Surrealist Architecture* of that year (Kunstmuseum Bern, Berne) two spoons aggressively thrust into the concavities of an elaborate "modern style" structure with clearly feminine attributes.

3. Dalí owned the second volume of the Biblioteca Nueva's Spanish translation of Freud's works, which contained the essay "Beyond the Pleasure Principle." For a discussion, see cat. no. 34, n. 3.

4. Salvador Dalí, "L'Amour," in *La Femme visible* (Paris: Editions Surréalistes, 1930), 65–69, translated in *The Collected Writings of Salvador Dalí*, ed. Haim Finkelstein (Cambridge: Cambridge University Press, 1998), 190–192.

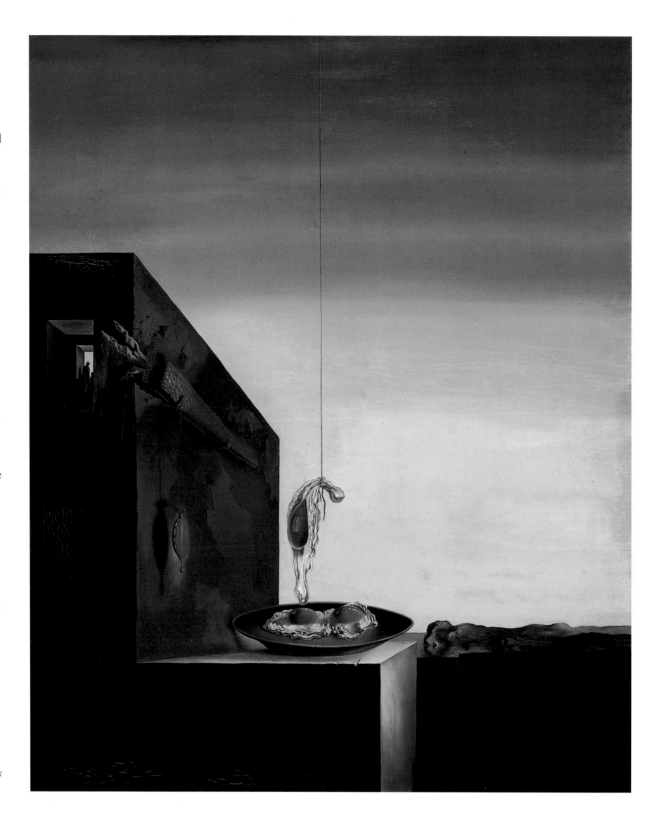

43. *Oeufs sur le Plat sans le Plat*, 1932

Oil on canvas

23 3/4 × 16 1/2 inches

Exhibitions
Paris 1933B
London 1934
Knokke le Zoute 1956
New York 1965

Oeufs sur le Plat sans le Plat is one of five paintings, all dated 1932, that feature the image of soft fried eggs. The scene is set in a crepuscular landscape with the rocks of Cap Creus and the placid Mediterranean sea brilliantly illuminated in the distance. In the tower of the foreground building, which also functions as a shelf for the eggs, two figures (a mother and child?) peer out at the sunset, undisturbed by the presence of several bizarre objects outside: three fried eggs, one of which hangs limply from a fishing line, a semilimp watch that is also suspended, and an enormous ear of red corn that is attached to the side of the tower. The phallic rigidity of the corn contrasts sharply with the detumescence of the three eggs, while the watch connotes the passage of time and, to repeat the title of a celebrated painting of 1931, the "persistence of memory."

Dalí mused over the extended associations of fried eggs in *The Secret Life*, linking their presence in his work to a fantasy of intrauterine regression:

[T]he intrauterine paradise was the color of hell, that is to say, red, orange, yellow and bluish, the color of flames, of fire; above all it was soft, immobile, warm, symmetrical, double, gluey. Already at that time all pleasure, all enchantment for me was in my eyes, and the most splendid, the most striking vision was that of a pair of eggs fried in a pan, without the pan; to this is probably due that perturbation and that emotion which I have since felt, the whole rest of my life, in the presence of this ever-hallucinatory image. The eggs, fried in the pan, without the pan, which I saw before my birth were grandiose, phosphorescent and very detailed in all the folds of their faintly bluish whites. These two eggs would approach (toward me), recede, move toward the left, toward the right, upward, downward; they would attain the iridescence and the intensity of mother-of-pearl fires, only to diminish progressively and at last vanish. The fact that I am still able today to reproduce at will a similar image, though much feebler, and shorn of all the grandeur and the magic of that time, by subjecting my pupils to a strong pressure of my fingers, makes me interpret this fulgurating image of the eggs as being a phosphene, originating in similar pressures: those of my fists closed on my orbits, which is characteristic of the foetal posture. It is a common game among all children to press their eyes in order to see circles of colors "which are sometimes called angels." The child would then be seeking to reproduce visual memories of his embryonic period, pressing his already nostalgic eyes till they hurt in order to extract from them the longed-for lights and colors, in order approximately to see again the divine aureole of the spectral angels perceived in his lost paradise.*[1]

Imagining the return to the womb as a form of psychic regression to a state of maternal *jouissance*, Dalí refuses, and indeed inverts, the signs of patriarchal authority that are figured elsewhere in the painting.

Closer inspection of the sources for Dalí's literary and visual imagery suggests that the form of the egg carried multiple associations for the artist. On the one hand, the egg represents the embryonic child in the womb, protected by its maternal container. But it is also an image associated with the male anatomy, signifying testicles (in Castilian, *huevos* [eggs] is slang for "balls"). What is more, the yolk of the egg suggests the brilliant light of the sun, which is both a source of life and a catalyst for delirium: to gaze upon the sun is to risk blindness, insanity, even death. In a poem of 1929, "Con el Sol," Dalí had already explored the multiple associations of the sun in relation to scatological imagery:

> With the sun a small cornet is born to me out of a handful of more than a thousand photographs of little dry asses.
> With the sun, near an empty, damp place, sing 6 blobs of spittle and a small snoring sardine.
> With the sun, there is a small milk, upright above the anus of a mollusk.
> With the sun, two small toothless sharks are born to me under my arms.[2]

What is lost in the translation is the pun contained in the title "Con el Sol" (With the sun), which plays on the Castilian slang for female genitals: *coño* = "cunt." This chain of associations, in which sun = cunt = anus = eggs = testicles, is a radically subversive strategy with likely sources in Georges Bataille's literary texts and dictionary entries for the journal *Documents*. In one particularly rich passage of *L'Histoire de l'oeil*, Bataille's pornographic novel of 1928, the author describes a conversation with his lover Simone:

Upon my asking what the word urinate *reminded her of, she replied:* terminate, the eyes, with a razor, something red, the sun. And egg? *A calf's eye, because of the color of the head (the calf's head) and also because the white of the egg was the white of the eye, and the yolk the eyeball. The eye, she said, was egg-shaped. She asked me to promise that we could go outdoors, I would fling eggs into the sunny air and break them with shots from my gun, and when I replied that it was out of the question, she talked on and on, trying to reason me into it. She played gaily with words, speaking about* broken eggs, *and then* broken eyes, *and her arguments became more and more unreasonable.*[3]

In a similar vein, Dalí's establishment of a metonymic chain of images serves to relate the desire for unity with the desire for fragmentation, self-affirmation with self-denial, and the life instinct with the death drive. Locating subjectivity in the space between pleasure and oblivion, Dalí, like Bataille, paints a dark picture of the human condition.

———

Notes

1. Salvador Dalí, *The Secret Life of Salvador Dalí* (New York: Dial Press, 1942), 27.

2. Salvador Dalí, "Con el Sol," *La Gaceta literaria* (Madrid) 54 (March 15, 1929): 1, translated in *The Collected Writings of Salvador Dalí*, ed. Haim Finkelstein (Cambridge: Cambridge University Press, 1998), 33–34.

3. Georges Bataille, *Story of the Eye*, trans. Joachim Neugroschel (San Francisco: City Light Books, 1987), 38–39.

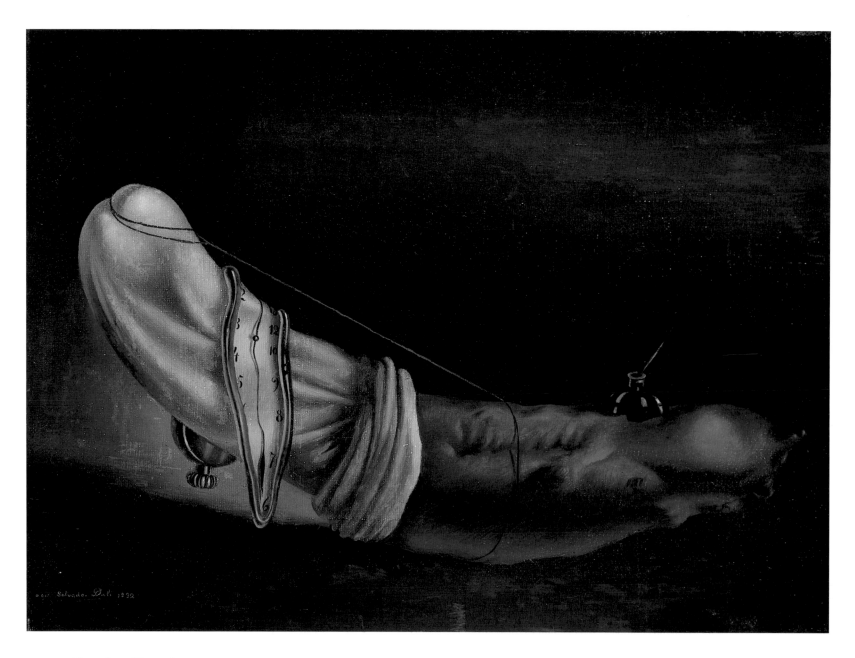

44. *Catalan Bread,* 1932

Oil on canvas
9 9/16 × 13 inches

Exhibitions
Figueres 1993
Paris 1995
Pittsburgh 1998

In this evocative painting of 1932 Dalí returns to a theme that first captured his imagination in 1926, when he painted the austere *Basket of Bread* (cat. no. 25). Like the earlier still life, *Catalan Bread* is organized as a centralized composition in which objects are brightly illuminated against a dark, relatively uninflected ground. The absence of a site marker —a table top or shelf—renders the size and scale of the bread ambiguous, increasing its air of mystery. The picture belongs to a series of works from the period in which the form of the bread suggests an ossified landscape resembling the mineral en*crust*ations of Cap Creus. The tumescent form of *Catalan Bread*, sheathed in a protective "pouch" with a suggestive tip, is also related to the grossly distorted heads of Dalí's bureaucrats and the phallic cranium of the Grasshopper Child (cat. nos. 48, 50, and 51). In another painting of 1932, *Surrealist Object, Gauge of Instantaneous Memory* (private collection), the loaf of bread ends in the image of a spoon bearing two fried eggs, relating this work to Dalí's ongoing investigations into the theme of edible beauty, ingestion, and physical incorporation.

As with the majority of Dalí's paintings of this period, the homespun *Catalan Bread* plays on the idea of sexual difference, or, more precisely, the collapse of gender boundaries. The pen and inkwell are conventional Freudian attributes for male and female, pointing us toward the bisexual ideal. Similarly, the decidedly phallic bread is sheathed in a cloth that suggests a certain indeterminacy, something mysterious, something to be desired, as in the veiled objects we have encountered in *Shades of Night Descending* and *Au Bord de la Mer* (cat. nos. 39 and 40). In an erotic text dated October 17, 1931, Dalí described the transubstantiation of a crust of bread into the form of a vessel, imagining a perverse morphology of desire in which male collapses into female and their difference is literally consumed:

Suddenly, and with no associations at all involved, I recall that, during lunch, I set my mind . . . on the crusted end of the loaf of bread that seemed burned enough, which I had decided to bring over to the couch to be hollowed out with meticulous care so as to be turned into a sort of vase. Then, with even greater care, I would have chewed it with my front teeth, pierced and squashed it into tiny well-ground pieces until the whole thing became a fine paste.[1]

For Dalí, of course, this act of symbolic ingestion/incorporation is specifically tied to a fantasy of infantile regression, signified in *Catalan Bread* by the presence of a limp pocket watch suggestively enveloping the loaf. In *The Secret Life*, Dalí discussed the first appearance of this enigmatic image in his work, referring to the genesis of his celebrated *Persistence of Memory* (Museum of Modern Art, New York) of 1931:

It was on an evening when I felt tired, and had a slight head-ache. . . . We were to go to a moving picture with some friends, and at the last moment I decided not to go. Gala would go with them, and I would stay home and go to bed early. We had topped off our meal with a very strong Camembert, and after everyone had gone I remained for a long time seated at the table meditating on the philosophic problems of the "super-soft" which the cheese presented to my mind. I got up and went into my studio, where I lit the light in order to cast a final glance, as is my habit, at the picture I was in the midst of painting. This picture represented a landscape near Port Lligat, whose rocks were lighted by a transparent and melancholy twilight; in the foreground an olive tree with its branches cut, and without leaves. I knew that the atmosphere which I had succeeded in creating with this landscape was to serve as a setting for some idea, for some surprising image, but I did not in the least know what it was going to be. I was about to turn out the light, when instantaneously I "saw" the solution. I saw two soft watches, one of them hanging lamentably on the branch of the olive tree. In spite of the fact that my head-ache had increased to the point of becoming very painful, I avidly prepared my palette and set to work.[2]

Although Dalí does not elaborate on the extended symbolism of the limp watch, it clearly represents a nostalgic return to a state of amorphousness. It was not until a year later, in paintings like *Catalan Bread*, that Dalí's dialectics of the soft and the hard would specifically be linked to the theme of infantile regression and gender de-differentiation.

Notes

1. Salvador Dalí, "Rêverie," *Le Surréalisme au service de la révolution* (Paris) 4 (December 1931): 31–36, translated in *The Collected Writings of Salvador Dalí*, ed. Haim Finkelstein (Cambridge: Cambridge University Press, 1998), 150–162.

2. Salvador Dalí, *The Secret Life of Salvador Dalí* (New York: Dial Press, 1942), 317.

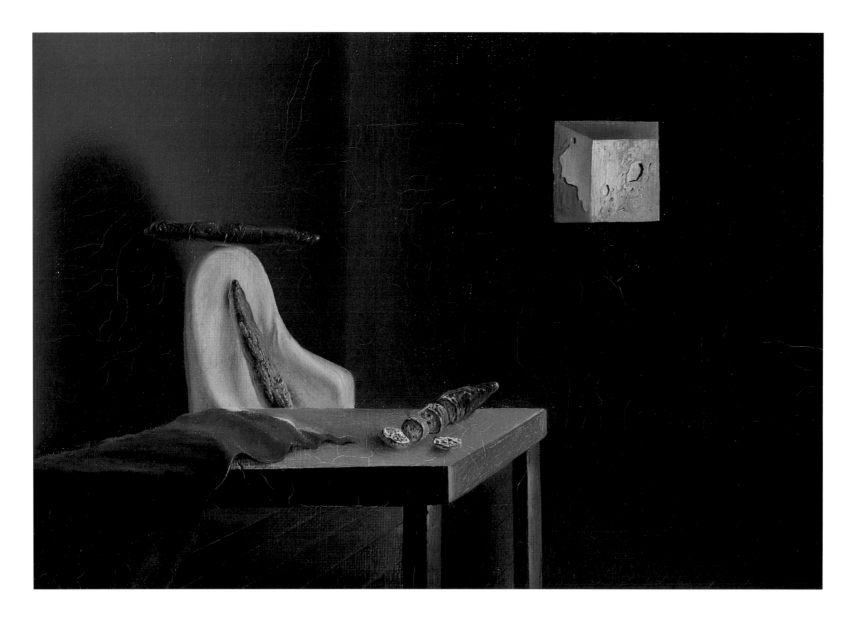

45. *The Invisible Man,* 1932

Oil on canvas
6 1/2 × 9 3/8 inches

Exhibitions
Paris 1932?
New York 1934?
New York 1965
Barcelona 1996

In this small oil of 1932 Dalí pursues the phallic symbolism of bread as a representation of the father. The crusty loaf of Catalan bread known as a *barra* appears three times: perched precariously on the back support of a highly anthropomorphic chair, thrusting upward in the seat, and stretched out on the table, partially dismembered. In this way, Dalí both asserts and figuratively "undercuts" the tumescent presence of the loaf, inscribing phallic, paternal authority within a discourse of abjection and emasculation.

In a related charcoal drawing of the same year, *Cannibalism of Objects* (André François Petit Collection, Paris), a figure slices its enormously distended breasts with a knife. This violent dismembering of body parts that look like loaves of Catalan bread in turn points to the masochistic implications of the imagery in *The Invisible Man*, in which autopunition may be interpreted as a reaction to the desire to kill the father. In *Retrospective Bust of a Woman* (private collection) of 1933, a female figure balances a loaf of bread on her head, topped by an inkwell in the form of the central figures from Millet's *Angelus*, a clear reference to the Oedipal drama.[1] Dawn Ades astutely observes that the image of bread balanced on the head represents a "transformation of the apple on the head of William Tell's son," a theme Dalí treated as early as 1930.[2] In the legend, the Swiss archer and patriot wages he can pierce an apple on his son's head from a distance of two hundred paces. Although the story has a happy ending, Dalí interprets it as a castration myth, a narrative of paternal tyranny, Oedipal rage, and filial guilt. Indeed, when Dalí was expelled from the family home in December 1929 (see cat. no. 36), he cut off his hair as a symbolic gesture and had Luís Buñuel photograph him with a sea urchin on his head, a clear reference to the William Tell legend.[3]

Notes

1. On the bisexual implications of the inkwell, see cat. no. 44. For a discussion of Dalí's interpretation of the *Angelus* painting in relation to his theories of predatory aggression and sexual cannibalism, see cat. no. 52.

2. Dawn Ades, *Dalí* (London: Thames and Hudson, 1982), 160. For a detailed analysis of Dalí's treatment of the William Tell legend, see also Dawn Ades, "Dalí and the Myth of William Tell," in *Salvador Dalí: A Mythology*, ed. Dawn Ades and Fiona Bradley, exh. cat., Tate Gallery, Liverpool, 1998, 32–50.

3. Dalí recounts the story of the sea urchin with significant alterations in *The Secret Life of Salvador Dalí* ([New York: Dial Press, 1942], 319), explicitly connecting his act with a psychoanalytic reading of the William Tell legend: "I had balanced on my head William Tell's apple, which is the symbol of the passionate cannibalistic ambivalence which sooner or later ends with the drawing of the atavistic and ritualistic fury of the bow of paternal vengeance that shoots the first arrow of the expiatory sacrifice—the eternal theme of the father sacrificing his son."

46. *Fantasies Diurnes*, 1932

Oil on canvas
32 × 39 1/2 inches

Exhibitions
Paris 1932
Knokke le Zoute 1956
New York 1965
Fort Lauderdale 1997
Liverpool 1998
Hartford 2000

Fantasies Diurnes is a thematic pendant to *Memory of the Child-Woman* (cat. no. 41). Once again, the landscape views along the margins of the painting can be identified as the rocks of Cap Creus and Port Lligat, the nostalgic site of Dalí's childhood memories *and* the location of his current residence with Gala, just over the hill from Cadaqués. Signs of Dalí's erotic attachment to Gala as the "Child-Woman" abound: in the snail shells that are scattered in the lower left of the painting; in the phallic key that is locked into one of the concave pockets in the fantastic, skull-like object that stretches across the middle ground; in the multiple inscription of the phrase "deux fois" in relation to the image of the key (a scheme borrowed from Magritte's word-image paintings that alludes here to Dalí's sexual relations with Gala); in the anamorphic head of the Great Masturbator that is inscribed on a red gem; and, most notably, in the obsessive repetition of the name "Guillaume Tell." The distended "anatomy" of the central object relates to Dalí's exploration of the theme of anamorphosis and the abject symbolism of soft forms, while the ram's skull in the foreground is a sign of putrescence, one of the three great simulacra in Dalí's vision of the human libido.

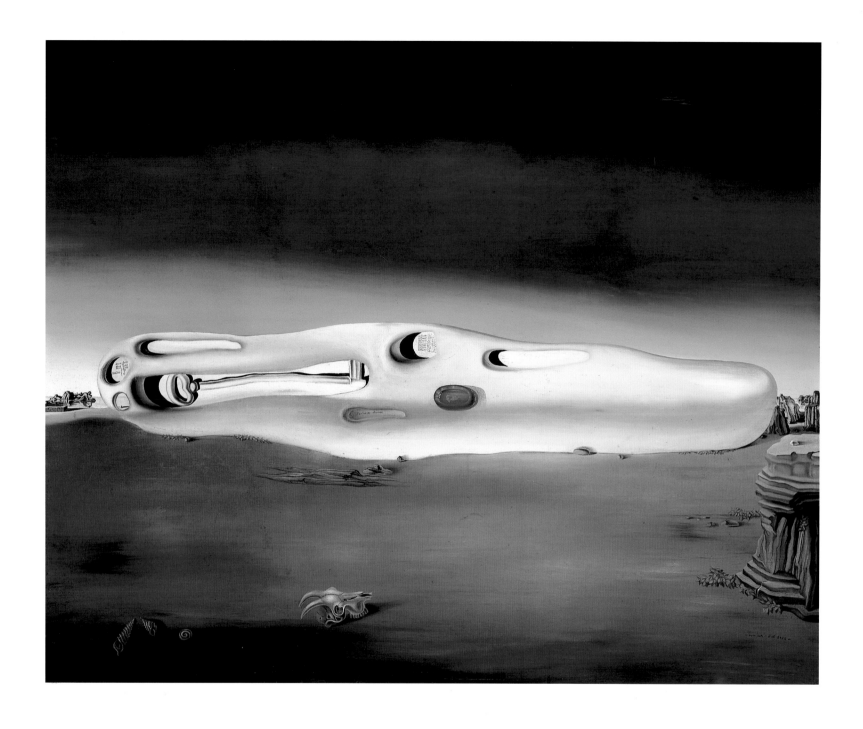

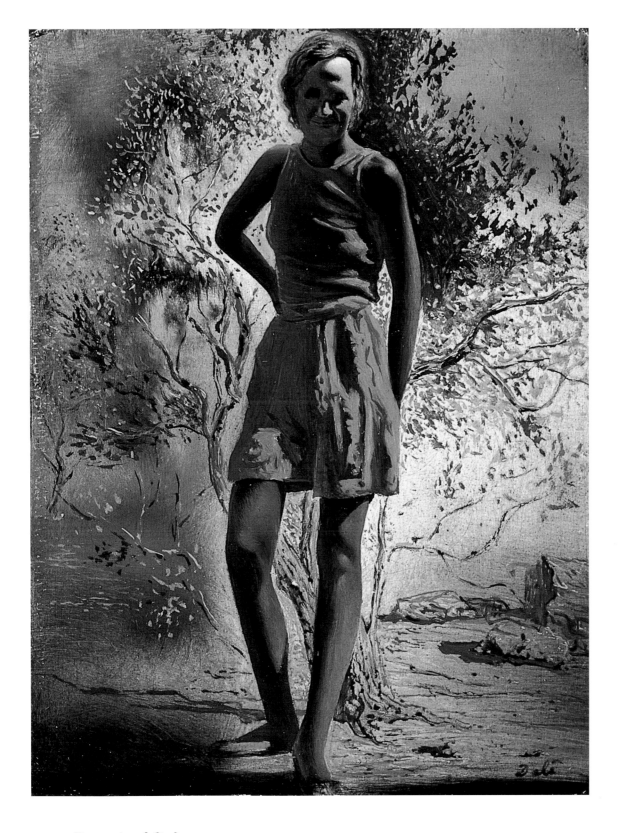

47. *Portrait of Gala*, 1932–33

Oil on panel

3 7/16 × 2 5/8 inches

Exhibitions
Paris 1934
Chicago 1941?
Los Angeles 1941?
New York 1941B?
St. Petersburg 1982
Rio de Janeiro 1998
Shinjuku 1999

Hailed by some as intelligent, mysterious, seductive, and cultured, and reviled by others as a temptress, a social climber, and a destroyer of men, the contradictory figure of Gala Dalí (1894–1982) presides over the artist's life and work. Born in Russia to a well-placed civil servant, Helena Diakanoff Devulina was ten years Dalí's senior. Despite the publication of two recent biographies, a degree of mystery surrounds Gala's early years. It is known that sometime in 1913, Gala, whose physical constitution as a young woman was fragile, entered the Clavadel Sanatorium near Davos, Switzerland, where she met the young poet Paul Eluard (né Eugène Grindel), whom she married in 1917. From this point on, Gala seems to have reinvented herself as a figure without a history, the object of Eluard's desire and his poetic muse.

Dalí and Gala met in August 1929, when the Eluards, their daughter, the Magrittes, Camille Goemans, and two friends sojourned in Cadaqués. In *The Secret Life*, Dalí describes his first encounter with the woman who would become his wife on January 30, 1934, investing Gala's persona with an aura of myth and fantasy as the mystical incarnation of his retrospectively invented childhood friend, Galuchka:

Gala, Eluard's wife. It was she! Galuchka Rediviva! I had just recognized her by her bare back. Her body still had the complexion of a child's. Her shoulder blades and the sub-renal muscles had that somewhat sudden athletic tension of an adolescent's. But the small of her back, on the other hand, was extremely feminine and served as an infinitely svelte hyphen between the wilful, energetic and proud leanness of her very delicate buttocks which the exaggerated slenderness of her waist enhanced and rendered greatly more desirable.[1]

In this revealing passage, the mythical muse Gala possesses both masculine and feminine secondary sex characteristics, a fitting mirror to Dalí's construction of a mobile, gendered self. To this end Dalí informs us that in anticipation of his meeting with Gala, he performed an elaborate masquerade:

I tried on my sister's ear-rings several times. I liked them on myself, but decided they would be a nuisance for the swim. Nevertheless I put on my pearl necklace. I made up my mind to get myself up very elaborately for the Eluards. . . . I took my finest shirt and cut it irregularly at the bottom, making it so short that it did not quite reach my navel, after which, putting it on me, I began to tear it artfully: one hole, baring my left shoulder, another, the black hairs on my chest, and a large square tear on the left side exposing my nipple that was nearly black.[2]

The story, of course, is apocryphal. Its function is to suggest the ambivalent nature of Dalí's identification with Gala in relation to his own anxieties concerning female sexuality and what

David Vilaseca has aptly characterized as "his uneasiness with regard to patriarchal norms of gender and cultural intelligibility."[3]

Gala entered Dalí's art shortly after their first meeting, although the so-called *First Portrait of Gala* (private collection) was not painted until 1931, and her image did not appear with any regularity until 1933. Initially, Gala's presence in Dalí's painting was symbolic: many of the artist's psychoanalytic narratives relating to themes of castration, Oedipal guilt, and paternal retribution were conceived in response to his anxieties about sexual initiation. Dalí also wrote his great prose poem *L'Amour et la mémoire*[4] as a "paean to Gala, to the change wrought on the painter's life by her appearance," to quote Ian Gibson[5] (see cat. no. 41). Indeed, Gala was an exceedingly complex figure in Dalí's life. The many pet names he had for her, including Gradiva,[6] Noisette Poilue (hairy hazelnut), and Lionete (little lion), suggest the multivalent nature of his identification with Gala, whom Dalí imagined as both a primal mother *and* a paternal imago, an omniscient figure without gender. In *Portrait of Gala*, the artist's muse appears as the all-powerful phallic mother, commanding the foreground space of the tiny oil painting in front of a brilliantly illuminated olive tree, which, like the burning bush of biblical narrative, suggests the force of Gala's presence. In another painting from the same period, *Automatic Beginning of a Portrait of Gala (Unfinished)*, 1932 (Fundació Gala–Salvador Dalí, Figueres), the olive tree actually grows from Gala's head, a sign of her transformative

power in Dalí's life and work. In both, Gala is represented as the eternal feminine, an image of unity, restoration, and primal force through which Dalí negotiates his own divided sense of self.

———

Notes

1. Salvador Dalí, *The Secret Life of Salvador Dalí* (New York: Dial Press, 1942), 229.

2. Dalí, *Secret Life*, 227–228.

3. David Vilaseca, *The Apocryphal Subject: Masochism, Identification, and Paranoia in Salvador Dalí's Autobiographical Writings* (New York: Peter Lang, 1995), 159.

4. Salvador Dalí, *L'Amour et la mémoire* (Paris: Editions Surréalistes, 1931).

5. Ian Gibson, *The Shameful Life of Salvador Dalí* (London: Faber and Faber, 1997), 293.

6. In an early text, *Delusions and Dreams in Jensen's* Gradiva, published in 1909, Freud considered the psychoanalytic implications of a story by the German writer Wilhelm Jensen that appeared in 1903. The protagonist of the story, an archaeologist named Norbert Hanold, becomes obsessed with a classical relief of a young woman walking, whom he names Gradiva ("the girl splendid in walking"). His obsession brings him to Pompeii, where he is convinced he will find evidence of the young woman's demise at the time of the

eruption of Mount Vesuvius. While wandering through the site, he spies a young woman moving about the ruins. Convinced that she is Gradiva, he approaches the woman, who turns out to be a childhood friend, Zoë Bertrang. Norbert's recognition of Gradiva as Zoë cures him of his delusions, and the couple are free to pursue a happy and productive life together. In Freud's interpretation, Zoë/Gradiva represents a figure of fact and fantasy that the subject, Norbert Hanold, has repressed, buried not in the ashes of Vesuvius, but in the unconscious. The archaeological metaphor—the unearthing of repressed desire—is here synonymous with the psychoanalytic process itself, the search to retrieve and restore lost objects of desire. For a discussion of the broader implications of the Gradiva "myth" for Dalí's work, see Fiona Bradley, "Gala Dalí: The Eternal Feminine," in *Salvador Dalí: A Mythology*, ed. Dawn Ades and Fiona Bradley, exh. cat., Tate Gallery, Liverpool, 1998, 54–76.

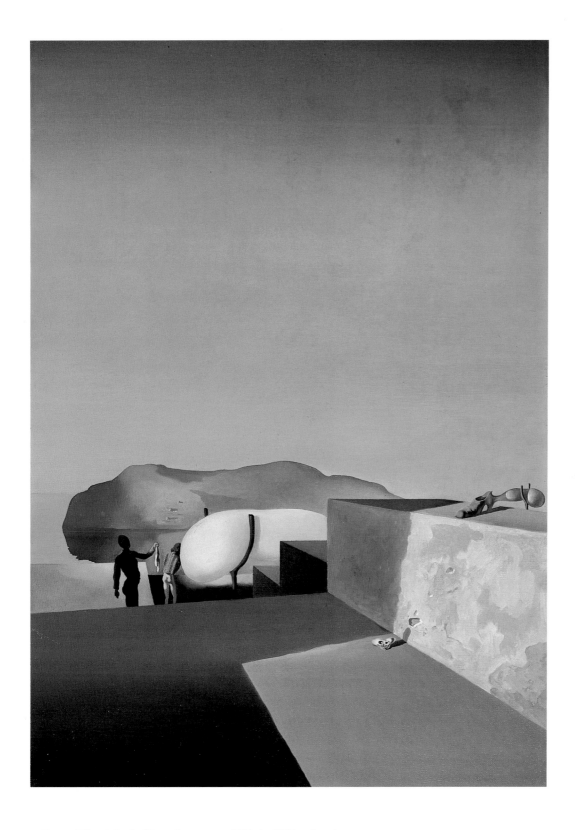

48. *Untitled (Persistence of Fair Weather)*, 1932–34

Oil on canvas
26 1/4 × 18 1/2 inches

Exhibitions
New York 1965
Fort Lauderdale 1997

Pittsburgh 1998
Shinjuku 1999

In *Persistence of Fair Weather* Dalí combines several themes that preoccupied him throughout the early 1930s: fetishism and the primal scene, anamorphosis and symbolic death, and abjection and desire. Each concept is in turn symbolically linked to a specific object in the painting: a woman's high-heeled shoe sprouting a soft appendage supported by a crutch, a distorted skull in the foreground, and, also supported by a crutch, a second bulbous form that is related to the image of the hydrocephalic bureaucrat (see cat. nos. 38 and 50). In the background a seminude Gala, identified by her jacket, hides her face in the same gesture of shame that Dalí frequently used to communicate Oedipal guilt (cat. nos. 35 and 36), while a haunting male specter holds what appears to be Gala's undergarment in his left hand.

The crutches that support the two bulbous masses offer some clues to the meaning of this enigmatic painting. As early as 1927, in *Apparatus and Hand* (cat. no. 27), Dalí explored the idea of a symbolic armature for his figure, who, like a cardboard cutout, is supported by dowels. It was not, however, until 1932 that the crutch became a leitmotif in Dalí's art.

In *The Secret Life* Dalí described the crutch as a symbolic support: "I inaugurated the 'pathetic crutch,' " Dalí informs the reader, "the prop of the first crime of my childhood, as the all-powerful, and exclusivist post-war symbol — crutches to support the monstrous development of certain atmospheric-cephalic skulls, crutches to immobilize the ecstasy of certain attitudes of rare elegance, crutches to make architectural and durable the fugitive pose of a choreographic leap, to pin the ephemeral butterfly of the dancer with pins that would keep her poised for eternity."[1] The reference to

childhood memories establishes a complex psychoanalytic provenance for the symbol, while shedding considerable light on Dalí's adult relationship with Gala. In "The Story of the Linden-Blossom Picking and the Crutch," a semi-apocryphal "True Childhood Memory" from *The Secret Life*, Dalí narrates the circumstances of his "first crime." The event takes place in the orchard of the Pitchot family estate, El Molí de la Torre, during the gathering of the linden blossoms. Three peasant women, one with particularly "turgescent breasts," take their place on ladders that are erected under the trees, while a fourth figure, a girl of twelve (that is, a "child-woman," as in cat. no. 41), captivates the young painter. Dalí instantly falls in love with the girl, christening her Dullita, the same name as that of another childhood sweetheart. In Dalí's mind, Dullita and her incarnation, Dullita Rediviva, fuse with that of a third fantasy woman, Galuchka, a retrospectively invented image of Gala herself. "The three images of my delirium mingled in the indestructible amalgam of a single and unique love-being," Dalí writes.[2] As if to draw nearer to the object of his desire, whose back is turned to him, Dalí gently touches Dullita with a crutch he discovered days earlier in the attic of Sr. Pitchot's house, fantasizing that the instrument is his scepter. His response to Dullita, however, is filled with ambivalence: "Dullita with a single moment of her presence had come to trouble, annihilate and ruin the architecture of the narcissistic temple of my divine solitude. . . ."[3] The scepter/crutch, then, functions as a fetish object *and* a symbolic support for Dalí's ego, which is threatened with annihilation through (con)fusion with Dullita, his love object.

Dalí in turn links this threat to the idea of abjection — a kind of foreclosure of the self — in an episode concerning a maggot-infested, dead hedgehog, which he pokes with the crutch, robbing his kingly scepter of its magic and transforming it into a "frightful object synonymous with death."[4] In David Vilaseca's penetrating analysis of the narrative, the abject represents that which challenges the coherence of Dalí as a subject. Following Julia Kristeva, Vilaseca characterizes the abject as that which shatters the self and that which the self, through its very constitution, represses or makes unrepresentable.[5] The abject, then, threatens to return the subject to the formless incoherence of a stage prior to symbolization. It represents the death of the subject *qua* subject. As Vilaseca writes: "[W]hat is threatening (frightening) about the abject is the fact that, by taking the subject back to this repressed 'pre-identity' stage, it challenges the subject's very status as 'alive,' as a supposedly self-present entity. The abject confronts the subject with the lack (the death) against which subjectivity is constructed and, by filtering the archaic economy of separation through the gaps of the subject's symbolized world, brings about the collapse of the whole field of meaning, of both the subject and its objects."[6]

An object of morbid fascination, the figure of Dullita/Dullita Rediviva/ Galuchka /Gala simultaneously threatens and redeems Dalí. As the narrative continues, Dalí transfers his erotic fixation from Dullita to the peasant woman with the "turgescent breasts" which he fantasizes fondling, but, in the end, achieves satisfaction through symbolic proxy by touching a ripe melon hanging from the rafters of

Sr. Pitchot's tower. Dalí devises an elaborate ruse whereby he coaxes the woman to mount her ladder and disentangle his toy top from a rose vine climbing the front of the house: "If the blossom-picker were to set up her ladder close to this window and climb up to a given height," he plots, "I should be able to see her breasts set in the frame of the window as if altogether isolated from the rest of her body, and I would then be in a position to observe them with all the voracity of my glance without feeling any shame lest my desire be discovered or observed by anyone. While I looked at the breasts I would exercise a caressing pressure by means of my crutch's bifurcation upon one of the hanging melons, while attempting to have a perfect consciousness of its weight by slightly lifting it."[7] The story is a kind of origin myth for the coming into being of subjectivity. The melon is a proxy for the mother's breast, the introjected object of the child's primary identification. It represents a moment of primal jubilation, of unity and totality anterior to the differentiation of the ego and its objects. The melon does not so much represent a desire *for* the other as a desire for symbolic incorporation (Dalí consumes the melon after touching it) that would eradicate the constituent structure of subjectivity itself. As Vilaseca writes, "[B]y barring direct access to the breast and locating desire's only possibility of satisfaction in a substitute for it (the melon), the Dalínian story points to the absolute anteriority of human subjectivity, a subjectivity which is born at the moment it sublimates its auto-erotic attachment to the breast, a subjectivity which is characterized by the structural impossibility of recovering that primal attachment except in the succession of its

secondary, always already sublimated and 'failed' movements."[8] Symbolically speaking, then, the melon serves a restorative function; it returns the subject to a moment of primal unity prior to symbolization and sexual division.

Such a structural equation is, however, a conundrum, and Dalí can only indulge the fantasy for so long. By the end of the narrative, he overcomes his aggression toward Dullita/Dullita Rediviva/Galuchka/Gala and, through his love object, establishes a new sense of self. The final image finds the couple on the rooftop of Sr. Pitchot's tower at sunset. The figures "merge" symbolically through the sacrifice of the toy top, which Dalí hurls into empty space, and the crutch is magically transformed from a "symbol of death" into a "symbol of resurrection!"

Notes

1. Salvador Dalí, *The Secret Life of Salvador Dalí* (New York: Dial Press, 1942), 260–261.

2. Dalí, *Secret Life*, 91.

3. Dalí, *Secret Life*, 93.

4. Dalí, *Secret Life*, 96.

5. Julia Kristeva, *Powers of Horror: An Essay on Abjection*, trans. Leon S. Roudiez (New York: Columbia University Press, 1982).

6. David Vilaseca, *The Apocryphal Subject: Masochism, Identification, and Paranoia in Salvador Dalí's Autobiographical Writings* (New York: Peter Lang, 1995), 94.

7. Dalí, *Secret Life*, 98.

8. Vilaseca, *Apocryphal Subject*, 193.

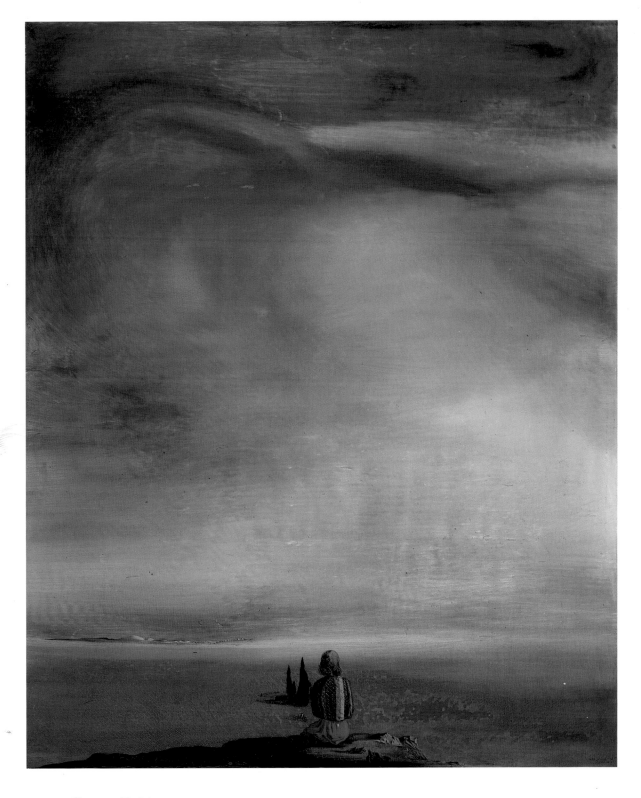

Sugar Sphinx is one of a series of paintings in which Gala appears in a multicolored, richly textured jacket with her back to the viewer (see also cat. no. 48). Seated in the foreground center on a promontory overlooking a vast plain at sunrise or sunset, Gala is a paragon of concentration and composure. In the distance two cypress trees, traditional symbols of death, stand on either side of a walled enclosure, framing a wheelbarrow and a couple at prayer that is derived from Jean François Millet's *Angelus.* Given Dalí's "paranoiac-critical" interpretation of Millet's celebrated painting as a scene of predatory aggression, sexual ambiguity, and death (see cat. no. 52), the enclosure may well be a cemetery. Indeed, in Dalí's reading, the archetypal couple mourn the death of their dead son, whom Dalí imagines to be buried beneath a basket in the foreground of the painting. The wheelbarrow is in turn viewed as a symbol of desire, and the female peasant as a combination Oedipal mother and sphinx.

The title of the painting plays on these multiple associations. Half woman, half lion, the enigmatic sphinx combines aspects of both male and female—the devouring mother and the castrating father. In the classical myth of Oedipus and the Sphinx, the hapless victim who is unable to solve the creature's riddle meets with death, a fate that Oedipus, in solving the riddle, is able to avoid. Dalí in turn projects these associations of terror, death, and desire onto Gala, who, as the title of the painting suggests, is also sweet and seductive, the manifestation of Dalí's masochistic fantasies of self-destruction through love.

49. *Sugar Sphinx*, 1933

Oil on canvas
28 5/8 × 23 1/2 inches

Exhibitions
New York 1934
Paris 1934

Liverpool 1998
Shinjuku 1999

Oil on canvas
8 3/4 × 6 1/2 inches

Exhibitions
Paris 1933B
New York 1933B
London 1936
San Francisco 1939
New York 1941A
Boston 1946
Cleveland 1947
Santa Barbara 1953
New York 1960A
New York 1965
Fort Lauderdale 1997

Dalí's perversely detumescent bureaucrat reappears in this disturbing painting of 1933. The fantastic, hornlike appendage growing from the bureaucrat's hydrocephalic skull belies his obvious impotence: wearing only a nightshirt and hose, the bureaucrat strokes his soft harp in a wasteful expenditure of sexual energy. The death's-head symbolism of the harp, in conjunction with its exaggerated, clenched teeth, further underscores the idea of emasculation, while the garter supporting the bureaucrat's hose and the enormous crutch are obvious phallic prostheses.[1]

William Rubin has interpreted Dalí's imagery within the context of the Freudian dream work. In his view, the bureaucrat "is 'milking' a giant skull whose 'soft constructions' hang down like cows' udders. The metaphor of a bureaucrat 'milking' the minds of his subordinates is a

50. *Average Atmospherocephalic Bureaucrat in the Act of Milking a Cranial Harp,* 1933

Average Atmospherocephalic Bureaucrat in the Act of Milking a Cranial Harp

simple Freudian metaphor-cum-dream image, and the notion of 'milking,' particularly when the milking is done with a bureaucrat's virtuoso skill, leads, on the dream level of metaphoric fusion, to the idea of harping, thus the 'cranial harp.' "[2] Although the poetic title of the painting would appear to justify such a reading, Dalí's vision is far more complex. Of particular importance is the status of Dalí's anamorphic imagery, which Rubin does not adequately address.

Anamorphosis is a distorted projection, a kind of visual rebus in which the form/identity of an object seen straight on is unintelligible but when viewed from an oblique perspective is reconstituted as a complete entity. References to the distorting mirror of anamorphosis can be detected in Dalí's work as early as 1928 (see cat. nos. 28 and 29), but it was not until 1933 that the artist exploited its full psychoanalytic potential. The most celebrated use of anamorphic imagery in the history of art is the skull in the foreground of Hans Holbein's great painting *The Ambassadors* (National Gallery of Art, London), which Dalí reproduced in his 1934 *Minotaure* magazine essay "Apparitions aérodynamiques des 'êtres-objets.' "[3] In Dalí's reinterpretation of this celebrated image, the anamorphic skull represents the divided nature of human subjectivity—the death, one might say, of the Cartesian, self-identical subject. Dalí specifically

associates the anamorphic skull with spectral apparitions, disintegration, instability, and the "destruction of illusory volume";[4] that is to say, with the eclipse of the desiring subject. As he insists elsewhere, anamorphosis is a psychic state that is defined by the "instantaneous reconstitution of desire deformed through its refraction by a cycle of memories."[5] In *Average Atmospherocephalic Bureaucrat in the Act of Milking a Cranial Harp*, the self-involved figure symbolically nurses from the maternal breast under the sign of the skull—the sign, one might say, of sexual division and symbolic castration under the Oedipal interdiction that defines him as a divided, desiring subject.

Notes

1. In other works from this period dealing with the theme of emasculation and the Oedipal drama, the garter is worn by the figure of William Tell and the male peasant from Millet's *Angelus.*

2. William Rubin, *Dada and Surrealist Art* (New York: Harry N. Abrams, 1969), 228.

3. Salvador Dalí, "Apparitions aérodynamiques des 'êtres-objets,' " *Minotaure* (Paris) 6 (winter 1934–35): 33–34.

4. Salvador Dalí, "The New Colors of Spectral Sex-Appeal," translated in *The Collected Writings*

of Salvador Dalí, ed. Haim Finkelstein (Cambridge: Cambridge University Press, 1998), 201–207. The text originally appeared as "Les Nouvelles couleurs du sex appeal spectral," *Minotaure* (Paris) 5 (February 1934): 20–22.

5. Salvador Dalí, "The Latest Modes of Intellectual Stimulation for the Summer of 1934," *Documents 34* (Paris) new series 1 (June 1934): 33–35. The text was originally published as "Dernières modes d'excitation intéllectuelle pour l'été 1934." See Finkelstein, ed., *Collected Writings*, 253–255.

51. *Myself at the Age of Ten When I Was the Grasshopper Child*, 1933

Oil on panel
8 5/8 × 6 3/8 inches

Exhibitions
Paris 1933B
New York 1933B
New York 1934
New York 1941A
Cleveland 1947
New York 1965
Fort Lauderdale 1997
Rio de Janeiro 1998
Hartford 2000

In his March 1929 essay "... The Liberation of the Fingers..." Dalí commented on the extended autobiographical associations of the grasshopper, just as grasshopper imagery made a strong appearance in his work:

I should mention that when I was about 7 or 8 years old, I had a great predilection for chasing grasshoppers. I don't have the slightest clue that could fully explain this predilection, since, as much as I recall clearly and in a particularly vivid way the pleasure I felt at the delicate tones of their wings when I spread them out with my fingers, it seems clear to me that this was not the ONLY cause for my chasing (I should point out that almost always I set free these little creatures shortly after capturing them).

It happened once in this same period, on the rocks in front of our house in Cadaqués, *that I caught a little fish in my hand; the sight of it so strongly affected me and in such an exceptional way as to make me throw it away with horror, accompanying my action with a great cry. Its face is like that of a grasshopper, I loudly exclaimed right away.*

I should also note that the anecdote with the fish was completely erased from my memory, without leaving the slightest conscious trace, until my father related it to me, and then I recalled it with uncommon clarity. This anecdote struck my father as being peculiar; he himself has professed this to me.

I had tried, however, to clarify to myself the origin of such a dread (until I knew the cited anecdote) by various suppositions and completely false anecdotes, to which I had come to accord a certain credence of reality.[1]

In the same essay, Dalí also related the story of his friend Eugenio Sánchez, a man of little culture whom he had befriended during the period of his military service and who, upon Dalí's prompting, "began automatically filling sheets upon sheets with texts of incomparable suggestiveness," spontaneously uttering the phrase "there is a flying phallus" without prior knowledge of Freud's interpretation of the image in ancient art (see cat. no. 28). Although the anecdote appears to be little more than a casual aside, it in fact frames the story of the grasshopper, suggesting that Dalí's "paranoiac" confusion of the form of the fish/grasshopper is actually a screen memory—a kind of retrospective rewriting of the history of the subject—in which his real fear of sexual intercourse is tied to a fantasy of sexual regression organized around the primal scene (the moment of the male child's realization of his mother's "lack" and his dual need to recognize and disavow the imagined threat of castration, as Freud first

outlined in his groundbreaking brochure of 1905, *Three Essays on the Theory of Sexuality*, and more fully in his 1927 essay on fetishism). In this light, the bisexual character of the grasshopper and the fish points to a state of polymorphous sexual identity prior to the subject's assumption of gender, as Dalí invokes the primal scene as a moment of terror and confusion. Indeed, when the painting was first exhibited in Paris in 1933, it was listed in the catalogue with the suggestive subtitle "castration complex."

In *Myself at the Age of Ten* ... Dalí explores gendered identity as a process that challenges the very corporeal boundaries of the subject. The extreme distortion of the ossified skull, which extends into a hornlike structure that is mirrored in the distant projection of the table, has clear phallic implications. The anamorphic structure of the skull, and its visual rhyme with the table, in turn suggest the obliteration of boundaries between the subject and the environment, between animate and inanimate beings and objects. Given that Dalí repeatedly painted anamorphic skulls at this time (see cat. nos. 50, 55, and 56) to signify the obliteration or symbolic "death" of the subject, the treatment of the grasshopper child's head suggests that the process of sexual division itself involves a symbolic death in which the subject is "cut off" from the body of the mother. The castration metaphor is also negotiated in *Myself at the Age of Ten* ... in relation to the exaggerated testicles of the grasshopper child, and the dislocation

of his shoe, which is separated from his body in a clear allusion to Freud's theory of fetishism.

Notes

1. Salvador Dalí, "... L'Alliberament dels dits ..." (... The liberation of the fingers...), *L'Amic de les arts* (Sitges) 4 (March 31, 1929): 6–7, translated in *The Collected Writings of Salvador Dalí*, ed. Haim Finkelstein (Cambridge: Cambridge University Press, 1998), 100. Years later, Dalí recounted the fish/grasshopper anecdote in more detail (*The Secret Life of Salvador Dalí* ([New York: Dial Press, 1942], 128–130), focusing not only on his initial horror at the sight of the fish with the grasshopper's head, but also on the torment he suffered at the hands of sadistic classmates who baited his fears.

52. *Meditation on the Harp*, 1933–34

Oil on canvas
26 1/4 × 18 1/2 inches

Exhibitions
Paris 1933A
Paris 1933B

New York 1947
New York 1950A
Rome 1954

New York 1965
Fort Lauderdale 1997
Liverpool 1998

In 1933 Dalí embarked on a series of paintings based on the *Angelus*, Jean-François Millet's popular masterpiece of 1858–59 (Louvre, Paris).[1] The interest Dalí took in the painting matched its mass appeal as an iconic image of peasant piety. Not only did a reproduction of the painting hang in the hallway of Dalí's grade school in Figueres, but almost from its inception, the *Angelus* was widely reproduced in a variety of print media, ultimately appearing in the form of mass-produced objects, such as tea sets, inkwells, and pillow shams. This peculiar migration of a sentimental academic painting from the walls of the museum to popular kitsch fascinated Dalí, who documented the process with the rigor of a social scientist.

According to his own testimony in *The Tragic Myth of Millet's "Angelus,"* a book-length manuscript Dalí began sometime in 1932–33 but did not publish until 1963, Millet's painting "suddenly appeared" in his mind's eye in June 1932 "without any recent recollection or conscious association to offer an immediate explanation." Dalí continues:

This image was composed of a very clear visual representation and was in colour. It was almost instantaneous and was not followed by other images. It left me with a profound impression, I was most upset by it, because, although in my vision of the aforementioned image everything "corresponded" exactly to the reproductions that I knew of the picture, it nevertheless "appeared to me" absolutely modified and charged with such a latent intentionality that the Angelus *of Millet suddenly became for me the most troubling of pictorial works, the most enigmatic, the most dense, the richest in unconscious thought that had ever existed.[2]*

Dalí subsequently explored the latent content of his obsession. Subjecting the *Angelus* to a process of "paranoiac-critical" interpretation through a strict analysis of primary and secondary "delirious phenomena" sparked by daydreams, fantasies, and chance encounters with the image in popular culture, he offered an interpretation of the painting as "the maternal variant of the grandiose, atrocious myth of Saturn, of Abraham, of the Eternal Father with Jesus Christ and of William Tell himself — all devouring their own sons."[3] In Dalí's reading, a latent content of castration and death is symbolically encoded in the painting. Like Freud's interpretation of the story of Oedipus, the *Angelus*, Dalí argued, structures a universal myth. Observing that the male peasant in Millet's painting is smaller in size than his wife, Dalí imagines a complex scenario of predatory female aggression, in which the woman, piously bowing her head in prayer, assumes the form of a praying mantis (in captivity, the female of the species is known to devour its partner during or immediately following mating). The wheelbarrow is in turn read as a kind of sexual surrogate, while the basket marks the grave of the couple's dead son.[4] Dalí then provides indisputable "proof" of his interpretation in the form of photographs, postcards, and popular illustrations that set into motion and subsequently document the secondary delirious phenomena.

Dalí's approach to the *Angelus* theme mimics the psychoanalytic process itself. His "case study" owes more than a little to Freud's 1910 essay "Leonardo da Vinci and a Memory of His Childhood" (see cat. no. 36), with the significant exception

that Dalí is not in the least interested in the biographical facts of Millet's life.[5] It is the psychoanalytic status of the *Angelus* as a *cultural* icon that Dalí seeks to explore. The fact that the painting had been slashed and seriously damaged on August 12, 1932, by a deranged unemployed engineer named Georges Pierre-Théophile Guillard only confirmed Dalí's suspicion that Millet's painting structured a cultural myth.[6]

Dalí explores his own "delirious" associations with the *Angelus* in *Meditation on the Harp*. The fork that is stuck in the earth in Millet's painting (in Dalí's reading, an allusion to sexual intercourse) has been transposed into a crutch that supports an anamorphic, skull-like appendage that extends from the foreground figure's elbow. The conic head of this figure and his grotesque hornlike left foot relate to Dalí's imagery of the grasshopper child (cat. no. 51), who, in the Oedipal triangle of the *Angelus* scenario, now represents the couple's dead son. The sexual aggression and incestuous desire of the mother for the son is suggested by her nudity, while the largely phantom figure of the male peasant bows his head in a gesture of shame rather than piety; his hat covers the site of his ignominy.

It is important to make a distinction here between Dalí's "paranoiac" interpretation of the *Angelus* theme and his production of visual images that illustrate that theme through a conscious process of secondary elaboration. At stake here is the problem of transcription itself — the translation of the delirious phenomenon into a concrete image. As early as 1930, in "L'Ane pourri," Dalí suggested the possibility of an active means to systematize

confusion: "I believe the moment is drawing near when, by a thought process of a paranoiac and active character, it would be possible (simultaneously with automatism and other passive states) to systematize confusion and thereby contribute to a total discrediting of the world of reality."[7] Several years later, in his prologue to *The Tragic Myth*, Dalí was more insistent on making a distinction between the "passive confusion of automatism" — the surrealist technique of oneiric transcription and free association used to generate images spontaneously, "in the absence of control exercised by reason," as Breton stated in the *First Manifesto of Surrealism* — and the "active and systematic confusion illustrated by the paranoiac phenomenon."[8] With a nod to psychoanalyst Jacques Lacan, whose 1932 doctoral thesis *De la Psychose paranoïaque dans ses rapports avec la personnalité* he had just read, Dalí interpreted the elaborate delusions of paranoiacs as a systematic manifestation of the subject's unconscious desires, with a specific and unique content. As both Dalí and Lacan insisted, "the paranoiac delirium already constitutes in itself a form of interpretation,"[9] one that Dalí's approach sought to replicate. By 1935, Dalí offered the most coherent definition to date of his theory of paranoia-criticism:

Paranoia: delirium of interpretive association bearing a systematic structure. Paranoiac-critical activity: spontaneous method of irrational knowledge based upon the interpretive-critical association of delirious phenomena. *The presence of active and systematic elements does not*

suppose the idea of voluntarily directed thought, nor of any intellectual compromise, for, as we know, in paranoia the active and systematic structure is consubstantial with the delirious phenomenon itself;—all delirious phenomena of paranoiac character, even when sudden and instantaneous, bears already "in entirety" the systematic structure and only becomes objective a posteriori by critical intervention. Critical activity intervenes solely as liquid revealer of images, associations and systematic coherences and finesses already existing at the moment when delirious instantaneousness is produced and that alone, for the moment to this degree of tangible reality, are given an objective light by paranoiac-critical activity. Paranoiac-critical activity is an organizing and productive force of objective chance.[10]

————

Notes

1. The central image from the *Angelus* of a peasant couple held Dalí's interest well into the 1960s and appears in various incarnations in the following paintings: *The Architectonic "Angelus" of Millet*, 1933 (Museo Nacional Centro de Arte Reina Sofía, Madrid); *Gala and the "Angelus" of Millet Preceding the Imminent Arrival of the Conic Anamorphoses*, 1933 (National Gallery of Canada, Ottawa); *Sugar Sphinx*, 1933 (cat. no. 49); *The "Angelus" of Gala*, 1935 (Museum of Modern Art, New York); *Atavism at Twilight*, 1933–34 (Kunstmuseum Bern, Berne); *Archaeological Reminiscence of Millet's "Angelus,"* 1933–35 (cat. no. 53); *Couple with Their Heads Full of Clouds*, 1936 (Museum Boijmans Van Beuningen,

Rotterdam); *Portrait of My Dead Brother*, 1963 (cat. no. 93); and *Perpignan Railway Station*, 1965 (Museum Ludwig, Koln). The peasant couple from the *Angelus* also appears in the background of *Imperial Monument to the Child-Woman* circa 1930, but this detail is likely to have been a later addition.

2. Salvador Dalí, *The Tragic Myth of Millet's "Angelus." A Paranoiac-Critical Interpretation* (St. Petersburg, Fla.: The Salvador Dalí Museum, 1986), 21.

 The history of Dalí's work on this project is complex. In a February 1933 letter to his friend the Catalan poet Josep-Vicenç Foix, Dalí indicated that his essay "Paranoiac-Critical Interpretation of the Obsessive Image in Millet's *Angelus*" was almost finished and would appear in the form of a book with thirty reproductions (Rafael Santos i Torroella, *Salvador Dalí, corresponsal de J. V. Foix, 1932–1936* [Barcelona: Editorial Mediterrània, 1986], 89–90). The imminent publication of the manuscript was announced in the May 15, 1933, issue of *Le Surréalisme au service de la révolution*, although only a theoretical prologue appeared in the June 1933 issue of *Minotaure* (Paris) 1: 65–67, with six illustrations. Dalí subsequently published a short text entitled "L'Angélus de Millet" as a catalogue essay for the exhibition "Salvador Dalí: Les Chants de Maldoror" at the Galerie des Quatres Chemins, Paris, in 1934. It is not clear when Dalí actually completed his book-length manuscript, as the title of the text he refers to in the letter to Foix corresponds to that of the

Minotaure article, not the book. It is clear, however, that Dalí developed the broader themes of his thesis at this time. The unpublished manuscript remained in Dalí's possession until 1940, at which time he fled the German advance on Paris. It was finally published with a new prologue in 1963 as *Le Mythe tragique de l'"Angélus" de Millet: Interprétation "paranoïaque-critique"* (Paris: Jean-Jacques Pauvert).

3. Dalí, *Tragic Myth*, 135.

4. When years later the painting was X-rayed, Dalí was elated to learn that conservators had discovered an area of overpainting beneath the basket. Dalí took this as confirmation of his view that the basket marks the site of a child's grave.

5. In the *Minotaure* essay (see n. 2, above), Dalí "reveals" his source in Freud by including a reproduction of Leonardo's *Virgin, Jesus, and St. Anne* (Louvre, Paris), an image that figured prominently in Freud's interpretation.

6. It is curious that Dalí makes no mention of this celebrated incident in his *Minotaure* essay. One wonders if this absence is strategic, as the event may well have sparked Dalí's interest in exploring the latent psychoanalytic content of Millet's painting. In *Tragic Myth*, however, Dalí does document the act of vandalism.

7. Salvador Dalí, "L'Ane pourri," in *La Femme visible* (Paris:

Editions surréalistes, 1930), 11–12; and *Le Surréalisme au service de la révolution* (Paris) 1 (July 1930): 9–12, translated in *The Collected Writings of Salvador Dalí*, ed. Haim Finkelstein (Cambridge: Cambridge University Press, 1998), 223.

8. Salvador Dalí, "Nouvelles considérations générales sur le mécanisme du phénomène paranoïaque du point de vue surréaliste" (prologue to "Interprétation paranoïaque-critique de l'image obsédante l'*Angélus* de Millet"), *Minotaure* (Paris) 1 (June 1933): 65–67, translated in Finkelstein, *Collected Writings*, 256–262.

9. Dalí, "Nouvelles considérations générales," in Finkelstein, *Collected Writings*, 260. Dalí and Lacan specifically took issue with the widely held view, advanced by psychiatrists P. Sérieux and J. Capgras in their 1909 treatise *Les Folies raisonnantes. Le Délire d'interprétation*, that the paranoiac delirium, despite its systematic character, proceeded from a false premise. Unlike the constitutionalist theories of his mentor, de Clérambault, who did not consider the content of the paranoiac hallucination to be of significance, Lacan interpreted the delirium as a manifestation of unconscious drives, offering significant keys to an understanding of the subject's personality.

10. Salvador Dalí, *Conquest of the Irrational* (New York: Julien Levy Gallery, 1935), 15–16.

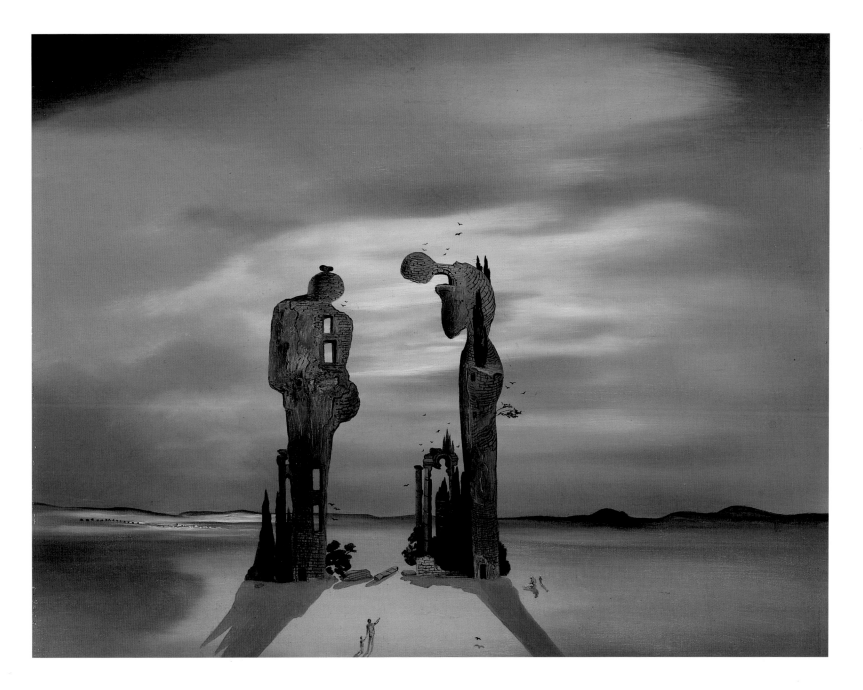

53. *Archeological Reminiscence of Millet's "Angelus,"* 1933–35

Oil on panel
12 1/2 × 15 1/2 inches

Exhibitions
New York 1934
Paris 1934
Cleveland 1947
New York 1965
Barcelona 1996
Shinjuku 1999

Dalí explores the atavistic implications of the *Angelus* myth in this small panel painting of 1933–35. Two enormous figures suggesting geological formations and the ruins of ancient towers dominate the vast open plain of the Empordà. The petrified form of this haunting ur-couple, primordial progenitors who mimic the pose of the two peasants in Millet's painting, alludes to the theme of predatory aggression and death that Dalí "discovered" in the painting (see cat. no. 52). Dwarfed by their presence, two groups of figures contemplate the couple: a young child dressed in a school frock accompanied by an adult in the lower middle foreground (presumably the young Salvador Dalí and his father), and a child accompanied by his wet nurse to the right of the female monolith. These sign-memories of an early stage of psychic development— the "reminiscence" to which the title refers—are, Dalí suggests, buried deep within the stratified layers of the unconscious, from which they can be retrieved only in the form of fragments.

In *The Tragic Myth of Millet's "Angelus,"* Dalí describes a secondary delirious phenomenon sparked by his obsession with the image that returns him to the landscape of his youth:

On an excursion to Cap Creus, located in the northeast part of Catalonia, where the mineral landscape is like a veritable geological delirium, I surrendered myself to a brief fantasy during which I imagined sculptures of the two figures in Millet's Angelus *carved out of the highest rocks there. Their spatial positions were the same as those in the painting, but they were completely covered with fissures. Several details of the two figures had been effaced by erosion. This helped make their origin seem to date back to a long bygone epoch contemporary with the origin of the rocks themselves. It was the man's figure that had been most deformed by the mechanical action of time. Practically nothing remained of him except the vague and formless block of his silhouette which thus became fraught with a terrible and particular anguish.*[1]

In this reading, the dual petrification and erosion of the male figure suggests both a literal death (of the peasant couple's child — a likely surrogate for Dalí himself — and of the father figure at the hands of his mate) and a symbolic death referring to the Oedipal interdiction and the child's separation from the maternal body.

Notes

1. Salvador Dalí, *The Tragic Myth of Millet's "Angelus." A Paranoiac-Critical Interpretation* (St. Petersburg, Fla.: The Salvador Dalí Museum, 1986), 12.

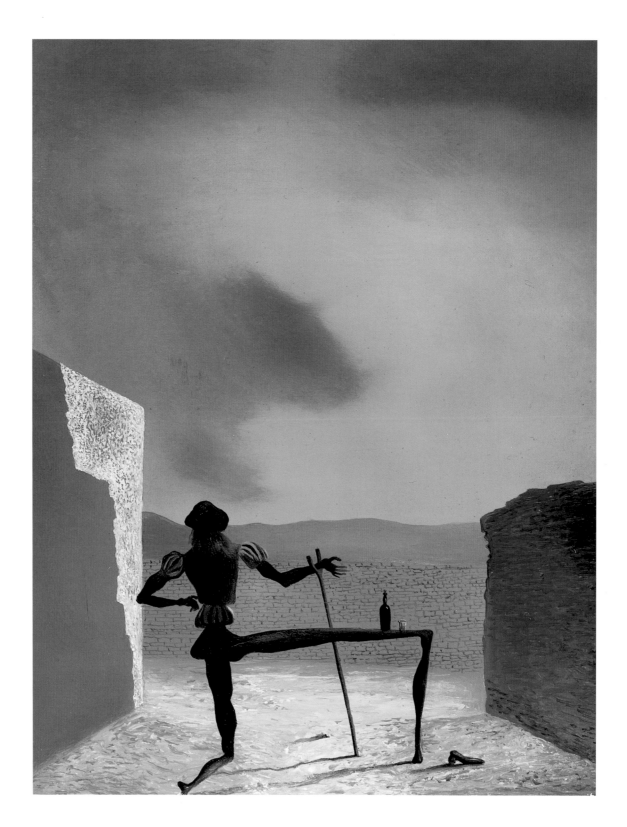

54. *The Ghost of Vermeer of Delft Which Can Be Used as a Table,* 1934

Oil on panel
7 1/8 × 5 1/2 inches

Exhibitions
Paris 1934
New York 1941A
Cleveland 1947
Rome 1954
New York 1965
Madrid 1983
Rio de Janeiro 1998

Dalí executed a series of paintings in 1934 in which the Dutch artist Johannes Vermeer (1632–1675) appears in the form of a large silhouette or spectral apparition viewed from the back. The setting for *The Ghost of Vermeer of Delft* . . . is a narrow lane in Port Lligat that leads to the cemetery. As the painter stops to admire the view of the distant mountains, he kneels on his left knee and extends his right leg in the same position as Dalí's Grasshopper Child (cat. no. 51), who, like the ghost of Vermeer, has a dismembered foot. The exaggerated extension of the right thigh is metamorphosed into a table or bench on which a glass and a bottle of wine rest, while the figure is propped up by a crutch that supports its limp, right wrist.

As early as 1926 Dalí had begun to examine the nature of Dutch realism (see cat. nos. 24 and 25). In a lecture he delivered on the occasion of Barcelona's third Autumn Salon two years later (see cat. no. 31), he described Vermeer as an artist who "makes use of the contours of the objective world, endowing it, however, with an appearance of absolute unreality, commonly taken as reality. Vermeer's reality, in contrast, is precisely that which escapes perception—poetic inspiration and lyricism."[1] As Dalí suggested, the art of perception has its "sweet and exciting moment" in Vermeer's painting precisely because the Dutch artist recognized the profound mystery in the surface appearance of things.[2] To look, Dalí repeatedly emphasized, is to discover.

As Dalí's theoretical platform evolved over the course of the 1930s, so, too, did his thoughts on Vermeer gain complexity and depth. In a little-known text of 1940, "Les Idées lumineuses," he described the Dutch artist as "the authentic painter of specters." Employing a characteristically baroque prose style, Dalí contrasts what he calls "le volume Oeuf" (the egg volume) with "le volume Perle" (the pearl volume). "In the former," Dalí writes, "we know that the idea delivers itself entirely and unconditionally to light. In the latter, exactly the opposite occurs. It is light which, giving body and soul to the idea . . . renders the idea itself luminous, as if it were on fire." Dalí then cites Vermeer's *Peseur de perles* (National Gallery of Art, Washington, D.C.) as an example of "the tirelessly complex, extra-lucid, timeless thought of this painter who possesses the luminous sense of death with the very hyper-evidence of the 'déjà vu.' "[3] This is a particularly obscure and difficult passage in which Dalí elaborates a complex theory of visuality that challenges the primacy of the perceiving eye (what Dalí calls the egg volume). Indeed, Dalí suggests that vision is configured at the intersection of perception and desire, a schema that locates the subject at the blind spot of representation. As the subject of desire (the unconscious) remains hidden to, but nonetheless continuously acts upon, the subject of reflexive consciousness, the physical signposts of the world begin to define psychic boundaries. Distinctions between inside and outside, animate and inanimate,[4] self and other, the speaking subject and the subject of the unconscious break down before the mortifying specter of the "déjà vu," the irruption of desire in the cracks and surfaces of the real.

Notes
1. Salvador Dalí, "Art català relacionat amb el més recent de la jove intel.ligència," *La Publicitat* (Barcelona), October 17, 1928, reprinted in *Salvador Dalí: L'Alliberament dels dits. Obra catalana completa*, ed. Fèlix Fanés (Barcelona: Quaderns Crema, 1995), 133–146.

2. Salvador Dalí, "Nous límits de la pintura" (part 1), *L'Amic de les arts* (Sitges) 22 (February 29, 1928), 167–169; translated in *The Collected Writings of Salvador Dalí*, ed. Haim Finkelstein (Cambridge: Cambridge University Press, 1998), 81.

3. Salvador Dalí, "Les Idées lumineuses," *L'Usage de la parole*, 1, no. 2 (February 1920); reprinted in *Salvador Dalí. Rétrospective, 1920–1980*, exh. cat., Musée National d'Art Moderne, Centre Georges Pompidou, Paris, 1979–80, 201–205.

4. See cat. no. 58.

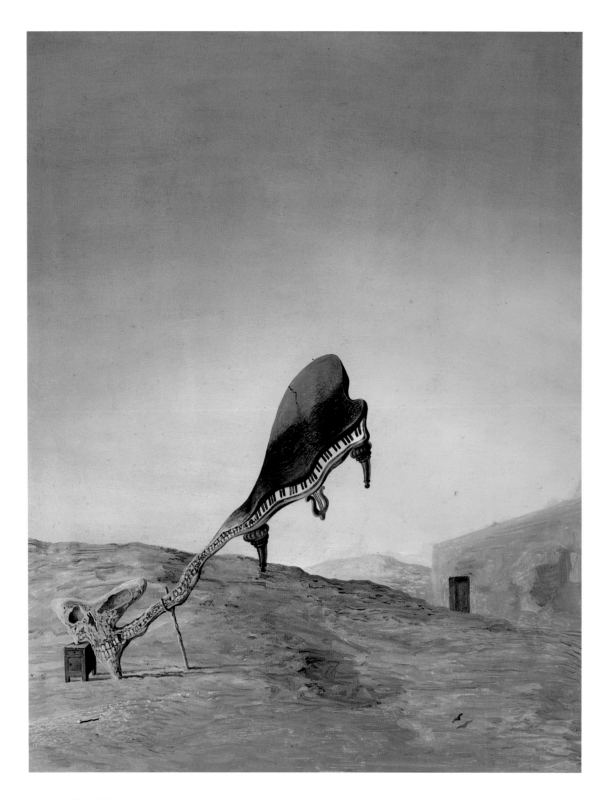

55. *Skull with Its Lyric Appendage Leaning on a Night Table Which Should Have the Exact Temperature of a Cardinal Bird's Nest*, 1934

Oil on panel
9 1/2 × 7 1/2 inches

Exhibitions
New York 1934
Paris 1934
London 1936
San Francisco 1939
Rome 1954
Hartford 2000

In both *Skull with Its Lyric Appendage Leaning on a Night Table* . . . and *Atmospheric Skull Sodomizing a Grand Piano* of the same year (cat. no. 56), Dalí exploits a visual rhyme that morphologically equates teeth with the keys of a grand piano. In keeping with his theories of soft and hard matter, Dalí imagines a fluid world in which the animate is transposed into the inanimate, and vice versa. The sexual economy of this exchange, which is structured around the axis ingestion/assimilation vs. excretion/separation, is linked to an early phase of libido development in which the anus and the mouth are the infant's primary erotogenic zones. In this light, the act of sodomy/penetration symbolically represents the infant's anal-sadistic impulses.

As we have seen (see cat. no. 39), the image of the piano has numerous implications for Dalí's work. Initially associated with childhood memories of musical gatherings with friends and family, the piano represents bourgeois leisure in the drawings Dalí produced for the *Libro de los putrefactos*. In *Un Chien andalou*, the protagonist of the film drags two Marist Brothers who are tied to a grand piano across the floor. And in

works like *The Average Bureaucrat* and *Shades of Night Descending* (cat. nos. 38 and 39), the piano appears in the form of an ominous shadow that looms over the landscape.

Skull with Its Lyric Appendage . . . plays on this idea of anxiety and threat. With a nod to Max Ernst's *Two Children Are Threatened by a Nightengale* of 1924 (Museum of Modern Art, New York), Dalí depicts a tiny bird flying close to the ground in the lower right corner of the painting. The lyrical music of the cardinal contrasts sharply with the harsh, desertlike conditions of the barren landscape and the terrifying scene of anal aggression that is figured in the central image.

That Dalí's iconography is linked to a fantasy of primal regression is suggested by the engravings he produced at this time for a new edition of *Les Chants de Maldoror* by Isidore Ducasse, the so-called Comte de Lautréamont (one of the engravings specifically locates the skull/piano image in relation to a male and female progenitor). Lautréamont's felicitous metaphor of a sewing machine and an umbrella on a dissecting table had long been championed by the surrealists as a poetic ideal of fusion through *l'amour fou*, but in Dalí's reading the text suggested other, darker possibilities. Anamorphic skulls abound in the engravings, at times configured in the shape of the peasant couple from Millet's *Angelus*. In other scenes limbs are lopped off and flesh is cut and torn apart. As David Lomas astutely puts it, "Dalí does his utmost to put the cadaver back into the *cadavre exquis*" of the surrealists.[1] Indeed,

not only does Dalí's imagery suggest a kind of pre-Oedipal aggression associated with the anal and oral phases of psychosexual development, but his horrific scenes of cannibalism and dismemberment dramatize what Lomas calls "the precarious condition of the subject faced by the abject"[2] (see cat. no. 48).

———

Notes

1. David Lomas, "The Haunted Self: Surrealism, Psychoanalysis, and Subjectivity" (Ph.D. diss., The Courtauld Institute of Art, University of London, 1977), 214. The reference is to the surrealist practice of *cadavre exquis*, a kind of parlor game in which a composite image would be produced by several artists or poets who would draw on a designated section of a piece of paper that had been folded to conceal, but for a few lead lines, the figuration produced by the other participants.

2. Lomas, "The Haunted Self," 217.

Catalogue 55

Skull with Its Lyric Appendage Leaning on a Night Table Which Should Have the Exact Temperature of a Cardinal Bird's Nest 93

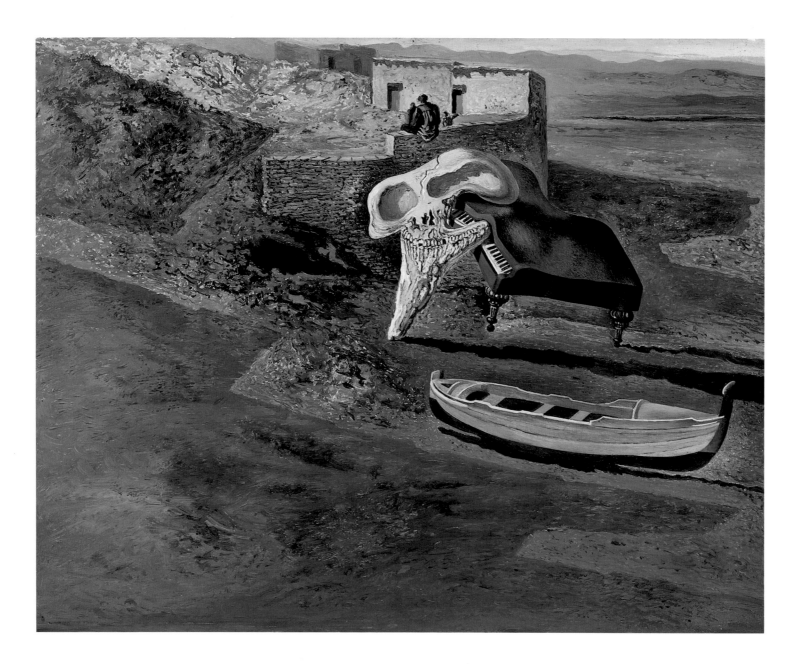

56. *Atmospheric Skull Sodomizing a Grand Piano*, 1934

Oil on panel

5 1/2 × 7 inches

Exhibitions

Paris 1934

Knokke Le Zoute 1956

New York 1965

Hartford 2000

In "The New Colors of Spectral Sex-Appeal," Dalí cites as an example of spectral representations (see cat. nos. 39 and 54), "a very large anamorphic skull, blindingly white, mad, sodomizing with its clear jaws a ruined grand piano, all this taking place in the bright spring sun behind an old tarred black boat, abandoned on a deserted and ill-equipped beach, on which hop along some sparrows, an herb omelette slipping dizzily on a polished marble ramp, etc."[1] The connection between anamorphosis, anal-sadistic eroticism, and food as a metaphor for ingestion/excretion supports an interpretation of the painting as a scene of primary sexual development. The presence of a young child with what may be the figure of a (wet) nurse seated on the retaining wall in the background in turn stages the theme of oral eroticism in relation to the infant's primary introjected object, the breast.

Ignoring Dalí's own emphasis on the psycho-sexual implications of the scene, Ian Gibson insists on a literal autobiographical reading of the imagery in relation to the artist's supposed homosexual panic. Referring to the work of art historian Rafael Santos i Torroella, he writes: "If [Santos i Torroella] is right, the picture, set on the beach at Port Lligat, alludes to Lorca's attempts to bugger the painter and shows that, despite the advent of Gala, these were still very much on Salvador's mind. The painter, that is, continued to be racked by the anxiety that, despite his protestations to the contrary, he might after all be homosexual."[2]

Notes

1. Salvador Dalí, "The New Colors of Spectral Sex-Appeal," translated in *The Collected Writings of Salvador Dalí*, ed. Haim Finkelstein (Cambridge: Cambridge University Press, 1998), 201–207. The text originally appeared as "Les Nouvelles couleurs du sex appeal spectral," *Minotaure* (Paris) 5 (February 1934): 20–22.

2. Ian Gibson, *The Shameful Life of Salvador Dalí* (London: Faber and Faber, 1997), 329. Santos i Torroella presents a highly speculative thesis concerning Dalí's homosexual panic in *"La Miel es más dulce que la sangre." Las Epocas lorquiana y freudiana de Salvador Dalí* (Barcelona: Seix Barral, 1984) and *Dalí: Epoca de Madrid* (Madrid: Residencia de Estudiantes, 1994).

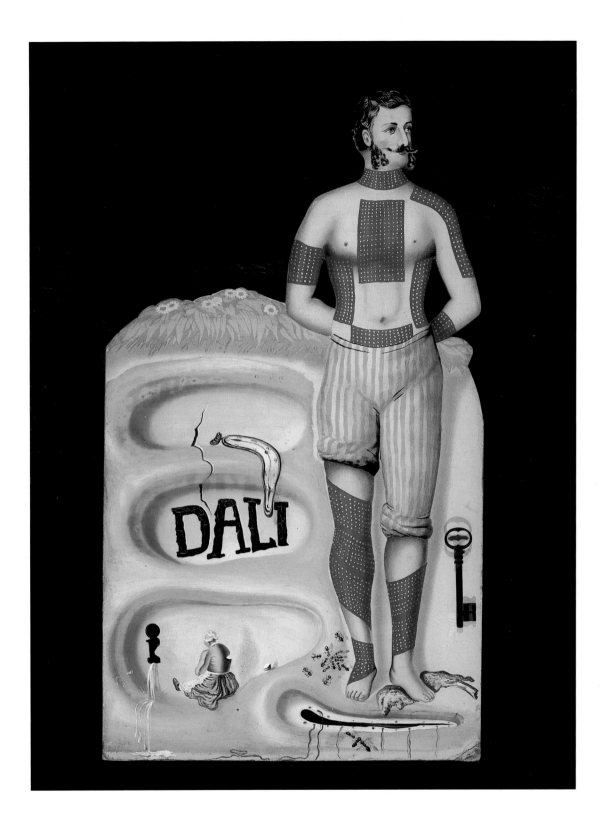

57. *Surrealist Poster*, 1934

Oil on cardboard with key

27 × 28 inches

Exhibitions

New York 1965

Fort Lauderdale 1997

Pittsburgh 1998

Dalí designed *Surrealist Poster* for his one-man show at the Julien Levy Gallery, New York, which ran from November 21 to December 10, 1934. Promoting Salvador Dalí, the artist/commodity, the image is painted over an advertisement for a medicinal mustard plaster that had appeared in a Barcelona newspaper on January 12, 1920. Dalí's overpainting brings together his most familiar symbols: the limp watch, a keyhole spouting water, ants, an actual key affixed to the surface of the cardboard ground, a lamb chop, and the artist's nurse seated with her back to the viewer.[1] The semiclothed male figure, covered with bandages treated with the plaster, and the hillock with daisies in the background are the only traces of the original poster. Indeed, so exacting is Dalí's technique that he effectively blurs the boundaries between the mass-produced and the painted images, producing what he referred to in the Levy catalogue as, "Snapshot photographs in color of subconscious images, surrealist, extravagant, paranoiac hypnagogical, extra-pictorial, phenomenal, super-abundant, super-sensitive, etc. of CONCRETE IRRATIONALITY."[2]

Dalí's use of an outmoded advertisement was well in keeping with surrealist practices. Not only was Miró's great *Peinture* series of 1933 based on collages of machine parts culled from industrial catalogues, but Max Ernst had produced his first surrealist book, *La Femme 100 têtes* of 1929, from rephotographed collages of Victorian engravings. In all three cases, a dual sense of nostalgia and distance obtains, as signs of the old and the recently obsolete implicitly set in motion a critique of commodity culture. As Walter Benjamin said of André Breton:

He can boast an extraordinary discovery. He was the first to perceive the revolutionary energies that appear in the "outmoded," in the first iron constructions, the first factory buildings, the earliest photos, the objects that have begun to be extinct, grand pianos, the dresses of five years ago, fashionable restaurants when the vogue has begun to ebb from them. The relation of these things to revolution—no one can have a more exact concept of it than these authors. No one before these visionaries and augurs perceived how destitution— not only social but architectonic, the poverty of interiors, enslaved and enslaving objects—can be suddenly transformed into revolutionary nihilism.[3]

Notes

1. The lamb chop rhymes with the extravagant sideburns of the figure and relates to Dalí's theories of physical consumption and psychic incorporation (see cat. nos. 38 and 44).

2. Salvador Dalí, artist's statement in *Dalí*, exh. cat, Julien Levy Gallery, New York, November 21– December 10, 1934. For a discussion of Dalí's thoughts on the extrapictorial implications of what he called "instantaneous color photography," see cat. no. 34.

3. Walter Benjamin, "Surrealism, the Last Snapshot of the European Intelligentsia," in Benjamin, *Reflections: Essays, Aphorisms, Autobiographical Writings*, trans. Edmund Jephcott (New York: Schocken Books, 1978), 177–192.

58. *The Weaning of Furniture-Nutrition*, 1934

Oil on panel

7 × 9 1/2 inches

Exhibitions

New York 1934

London 1936

San Francisco 1939

Rome 1954

New York 1958

New York 1965

New York 1973

Madrid 1983

Dalí explored the theme of the nondifferentiation of people and objects and of objects and ambient space throughout the 1930s. In "Aerodynamic Apparitions of 'Beings-Objects' " of 1934, an important transitional text in his evolving theory of "paranoia-criticism (see cat. no. 52), Dalí traces man's conception of space from Euclid to Descartes, Newton, and Einstein. "Until Newton," Dalí writes, "space proposes itself to us less as flesh than as the container of this flesh, as the vessel, the container of the force of gravity of the said flesh; the role played by space is passive and chronically masochistic."[1] However, with the Theory of Relativity, Dalí maintains:

space became important, material and real to such an extent that it even ended up having four dimensions, including time which is certainly a delirious and Surrealist dimension par excellence. It is for all these reasons that, in the actuality of the present time, space has become that good flesh, colossally alluring, voracious, and personal, that presses at every moment with its disinterested and soft enthusiasm the smooth finesse of the "strange bodies," as well as the bodies of the "Beings-Objects."[2]

Employing a chacteristically abstruse, corporeal metaphor — the "serene ejection" of the pasty contents of a blackhead that has been squeezed from the flesh of the nose —Dalí argues against the ontology of differentiated subject/object relations according to the tradition of idealist metaphysics and imagines a world that has been invaginated by the "internal secretions" of the desiring subject:

[F]loating kidneys will be matched by floating engines, soft engines, because the "period of the soft," the period of "soft watches," "soft automobiles," "soft night tables," carved out of the supersoft and Hitlerian backs of atavistic and tender nannies, is the period that has been forcast by the "mediums" of Art Nouveau, the creators of the famous soft cathedral situated in Barcelona. Central saliva systems will be running throughout the aerodynamic curves of the imminent houses that will be soft, *vaginal, curved, ornamental, imperial, recreational, imaginative, anxiety-ridden, perverted, and Surrealist.*[3]

In this perverse new world without boundaries, Dalí suggests elsewhere, subject, object, and ambient space will be joined in a delirious "imperialistic furor of precision."[4]

Dalí's reference to "soft night tables" carved from the backs of "atavistic and tender nannies" represents more than a casual reference to *The Weaning of Furniture-Nutrition* and related works in which the image of the wet nurse mending a fishing net on the beach at Port Lligat appears (see cat. nos. 55, 57, 65, and 70). Indeed, it sheds light on the broader implications of what one might call his theory of objecthood. On the most concrete level of visual puns, the night table is a physical extension of the nurse from whose body it has migrated, producing its own identical offspring. On the deeper, psychoanalytic level, however, the imagery allegorizes the process of ego formation and the child's separation (weaning) from the mother. Dalí's description of the atavistic nanny suggests a nostalgic desire to return to the maternal body, to a moment of primal unity before the self and its objects are differentiated. If this return of the subject to his/her origins is a structural impossibility, Dalí suggests that the exchange between beings and

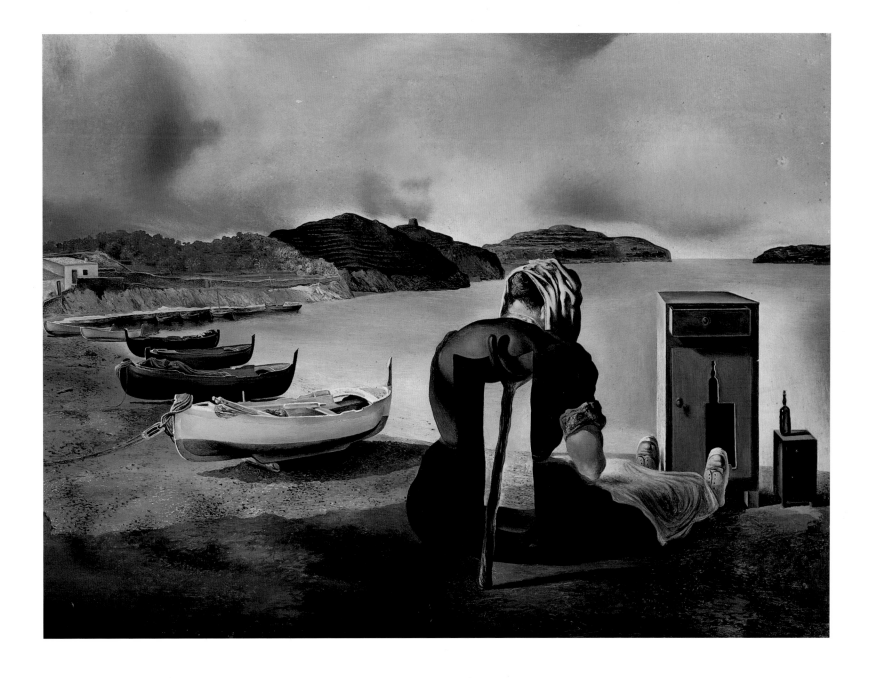

objects can at least be explored
productively through the paranoiac-
critical method.

———

Notes

1. Salvador Dalí, "Apparitions
aérodynamiques des 'Etres-
objets,' " *Minotaure* (Paris) 6
(winter 1934–35): 33–34,
translated in *The Collected Writings
of Salvador Dalí*, ed. Haim
Finkelstein (Cambridge:
Cambridge University Press,
1988), 207–211.

2. Dalí, "Apparitions," in Finkelstein,
Collected Writings, 208.

3. Dalí, "Apparitions," in Finkelstein,
Collected Writings, 209.

4. As Dalí declared in 1935: "My
whole ambition in the pictorial
domain is to materialize the
images of concrete irrationality
with the most imperialistic furor
of precision, so that the world of
imagination and concrete
irrationality may be of the same
objective clearness, of the same
consistency, of the same durability,
of the same persuasive,
cognoscitive and communicable
thickness as that of the external
world of phenomenal reality."
Salvador Dalí, *Conquest of the
Irrational* (New York: Julien Levy
Gallery, 1935), 12.

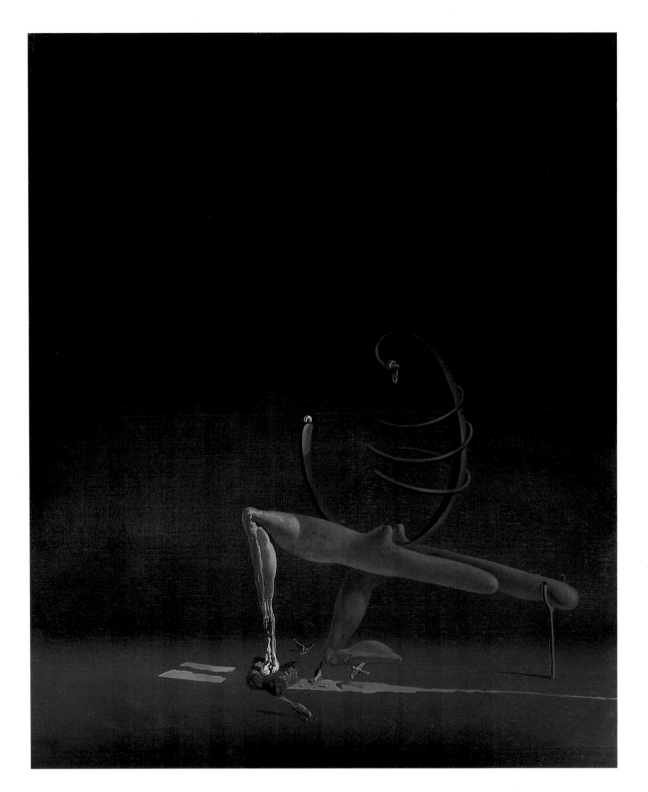

59. *The Javanese Mannequin*, 1934

Oil on canvas
25 1/2 × 21 1/4 inches

Exhibitions
New York 1934
Paris 1934
New York 1941A
Boston 1946
Cleveland 1947
New York 1965
Shinjuku 1999

Like numerous works of 1933 and 1934, including the *Angelus* series (cat. nos. 52 and 53), the imagery of *The Javanese Mannequin* relates to the forty engravings Dalí produced for Albert Skira's deluxe edition of *Les Chants de Maldoror*, Isidore Ducasse's (1846–70) haunting novel of 1869. The ossified figure of the mannequin, half bone, half rotting flesh, appears as an illustration to Maldoror's second song, where it relates to the general theme of putrescence and decomposition. In the painting, a worm or maggot hangs from the very top of the mannequin's curved spinal column, while on the ground below, birds pick at crumbs that seem to have their source in the rotting, ulcerated flesh of the figure's right leg or the loaflike protrusion of its buttocks. As he reconfigures the human body, Dalí, like his colleague Georges Bataille, establishes an anatomy of the abject.

Bataille's project, as outlined in his dictionary entries for *Documents* in 1929–30 and in subsequent short essays, involved inverting the hierarchies of the ideal human form. The impact of his thought in the early 1930s extended to artists as diverse as Joan Miró and Alberto Giacometti. In 1933 Picasso himself produced eighteen drawings of hybrid humanoid figures that he imagined as pieces of furniture and still-life objects. Published in the first issue of *Minotaure* magazine (February 1933), Picasso's series, entitled "An Anatomy," must have captured Dalí's imagination, for he produced an engraving that same year in which he added his own figuration of rotting corpses and dismembered bodies to the ground of a print by Picasso with related imagery, attempting to pass off his hybrid *Figures surréalistes* as a collaborative effort.[1]

Within Dalí's own work, the abject architecture of *The Javanese Mannequin* has immediate sources in the distended legs and buttocks of the central figure of *The Enigma of William Tell*, 1933 (Moderna Museet, Stockholm), and, even more closely, in the grotesque female "corpse" that towers above a young male child in *The Specter of Sex-Appeal*, 1934 (Fundació Gala–Salvador Dalí, Figueres). An almost identical version of the mannequin appears in the lower right-hand corner of *Imperial Monument to the Child-Woman* of circa 1930, although it is undoubtedly a later addition.

———

Notes

1. In a 1977 interview with Baltasar Porcel ("Con Salvador Dalí en su Teatro-Museo bajo la sombra místico-aurífera y el eco de Ramón Gómez de la Serna," published as an epilogue in Ramón Gómez de la Serna, *Dalí* [Madrid: Espasa-Calpe, 1977]), Dalí claimed that he and Picasso had collaborated on the engraving. However, as Rainer Michael Mason has demonstrated, Dalí merely appropriated Picasso's print *Trois Baigneuses, II* and made additions (*Dalí verdadero/grabado falso. La obra impresa 1930–1934*, exh. cat., IVAM, Centre Julio González, Valencia, 1992). For a discussion, see Ian Gibson, *The Shameful Life of Salvador Dalí* (London: Faber and Faber, 1997), 309–310.

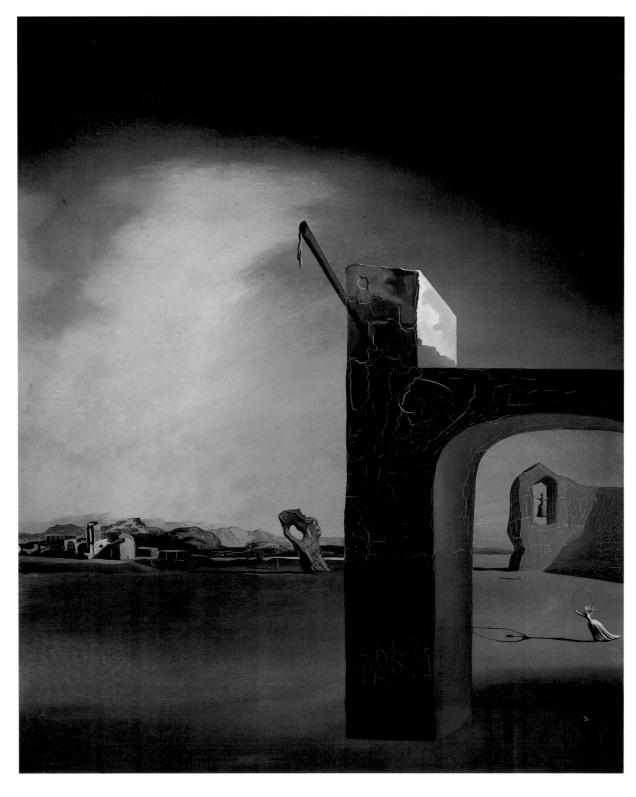

Dalí explores the paranoiac principle of formal repetition in this nostalgic painting from the "Morphological Echo" series of the mid-1930s (see cat. no. 65). The flat open landscape of the Empordà is the setting for a series of formal analogies and transmutations among animate and inanimate objects. With a nod to Giorgio de Chirico's great *Melancholy and Mystery of a Street* of 1914, from which the oddly prosaic motif of a young girl jumping rope has been adapted, Dalí envisions the landscape of his youth as the site of provocative encounters.[1] As the early morning or late afternoon light falls upon a rocky outcropping and the ruins of two buildings, deep shadows are projected that add to an overall atmosphere of mystery and threat. The curiously disturbing image of the young girl appears three times in this foreboding landscape: in her "original" incarnation in the lower right; in the form of a bell hanging from a tower in the middle ground; and in the configuration of a bizarre rock formation immediately to the left of the central architectural motif. The conflation of the girl with a church bell, which has obvious sexual connotations, adds an uncanny dimension to the landscape as Dalí stages the return of the repressed in relation to childhood memories. Indeed, the bell tower is probably a reference to a church school Dalí's sister, Ana María, attended near the family home in Figueres. Destroyed during the Spanish Civil War, it appears in a painting of circa 1926, *Woman at the Window in Figueres* (private collection).

60. *Morphological Echo,* 1934–36

Oil on canvas
25 1/2 × 21 1/4 inches

Exhibitions
London 1936?
London 1951?
Barcelona 1996
Fort Lauderdale 1997
Pittsburgh 1998
Shinjuku 1999
Tallahassee 1999

Notes

1. The image of a young girl playing with a hoop also appears in the

following works: *Nostalgic Echo*, 1935 (private collection); the frontispiece to Paul Eluard's *Nuits Partagées*, 1935; *Landscape with Young Girl Jumping Rope*, 1936 (Museum Boijmans Van Beuningen, Rotterdam); *Suburbs of a Paranoiac-Critical Town: Afternoon on the Outskirts of European History*, 1936 (Museum Boijmans Van Beuningen, Rotterdam); *Telephone in a Dish with Three Grilled Sardines at the End of September*, 1939 (cat. no. 69); an illustration for the June 1, 1939, cover of *Vogue* magazine; and an etching for the deluxe edition of Lewis Carroll's *Alice's Adventures in Wonderland* (New York: Maecenas Press/Random House, 1969).

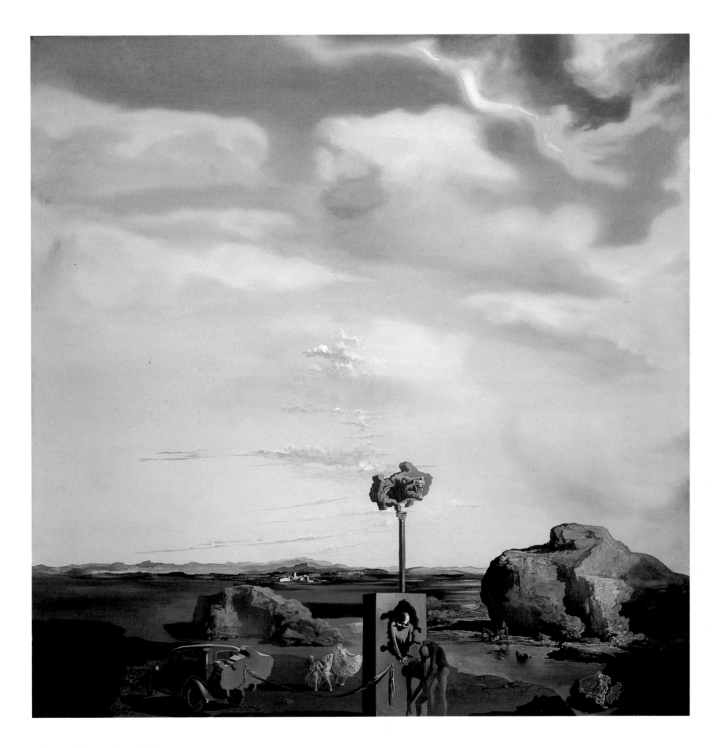

61. *Puzzle of Autumn*, 1935

Oil on canvas
38 1/2 × 38 1/2 inches

Exhibitions
New York 1936A
New York 1965
Fort Lauderdale 1997
Pittsburgh 1998
Shinjuku 1999

In a series of still-life paintings executed roughly between 1934 and 1936, Dalí explored the principle of figurative iteration as an extension of the paranoiac-critical method (see also cat. nos. 60 and 65). Establishing thematic analogies through the repetition of morphologically similar objects, Dalí opened the visual field to the play of multiple significations.

The title *Puzzle of Autumn* suggests a conundrum of sorts. On one level, it refers to the two jigsaw-like cutouts (an irregular object attached to the rear bumper of an antique car and its identical twin in the center of the composition from which a lion's head protrudes) that have been displaced from the rectangular box that rests on the foreground plane. On a deeper level, however, the title suggests the duplicity of vision and the treachery of the world of images through which the subject negotiates an uncertain path. Indeed, the form of the cutout reappears as an obsessive idea throughout the composition: in the ochre-colored "stain" among the clouds in the upper center of the composition, in the irregular formations of the rocks of Cap Creus in the middle ground, and, to the viewer's great surprise, in the contours of a group of bare-chested ballerinas to the left of the rectangular box.[1] As with Dalí's

"anthropomorphic landscapes" (see cat. no. 63), the displacement of objects from their literal ground is transformed at the structural level through the device of formal repetition into an inversion of figure/ground relationships *tout court*. Violating the system of Renaissance perspective in which discrete objects in space are carefully demarcated, Dalí envisions a new spatial regime in which figure collapses into ground and subject/object relations are radically decentered.

Dalí's spatial conceit, particularly his engagement with formal repetition and/or morphological analogy, has broad implications for an interpretation of the painting in relation to ego psychology. As with all his work, the landscape is geographically specific to Dalí's native region: the rocks of Cap Creus, the distant Pyrenees, and the vast open plane of the Empordà figure prominently in *Puzzle of Autumn* and invoke a much beloved and familiar environment.[2] The lion's head, in conjunction with the figure of the bureaucrat who emerges from the rectangular block and gestures toward an anguished woman in the foreground, likely represents the idea of the punishing super-ego, the mechanism of self-censorship.[3] In this light, the tiny figure contemplating his image in the reflection of an inlet beneath an enormous rock in the far-right middle-ground almost certainly alludes to the beautiful but self-deluded youth Narcissus, who, in the classical myth, is so enamored of his own reflection that he is ultimately consumed by it, in what David Lomas, quoting Julia Kristeva, describes as the "moment of

narcissistic perturbation."[4] If the narcissistic double, in Freud's reading, is a kind of "insurance against the destruction of the ego," Dalí's double falls under the shadow of the death drive, one of whose primary characteristics is the compulsion to repeat.[5] Faced with inauthenticity—the threat of the simulacrum, whose figurative principle in *Puzzle of Autumn* is morphological repetition—Dalí's Narcissus, locked in a frozen relation of proximity with his own inorganic reflection, is barred from achieving true self-knowledge.

———

Notes

1. The three ballerinas reappear in *Le Calme blanc* of 1936 (Museum Boijmans Van Beuningen, Rotterdam).

2. As in *The Font* of 1930 (cat. no. 36), the standing column is probably an oblique reference to the ruins of the ancient Greek settlement of Empúries, near the Bay of Roses.

3. On the symbolism of the bureaucrat in Dalí's work see cat. no. 38.

4. Julia Kristeva, *Powers of Horror: An Essay on Abjection*, trans. Leon S. Roudiez (New York: Columbia University Press, 1982), 14, as cited by David Lomas, "The Metamorphosis of Narcissus: Dalí's Self-Analysis," in *Salvador Dalí: A Mythology*, ed. Dawn Ades and Fiona Bradley, exh. cat., Tate Gallery, Liverpool, 1998, 78–100. The imagery in *Puzzle of Autumn* forms a kind of prelude to Dalí's

great painting of 1937 *Metamorphosis of Narcissus* (Tate Gallery, London) and an eponymous poem of the same year (*Metamorphose de Narcisse* [Paris: Editions surréalistes, 1937]).

5. Sigmund Freud, "The Uncanny" (1919), in *The Standard Edition of the Complete Psychological Works of Sigmund Freud*, translated from the German under the general editorship of James Strachey, in collaboration with Anna Freud (London: Hogarth Press and the Institute of Psycho-Analysis, 1953–1974). For a discussion of repetition in relation to the death drive, see Lomas, "Metamorphosis of Narcissus," 99.

62. *Paranonia*, 1935–36

Oil on canvas
15 × 18 1/2 inches

Exhibitions
Boston 1946
Cleveland 1947
Shinjuku 1999
Hartford 2000

Paranonia belongs to a series of "anthropomorphic landscapes" of the mid- to late 1930s in which Dalí explores the visual conceit of dual or multiple figurations — an image that, when viewed in a certain way, dissolves or coalesces to form a secondary or tertiary scene.[1] In an attempt to systematize confusion and emphasize the active character of paranoiac thought, Dalí challenges the viewer's visual mastery of form and opens the interpretative process to multiple and often conflicting significations. In *Paranonia*, the head of the woman/bust simultaneously configures a scene of horsemen in battle. When seen frontally, parallel to the viewer's plane of vision, the head and bust form a coherent gestalt, but when viewed in perspective, perpendicular to the plane of vision, the head dissolves into the battle scene and the woman

exists as a trace only, an unfulfilled presence. In this reading, the battle scene metaphorically stages a struggle for recognition that is literally enacted at the level of form — the struggle, as it were, to recognize and capture the elusive, phantom object of desire.

Dalí explores a similar conceit in *The Grand Paranoiac* of 1936 (Museum Boijmans Van Beuningen, Rotterdam), *Spain* of 1938 (Museum Boijmans Van Beuningen, Rotterdam), and *Enchanted Beach with Three Fluid Graces* of 1938 (cat. no. 67). Only the latter two paintings incorporate the battle scene, but all three works have a likely source in Leonardo's unfinished *Adoration of the Magi*, 1481 (Uffizi, Florence), from which the horsemen in battle and, in the case of *The Grand Paranoiac*, the technique of a brown oil wash, probably derive. Indeed, in a statement he prepared for the catalogue of his 1939 exhibition at the Julien Levy Gallery in New York, Dalí specifically invoked Leonardo's name in relation to the shifting boundaries of the figure/ground relationship in his anthropomorphic landscapes. "Leonardo da Vinci," he wrote,

proved an authentic innovator of paranoiac painting by recommending to his pupils that, for inspiration, in a certain frame of mind they regard the indefinite shapes of the spots of dampness and the cracks on the wall, that they might see immediately rise into view, out of the confused and the amorphous, the precise contours of the visceral tumult of an imaginary equestrian battle. Sigmund Freud, in analysing the famous invisible vulture (which appears in that strangest of all pictures, Leonardo's Virgin of the Rocks*) involuntarily laid the epistemological and philosophical cornerstone of the majestic edifice of imminent "paranoiac painting."*[2]

Reading Leonardo's recipe for visual inspiration through the grid of Freud's psychobiography of the artist's life and work, Dalí suggested that the motivation for and the meaning of his figuration was anything but arbitrary: "The 'paranoiac phenomenon' is consubstantial with the human phenomenon of sight."[3]

The theoretical roots of Dalí's obsession with multiple images can be traced to 1929. In one of his *Documentals*, short, cryptic texts about cultural life in Paris he published in the Barcelona daily *La Publicitat*, the artist makes brief mention of "one of the latest productions of René Magritte," a painted pipe with the inscription "Ceci n'est pas une pipe."[4] The calligrammatic structure of the word/image relationship in Magritte's celebrated painting of 1928, in which the inscription simultaneously reinforces and negates the hyperrealist image of a pipe that hovers above it, fascinated Dalí, particularly the way in which the Belgian artist played on the meaning of the word "ceci" (this). For as Michel Foucault observed years later, indexical shifters like "this" and "that," "me" and "you" are empty signs whose meaning, in linguistic terms, is entirely driven by context.[5] In the case of Magritte's painting, Foucault argued, "ceci" at once refers to the image of the pipe, to the remainder of the inscription ("n'est pas une pipe"), and to the compound image/text structure; in other words, it is "this" *and* "that," "here" *and* "there," both present *and* absent at the same time, like the unstable figuration of Dalí's multiple-image works. Indeed, had Foucault probed deeper in his analysis of Magritte's enigmatic painting, he might have recognized that the indeterminacy, or instability of the image/text relationship is an apt metaphor for the

structure of desire itself (a structure that is symbolically figured in the image of the pipe-as-phallus).

The issue at hand for Dalí, then, involves far more than a game of visual gymnastics. In effect, Dalí attempted to locate desire within the structure of painting itself, an extension, in his view, of the visual field *tout court*. Referring to *Sleeping Woman, Horse, and Lion* of 1930 (private collection, Paris), one of his earliest multiple-image paintings, Dalí announced that year:

Recently I have obtained, by a distinctly paranoiac process, an image of a woman, whose position, shadow, and morphology, without altering or deforming in the slightest its real appearance, help form at the same time the image of a horse. It should not be forgotten that attaining the appearance of a third image is merely a question of a more violent paranoiac intensity, and thus a fourth one, or thirty images. In that case, I would be curious to find out what it is that the image under consideration really represents, what is the truth; and, right away, doubts are raised in our minds regarding the question of whether the images of reality itself are not merely products of our own paranoiac capacity.[6]

The nascent paranoiac-critical method (see cat. no. 52) provided a means for Dalí to test his hypothesis that desire is always/already implicated in the structure of the visual field, and to reproduce that structure symbolically in painting while simultaneously exploring its latent content. As Dalí insisted in a famous surrealist tract:

I submit to a materialist analysis the type of mental crisis that might be provoked by such an image; I submit to it the far more complex problem of determining which of these images has the

highest potential for existence, once the intervention of desire is accepted; and also the more serious and general question whether a series of such representations accepts a limit, or, whether, as we have every reason to believe, such a limit does not exist, or exists merely as a function of each individual's paranoiac capacity.[7]

———

Notes

1. For a discussion, see Haim Finkelstein, "Salvador Dalí's Anthropomorphic Landscapes," *Pantheon* 46 (1988): 142–148.

2. Salvador Dalí, "Dalí, Dalí," statement in *Salvador Dalí*, exh. cat., Julien Levy Gallery, New York, March 21–April 17, 1939.

3. On Freud's essay, "Leonardo da Vinci and a Memory of His Childhood," see cat. no. 36.

4. Salvador Dalí, "Documental–Paris–1929," Part 4, *La Publicitat* (Barcelona), May 23, 1929, translated in *The Collected Writings of Salvador Dalí*, ed. Haim Finkelstein (Cambridge: Cambridge University Press, 1998), 111–114.

5. Michel Foucault, *Ceci n'est pas une pipe* (Montpellier: Fata Morgana, 1973).

6. Salvador Dalí, "Posició moral del surrealisme," *Hèlix* (Vilafranca del Penedès) 10 (March 22, 1930): 4–6, translated in Finkelstein, ed., *Collected Writings*, 221.

7. Salvador Dalí, "L'Ane pourri," in *La Femme visible* (Paris: Editions surréalistes, 1930), 11–12, translated in Haim Finkelstein, *Collected Writings*, 224.

63. *The Man with the Head of Blue Hortensias*, 1936

Oil on canvas
6 3/8 × 8 5/8 inches

Exhibitions
New York 1936B
New York 1965

Side by side with works characterized by a smooth, almost crystalline surface, Dalí produced paintings in which the brushwork is loose and the treatment of surface detail summary. The sketchy *Man with the Head of Blue Hortensias* belongs to a group of paintings in which Dalí exploited the *non-finito* of landscape and figural motifs to encourage the viewer's faculties of projection and free association (see also cat. no. 66). Dalí in effect sets this process in motion by establishing a double image in the form of a seated man in the lower right-hand corner whose head can alternately be read as bowed or upright (the cavity in the rock formation behind him forms the secondary image). In disturbing figure/ground relationships Dalí once again challenges the ocular and logocentric perspective of the viewer.

Reynolds Morse has suggested that Dalí was inspired by the nineteenth-century Catalan landscape painter Ramón Martí i Alsina, whose works were much admired by the Catalan bourgeoisie.[1] If this is the case—and it should be noted that the Italian Renaissance artist Bracelli has also been proposed as a source for Dalí's choppy, circular brushwork—the artist has transformed Martí i Alsina's sentimental regionalist vision into a disturbing paranoiac landscape.[2] Dalí's approach can only

be described as ironic, given the contempt he publicly expressed for Catalan regionalist painting of the so-called *Escola d'Olot* (a nineteenth-century Catalan interpretation of the French Barbizon school) in articles, manifestos, and theoretical tracts of the later 1920s.[3]

Notes

1. A. Reynolds Morse, *Salvador Dalí: A Panorama of His Art* (Cleveland: The Salvador Dalí Museum 1972), 163. Morse specifically cites Martí i Alsina's *Camí de Granollers* as a possible source.

2. On the possible influence of Bracelli and the Renaissance painter Magnasco, see James Thrall Soby, *Salvador Dalí* (New York: Museum of Modern Art, 1941), 22–23.

3. See, in particular, Dalí's denunciation of "painters of twisted trees" in the *Manifest groc* (Yellow manifesto) of March 1928 (Barcelona: Fills de F. Sabater). The leaflet was co-signed by Lluís Montanyà and Sebastià Gasch and was distributed in Barcelona.

64. *Three Young Surrealist Women Holding in Their Arms the Skins of an Orchestra,* 1936

Oil on canvas
21 3/4 × 25 5/8 inches

Exhibitions
New York 1936B
New York 1941A
New York 1965
New York 1997B
Pittsburg 1998
Hartford 2000

In *Three Young Surrealist Women* Dalí returns to the theme of soft matter as a metaphor for the dissolution of corporeal boundaries (see cat. nos. 55 and 56). The flaccid piano and violoncello are obvious symbols of detumescence at the hands of three Siren-like creatures who display their pathetic instruments like dead prey. A tuba, abandoned in the lower left-hand corner of the composition, alludes to the unfulfilled promise of phallic mastery. The predatory nature of the women, whose heads have been "castrated" and replaced by flowers, is patently evident, as signs of sexual activity are inscribed in the exaggerated contours of their voluptuous bodies and in the rosebuds that form the heads of the two figures to the right.[1] Not only is a morphology of desire thereby suggested in relation to sexual difference, but the abject returns as Dalí dissolves the boundaries between natural and man-made objects: the form of the soft piano mimics that of the rocks of Cap Creus in the background.

The sophisticated elegance of the three women also points to the growing impact of fashion design on Dalí's work. One of the artist's submissions to the May 1936 exhibition of the surrealist object at the Galerie Charles Ratton, Paris, was the infamous *Aphrodisiac Dinner Jacket* in which Dalí attached glasses of milk to the surface of a man's jacket, beneath which he layered a pair of women's bloomers and a bra. Dalí also designed hats in the form of shoes for his close friend the great couturier Elsa Schiaparelli in 1936 and would soon collaborate with Schiaparelli and Coco Chanel on the costumes for the ballet *Tristan Fou* (cat. no. 68). In his foray into the world of fashion Dalí followed in the footsteps of other surrealist artists, including Man Ray, who produced a number of photographs of women wearing suggestively phallic and vaginal hats for his 1933 series *Morphologies.* The significant difference between Dalí's practice and that of his peers, however, is that Dalí ultimately entered into a close working relationship with industry, producing all manner of "surrealistic" commodities from which he profited. Indeed, by 1936 Dalí had become a commodity himself, appearing on the December 14 cover of *Time* magazine in a photograph taken by Man Ray. For the June 1, 1939, issue of *Vogue* magazine, one of the premier fashion reviews of its day, Dalí returned to the image of a woman with a head of flowers, thereby drawing an explicit link between earlier paintings like *Three Young Surrealist Women* and his current work in fashion design.

Notes

1. On the rose as a symbol for female genitalia, see cat. no. 41. The conceit of a female figure whose hair or entire head is composed of flowers can be found in Dalí's work as early as 1932, in his *Portrait of the Vicomtesse Marie-Laure de Noailles* (private collection). The woman with a head of flowers also appears in related paintings of this period: *Woman with the Head of Roses,* 1935 (Kunsthaus Zürich, Zürich), in which a figure is extravagantly dressed in what might best be described as a surrealist costume; *The Dream Places a Hand on a Man's Shoulder,* 1936 (private collection), in which the female figure functions as a muse of sorts; and in *Necrophiliac Springtime,* 1936 (private collection). The image of a figure lifting a soft piano by the "skin" appears in *A Chemist Lifting with Extreme Precaution the Cuticle of a Grand Piano,* 1936 (private collection).

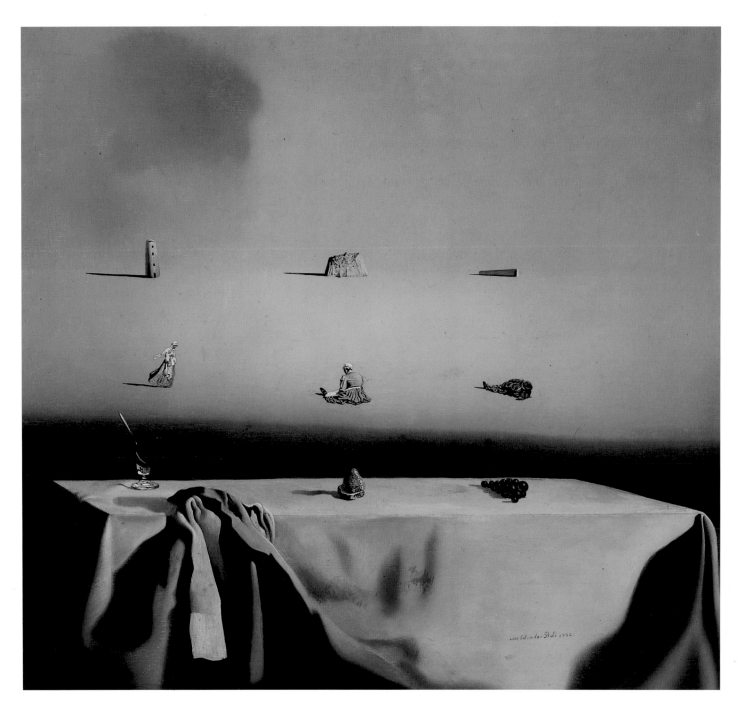

65. *Morphological Echo*, 1936

Oil on panel
12 × 13 inches

Exhibitions

London 1936?
San Francisco 1939
London 1951?

New York 1965
Atlanta 1996
New York 1999

In his most comprehensive statement about the mechanism of paranoia-criticism Dalí described paranoia as a

"delirium of interpretative association involving a systematic structure" in the 1935 tract *Conquest of the Irrational*.[1] The artist's evolving theory of paranoia paralleled ideas advanced by the young French psychiatrist Jacques Lacan, with

whom Dalí was in contact by 1933. In an important early text published in the same issue of *Minotaure* magazine in which Dalí's prologue to a book-length study of Millet's *Angelus* appeared (cat. no. 52), Lacan used the phrase "iterative identification of the

object" to characterize the symbolic expression of paranoiacs in relation to their complex system of associations: "[T]he delirium is found to be very rich in phantasms of cyclical repetition, ubiquitous multiplications, endless periodic recurrences of the same events, doubling, and tripling of the same persons and, occasionally, hallucinations of doubling of the subject's own self."[2] Adding a new level of complexity to his own work on the structure of doubling, Dalí, like Lacan, explored the systematic nature of paranoia as a problem in visual form.

In *Morphological Echo*, the paranoiac-critical mechanism engenders a series of substitutions in which the status of the signifier—the graphic mark or the written form of a word or image that acts as the physical container for a concept or meaning (the "signified" in linguistic terminology)—is fully activated. On a deep illusionistic stage, Dalí aligns nine objects in rows of three, mapping the coordinates of a precise grid. The regularity of this structure, which spreads across the picture's surface horizontally and vertically, reduces each object to a singular status and size. Reading the painting horizontally, each row corresponds to a particular classification of object: the glass, crust of bread, and bunch of grapes belong to the category "food" (the glass and spoon signifying consumption); the woman, nurse, and reclining figure of Lenin belong to the category "human"; and the tower, mountain, and wall correspond to the category "inanimate structures." Within each category the objects also respond to a consistent set of physical conditions, alternating in their axial placement from a vertical to a

horizontal orientation. Reading the painting vertically, we move between the three levels of classification in a consistent (systematic) order that threatens to reduce everything to sameness through morphological similitude and thereby destroy the complex play of oppositions through which meaning itself is engendered.

The objects, however, return to assert their presence. Defying the boundaries of their rigid container, the nine objects cast long shadows that serve to define their physical position in three-dimensional space. Once the spatial orientation of the individual objects is understood to be mediated by perspective, their apparent uniformity is canceled. Governed by the physical laws of spatial recession, the largest elements, relegated to the background, merely "appear" to be equal in size to the considerably smaller objects assembled on the foreground table, as the system of perspective furnishes rational "proof" of the concrete nature of the delirium. In this way, by exposing the arbitrary links that tie words and images to objects and concepts, Dalí articulates a primary condition of paranoiac-critical activity: the mobility of interpretation within the systematic order of language.

Dalí's novel approach to furnishing concrete visual proof of the paranoiac delirium, particularly his interest in the structure of language, has a likely source in the word/image paintings of his friend René Magritte. Dalí had certainly read the Belgian artist's picture essay "Les Mots et les images," which appeared in the December 15, 1929, issue of *La Révolution surréaliste*. Adapting Magritte's analysis of the arbitrary nature of the linguistic and

retinal sign to the problem of paranoiac interpretation, Dalí gave full reign to the empire of the signifier in the "Morphological Echo" series, foreshadowing Jacques Lacan's later work on paranoia in his third seminar of 1955–56.[3] If, however, Magritte provided Dalí with a philosophical and linguistic model for his ongoing research, Vermeer provided a formal source. The sculptural treatment of the table linen in *Morphological Echo*, which appears to generate figural associations of its own, owes more than a little to the tablecloth in Vermeer's *Mistress and Maid* of 1665–70 (The Frick Collection, New York).[4]

Notes

1. Salvador Dalí, *Conquest of the Irrational* (New York: Julien Levy Gallery, 1935), 15.

2. Jacques Lacan, "Le Problème du style et la conception psychiatrique des formes paranoïaques de l'expérience," *Minotaure* (Paris) 1 (June 1933): 68–69, as translated in Haim Finkelstein, *Salvador Dalí's Art and Writing, 1927–1942: The Metamorphoses of Narcissus* (Cambridge: Cambridge University Press, 1996), 197.

3. Jacques Lacan, *Séminaire de Jacques Lacan. Livre 3: Les Psychoses*, ed. Jacques-Alain Miller (Paris: Seuil, 1973).

4. A. Reynolds Morse, *Salvador Dalí: A Panorama of His Art* (Cleveland: The Salvador Dalí Museum, 1972), 164.

66. *Anthropomorphic Echo*, 1937

Oil on panel
5 5/8 × 20 3/8 inches

Exhibitions
New York 1965
Tallahassee 1999

The vast open plain of the Alt Empurdà, extending beyond the boundaries of Figueres to the snow-covered peaks of the Pyrenees, assumed an almost mythical status in Dalí's art and writings. Dalí identified the experience of his native landscape with the idea of

visual mastery, describing the physical world as a function of memory and the artist's probing gaze. In *The Secret Life* of 1942, he recounted his student days at the Marist Brothers' School in Figueres in terms that insist upon a structural approximation between memory and vision:

I shut my eyes and I turn my mind to my most distant memories in order to see the image that will appear to me most spontaneously, with the greatest visual vividness, in order to evoke it as the first

and inaugural image of my true remembrances. . . .

I see two cypresses, two large cypresses of almost equal height. The one on the left is the smaller, and its top leans slightly toward the one on the right, which is impressively vertical; I see these two cypresses through the window of classroom 1 of the Christian Brothers' School of Figueras.[1]

Describing the window as a "frame to my vision," Dalí establishes a series of symbolic associations between the act of looking, the

object of the gaze, and the persistence of memory in the organization of the visual field. In this way, Dalí suggests that visuality is a condition of the desiring subject whose shadow is projected across a fertile landscape of unconscious thoughts and memory fragments. That Dalí underscored the presence of two cypress trees in his autobiographical narrative is less a matter of *what* he actually saw than *how* he sees; in Lacanian, psychoanalytic terms, the phallic form of the cypress tree, a traditional

funerary symbol, is a metaphor for the condition of desire in relation to the division (or death) of the subject.

Anthropomorphic Echo implicates the occluded subject of desire in the landscape of Dalí's youth. From his classroom window at the Marist Brothers' School, Dalí could see the belfry of the Romanesque church of Saint Mary of Vilabertran a short distance from Figueres. Dalí's reminiscence of the belfry is in turn conflated with memories of the bell tower of the school his sister attended (see cat. no. 60). The form of the bell is strategically repeated in that of a bishop holding his crozier in the center foreground, and in the image of a girl holding aloft a jump rope in the far right foreground. By duplicating—echoing—formal elements, Dalí establishes a series of unlikely analogies that transform the landscape into the site of an erotic encounter. In addition to the bishop and the young girl, the protagonists of Dalí's dreamscape include St. George and the dragon—a nostalgic reference, perhaps, to the patron saint of Catalonia—the artist's childhood nurse, seated with her back turned to the viewer, and two enigmatic figures standing at the far left: a female muse pointing toward the action on the plain below, and a troll-like male figure dressed in a fancy costume that distantly echoes that worn by Johannes Vermeer in *The Art of Painting* of 1666–67 (Kunsthistorisches Museum, Vienna).

———

Notes

1. Salvador Dalí, *The Secret Life of Salvador Dalí* (New York: Dial Press, 1942), 63.

67. *Enchanted Beach with Three Fluid Graces*, 1938

Oil on canvas
25 5/8 × 32 inches

Exhibitions
Paris 1938
New York 1939
New York 1941A
Chicago 1941
Los Angeles 1941
Cleveland 1947
New York 1965
Fort Lauderdale 1997
Figueres 1999
Shinjuku 1999

Enchanted Beach with Three Fluid Graces belongs to Dalí's extended series of "anthropomorphic landscapes" of the mid- to late 1930s. It shares with *Paranonia*, 1935–36 (cat. no. 62), the visual conceit of a woman's face composed of figures and horsemen, and, with *The Man with the Head of Blue Hortensias*, 1936 (cat. no. 63), the configuration of a head composed of landscape elements: a boulder in the case of the figure to the left, and an open cavity in a rock formation in the case of the figure to the right. As Dalí continued to exploit the fluid passage between objects and ambient space, he increasingly resorted to a vocabulary of stock images and familiar visual puns.

The classical reference to the three Graces, symbols of ideal beauty, may be interpreted as an allegory of Dalí's assault on the Renaissance tradition of form, which locates a unitary subject at the origin of a rational spatial system. As Dalí collapses perspective and dismantles familiar figure/ground relationships, a different conception of the subject engenders the visual field: the mobile subject of desire whose precise coordinates cannot be mapped.

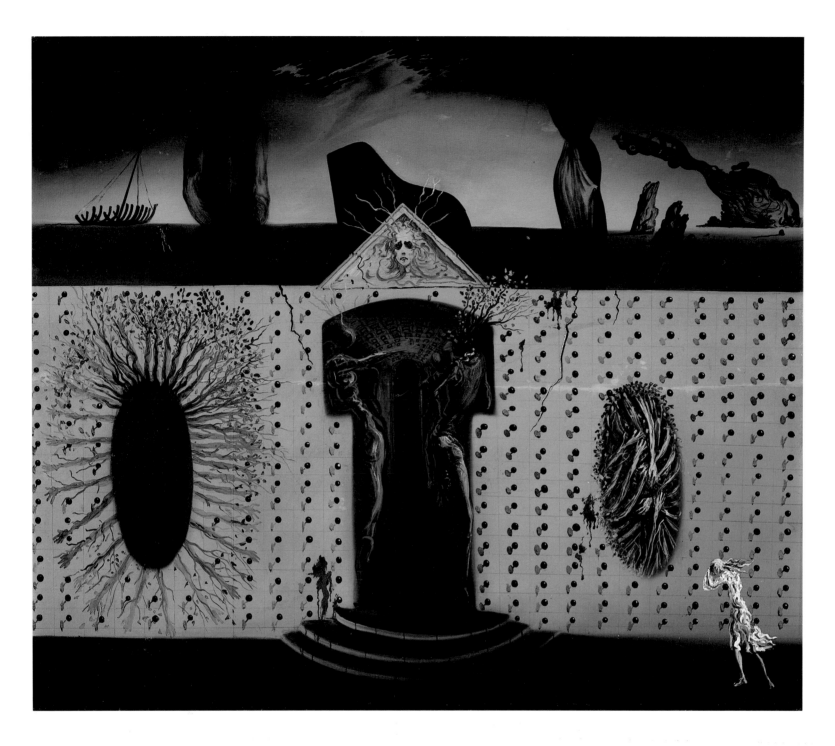

68. *Tristan Fou,* 1938–39

Oil on panel

18 × 21 5/8 inches

Exhibitions

New York 1939

New York 1945

New York 1965

In August 1937 Dalí signed a contract with Léonide Massine of the Ballet Russe de Monte-Carlo to produce a ballet entitled *Tristan Fou*, with costumes designed by the great couturier Elsa Schiaparelli. In so doing, Dalí claimed his place beside other noted artists who worked for the theater and ballet. Not only had Picasso and Léger executed important stage designs, but among the surrealists, Ernst and Miró had collaborated with the Ballets Russes' 1926 production of *Romeo and Juliet*, earning the censure of André Breton for their participation in bourgeois spectacular culture. When Miró collaborated with the Ballet Russe de Monte-Carlo on the 1932 production of *Jeux d'enfants*, Dalí expressed his disapproval in letters to the art critic Sebastià Gasch and the poet Josep-Vicenç Foix.[1] Five years later, as Dalí's relationship with Breton and the surrealists deteriorated, the artist seems to have reconsidered his once militant position.

Although the initial plans for *Tristan Fou* date to the summer of 1937, Dalí did not begin to work in earnest on the ballet for another year. While vacationing with Gala at Coco Chanel's villa in Roquebrune in the summer/autumn of 1938, Dalí maintained close contact with Massine and produced sketches and related paintings for the sets of what he called "The First Paranoiac Ballet." Chanel, Schiaparelli's arch rival, would now design the

costumes. At some point early in the planning stages, *Tristan Fou* was renamed *Venusburg* in reference to a key score from Wagner's *Tannhauser*, and was subsequently titled *Bacchanale*. Scheduled to open in Covent Garden, London, in September 1939, the ballet was postponed due to the outbreak of World War II. When the ballet finally premiered in New York City on November 9, 1939, it caused a *succès de scandale*, launching a successful American tour. Four years later, the Ballet International restaged *Tristan Fou* with sets in Dalí's new classicizing manner.[2]

Loosely based on the life of mad King Ludwig II of Bavaria, Wagner's patron and the founder of Bayreuth, *Tristan Fou* was part reality, part myth, and part fantasy. Dalí conflated a historical figure with an operatic one—Wagner's *Tannhauser*—indulging his speculations about Ludwig's madness in relation to his own erotic fantasies. The original set included an enormous swan with outstretched arms, its breast cavity forming an enclosure for a Venus figure, and topped by a classical pediment with a Medusa's head inscribed within its triangular frame. A related series of devices are present in the St. Petersburg oil, which represents what is probably an early conception for the set design. In place of the swan, Dalí has painted a keyhole flanked by two figures who guard access to a deep, barrel-vaulted space. The sexual, Freudian connotations of the keyhole, suggesting penetration, conjoin with the Venus imagery of the ballet to underscore the erotic subtext of Dalí's narrative. To the sides of the keyhole are two ovoid forms—one open, one closed—that relate to the Medusa

figure and suggest both spreading roots (they are, in fact, outstretched hands) and hairy, female genitals. Looming above the foreground structure are two ur-figures—a primal mother and father—that are derived from Dalí's *Angelus* paintings (see cat.53). In conjunction with the young girl dressed in virginal white in the lower right, the couple suggests an interpretation of the painting and, more broadly, the ballet, that hinges on the question of sexual difference and Oedipal guilt as the source of King Ludwig's hallucinations.

———

Notes

1. For a detailed account of the events surrounding Dalí's response to Miró's collaboration with the Ballet Russe de Monte-Carlo, see Rafael Santos i Torroella, *Salvador Dalí, corresponsal de J. V. Foix, 1932–1936* (Barcelona: Editorial Mediterrània, 1986).

2. For the full circumstances of Dalí's work on *Tristan Fou*, see Meredith Etherington-Smith, *The Persistence of Memory: A Biography of Dalí* (New York: Random House, 1995), and Ian Gibson, *The Shameful Life of Salvador Dalí* (London: Faber and Faber, 1997).

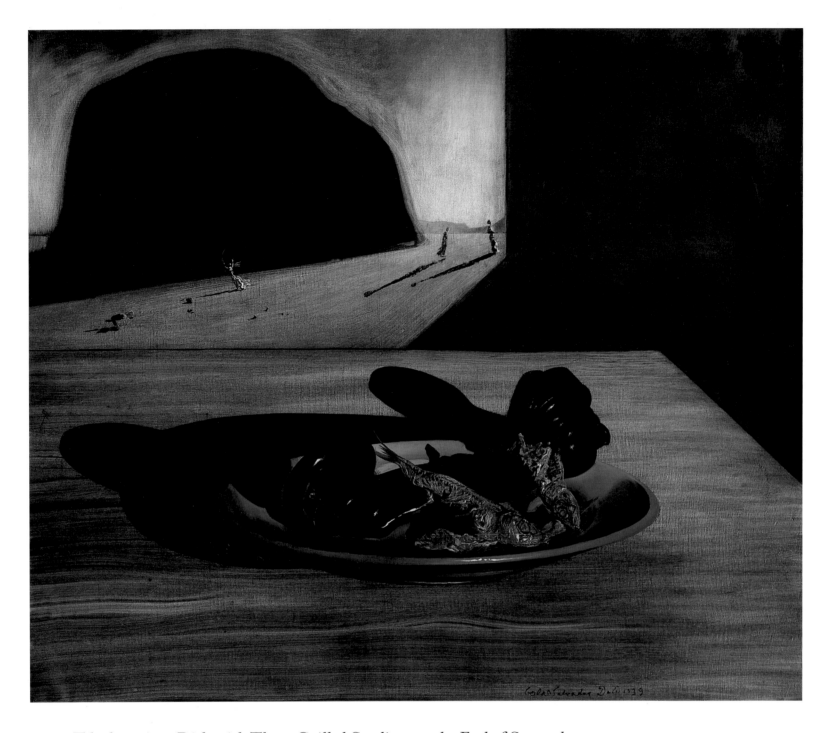

69. *Telephone in a Dish with Three Grilled Sardines at the End of September,* 1939

Oil on canvas

18 × 21 5/8 inches

Exhibitions

Paris 1939

New York 1965

New York 1997

Liverpool 1998

Figueres 1999

Shinjuku 1999

The strange boulder that appears in the background of *Enchanted Beach with Three Fluid Graces* reappears in *Telephone in a Dish with Three Grilled Sardines at the End of September* in the form of an enormous black silhouette set against a backlit sky. Several figures in the background — the familiar image of a young girl jumping rope and the archetypal couple from Millet's *Angelus* — animate an otherwise lifeless and foreboding environment characterized by strange dislocations of scale and perspective. In the foreground a telephone receiver and three sardines, at least one of which appears partially eaten, are served up on a disproportionately large plate.

The painting is related to a series of works in which the telephone receiver occupies a prominent position: *The Sublime Moment*, 1938 (Staatsgalerie Stuttgart, Stuttgart); *Beach with Telephone*, 1938 (Tate Gallery, London); *Imperial Violets*, 1938 (Museum of Modern Art, New York); *The Enigma of Hitler*, circa 1939 (Museo Nacional Centro de Arte Reina Sofía, Madrid); and *Landscape with Telephones on a Plate*, 1939 (Galería Theo, Madrid), the last of which bears the closest formal similarities with *Telephone in a Dish with Three Grilled Sardines*. The imagery relates to Dalí's preoccupation with the threat of world war in the autumn of 1938 and Neville Chamberlain's attempts to avert conflict at all costs by making concessions to Hitler. Chamberlain's phone calls to the German leader resulted in the ill-fated Munich Agreement of September 1938, which was annulled when Germany invaded Poland, and

Britain and France declared war on September 1, 1939. The signs of decay and failed hopes are patently visible in the form of the sardines and the pathetic receiver, which has been "cut off" from the body of the telephone box.

Dalí's sense of despair is significant in light of accusations by the surrealists that he had a morbid fascination with the figure of Adolf Hitler. As early as 1933 Dalí insisted that politics, including the Nazi question, become a subject of surrealist investigation in relation to the psychological implications of Fascism. Dalí's increasing interest in the Nazi phenomenon, and his defense of academic painting at a time when Hitler persecuted avant-garde artists, so disturbed Breton that he demanded in a letter dated January 23, 1934, that Dalí publicly declare his allegiance to the cause of the proletarian revolution. Dalí responded to Breton's accusations in a carefully scripted letter, insisting that the nature of German Fascism (and his own perverse fascination with the phenomenon) demanded investigation and that, in any event, his own work would surely be branded "entartete kunst" (decadent art) by the Nazis. When several days later Dalí defied the surrealist ban on participating in bourgeois exhibitions by showing *The Enigma of William Tell*, 1933 (Moderna Museet, Stockholm), at the Salon des Indépendants, a painting in which Dalí equated Tell with the grotesquely distorted figure of Lenin, Breton and other members of the surrealist group signed a resolution banning Dalí from the movement. The decision was reversed when Dalí convinced the

group to excuse his behavior, but his relations with Breton and other orthodox surrealists remained severely strained.[1]

Notes

1. An account of the events surrounding Dalí's Hitlerian imagery is given by Ian Gibson, *The Shameful Life of Salvador Dalí* (London: Faber and Faber, 1997), 320–324. For related documents, including Breton's and Dalí's letters, see José Pierre, "Dalí, Hitler, Lénine . . . et Breton," in *Salvador Dalí Rétrospective: 1920–1980*, exh. cat., Musée National d'Art Moderne, Centre Georges Pompidou, Paris, 1979, 134–138; and Karin Von Maur, "Breton et Dalí, à la lumière d'une corréspondance inédite," in *André Breton: La Beauté convulsive*, exh. cat., Musée National d'Art Moderne, Centre Georges Pompidou, Paris, 1991, 179–182.

Oil on canvas

19 5/8 × 25 5/8 inches

Exhibitions

Chicago 1941

Los Angeles 1941

New York 1941A

New York 1965

Painted during World War II while Dalí was in exile in America (see cat. no. 71), *Old Age, Adolescence, Infancy (The Three Ages)* represents a nostalgic return to origins from the perspective of a mature artist at the height of his career. At the time he executed this painting Dalí was working on his great autobiography, *The Secret Life of Salvador Dalí*, whose complex structure of historical anecdotes, true and false childhood memories, and oneiric passages modeled on Freudian dream narratives is given visual form in *The Three Ages*. The multiple image returns in the form of three heads that are configured from landscape and figural elements. Old age is represented on the left by the image of a bearded man whose face is formed by a rocky precipice seen through the opening in a ruined brick wall. For the central figure of adolescence Dalí returns to the image of the young child with his wet nurse, both of whom look across the Bay of Cadaqués to distant houses in the background. Finally, infancy is allegorized in the form of a smaller face whose mouth is comprised of an atavistic, secondary image of a woman mending a fishing net on the beach. As these images come in and out of focus through the push and pull of foreground and background elements, Dalí in effect stages the temporal experience of subjectivity: the persistence of memory.

The complexity of Dalí's formal conceit required considerable elaboration. A preliminary sketch for the painting, in the collection of the Salvador Dalí Museum, represents a slightly different structure: the contours of the three faces are formed by three arches of a loggia. The seated nurse from the back forms the mouth and nose of the figure (as in "adolescence" from *The Three Ages*), while the eyes are formed by the dark cavities of a second loggia visible through the foreground arches. In this way, Dalí not only works with the paranoiac figuration of double images, but he also returns to the theme of formal repetition that is put into play in the "morphological landscapes" of the mid-1930s (cat. nos. 60 and 65).

Dalí produced a number of multiple-image paintings before leaving for America. Of these, *Apparition of Face and Fruit Dish on a Beach*, 1938 (Wadsworth Atheneum, Hartford), and *The Endless Enigma*, 1938 (Museo Nacional Centro de Arte Reina Sofía, Madrid), are the most elaborate. But as Dalí's visual gymnastics evolved, his paintings became more contrived and mannered. In the catalogue for his 1939 show at the Julien Levy Gallery in New York (March 21–April 17), Dalí carefully diagrammed the presence of six distinct images in *The Endless Enigma*, which, despite the artist's best efforts, do not cohere into a unified *gestalt*. Indeed, a month later André Breton publicly dismissed Dalí's recent work, effectively excommunicating him from the surrealist movement. "Dalí's painting," Breton declared in *Minotaure* magazine, "is already being eroded by profound and absolute monotony. His determination to rarefy his paranoiac method still further has reduced him to concocting entertainments on the level of *crossword puzzles*."[1]

Notes

1. For a discussion of Breton and Dalí's deteriorating relationship, see cat. no. 69. More than the form of Dalí's art, Breton was disturbed by what he considered to be the artist's counterrevolutionary, reactionary politics.

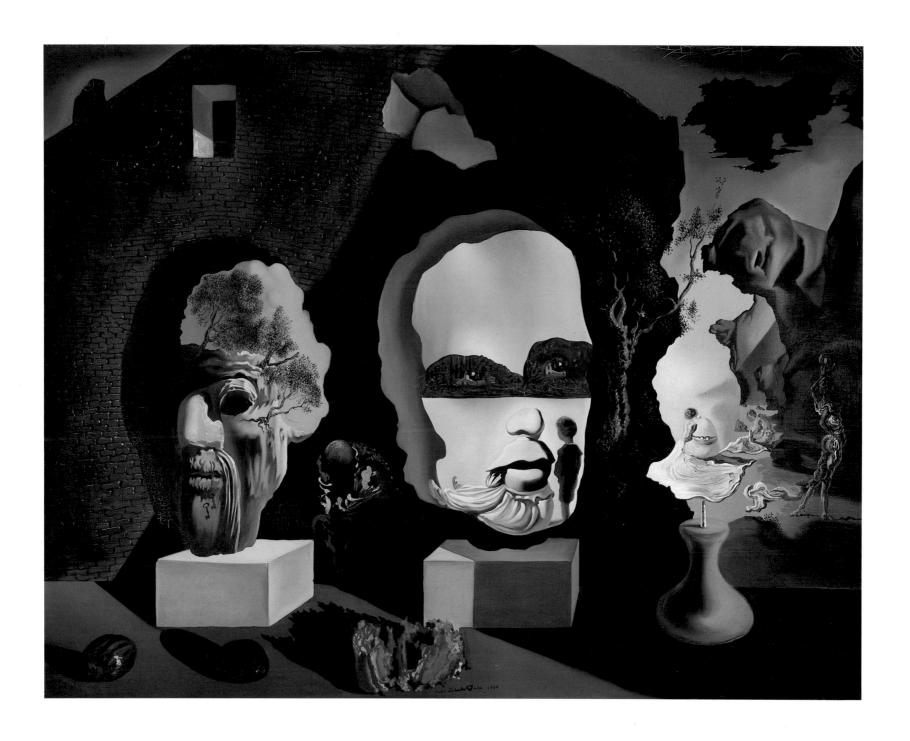

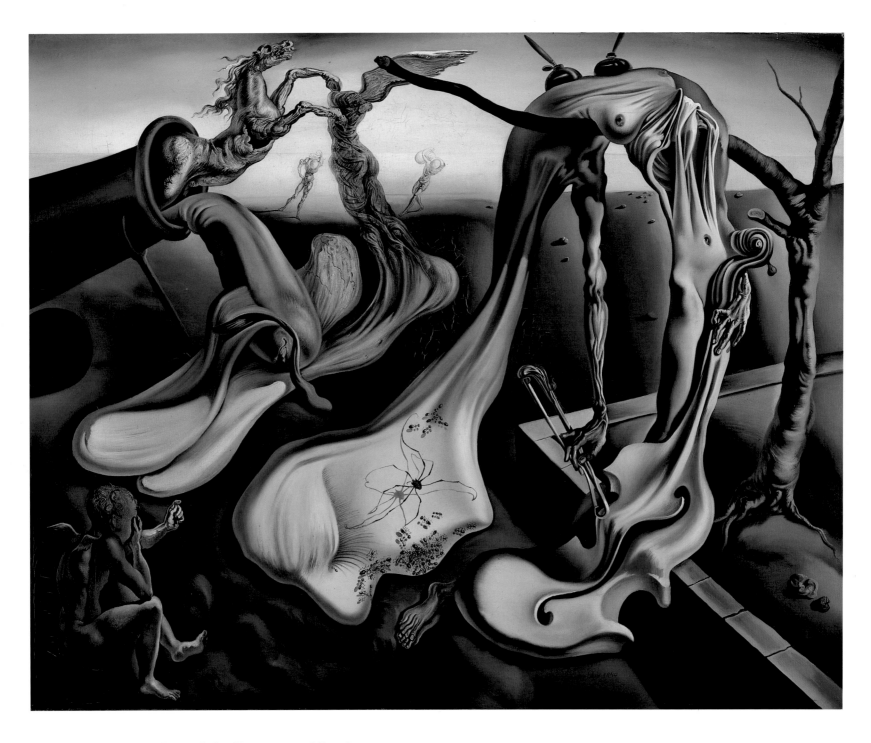

71. *Daddy Longlegs of the Evening—Hope!*, 1940

Oil on canvas
10 × 20 inches

Exhibitions
Chicago 1941
Los Angeles 1941
New York 1941B
New York 1943A
Cleveland 1947
Rome 1954
New York 1965

According to Ian Gibson, *Daddy Longlegs of the Evening—Hope!* was the first work Dalí painted in America.[1] With the fall of Paris to the Nazis in June 1940, Dalí traveled to Figueres to see his family, while Gala went to Lisbon to make arrangements for the couple's trip to America. Dalí and Gala arrived in New York on August 16, before continuing on to Hampton Manor, Caresse Crosby's estate in Virginia.

Dalí had been introduced to Caresse Crosby in the summer of 1932. The wealthy American expatriate, co-founder with her late husband of the Black Sun Press, hosted literary gatherings at her country home outside Paris that were attended by André Breton, René Crevel, D. H. Lawrence, and Hart Crane, among others. Crosby and Dalí soon developed a close friendship, and the socialite took it upon herself to promote Dalí's work. Crosby was instrumental in making Dalí a media sensation on the occasion of his first trip to New York in November 1934, and in introducing him to high-society patrons and collectors in Europe and America.

Dalí spent much of his time at Hampton Manor working on his memoirs and executing a few key paintings that mark the end of his work as a surrealist in the strict sense and his entry into the world of advertising, commercial cinema, and mass culture. *Daddy Longlegs of the Evening—Hope!* is a transitional work in this process, in which the artist expresses the unsettling, harrowing experience of war and exile. At the center of the painting is the distended, self-portrait head of the Great Masturbator, whose jaundiced skin is loose and flaccid. The head is attached to an equally soft and abject female figure who barely has the energy to hold, let alone play, a limp violoncello (an obvious sexual surrogate). Resting on the figure's back, just above the breasts, are two inkwells that probably refer to Dalí's father, a notary. In this case, however, Dalí's imagery refers less to phallic authority than it suggests a sense of loss and nostalgia for his homeland.[2] Presiding over this barren landscape punctuated by a lifeless tree whose limbs have been symbolically "castrated" is a small putto who covers his face. Once again, Dalí has adapted a familiar visual trope from his early psychoanalytic paintings—the gesture of the guilty son (see cat. nos. 35 and 36)—to a new social context. In this sense, one might say that Dalí has moved from the level of metaphor in his early work to that of allegory, in which his formative imagery has become a screen for the expression of a social rather than a psychoanalytic content. This idea is borne out in relation to the presence of motifs that specifically encode the subtext of global war: the spider, which represents good luck,[3] and the cannon from which a fantastic horse and a limp airplane emerge. Not only does the Pegasus-like horse inject a note of optimism into this scene of dissolution and decay, but the symbolic figure of Winged Victory herself—the *Nike of Samothrace* (Louvre, Paris)—extends like a spectral apparition from the soft remains of the airplane's wing.

———

Notes

1. Ian Gibson, *The Shameful Life of Salvador Dalí* (London: Faber and Faber, 1997), 410.

2. Dalí's soft vision, his image of dissolution in *Daddy Longlegs of the Evening—Hope!*, is related to a series of works in which he interpreted the Spanish Civil War as a kind of cannibal feast: *Soft Construction with Boiled Beans—Premonition of Civil War* (Philadelphia Museum of Art, Philadelphia) and *Autumn Cannibalism* (Tate Gallery, London), both of 1936.

3. According to A. Reynolds Morse, *Dalí: A Study of His Life and Work* (Greenwich, Conn.: New York Graphic Society, 1958), 51, in France a spider seen in evening represents good luck.

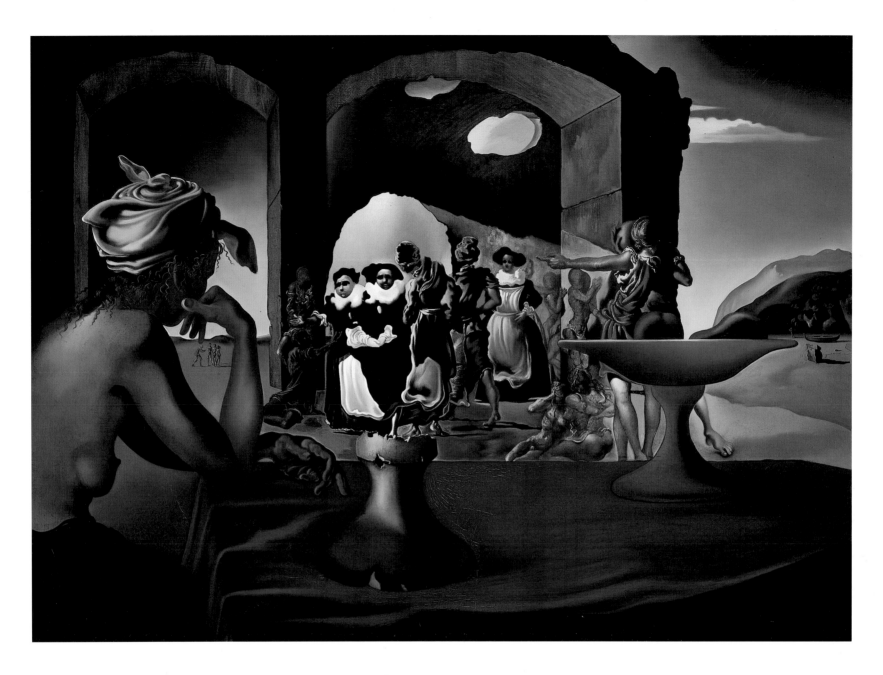

72. *Slave Market with the Disappearing Bust of Voltaire*, 1940

Oil on canvas
18 1/4 × 25 3/4 inches

Exhibitions
Chicago 1941
New York 1941B
Boston 1943
Rome 1954
New York 1965

Dalí painted two versions of *Slave Market with the Disappearing Bust of Voltaire* (see also cat. 73). The earlier painting (cat. no. 72) was executed in the village of Arachon, France, in 1940, prior to Dalí's departure for New York. The second, looser version was painted in the United States. In both canvases Dalí returns to the double image, achieving results that are far more convincing than the multiple-image paintings of 1938, with which they share certain details. The visual pun of a head or a bust that is also a fruit dish appears, for example, in *Apparition of Face and Fruit Dish on a Beach* of 1938 (Wadsworth Atheneum, Hartford). In *Slave Market with the Disappearing Bust of Voltaire* this formal conceit has been adapted to form two distinct images: the bust of Voltaire, whose face is formed by two standing women dressed in seventeenth-century Spanish costume, and a neighboring fruit dish, whose base visually rhymes with that of the statue.

Overseeing the tabletop still life in the earlier painting is Gala, the artist's muse. In a somewhat cryptic remark about the painting Dalí stated, "Through her patient love Gala protects me from the ironic and swarming world of slaves. Gala in my life destroys the image of Voltaire and every possible vestige of scepticism."[1] The figure of Voltaire, the great Enlightenment *philosophe* whose given name was François-Marie Arouet (1694–1778), towered over the world of philosophy and letters in eighteenth-century France. Often at odds with the prevailing social system—his famous *Lettres anglaises ou lettres philosophiques* were conceived as an attack on the institutions of church and state in France—Voltaire found favor at the court of Louis XV and was elected to the French Academy in 1746. Celebrated in his day, he was portrayed by the great sculptor Jean-Antoine Houdon on a number of occasions, including in a bust in the Victoria and Albert Museum, London, that was Dalí's visual source. Dalí may have seen the bust on his trip to London in July 1938 for an audience with Sigmund Freud, but it appears that the historical role played by Voltaire, particularly his advancement of a philosophical creed based on rational thought, was far more important to Dalí than his physical likeness was. In effect, Voltaire's work represents the antithesis of Dalí's project; the slavery to which the title of Dalí's painting alludes is epistemological in nature, as the artist attacks the very foundations of Enlightenment reason.

———

Notes
1. As quoted by Paul Moorhouse, *Dalí* (London: Bison Books, 1990).

73. *Disappearing Bust of Voltaire*, 1941

Oil on canvas
18 1/4 × 21 3/4 inches

Exhibitions
New York 1965
Fort Lauderdale 1997

Pittsburgh 1998
Shinjuku 1999
Hartford 2000

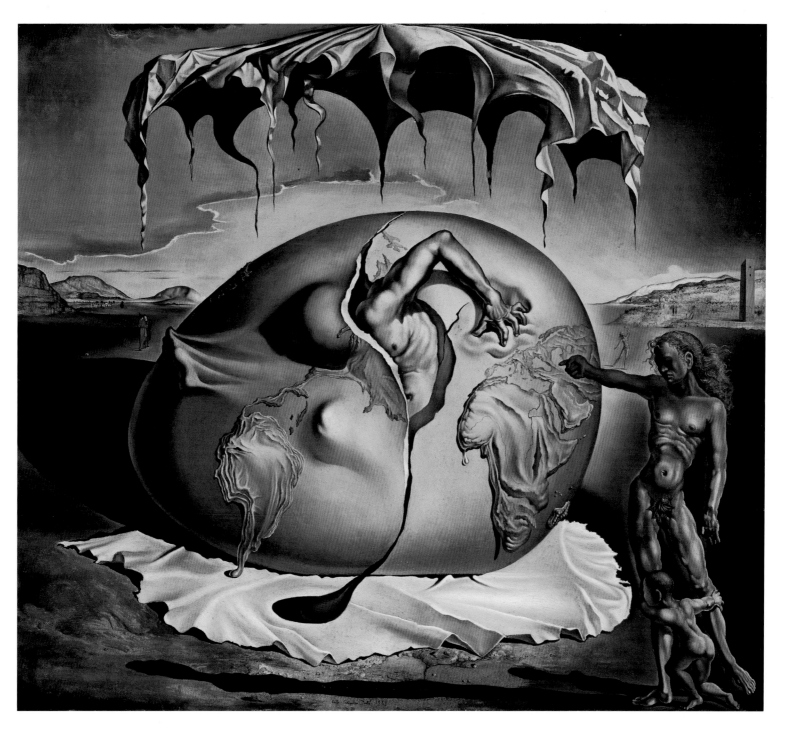

74. *Geopoliticus Child Watching the Birth of the New Man*, 1943

Oil on canvas

18 × 20 1/2 inches

Exhibitions

New York 1943B

Boston 1945

Boston 1946

Pittsburgh 1949

New York 1965

Shinjuku 1999

Geopoliticus Child Watching the Birth of the New Man is Dalí's paean to the emergence of a new postwar world order. Toward the end of *The Secret Life* Dalí allegorizes the Second World War as a cleansing ritual through which he will realize an apotheosis of the self:

To live! To liquidate half of life in order to live the other half enriched by experience, freed from the chains of the past. For this it was necessary for me to kill my past without pity or scruple, I had to rid myself of my own skin, that initial skin of my formless and revolutionary life during the Post-War Epoch. It was necessary at all costs that I change skins, that I trade this worn epidermis with which I have dressed, hidden, shown myself, struggled, fought and triumphed, for that other new skin, the flesh of my desire, of my imminent renaissance which

will be dated from the very morrow of the day this book appears.[1]

Eliding his personal history as a self-proclaimed artistic genius with the course of world politics, Dalí marks his exile in America as a watershed event in a wider process of global transformation.

As with *Daddy Longlegs of the Evening—Hope!*, 1940 (cat. no. 71), Dalí adapts images and narratives from his early psychoanalytic work to establish the symbolic terms of a contemporary allegory. Of particular interest is the image of the earth as an egg from which the new man hatches. The pliable skin of the shell relates to Dalí's long-standing interest in the dialectics of soft and hard matter, while the egg itself is linked symbolically with Dalí's fantasy of intrauterine memories (cat. no. 43).

That the new man is a surrogate for the artist himself is suggested by the fact that he emerges from the North American continent, Dalí's temporary home and the geopolitical site of the new world order.[2] To the right, an androgynous woman with a fig or acanthus leaf covering her genitals points to the egg as a curious but frightened child looks on with hesitation. Her gesture closely approximates that of a small male figure above her arm in the background. A note of trepidation and uncertainty is suggested by the tear that drips from the African continent, while a large drop of blood oozing from the broken eggshell is a likely reference to the carnage of war. Above the egg the placenta of the new nation hovers in a somewhat menacing fashion, while a mysterious couple wearing conical hats in the background

are oblivious to the momentous event unfolding before them.

———

Notes

1. Salvador Dalí, *The Secret Life of Salvador Dalí* (New York: Dial Press, 1942), 393.

2. A retouched photograph of Dalí curled in a fetal position inside an egg, taken by Philippe Halsman in 1942 and published in *The Secret Life*, confirms this reading. The egg also appears in *Poetry of America—The Cosmic Athletes*, 1943 (Fundació Gala–Salvador Dalí, Figueres). Other images related to Dalí's conception of the New World as the site of new artistic beginnings are found in *Nativity of a New World*, 1942 (private collection).

75. *Sentimental Colloquy*, 1944

Oil on canvas
10 3/4 × 16 1/8 inches

Exhibitions
Dayton 1945
New York 1946
New York 1965
Fort Lauderdale 1997
Rio de Janiero 1998
Shinjuku 1999

The diminutive size of *Sentimental Colloquy*, packed with detail and visual incident, belies its monumental scale. Dalí used the same design for the backdrop of the Ballet International's

production of the same title, which opened in New York on October 30, 1944, at the International Theatre. Based loosely on Paul Verlaine's eponymous poem, the ballet was set to the music of Paul Bowles and was choreographed by André Eglevesky. Dalí executed the decor and costumes.

As Dalí became increasingly involved in commercial endeavors, from advertising and product design to book illustrations and theatrical sets, he often recycled familiar, at times notorious, imagery from previous works. The protagonists of

both the set design and painting *Sentimental Colloquy*—the bicyclist and the piano—were brought together in a preparatory drawing entitled *Surrealist Gondola Above Burning Bicycles* (Fashion Concepts, New York) that Dalí executed in 1937 for a film project with the Marx Brothers. The cyclist made another notable appearance in a shadow box with glass panels (Minami Art Museum, Tokyo) that Dalí executed in 1932 in conjunction with his work on the scenario for a film entitled *Babaouo*. An indication of the deep, illusionistic space of that

object/painting, which Dalí was to realize in a more literal way in his theatrical work, is already present in *Illumined Pleasures* of 1929 (Museum of Modern Art, New York), in which the artist exploits the visual conceit of discrete spatial registers and frames within frames. Thus, an overriding visual intelligence joins Dalí's work in painting, sculpture, film, and theater as the artist adapts a recurring motif to different media.

Dalí's return to stock motifs also points to the persistence of symbolic associations in his work. The cyclist in *Sentimental Colloquy*

made an appearance in *Un Chien andalou*, as did the piano, which supports the carcasses of two rotting donkeys in Dalí and Buñuel's scandalous film of 1929. Prior to this, Dalí had used piano imagery in his illustrations for *El Libro de los putrefactos*, which parodied bourgeois culture and Spanish provincial customs.[1] Given these associations, the presence of the piano in the backdrop for *Sentimental Colloquy* is ironic, as Dalí appears to mock the seriousness of ballet as the cultural expression of an elite public. Indeed, Paul Bowles was disturbed by the incongruity of Dalí's imagery, Verlaine's pristine poetry, and his own score for the ballet:

There were men with yard-long beards riding bicycles at random across the stage, and there was a large mechanical tortoise encrusted with coloured lights. . . . The Marquess [de Cuevas] had assured me repeatedly that this ballet would have none of the usual Dalí capers; it was to be the essence of Verlaine, nothing more. I had been royally duped.[2]

Notes

1. See cat. nos. 27 and 31 for a full discussion of this project.

2. Paul Bowles, *Without Stopping* (London: Hamish Hamilton, 1972), 252, as cited by Ian Gibson, *The Shameful Life of Salvador Dalí* (London: Faber and Faber, 1997), 432.

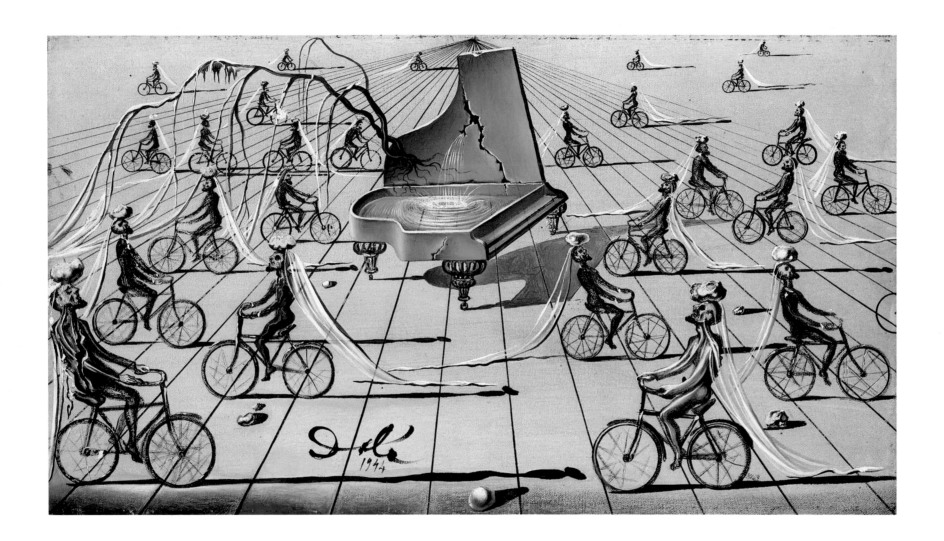

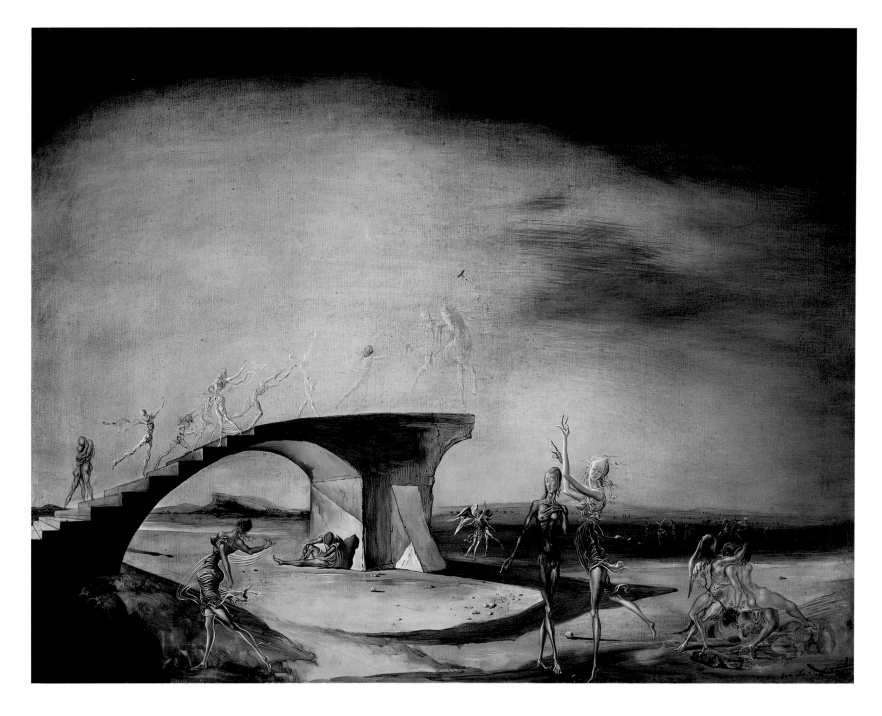

76. *The Broken Bridge and the Dream,* 1945

Oil on canvas
26 1/4 × 34 3/16 inches

Exhibitions
New York 1945B
Pittsburgh 1947

Indianapolis 1947
New York 1965
Shinjuku 1999

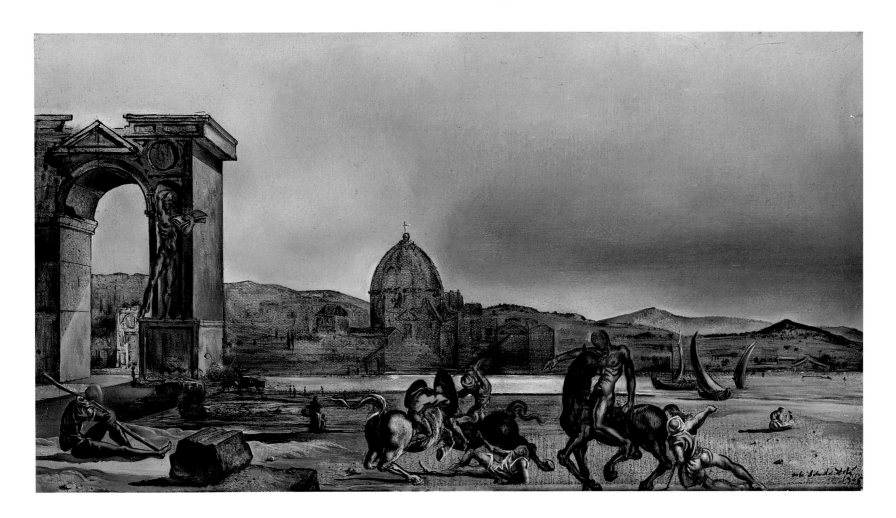

77. *Autumn Sonata,* 1945

Oil on canvas
6 1/2 × 12 inches

Exhibitions
New York 1945B
New York 1960

New York 1965
Fort Lauderdale 1997

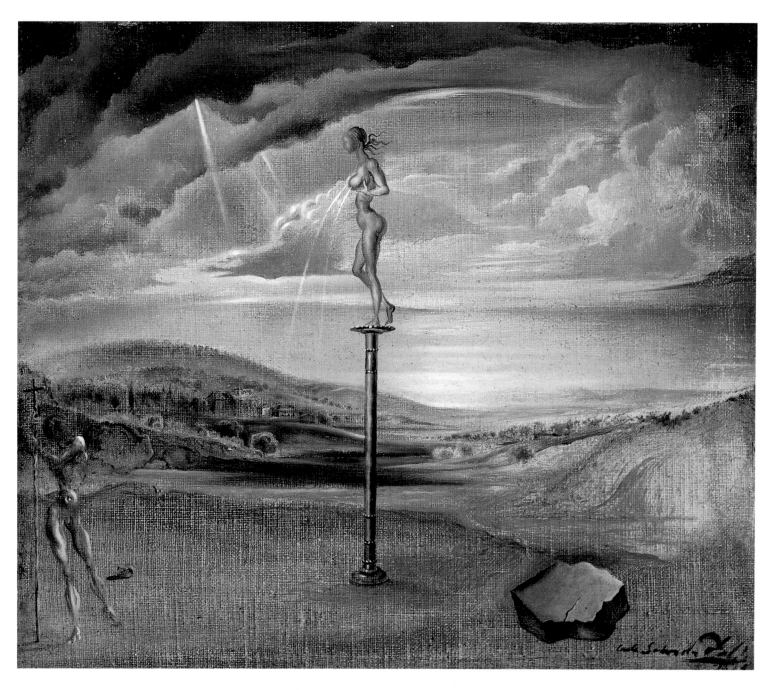

78. *Fountain of Milk Spreading Itself Uselessly on Three Shoes,* 1945

Oil on canvas
7 1/4 × 8 1/2 inches

Exhibitions
New York 1945B
Cleveland 1947
New York 1965

The change in the world order that Dalí announced in *The Secret Life* and imagined in *Geopoliticus Child Watching the Birth of the New Man* (cat. no. 74) paralleled a broad transformation in his subject matter. In his autobiography Dalí suggested that the modernist tradition, which he would increasingly attack in his art and writings, had collapsed of its own excessive weight. "It was dying," he declared, "of lack of rigor, lack of form; it was dying asphyxiated by the materialist scepticism of negativistic, nihilistic theories, of 'isms' of all kinds. It was dying of arbitrariness, indolence, gratuity, psychological orgy, moral irresponsibility and promiscuity, the dehierarchization, the uniformization of the socializing tendencies. It was dying of the monstrous error of specialization and analysis, of lack of synthesis, lack of cosmogony, lack of faith."[1] In Dalí's mind, the age of revolution and experimentation—aesthetic and social—had come to an end; a new era of order and rigor characterized by an abiding faith in normative values and classical measure would take its place. As the artist announced in a polemical statement he prepared for the catalogue of his April 1941 exhibition at the Julien Levy Gallery:

Dalí has found once more the means of remaining alone and totally removing himself from that crowd of followers and imitators which he sees multiplying too rapidly about him, and he does this with a gesture of absolute originality, indeed: during these chaotic times of confusion, of rout and of growing demoralization, when the warmed over vermicelli of romanticism serves as daily food for the sordid dreams of all the gutter rats of art and literature, Dalí himself, I repeat, finds the unique attitude towards his destiny: TO BECOME CLASSIC! As if he has said to himself: "Now or never."[2]

Classical motifs had, in fact, entered Dalí's work in 1937 and 1938, when the artist sojourned in Italy. Dalí's new emphasis on the values of order, hierarchy, and synthesis is, however, characteristic of his postwar production, during which time his creative energies were divided between painting and a range of commercial endeavors, including book illustration, advertising projects, costume and set design, and film. Indeed, not only did Dalí produce designs for a new production of *Tristan Fou* in his classicizing manner (see cat. no. 68), but several of the loose, panoramic landscapes he executed at this time, including cat. nos. 76, 77, and 78, have the effect of stage sets. *The Broken Bridge and the Dream* and *Autumn Sonata* (cat. nos. 76 and 77) are particularly "theatrical," as the figures are not so much integrated with their surroundings as they appear to perform before an elaborate backdrop of classical ruins and architectural props.

Typical of his postwar production Dalí has once again borrowed stock motifs from early surrealist paintings.

The arched stairway in *The Broken Bridge and the Dream* recalls the imagery of steep stairs that functioned as a Freudian allusion to sexual intercourse in *The First Days of Spring* and *La Main (Les Remords de conscience)* (cat. nos. 34 and 37). It would, however, be incorrect to dismiss these later landscapes as hackneyed copies or pastiches of Dalí's early work, an accusation that has often been made. The fact that one is invited to read Dalí's later imagery through a familiar lexicon of symbols and narrative situations suggests, rather, that these paintings function at the level of allegory. This hypothesis is in part confirmed by the presence of related imagery in other works of this period with a patently allegorical character. Just as the whimsical female figures who dance about in *The Broken Bridge and the Dream* reappear in *Untitled—Scene with Marine Allegory* (private collection) and the richly allegorical *Melancholy, Atomic, Uranic Idyll* of 1945 (Museo Nacional Centro de Arte Reina Sofía, Madrid), the curious chunk of rock that seems so out of place in the foreground of *Fountain of Milk Spreading Itself Uselessly on Three Shoes* reappears in the form of a lapidary inscription on a classical ruin in *Apotheosis of Homer* of 1944–45 (Staatsgalerie Moderner Kunst, Munich).

———

Notes

1. Salvador Dalí, *The Secret Life of Salvador Dalí* (New York: Dial Press, 1942), 395.

2. Felipe Jacinto (Salvador Dalí), "The Last Scandal of Salvador Dalí," *Salvador Dalí*, exh. cat., Julien Levy Gallery, New York, April 22–May 20, 1941. The text is reprinted in *The Collected Writings of Salvador Dalí*, ed. Haim Finkelstein (Cambridge: Cambridge University Press, 1998), 336–339.

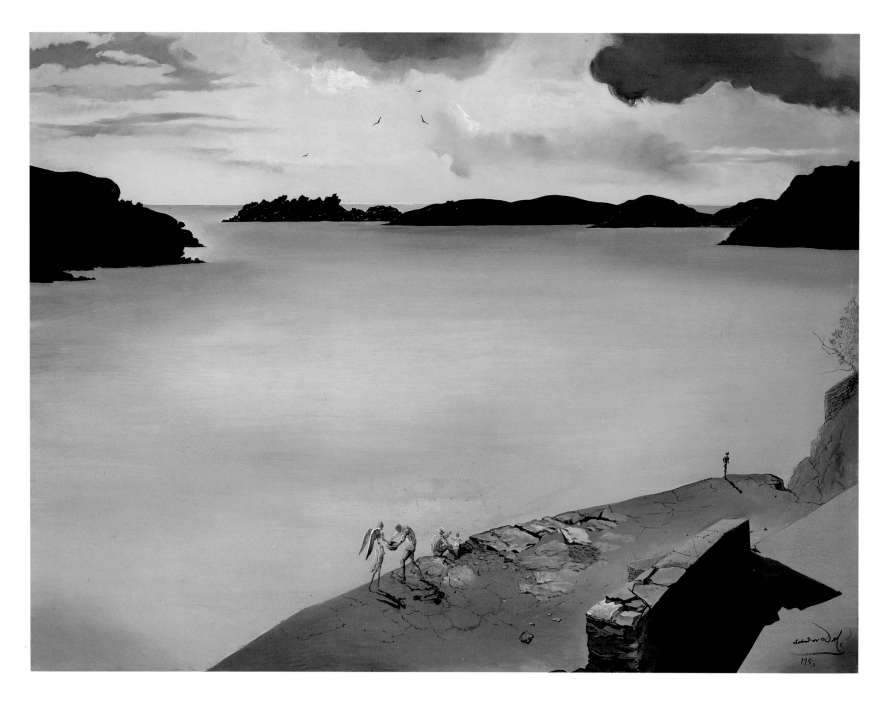

79. *Landscape of Port Lligat, 1950*

Oil on canvas

23 × 31 inches

Exhibitions
Santa Barbara 1953
Rome 1954
New York 1965
Fort Lauderdale 1997

Pittsburgh 1998
Shinjuku 1999

"I am home only here; elsewhere I am camping out," Dalí wrote of Port Lligat in his autobiographical tract, *The Unspeakable Confessions of Salvador Dalí.*[1] Upon their return to Europe in

1948, Dalí and Gala divided their time between Paris and Port Lligat, the tiny village over the mountain from Cadaqués where Dalí had bought a small fisherman's house in 1930. Initially the artist's summer retreat, over the years Dalí added to the house and established himself as

the most illustrious member of this primitive community untouched by the modern world.

Landscape of Port Lligat is one of several paintings Dalí executed in the years 1950–52 (see cat. no. 80) in which extraordinary events occur in a landscape otherwise characterized by a

scrupulous empiricism. Dalí lyrically described the austere beauty of the site in *The Secret Life:*

Port Lligat is one of the most arid, mineral and planetary spots on the earth. The mornings are of a savage and bitter, ferociously analytical and structural gaiety; the evenings often become morbidly melancholy, and the olive trees, bright and animated in the morning, are meta-morphosed into motionless gray, like lead. The morning breeze writes smiles of joyous little waves on its waters; in the evening very often, because of the offshore islands that make of Port Lligat a kind of lake, the water becomes so calm that it mirrors the dramas of the early twilight sky.[2]

The text closely corresponds with the scene depicted in *Landscape of Port Lligat*, with the exception of the tiny angel in the foreground, whose discreet presence among the villagers transforms the artist's sober vision of the natural environment into an expression of mystical communion.

Notes

1. Salvador Dalí, *The Unspeakable Confessions of Salvador Dalí (as Told to André Parinaud)* (London: Quartet Books, 1977), 131.

2. Salvador Dalí, *The Secret Life of Salvador Dalí* (New York: Dial Press, 1942), 268.

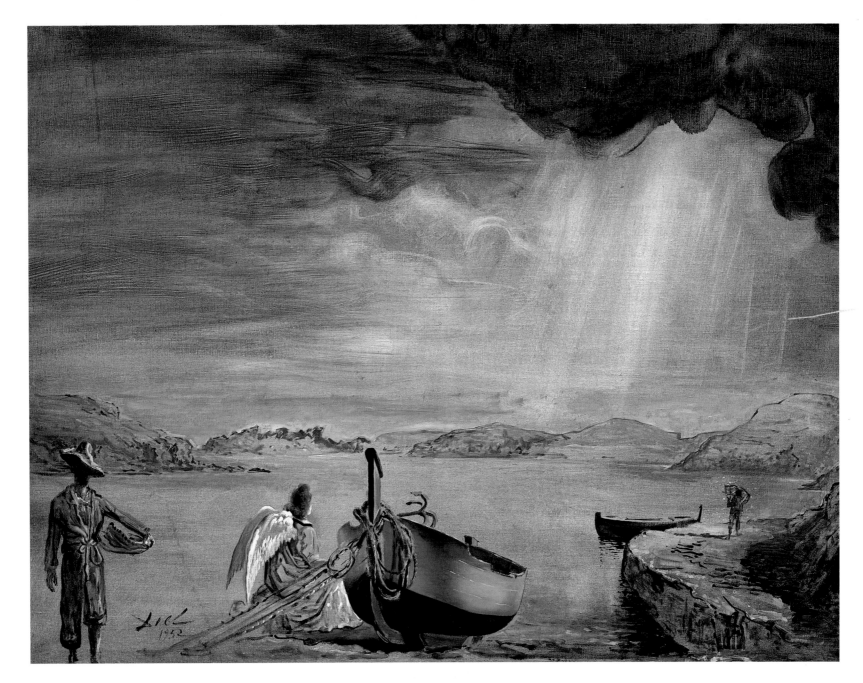

80. *The Angel of Port Lligat,* 1952

Oil on canvas
23 × 30 3/4 inches

Exhibitions
New York 1952
Rome 1954
Knokke Le Zoute 1956
New York 1965
Fort Lauderdale 1997
Rio de Janeiro 1998

Dalí painted two versions of *The Angel of Port Lligat* in 1952. The second version, in a private collection, is far more worked up in the manner of *Landscape of Port Lligat* (cat. no. 79). There are also notable differences in iconography: subsidiary figures are absent from the second version, while the angel's coiffure in cat. no. 80 identifies the figure as Gala.

Almost from the moment he met her, Dalí created an elaborate mythology around the figure of Gala, whom he imagined as both his artistic muse and the mysterious child-woman (see cat. no. 41). Following his return to Port Lligat in 1948, Dalí added Madonna and divine messenger to this cast of symbolic characters. In two well-known paintings of 1949 and 1950 entitled *The Madonna of Port Lligat* (Haggerty Museum of Art, Marquette University, Milwaukee; and private collection, respectively), a statuesque Gala in the pose of a Raphaelesque Madonna is enthroned on an elaborate altar, her hands clasped in prayer with the infant Jesus on her lap. Characteristic of Dalí's transformation of his native landscape into a site of a divine communion, Gala appears to float above the sea and the terraced hills of Port Lligat. Dalí employed a similar conceit in his great *Christ of St. John of the Cross* of 1951 (Glascow Art

Gallery, Glascow), in which a radically foreshortened Christ hovers over the bay of Port Lligat, the foot of his cross directly aligned with a small fishing boat on the shore (the same vessel appears in *The Angel of Port Lligat*). Evoking Port Lligat as the site of a mystical communion among himself, God, and nature, Dalí wrote in *The Secret Life:*

Port Lligat: a life of asceticism, of isolation. It was there that I learned to impoverish myself, to limit and file down my thinking in order that it might become effective as an ax, where blood had the taste of blood, and honey the taste of honey. A life that was hard, without metaphor or wine, a life with the light of eternity. The lucubrations of Paris, the lights of the city, and of the jewels of the Rue de la Paix, could not resist this other light—total, centuries-old, poor, serene and fearless as the concise brow of Minerva. At the end of two months at Port Lligat I saw rising day after day before my mind the perennial solidity of the architectural constructions of Catholicism. And as we remained alone—Gala and I, the landscape and our souls—the ancient brows of the Minervas came more and more to resemble those of the Madonnas of Raphael, bathed in a light of oval silk.[1]

Dalí conceived his religious paintings as an expression of his return to Catholicism, an attitude that, in Franco's Spain, was politically suspect in the eyes of leftist intellectuals as a gesture of compliance with the regime. The question of Dalí's changing political and social sympathies is, however, complex, given the artist's early support for anarchist and Communist causes. There is no question that Dalí opportunistically exploited his return

to Catholicism as a means to win favor in official circles. On November 23, 1949, he presented the first version of *The Madonna of Port Lligat* to Pope Pius XII in a much publicized gesture of obedience to the Church. But it is also true that Dalí had become deeply disillusioned with the ideological politics of the 1930s and the often embattled, if not outwardly compromised, position of the radical Left. The fact that he had been censored by André Breton on several occasions for his Hitlerian imagery and his use of academic painting techniques (see cat. no. 69) surely embittered Dalí, who was in a position to question surrealism's much publicized commitment to the freedom of thought. Still, Dalí had options, and might well have retreated from the political arena entirely. However opportunistic his return to religion was, it surely did not resonate as an empty gesture in the context of postwar repression in his homeland. Indeed, in a footnote to his discussion of Dalí's work in the 1950 edition of *Anthology of Black Humour*, André Breton expressed his outrage over Dalí's meeting with Pius XII: "It goes without saying that the present account only applies to the first Dalí, who disappeared towards 1935 to give way to the personality better known as Avida Dollars, a painter of society portraits who has recently embraced the Catholic faith and 'the artistic ideal of the Renaissance', and who now benefits from the felicitations and encouragement of the pope."[2]

———
Notes
1. Salvador Dalí, *The Secret Life of Salvador Dalí* (New York: Dial Press, 1942), 302.

2. André Breton, *Anthologie de l'humour noir* (Paris: Editions de Sagittaire, 1950), translated in Ian Gibson, *The Secret Life of Salvador Dalí* (London: Faber and Faber, 1997), 453.

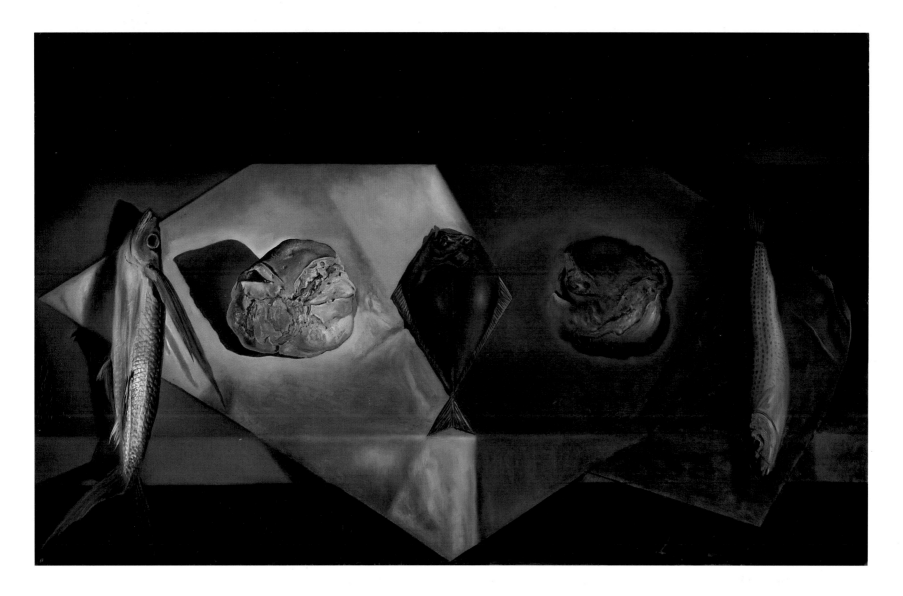

81. *Eucharistic Still Life (Nature Morte Evangélique)*, 1952

Oil on canvas
21 1/2 × 34 1/4 inches

Exhibitions
New York 1965
Fort Lauderdale 1997
Shinjuku 1999
Hartford 2000

"The two most subversive things that can happen to an ex-Surrealist in 1951," Dalí stated in his "Mystical Manifesto" of the same year, "are, first, to become a mystic; and second,

to know how to draw."[1] Dalí's self-styled spiritual "conversion" carried numerous implications for his postwar work. With Renaissance aesthetics as his guide—the artist waxed lyrical about Bramante's Tempietto de San Pietro in Montorio and Juan de Herrera's austere Escorial palace outside Madrid—Dalí launched a full-scale attack on the modernist tradition: its skepticism, positivism, progressivism, rationalism, and materialism. As he argued in the "Mystical Manifesto":

[I]n aesthetics it is up to the mystics and only they to resolve the new "golden sections" of the soul of our time; if a powerful Renaissance of mystical painting has not yet begun, it is due to the fact that the artists, this time very late in relation to today's scientific progress, still vegetate in the abominable pastures of the last consequences of the most sordid materialism, it is because they have nothing to paint, that today's artists paint nothing, in other words, what is non-figurative, non-objective, non-expressive, non-non-no no no no no no. NO![2]

Eucharistic Still Life is one of several paintings in which Dalí adapted the Golden Section, an age-old system of proportions based on the ideal human form, to the problems of the modern still life. Ironically, Dalí had singled out for criticism what he termed the "Sticky and retarded Kantians of scatological *sections d'or*" in his 1935 treatise *Conquest of the Irrational*, referring to painters like Albert Gleizes and Jean Metzinger who transformed the cubism of Picasso and Braque into a

precise geometrical system.[3] Rejecting the nonfigurative uses to which that system was ultimately put in the work of abstract artists of the 1930s, Dalí proposed returning the Golden Section to its mystical origins. In *Eucharistic Still Life* Dalí effects this transformation at both the structural and iconographic levels. The three fish and two loaves of bread—staples of life in Port Lligat that are symbolically "transubstantiated" into traditional icons of Christian salvation—are methodically and evenly spaced across the expanse of a wide table whose top is tilted forward. Dalí's unsparing realism, with sources in his early work (cat. no. 25) and the still-life paintings of Francisco de Zurbarán, belies his precise geometrical structure: the fish in the center establishes an elaborate play of orthogonal angles that are systematically repeated throughout the composition. In this way Dalí endows the most prosaic elements of the physical world with a mystical aura, transforming the spectacle of nature into a symbolic expression of universal order.

Notes

1. Salvador Dalí, "Manifeste mystique" (Paris: Robert J. Godet, 1951), translated in *The Collected Writings of Salvador Dalí*, ed. Haim Finkelstein (Cambridge: Cambridge University Press, 1998), 363–366.

2. Dalí, "Manifeste mystique," in Finkelstein, *Collected Writings*, 365.

3. Salvador Dalí, *Conquest of the Irrational* (New York: Julien Levy Gallery, 1935), 19.

82. *The Disintegration of the Persistence of Memory*, 1952–54

Oil on canvas
10 × 13 inches

Exhibition
New York 1952

On October 19, 1950, Dalí delivered his second talk at the Ateneu Barcelonès, where he had lectured twenty years earlier on "The Moral Position of Surrealism." "Why I Was Sacrilegious, Why I Am a Mystic," the title of Dalí's talk, was a retrospective consideration of the artist's life and work before and after his conversion to Catholicism. Among Dalí's themes were a new emphasis on Renaissance optics in relation to the Spanish tradition of realism and mysticism (the ecstasy of Saint John of the Cross and Saint Theresa of Avila); the idea that science and modern physics confirmed the existence of God; and an unapologetic return to time-honored classics: the work of Heraclitus, Pythagoras, and Vitruvius. A version of the Ateneu lecture was published in French and Latin in April 1951 as the "Mystical Manifesto," in which Dalí attempted to align modern science and mathematics (nuclear physics and quantum theory) with metaphysics and religious faith. Dalí argued:

Ever since the theory of relativity substituted the substratum of the universe for the ether, thus dethroning and reducing time back to its relative role, which Heraclitus already assigned it when he said that "time is a child," and Dalí too when he painted his famous "soft watches," ever since that unknown and delirious substance seemed to fill the whole universe; since the explosive equivalence of mass-energy— all those who think, apart from the Marxist inertia, know that it is up to the metaphysicians to work precisely on the question of matter.[1]

Seven years later Dalí again drew an explicit parallel between his new work and modern science, invoking the name of Werner Karl Heisenberg (1901–76), the great German physicist and architect of quantum theory, as his new role model: "In the surrealist period I wanted to create the iconography of the interior world —the world of the marvelous, of my father Freud. I succeeded in doing it.

"Today the exterior world—that of physics—has transcended the one of psychology. My father today is Dr. Heisenberg."[2]

There is no question that Dalí's understanding of the new physics was both rudimentary and opportunistic. It allowed him to drive a wedge between his current work and his former production as a surrealist. Indeed, in *The Disintegration of the Persistence of Memory* of 1952–54 Dalí has dismantled his earlier surrealist masterpiece at the figurative level, pulling back the skin of the distant seascape to reveal a new structure that is meant to visualize quantum mechanics. An elaborate perspectival grid of rectangular blocks—the meticulous work of Dalí's studio assistant, Emilio Puignau— represents the disintegration and reintegration of matter in relation to the space/time continuum, while the limp watches persist as a reminder of Dalí's earlier conception of the temporal dimension as the expression of desire and the drives. As with his allegorical landscapes of the early 1940s (cat. nos. 70, 71, and 74), Dalí again comes full circle, rewriting his history as an artist in relation to a highly idiosyncratic conception of pseudoscience.

Notes

1. Salvador Dalí, "Manifeste mystique" (Paris: Robert J. Godet, 1951), translated in *The Collected*

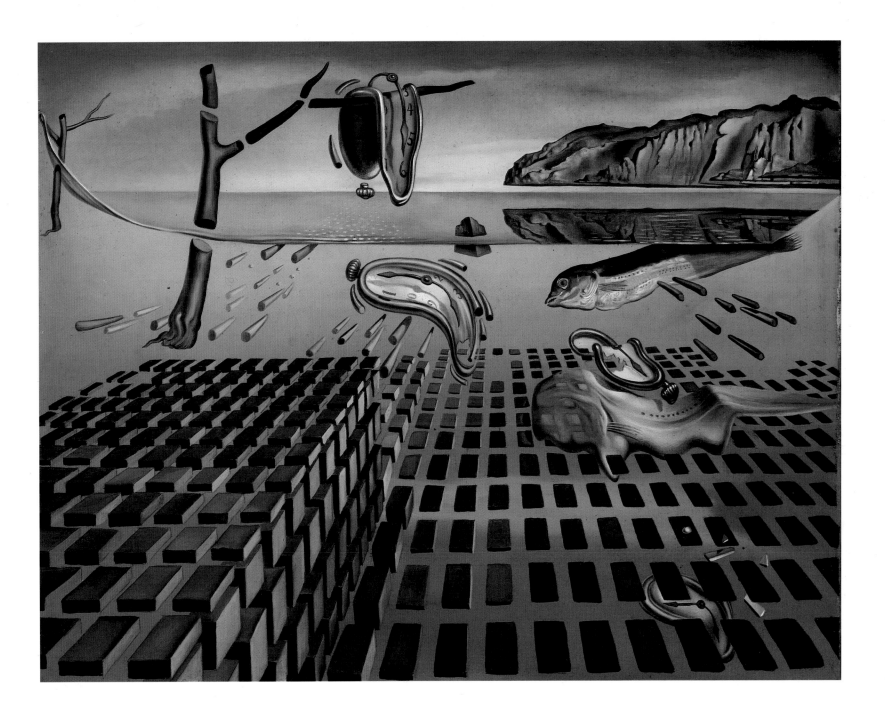

Writings of Salvador Dalí, ed. Haim Finkelstein (Cambridge: Cambridge University Press, 1998), 363–366.

2. Salvador Dalí, "Anti-Matter Manifesto," artist's statement in *Salvador Dalí*, exh. cat., Carstairs Gallery, New York, December 1958–January 1959; reprinted in *The Collected Writings of Salvador Dalí*, ed. Haim Finkelstein (Cambridge: Cambridge University Press, 1998), 366–367.

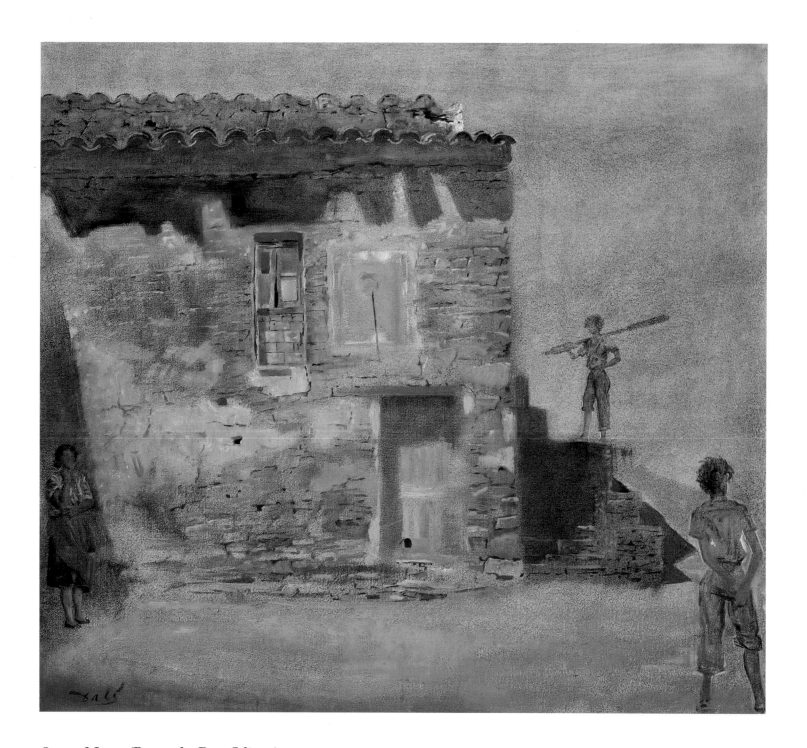

83. *Noon (Barracks Port Lligat)*, 1954

Oil on canvas
14 3/4 × 16 5/8 inches

Exhibitions
New York 1965
Fort Lauderdale 1997

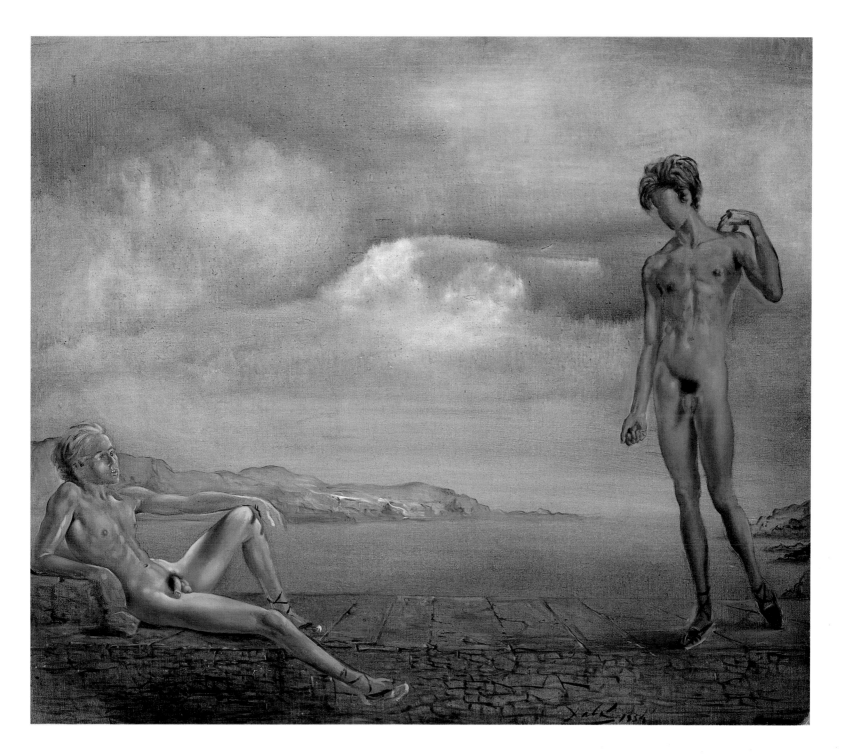

84. *Two Adolescents*, 1954

Oil on canvas
22 × 25 1/2 inches

Exhibitions
New York 1965
Fort Lauderdale 1997

Dalí was engaged in a number of different projects in 1954. In addition to preparing for a small-scale retrospective of his work at the Palazzo Pallacivini in Rome that May, the artist worked with French photographer Robert Descharnes on a film project entitled *The Prodigious History of the Lacemaker and the Rhinoceros*, which was left unfinished. In painting, Dalí worked with a range of themes, executing a series of historical subjects, portraits of Gala, Raphaelesque Madonnas in line with his new theory of nuclear mysticism (see cat. no. 82), society portraits, and completing his great *Corpus Hypercubus (Crucifixion)* (Metropolitan Museum of Art, New York). Amid this activity, Dalí also painted two pastoral scenes of life in Port Lligat, far removed from the international stage on which he now performed.

Noon (Barracks Port Lligat) and *Two Adolescents* are both painted in grisaille. In the former, the gray ground establishes a muted tonal effect whose monotony is relieved by the play of brilliant yellow highlights, the reflection of the hard, even light of summer. Two fishermen, one at ease, the other attending to his daily work, stand before a building used to store marine traps and nets. That the image relates to Dalí's own domestic life is suggested by the presence of his maid, Katarina, on the left, and the proximity of the building to his studio.

Although the setting for *Noon (Barracks Port Lligat)* calls to mind the austere landscapes of Dalí's surrealist period (cat. nos. 55 and 56), the image remains little more than a sentimental genre scene. In contrast, *Two Adolescents* is a patently erotic image of sexual maturation. The two youths, wearing traditional Catalan sandals known as *espardenyes*, pose in the nude on the wall of Dalí's garden, with the Bay of Port Lligat in the distance. The treatment of the lithe reclining figure, whose pose is based on Michelangelo's *Adam* from the ceiling of the Sistine Chapel, is far more detailed than that of his companion; Dalí pays particular attention to the youth's fleshy pink genitals and dark pubis. The standing figure, whose pose is based on Michelangelo's *David* (Accademia, Florence), is an image of nascent masculinity and youthful pride. Executed in a more summary manner, and lacking a face with which to return the intense gaze of his mate, he is transformed into an erotic object, the narcissistic double of the reclining youth.

85. *Nature Morte Vivante (Still Life—Fast Moving)*, 1956

Oil on canvas
49 1/4 × 63 inches

Exhibitions
Southampton 1958
New York 1965
Pittsburgh 1998
Shinjuku 1999

Nature Morte Vivante (Still Life—Fast Moving) is one of Dalí's most accomplished paintings of the postwar years. Dalí labored on the painting for a period of five months, producing numerous preparatory sketches and oil studies. He described his self-conscious masterwork as an "explanatory painting where one can observe the dynamic and irrational dividing of a fruit dish following the coefficients of uncertainty of Heisenberg in opposition to the positive security which cubist pictures once tried to offer us."[1] The reference to Werner Karl Heisenberg, the German scientist renowned for his work on quantum theory, points to Dalí's interest in modern physics as the justification for a new spatial regime in painting. In Dalí's highly idiosyncratic conception of modern science, Heisenberg's theory is in turn linked with a rudimentary conception of atomic physics. Indeed, the title of the painting plays on the French term *nature morte*—literally "dead nature" —in counterpoint to which Dalí proposes the idea of a "fast-moving" still life in which matter is suspended within a dynamic space-time continuum. In Dalí's mind, modern physics demonstrates unequivocally that cubism (symbolized by the floating bottle of Anis del Mono, a

familiar studio prop in Picasso's work) and the tradition of abstract art it spawned correspond to a conception of space that nuclear physics has rendered obsolete.

In *Nature Morte Vivante* Dalí imagines a universe in which objects are poised in dynamic tension. Although he constructs his still life within the established guidelines of the Renaissance tradition, Dalí dismantles the classic figure-ground relationship that is its hallmark: not only do objects rotate in a circular motion, but the play of light and shadow is arbitrary. In effect, Dalí produces a deep, illusionistic vista only to subvert its spatial logic. In its place he adopts a precise harmonic structure based on Matila Ghyka's formula for the "perfect" rectangle in *The Geometry of Art and Life*.[2] To emphasize the structural logic of this system, Dalí dispenses with atmospheric perspective entirely. All objects are in equal focus, and sharp lines define discrete areas of color.

Dalí's pseudoscientific approach extends to an analysis of the double-helix structure of the DNA molecule and, more generally, of the logarithmic spiral. On the far left side of the painting a hand holding a rhinoceros horn intrudes upon the composition. The curving shape of the horn represents a kind of mise-en-scène for the overall formal structure of the painting, as objects appear to move about in a spiraling motion, from the fruit dish in the upper center to the intricate structure of the cauliflower in the far right. The rotation of the still-life objects like planets around the sun, or electrons around an atomic nucleus, underscores the idea of a single cosmic order that embraces both the most infinitesimal particles and the expanding structure of the universe itself.

Notes

1. A. Reynolds Morse, *Salvador Dalí: A Panorama of His Art* (Cleveland: The Salvador Dalí Museum, 1972), 186.

2. Matila Ghyka, *The Geometry of Art and Life* (New York: Sheed and Ward, 1946).

86. *Saint Helena of Port Lligat,* 1956

Oil on canvas
12 1/4 × 16 3/4 inches

Exhibition
New York 1965

Among the symbolic roles Gala filled in Dalí's life and work, her function as a spiritual guide assumed special significance for the artist following his return to Europe in 1948. In her incarnation as Madonna, Angel, and Magdalen, Gala is interpreted as the spiritual force who leads Dalí back to Christianity. In *Saint Helena of Port Lligat* she appears in the guise of the early Christian saint and mother of Constantine the Great, who prevailed upon her son to adopt Christianity as the official religion of the late Roman Empire in 313 C.E. In the year 325 the devout Helena embarked on a trip to the Holy Land to identify the sacred sites of Christianity. Divinely inspired visions led her to the home of Mary Magdalene, to the site of Christ's crucifixion, and to the Holy Sepulcher, where Constantine erected basilicas. Saint Helena is also reputed to have discovered the remains of the "true" cross.

Dalí envisions Gala as his own religious "mother" in the guise of Saint Helena. Seated on rocks along the shore of the Bay of Port Lligat, she holds her attribute, the cross, in one hand, and the gospels in the other. The statuesque figure of Gala is modeled on Michelangelo's *Moses*, an art-historical conceit that Dalí increasingly employed (see cat. no. 84). The image reappears in Dalí's monumental *Ecumenical Council* of 1960 (cat. no. 91).

The austere beauty of Port Lligat is a fitting backdrop for this image of unquestioning faith and religious zeal. Dalí has fully indulged his penchant for drama, fashioning dark billowy clouds from which the light of inspiration rains down on distant hills. The figure of the lone saint appears like a rock, solidly planted in a landscape that is summarily painted. Dalí has employed a range of techniques to achieve the effect of a severe and ascetic environment: grisaille is combined with blotting and finger painting in the foreground and background, and a thick varnish has been applied to the sea.

87. *Velázquez Painting the Infanta Marguerita with the Lights and Shadows of His Own Glory,* 1958

Oil on canvas
60 1/2 × 36 1/4 inches

Exhibitions
New York 1965
Hartford 2000

The imposing figure of Diego Rodríguez Velázquez de Silva (1599–1660) stands behind Dalí's art. As early as 1919, Dalí published a short text on the great Spanish master in *Studium*, the short-lived magazine he edited in Figueres. Following contemporary trends in art history, the precocious painter, at the tender age of fifteen, viewed Velázquez as a quintessential realist whose "impressionistic" approach to color and form presaged developments in modern art: "His composition and distribution of colors seem, in certain cases, to be those of an Impressionist. Velázquez must be considered one of the greatest, perhaps the greatest, of all Spanish artists and one of the best in the world."[1] Years later, Dalí would interpret Velázquez's approach to form and color in relation to his theory of nuclear mysticism, but it was Velázquez's inspired naturalism that remained his most insistent point of reference.

In the 1950s, as Dalí returned to the Old Masters in a much publicized revision of the history of art, Velázquez entered his painting and writing with renewed force. In 1957 Picasso had executed an elaborate series of variations on *Las Meninas*, which Dalí, Picasso's admirer and archrival, sought to outdo. Between 1958 and 1982 Dalí executed a number of paintings after works by Velázquez: *Las Meninas*, 1656; *Portrait of Infanta Marguerita of Austria*, 1660; *Equestrian Portrait of Príncipe Baltasar Carlos*, 1635; *Portrait of the Duke of Olivares*, circa 1635; and *Portrait of Sebastián de Mora*, circa 1643–49. Dalí's identification with the Spanish artist extended to his personal appearance; his extravagant mustache bears a striking resemblance to that of King Philip IV in Velázquez's great portrait.

Velázquez Painting the Infanta Margarita with the Lights and Shadows of His Own Glory is the earliest work in Dalí's extended series of variations. This elaborate painting is actually based on three sources: *Las Meninas*, which provides the conceit for the artist painting the Infanta and the structure for the wall of panels through which light passes on the right side of the composition; *Portrait of Infanta Marguerita of Austria*, from which the semitransparent central image and the anamorphic figure, painted in grisaille on the central panel, are derived; and Jan Brueghel's allegory *Los Sentidos Corporales, La Vista y el Olfato*, from which Dalí has borrowed the deep perspective of the gallery in the upper left of the painting. Standing before the portrait of Infanta Marguerita is the figure of Velázquez from *Las Meninas*, viewed from behind as if Dalí were standing in the pictorial space of the baroque artist's great painting. The presence of the painter underscores the theme of art and artifice that is a hallmark of Velázquez's canvas, while the steep, rushing perspective, the anamorphic portrait of the Infanta, and her apparition on the frontal plane of the picture in an explosion of color and form point to Dalí's interest in the complex visual structure of *Las Meninas*.

Characteristically, Dalí reinterpreted Velázquez's technique according to developments in modern science. As he explained in the "Anti-Matter Manifesto" of 1959: "My ambition, still and always, is to integrate the experiments of modern art with the greater classical tradition. The latest microphysical structures of Klein, Mathieu and Tapié must be used anew to paint, because they are only what, in Velázquez's day, was the "brush stroke," about which the sublime poet Quevedo, already at that time, said that he painted with 'stains and distant spots.' "[2] Two years later Dalí specifically identified Velázquez as a precursor to both Action Painting and modern physics, citing Willem de Kooning and the physicist Max Planck as the painter's legitimate heirs.[3]

In *Velázquez Painting the Infanta Marguerita with the Lights and Shadows of His Own Glory* the signs of the artist's historical revision of Spanish baroque painting are clearly visible in the movement of the logarithmic spirals that sweep across the Infanta's body in a dazzling display of light and energy, and in the overall atomization of form, especially in the area around the Infanta's face and brilliantly illuminated left hand. Collapsing the historical past with present-day developments in art and science—the gestural abstraction of de Kooning, the calligraphy of Mathieu and L'Art informel, and nuclear physics—Dalí locates Velázquez in a continuum that spans the entire history of Spanish painting, from the Golden to the Atomic Age.

Notes
1. Salvador Dalí, "Velázquez," *Studium* (Figueres) 5 (June 1919).

2. Salvador Dalí, "Anti-Matter Manifesto," artist's statement in *Salvador Dalí*, exh. cat., Carstairs Gallery, New York, December 1958–January 1959, reprinted in *The Collected Writings of Salvador Dalí*, ed. Haim Finkelstein (Cambridge: Cambridge University Press, 1998), 366–367. As early as 1951 Dalí had declared in an apology for Spanish painting: "Each day, or better yet, every quarter of an hour, I come to consider, and with a most imperialistic fury to specify, that the universe is a unity, like a total monarchy in which the phenomenon of Spanish painting appears to me to be the most perfect courtier of this majestic and absolute king that is modern physics, without which each minute that passes more tyrannically will soon make it impossible even to attempt to pick up the brush." (Salvador Dalí, *Genio y figura de la pintura española* [Madrid: Herederos de D. Manuel Herrera Oria, 1951].)

3. Salvador Dalí, "Ecumenical 'chafarrinada' of Velasquez," *Art News* (New York) (February 1961), 30.

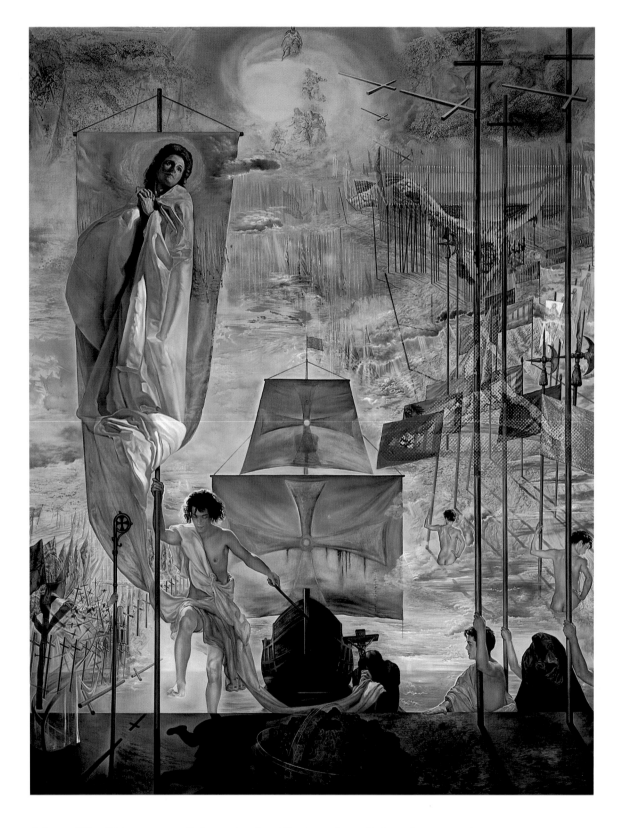

88. *The Discovery of America by Christopher Columbus*, 1958–59

Oil on canvas
161 1/2 × 122 1/8 inches

Exhibitions
New York 1964
New York 1965
St. Petersburg 1982

This enormous canvas, measuring approximately 13 × 10 feet, depicts Columbus stepping ashore on the New World and planting the banner of the Inmaculada on its soil. The image of the Virgin is a portrait of Gala, and Dalí himself is present in the form of a monk kneeling on the shore and holding aloft a crucifix. Thus conflating a historical event with biographical detail and religious fervor, Dalí in effect imagines his own apotheosis in America as a Catholic artist and defender of the "true" faith of painting under the watchful protection of Gala.

The Discovery of America by Christopher Columbus was commissioned in 1957 by Huntington Hartford for his Gallery of Modern Art in New York City. Dalí worked on the painting—his largest canvas to date—for a period of six months, assisted by Isador Bea. The model for Columbus was a young man of Greek descent named Christos Zoas, whom Dalí and Gala had met in 1956 at the Russian Tea Room in New York City,

where he was working. Zoas also served as the model for the three young men holding banners in the lower right-hand corner of the painting.

Characteristic of his later "mythic" and allegorical paintings, Dalí weaves historical sources with popular legends. The standards and banners to the right representing the Spanish provinces are an oblique reference to Velázquez's great *Surrender of Breda* in the Prado, Madrid. The bishop on the lower left, a portrait of Bea, represents Saint Narciso, the patron of the medieval city of Girona near Dalí's home in Figueres. The reference is to a popular tradition in Catalonia that holds that Columbus was in fact a Jew from Girona, not a devout Italian Catholic from Genoa. The flies that hover near the saint's body refer to yet another legend in which gadflies emerged from the tomb of St. Narciso to rout French invaders in the twelfth century. To this Dalí has added the image of Ferdinand and Isabella receiving Columbus in the presence of Saint Salvador and a scene of the pietà in a mandorla in the upper center, as well as a reference to his *Christ of St. John of the Cross*, 1951 (The Glascow Art Gallery, Glascow) amid the banners in the upper right. On the shore directly in front of the image of the Santa María, the ship that brought

Columbus to the New World, is a sea urchin surrounded by cosmic rings— an allusion, according to Dalí, to the new age of space travel. Finally, the structure of the painting, based on the ideal proportions of the harmonic rectangle calculated by Matila Ghyka in *The Geometry of Art and Life* adds a note of scientific rigor bordering on metaphysical mystery to Dalí's complex historical and autobiographical narrative.[1]

———

Notes
1. Matila Ghyka, *The Geometry of Art and Life* (New York: Sheed and Ward, 1946).

89. Dionysus Spitting the Complete Image of Cadaqués on the Tip of the Tongue of a Three-Storied Gaudinian Woman, 1958–60

Oil on panel
12 1/4 × 9 inches

Exhibitions
New York 1965
Fort Lauderdale 1997
Pittsburgh 1998

Dalí makes reference to a number of his most familiar themes of the 1920s and 1930s in the harrowing scene of *Dionysus Spitting the Complete Image of Cadaqués:* the abject body (cat. nos. 28 and 29), physical decomposition, the metamorphosis of beings and objects (cat. nos. 58, 60, and 65), the "edible" beauty of art nouveau architecture (cat. nos. 35 and 36), and sexual aggression. The source material for the painting was a school primer depicting images of fruits, which Dalí incorporated into the fantastic, three-tiered body of his grotesque Gaudinian woman, complete with sagging breasts, hideously deformed feet, and a distended vagina. In the background peasants till the fields, while a group of young girls recalling Dalí's early scenes of pastoral life (cat. no. 14) engage in play. The diminutive and semiliquid image of Cadaqués that Dionysus spits from his mouth pours into the bifurcated head of the Gaudinian woman, who consumes it. The sexual meaning of this act of ingestion is suggested by the "erect" bottle of wine and plump, red cherries that are surrogates for Dionysus's genitals.

Dalí's *facture* in the painting, a combination of pointillist dots and loose calligraphic lines, relates to his theory of "nuclear mysticism" and his interest in the disintegration and reintegration of matter (see cat. no. 82). The idea for constructing a figure from still-life objects, however, may have a more distant source in the work of Giuseppe Arcimboldo (c. 1530–93), whom Dalí admired.[1] Closer to home, Dalí's decision to use a school primer as source material recalls Magritte's work of 1928–30, especially the Belgian artist's famous *Wind and the Song/Ceci n'est pas une pipe* of 1928, which Dalí referred to on one occasion (see cat. no. 62). Unlike Arcimboldo, who constructed elaborate figural gestalts from fruits and vegetables, and Magritte, who was primarily interested in the word/image structure of the school primer, Dalí used still-life objects as actual surrogates for body parts, thereby opening his work to the rich play of metaphor.

The grotesque form of the two decomposing figures also points to the influence of André Masson of the 1930s and Picasso's grossly distorted heads of circa 1936–38, the so-called weeping women. In the "Mystical Manifesto" of 1951 Dalí described the Andalusian artist as a painter of the abject body:

Picasso, thank you! With your Iberian, anarchical and integral genius you have killed the ugliness of modern painting: without you, given the prudence and moderation that characterize and are the honor of French art, we were in danger of having one hundred years of painting more and more ugly, until we have progressively arrived at your sublime "esperpentos abatesios" of the Dora Maar series. You, with a single blow of your categorical sword, you have brought down the bull of ignominy, and also and above all, the even blacker one of materialism in its entirety. Now the new era of mystic painting begins with me.[2]

However much Dalí emphasized the distance that separated his new work from that of his contemporaries, *Dionysus Spitting the Complete Image of Cadaqués* remains deeply rooted in the themes and visual conceits of the artist's surrealist work.

Notes

1. On Dalí's interest in Arcimboldo in relation to the production of multiple images, see "Dalí, Dalí," artist's statement in *Salvador Dalí,* exh. cat., Julien Levy Gallery, New York, March 21–April 17, 1939.

2. Salvador Dalí, "Manifeste mystique" (Paris: Robert J. Godet, 1951), translated in *The Collected Writings of Salvador Dalí,* ed. Haim Finkelstein (Cambridge: Cambridge University Press, 1998), 363–366.

Dionysus Spitting the Complete Image of Cadaqués on the Tip of the Tongue of a Three-Storied Gaudinian Woman

90. *Beatrice,* 1958–60

Oil on canvas
15 1/2 × 11 3/4 inches

Exhibitions
New York 1965
Fort Lauderdale 1997
Pittsburgh 1998

The disposition of the figure in *Beatrice*, whose title refers to Dante's great love and soul mate in *The Divine Comedy*, closely approximates two paintings of 1949 in which Dalí imagined Gala enthroned as the mythical character Leda (*Leda Atomica*, Fundació Gala–Salvador Dalí, Figueres) and the Virgin Mary (*The Madonna of Port Lligat*, Haggerty Museum of Art, Marquette University, Milwaukee). Closer to the time of its execution, the painting relates to another series of works of 1960 representing the apotheosis of Saint Anne and the Infant Jesus, St. Anne and St. John, and the mystical apparition of the Virgin in St. Peter's Basilica, Rome. That same year, Dalí produced his maximum statement of religious faith in the great *Ecumenical Council* (cat. no. 91), where the statuesque figure of Gala once again appears in a state of glory.

The unfinished portrait of Beatrice, painted in grisaille, has all the markings of a delicate pastel sketch. In places Dalí's line is summary yet fluid. Elsewhere, his brush establishes a staccato rhythm of calligraphic lines that at once suggest fine embroidery work on Beatrice's gown and the sign for atomization familiar from Dalí's "nuclear mystical" canvases (cat. nos. 82, 87, and 89). The rich play of highlights and shadows adds dramatic movement to the composition, such that Beatrice appears to rise from the ground on a carpet of clouds, or to emerge from a dark grotto.

Dalí's involvement with Dantesque subject matter dates to 1950, when he received a commission from the Italian government to illustrate *The Divine Comedy*. Although the project ultimately fell through when left-wing members of the Italian Parliament objected to Dalí's involvement on the grounds that he was sympathetic to Franco's regime, the artist managed to produce 102 watercolors on the theme. The watercolors were later issued as woodcuts in separate signed and unsigned editions.

91. *The Ecumenical Council,* 1960

Oil on canvas

118 × 100 inches

Exhibitions
New York 1965
Shinjuku 1999

The Ecumenical Council is Dalí's last epic painting on the theme of religious mysticism. Constructed like a baroque altarpiece to suggest a divine apotheosis, the scene is divided into two zones: an earthly realm, the site of the artist at his easel with the imposing cliffs of Cap Creus in the distance, and a vast heavenly paradise in which the Holy Trinity presides over a scene of cardinals of the Catholic Church and other religious figures in glory. Interceding between the two spheres is the figure of Gala as Saint Helena, discoverer and defender of the True Cross (see cat. no. 86). Seated in the monumental pose of Michelangelo's *Moses*, she looks out at the viewer, drawing us into the scene. As with all of Dalí's later imagery, Gala appears as a kind of inspired being or magical vessel through which the artist's religious and creative energies are channeled.

The title of the painting refers to Pope John XXIII's historic meeting with the archbishop of Canterbury in 1960 in a gesture of religious ecumenism. The election of Angelo Giuseppi Cardinal Roncalli in 1958 as the two hundred sixty-first head of the Catholic Church greatly pleased Dalí, who represents the pope's coronation three times in the center of the composition and once in the upper right-hand corner. The pontiff's role as God's messenger on Earth is graphically suggested by the presence of God the Father emerging from a niche in St. Peter's, Rome, flanked by images of the Son and the Holy Ghost. The detailed rendering of the great basilica and seat of the Catholic Church, the work of Dalí's assistant Isador Bea, adds a note of historical accuracy to the scene.[1]

Belying the apparent complexity of Dalí's multifigural composition is a precise geometrical structure that is again based on Matila Ghyka's formulas for harmonic rectangles (see cat. no. 88). The composition is divided into several horizontal tiers and a precise, tripartite structure along the vertical axis. The cross held by God the Son just above the center of the composition forms the apex of a compositional triangle whose structure is repeated in that of a secondary triangle below. In this way Dalí inscribes Catholic mysticism within a discourse of geometrical purity, insisting that his religious beliefs have a corollary in visual form.

Notes

1. A nearly identical architectural vignette also appears in Dalí's *St. Peter's in Rome (Explosion of Mystical Faith in the Midst of a Cathedral)* of 1960–74 (Fundació Gala–Salvador Dalí, Figueres).

Oil on canvas
120 × 163 1/2 inches

Exhibitions
New York 1963
New York 1965
Stuttgart 1989
Fort Lauderdale 1997

On September 26, 1963, the Rio Llobregat flooded just outside of Barcelona, killing more than four hundred people. In response Dalí painted two canvases: *Cristo de Vallès*, which was sold to raise money for the flood victims; and the enormous *Galacidalacidesoxiribunucleicacid (Homage to Crick and Watson)*, which symbolically commemorates the terrible event. In a dedication he wrote for the painting on the occasion of its exhibition in 1965, Dalí explained his highly idiosyncratic iconography:

Into the name of my own genetic memory I mix the name of my wife Gala, of Allah, that of the Cid Campeador (the feminine Cid) with that of desoxiribunucleic acid. The arm of the eternal God carries the man-Christ back up to heaven as the Jesuit Father Teilhard de Chardin would have

had it, thus verifying the Dalinian idea of the "persistence of memory"; in my own life, the persistence of memory of the history of Spain, my country, and of the Arab people, consubstantially mingled to the point that only the cybernetic machines of the future will be able to disentangle them with clarity, thanks to the microphysical structures of moire, mescaline of the retina.[1]

Characteristically, Dalí weaves his beliefs on nuclear mysticism into a complex and often esoteric historical narrative. The title of the painting is formed by combining the words G-A-L-A, the artist's wife, spiritual guide, and muse; C-I-D, a reference to the great Spanish soldier El Cid of popular folklore; A-L-A, a shortened version of "Allah," the arabic word for the Supreme Being; and DESOXIRIBUNUCLEIC ACID or DNA for short, whose molecular structure was identified by Dr. Francis Crick and Dr. James Watson in 1953. The reference to Pierre Teilhard de Chardin (1881–1955), a French Jesuit priest who, like Dalí, attempted to reconcile modern science with religious mysticism, serves to justify the artist's project, however much

Dalí's suggestion of his own "genetic memory" is a clever fiction staged in relation to his putative Arab roots.[2]

Dalí conceived *Galacidalacidesoxiribunucleicacid* as an elaborate cycle of birth, death, and rebirth. In the center left, the double-helix spiral of the DNA molecule represents the building-block of life, which is counterbalanced on the left by a group of Arab gunmen in "molecular" formations who signify death and self-annihilation, in addition to the scientific legacy of the Arabs in Spain. Above, God the Father extends his arm downward to lift up the dead body of Christ, as Gala, her coiffure in the form of a eucharistic crust of bread, looks on. Figures kneel in prayer before the image of God the Father, whose head contains an image of the Madonna and Child surrounded by angels. Floating in the clouds in the upper left is the Prophet Isaiah, who foretold the birth of Christ. In his hand is a scroll inscribed with the title of the painting.

Dalí's cosmology of racial and historical memory, religious mysticism, biographical agency, and nuclear science represents a

decidedly abstruse response to the catastrophe at hand. Only the minute image of an isolated village in an inundated plain gives some clue to the events that inspired this monumental canvas. As an image of historical fantasy bordering on science fiction, however, *Galacidalacidesoxiribunucleicacid* remains a key work in Dalí's postwar artistic production.

———

Notes

1. The dedication is reprinted in *Galacidalacidesoxiribunucleicacid (Homage to Crick and Watson)*, a brochure published by The Salvador Dalí Museum to celebrate its acquisition of the painting in 1992.

2. Dalí executed a number of paintings focusing on Arab themes at this time, including the monumental *Battle of Tetuán* of 1962 (Minami Art Museum, Tokyo), after Mariano Fortuny.

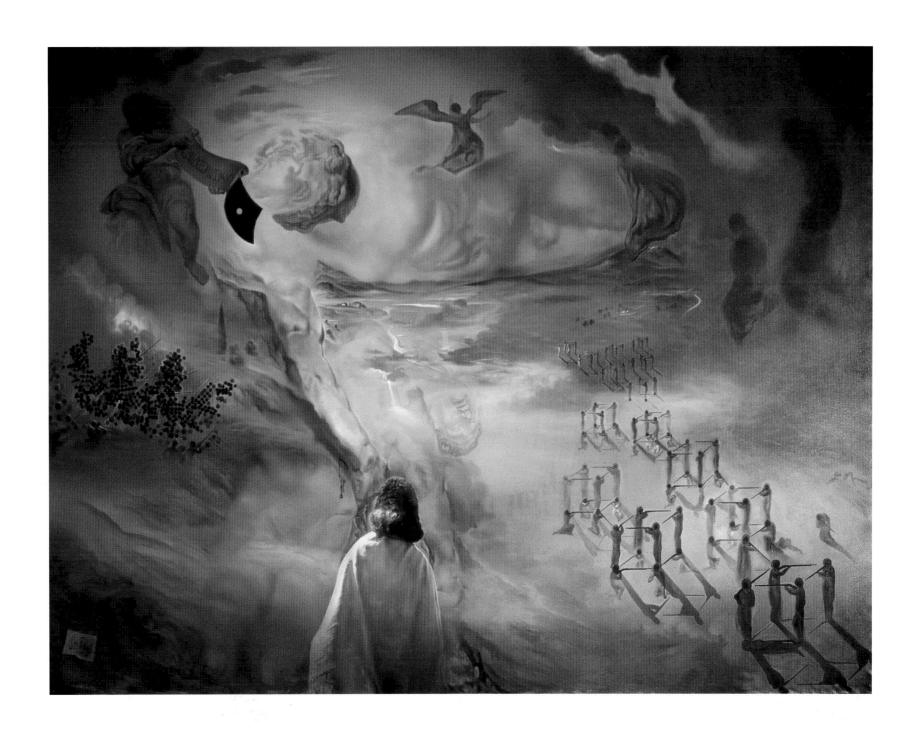

Galacidalacidesoxiribunucleicacid (Homage to Crick and Watson)

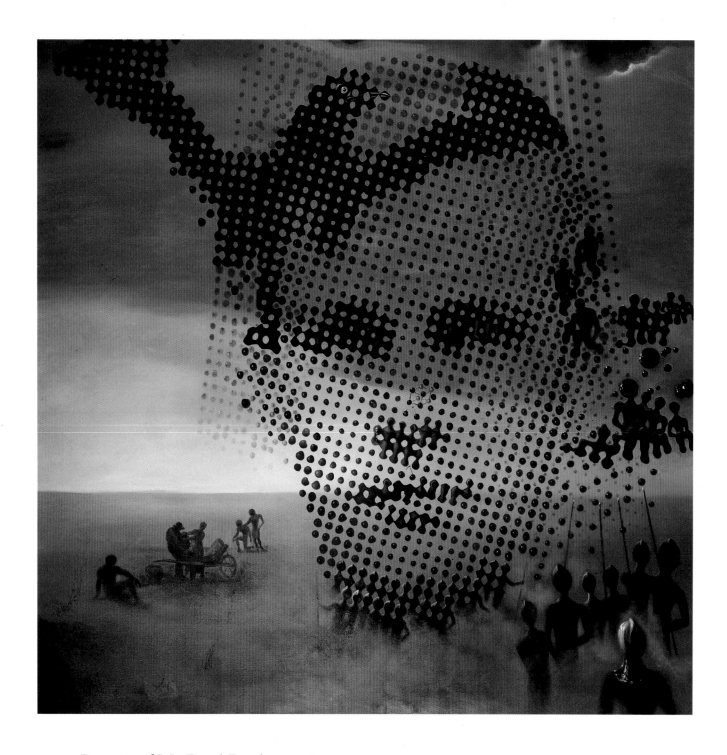

93. *Portrait of My Dead Brother,* 1963

Oil on canvas
69 × 69 inches

Exhibitions
New York 1963
New York 1965

San Diego 1969
Stuttgart 1989
Liverpool 1998

Pittsburgh 1998
Hartford 2000

Dalí returns to the theme of mythic autobiography in *Portrait of My Dead Brother*. In a text that postdates the painting, *The Unspeakable Confessions of Salvador Dalí*, the artist recounted the traumatic events surrounding his older brother's death:

As is known, three years after the death of my seven-year-old elder brother, my father and mother at my birth gave me the same name, Salvador, which was also my father's. This subconscious crime was aggravated by the fact that in my parents' bedroom—an attractive, mysterious, redoubtable place, full of ambivalences and taboos—there was a majestic picture of Salvador, my dead brother, next to a reproduction of Christ crucified as painted by Velázquez; and this image of the cadaver of the Saviour whom Salvador had without question gone to in his angelic ascension conditioned in me an archetype born of four Salvadors who cadaverized me. The more so as I turned into a mirror image of my dead brother.

I thought I was dead before I knew I was alive. The three Salvadors reflecting each other's images, one of them a crucified God twinned with the other who was dead and the third a dominating father, forbade me from projecting my life into a reassuring mold and I might say even from constructing myself. At an age when sensibilities and imagination need an essential truth and a solid tutor, I was living in the labyrinths of death which became "my second nature." I had lost the image of my being that had been stolen from me; I lived only by proxy and reprieve.[1]

Dalí's memory in 1977 was deliberately faulty. In *The Secret Life* of 1942 he recounted that his brother had died at the age of three from an attack of meningitis. In fact, Salvador

Galo Anselmo Dalí i Cusí was born on October 12, 1901, and died at the age of twenty-two months on August 1, 1903. Almost nine months to the date, Salvador Dalí III was born—destined, as he was to write in his autobiography, for greatness.

Dalí's reminiscence in *The Unspeakable Confessions* is laced with filial guilt and rage, fantasies of martyrdom and self-sacrifice, and self-doubt bordering on self-abnegation. There is no question that the death of the elder Salvador haunted Dalí throughout his life, and that to exorcize his spell and reestablish a secure sense of self, the artist had to assassinate his narcissistic double. As he confided to the poet Alain Bosquet, "Every day, I kill the image of my poor brother . . . I assassinate him regularly, for the 'Divine Dalí' cannot have anything in common with this former terrestrial being."[2] Yet it is also clear that Dalí used his brother's death as a pretext to stage his psychic fragmentation as one-half of a double whose unity was irretrievable. For all his Napoleonic fantasies of grandeur, Dalí imagined himself in a state of perpetual crisis.

The apocryphal nature of Dalí's self-sacrifice in *Portrait of My Dead Brother* is underscored by the fact that that image of the dead Salvador is an elaborate fiction. The visage of the child, who appears to be an adolescent boy, does not correspond to either Dalí, but, rather, is meant to suggest a generic image of wholeness and completion (indeed, the enormous head looms large over a desolate landscape). What is more, the vulture that merges with the figure's head establishes a dual psychoanalytic and psycho-biographical narrative for the scene: it represents the maternal vulture,

about which Freud wrote in his essay on Leonardo da Vinci (see cat. no. 36)[3]—an image of incestuous desire—and it restates the theme of predatory female aggression, which Dalí had explored in his *Angelus* paintings (cat. nos. 52 and 53), represented here in the scene of a peasant couple by a wheelbarrow.[4] Indeed, Dalí was explicit about his literary sources. In a statement published in the catalogue accompanying his 1963 show at Knoedler Gallery, New York, he explained: "The Vulture, according to the Egyptians and Freud, represents my mother's portrait. The cherries represent the molecules, the dark cherries create the visage of my dead brother, the sun-lighted cherries create the image of Salvador living thus repeating the great myth of the Dioscuri Castor and Pollux."[5]

Once again, Dalí recasts his earlier psychoanalytic work in relation to his current preoccupations with science, history, and the accumulated weight of tradition. The Spanish guards in the lower right, their lances raised, may represent the idea of the artist's ego under siege (the figures actually merge with the youth's face in the area around the chin, eyes, nose, and mouth). At the same time there may be an art-historical reference to Velázquez's *Surrender of Breda* in the Prado, Madrid. Dalí's interest in atomic science is indicated by brilliantly illuminated cherries joined in a molecular structure just below the bridge of the youth's nose. The cherries in turn relate to the publication of Dalí's *Le Mythe tragique de l'"Angelus" de Millet* that same year, in which a postcard with a photographic reproduction of a woman with two cherries dangling from her mouth is provided as

concrete "proof" of the ubiquitous theme of female aggression in high and mass culture. Thus Dalí comes full circle, forging an elaborate network of associations in which he redefines his past in relation to myth and psychoanalysis, using the weight of art history and modern science to shore up a divided, if elaborately constructed, self.

Notes

1. Salvador Dalí, *The Unspeakable Confessions of Salvador Dalí (as Told to André Parinaud)* (London: Quartet Books, 1977), 241.

2. Alain Bosquet, *Conversations with Dalí*, trans. Joachim Neugroschel (New York: Dutton, 1969), 32.

3. Sigmund Freud, "Leonardo da Vinci and a Memory of His Childhood," reprinted in *The Freud Reader*, ed. Peter Gay (New York: W. W. Norton, 1989), 443–481.

4. See Fiona Bradley, "Dalí as Myth-Maker: The Tragic Myth of Millet's *Angelus*," in *Salvador Dalí: A Mythology*, ed. Dawn Ades and Fiona Bradley, exh. cat., Tate Gallery, Liverpool, 1998, 12–28.

5. *Salvador Dalí*, exh. cat., Knoedler Gallery, New York, November 26–December 16, 1963.

Oil on canvas
157 × 118 inches

Exhibition
New York 1970

Dalí returns to the double image in *The Hallucinogenic Toreador,* a monumental canvas that is a retrospective vision of his life and art. Dalí worked on the enormous painting for fifteen months after producing a series of detailed, preparatory drawings. From the start he conceived of the painting as a masterwork, prevailing upon the writer Luís Romero to document his progress on the canvas in a detailed study.[1] Such were Dalí's efforts that he did not complete the painting until after it was exhibited in New York at Knoedler Gallery in 1970, at which time it was acquired by Reynolds and Eleanor Morse.

The conceit for the double image of the Venus figure to the left whose breast and torso form the nose and mouth of the "invisible" toreador came to Dalí by chance upon seeing a reproduction of the Venus de Milo on a packet of pencils manufactured by the Venus Pen & Pencil Company. The white gown of Venus, with a lime-green shadow to the left, in turn establishes the image of the toreador's shirt and tie, respectively. As with *Paranonia* of 1935–36 (cat. no. 62) and *Slave Market with the Disappearing Bust of Voltaire* of 1940 (cat. no. 72), the secondary image fades in and out of view, yet its presence, like a phantom apparition, like desire itself, haunts the scene. Indeed, an elaborate heterosexual matrix centered around the theme of love and desire is formed by the Venus figure, who represents classic femininity, and the toreador, who functions as a cultural icon of exaggerated masculinity.

Throughout the painting Dalí makes reference to earlier images, anthologizing his work as an artist. The Venus figure first entered Dalí's work in 1936 as a plaster cast entitled *Venus de Milo of the Drawers,* a work that played on the sexual availability of the goddess of love. Standing beneath the monumental Venus in Dalí's painting is the image of a young boy in a sailor suit—the artist himself—proudly displaying his erect "bone" to the phallic mother. The image also appears in *The Specter of Sex-Appeal,* 1934 (Fundació Gala–Salvador Dalí, Figueres), and *Old Age, Adolescence, Infancy (The Three Ages),* 1940 (cat. no. 70). Other familiar images include the bust of Voltaire floating on the brilliant scarlet garment of the Venus figure to the right; the rose of passion (see cat. no. 41); the female peasant from Millet's *Angelus,* who is present in the form of shadows cast by three tiny Venus figures in the foreground; the cutout in the backs of four of the large Venus figures, a clear reference to works like *The Weaning of Furniture-Nutrition,* 1934 (cat. no. 58); and the flies associated with St. Narciso of Gerona (see cat. no. 88). To this catalogue of types and symbols culled from his own work Dalí has added a series of broader cultural references: the arena is a conflation of a Spanish bullring, the old theater in Figueres that would soon become the home of the Teatre-Museu Dalí, and Palladian structures the artist had seen in Italy;[2] the still life on the chair to the left is based on a cubist painting by Juan Gris of 1917, while the classical torso that projects from it alludes to the Venus of Empordà, a sculpture excavated in the early twentieth century at the ancient Greek settlement of Empúries on the Costa Brava; the tiny figure floating on a raft in the bay of Cadaqués is a reference to the recent development of the tourist industry in Dalí's native region; the dead bull with banderillas in his neck reinforces the theme of putrefaction; and the semivisible dog in the center foreground may be an oblique reference to García Lorca, Dalí and Buñuel's "perro andalus."[3] Above the scene in the upper left hovers the ghostly visage of Gala, who, in contrast to the Venus figures, appears more like a classical fury than a muse. Beneath her a toreador raises his cap in a gesture of homage.

Notes

1. See Luís Romero, *Todo Dalí en un rosto* (Barcelona: Editorial Blume, 1975).

2. Robert Descharnes, *Dalí* (New York: Harry N. Abrams, 1992), 164.

3. For a discussion see Ian Gibson, *The Shameful Life of Salvador Dalí* (London: Faber and Faber, 1997), 540–541.

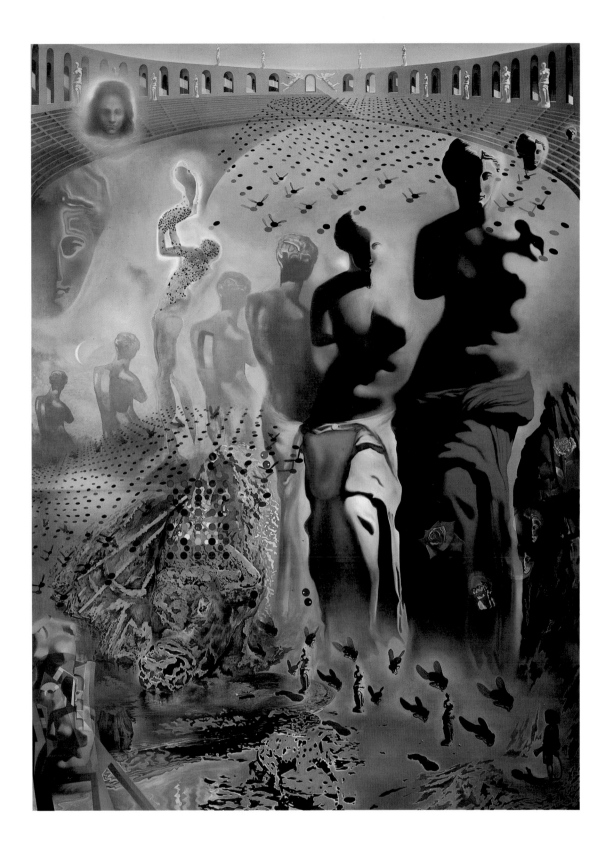

Juliana Kreinik

1904 On May 11, Salvador Felipe Jacinto Dalí
is born to Salvador Dalí i Cusí and Felipa
Domènech i Ferrés in Figueres, Spain.
His twenty-two-month-old brother,
Salvador Galo Anselmo, dies
approximately nine months prior to his
birth from a gastrointestinal infection.

1908 Dalí's sister, Ana María, is born January 8.

Dalí attends the Figueres Municipal
Primary School.

Pepito Pitchot, a close friend of Dalí's
father, invites the Dalí family to his
summer home in Cadaqués, called Es
Sortell. The Dalís rent a converted stable
near Es Sortell called Es Llané, which
will serve as their summer residence for
years to come.

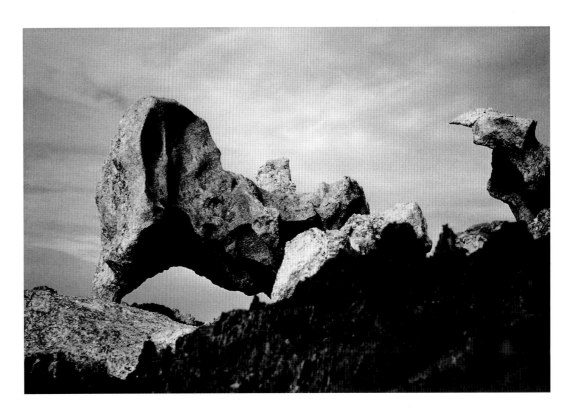

Rock formations, Cap Creus, Spain.

Salvador Dalí, age 4, 1908.

1910 Dalí is enrolled in the Figueres college
nicknamed Els Fossos (The holes),
established the year before as a
Spanish extension of the Institut des
Frères des Ecoles Chrétiennes.
Classroom instruction is given in
French.

1912 In early July, Salvador Dalí i Cusí moves
his office and family to a new location in
Figueres, at Carrer Monturiol, 24. In an
empty laundry room on the rooftop
terrace, Dalí sets up a tiny studio. Dalí's
earliest-known paintings—a series of
tiny undated landscapes—are executed
there.

On October 5, Dalí's paternal
grandmother, Teresa i Cusí, dies in
Barcelona.

1916 In June, Dalí passes the entrance exam to
the Figueres Instituto and spends the
summer with Pepito Pitchot at his recently
acquired country house and estate outside
Figueres, El Molí de la Torre.

In late summer, Dalí's father enrolls him
at the Marist Brothers' School in
Figueres to supplement the official
teaching of the Instituto.

In autumn, Dalí enrolls in drawing
classes at the Municipal Drawing School
in Figueres, taking instruction with the
Andalusian artist Juan Núñez Fernández.

1917 Dalí passes his first-year exams at the
Figueres Instituto in May. At the
Municipal Drawing School on June 17,
Dalí receives the *diploma de honor,* a
special-merit certificate for his work.

Dalí family at the beach at Es Llané, Cadaqués, circa 1910. From left: Aunt María Theresa, Dalí's mother, Dalí's father, Dalí, Auntie Catalina, Ana María Dalí, Dalí's grandmother Ana.

1918 Dalí exhibits his work for the first time, in December at the Teatro Principal, Figueres.

1919 Dalí and his friends produce the first issue of *Studium*, a student-edited magazine published in Spanish that includes poetry, essays, and illustrations. Dalí contributes a series of articles on Goya, El Greco, Dürer, Leonardo da Vinci, Michelangelo, and Velázquez, several illustrations, and two short pieces of prose. The artist begins to keep a diary (in Catalan), which he entitles *My Impressions and Intimate Memories*, with entries through December 1920.

1920 In February/March, Dalí rents a studio at Carrer Muralla, 4, in Figueres. At the Municipal Drawing School, Dalí is awarded first prize for his work.

1921 Ramon Pitchot sends a collection of futurist publications to Dalí via his brother Pepito. These include the *Futurist Manifesto*, anthologized texts, and reproductions of artworks by Boccioni, Carrà, Russolo, Balla, Severini, and Soffici.

In February, Dalí's mother, Felipa Domènech, dies of uterine cancer, after complications following an operation in Barcelona. In July, Pepito Pitchot dies unexpectedly.

Dalí designs book covers for the poet Maurici Soler (1898–1981).

Dalí, Martí Vilanova, Rafael Ramis, and Jaume Miravitlles establish a short-lived Marxist group called Renovació Social. They publish one issue of a periodical (of the same name), appearing on December 26 with the subtitle *Fortnightly Mouthpiece of a Group of Socialists of This Town.*

1922 In January, Dalí exhibits his work in Barcelona for the first time, at an exhibition held at Josep Dalmau's gallery. Organized by the Catalan Students Association, the show includes 134 works by forty artists.

The publishing house Biblioteca Nueva begins to release Spanish translations of Sigmund Freud's works, including *The Psychopathology of Everyday Life* and *Three Essays on the Theory of Sexuality.*

Dalí passes his *bachillerato* in June, and his father makes plans for the artist to attend the Royal Academy Special School in Madrid.

In July, Dalí participates in an exhibition of Empordanese artists in Figueres.

After passing the entrance exam to the San Fernando Royal Academy of Fine Arts in early September, Dalí moves into the Residencia de Estudiantes, a dormitory in Madrid that attracts students of medicine, engineering, art, and many other courses of study. At the "Resi," as the dorm is known, lectures are given by artists, writers, poets, musicians, and composers, including Louis Aragon, José Ortega y Gasset, Max Jacob, Igor Stravinsky, and the Catalan writer and art critic Eugenio d'Ors. Dalí meets José "Pepín" Bello Lassierra and Luís Buñuel, who are living at the Resi.

Dalí's maternal grandmother, Maria Ana i Ferrés, dies in Figueres on October 9.

On November 17, André Breton presents a lecture in Barcelona in conjunction with an exhibition of work by Francis Picabia at the Dalmau Gallery.

On December 22, Salvador Dalí i Cusí marries his sister-in-law Catalina.

1923 Dalí meets Federico García Lorca, the Andalusian poet/playwright, who returns to the Resi after an extended stay at his home. The two men become friends, and Dalí attends many nightly gatherings with Lorca, Pepín Bello, and Buñuel.

In June, Dalí passes his end-of-term exams in Perspective, Anatomy, and Statue Drawing and receives a prize in his History of Art (Antiquity and the Middle Ages) course. He spends the summer in Cadaqués.

Dalí returns to the Special School and the Residencia in September.

On October 17, a public juried election takes place to hire a new Chair of Open-Air Painting. Students and progressive critics support the well-known artist Daniel Vázquez-Díaz, whom the jury rejects. As a result of his alleged participation in vehement student protests after the election, Dalí is officially suspended from the Academy on October 22 for the 1923–24 academic year. He returns to Figueres, where he learns engraving from Juan Núñez, his former professor at the Figueres Instituto.

1924 Following a visit by King Alfonso XIII to Girona and Figueres on May 15, Dalí is arrested and placed in jail for three weeks along with other suspected political dissidents, including Martí Vilanova and Jaume Miravitlles, close friends and militant Communists.

In September, Dalí reenrolls in the Special School in Madrid. He participates in Luís Buñuel's version of Zorrilla's *Don Juan Tenorio*, entitled *The Profanation of Don Juan.*

The Biblioteca Nueva releases a Spanish translation of Freud's *Interpretation of Dreams*, which Dalí reads during the 1920s. In October, André Breton's *First Manifesto of Surrealism* is published.

1925 In April, Lorca accompanies Dalí to Cadaqués to stay with the artist's family during Holy Week. While Dalí and Lorca are away, Louis Aragon gives a lecture on surrealism at the Residencia de Estudiantes on April 18. The lecture is published in the June 1925 issue of *La Révolution surréaliste.*

The first exhibition of La Sociedad de Artistas Ibéricos, a forum for modern art, opens in Madrid on May 28 at the Palacio de Velázquez. Dalí shows eleven paintings.

Rock formations, Cap Creus, Spain.

Dalí decides not to return to the Royal Academy Special School for the 1925–26 session. He spends the fall months preparing for an exhibition of his work, held November 14–27 at the Dalmau Gallery in Barcelona.

1926 In January, the *Heraldo de Madrid*, a progressive Spanish newspaper, sponsors an exhibition of modern Catalan art at the Círculo de Bellas Artes in Madrid. Dalí sends two paintings to the show.

Josep Dalmau writes letters of recommendation for Dalí, addressed to Max Jacob and André Breton. The artist brings these letters with him on his first trip to Paris, which he makes with his aunt and sister on April 11. During this time, Dalí arranges to have a studio visit with Picasso. Dalí also makes a brief trip to Brussels.

Lorca's "Ode to Salvador Dalí" is published in the April issue of José Ortega y Gasset's *Revista de occidente*.

Dalí reregisters at the Royal Academy School but fails his end-of-year exams in June after refusing to participate fully in the oral section. He is permanently expelled.

Dalí shows two paintings in Barcelona's first annual Autumn Salon, held in October at the Sala Parés.

At the same time, Dalí participates in an exhibition entitled "Exhibition of Catalan Pictorial Modernism Compared with a Selection of Works by Foreign Avant-Garde Artists" that opens at Josep Dalmau's new gallery on the Passeig de Gràcia.

December 31–January 14, 1927, Dalí shows twenty-three paintings and seven drawings in his second one-man exhibition at the Dalmau Gallery.

1927 In February, Dalí begins his required military service, which he completes a year later.

On June 24, Lorca's production of the play *Mariana Pineda* opens at the Teatro Goya, with sets and costumes designed by Dalí.

In the July issue of *L'Amic de les arts*, Dalí publishes a prose poem entitled "Saint Sebastian," which he dedicates to Lorca. The editor of *L'Amic de les arts*, Josep Carbonell, invites Dalí to contribute regularly to the periodical.

Dalí meets Joan Miró and his dealer, Pierre Loeb, who visit Figueres in September.

Spain's year-old cultural review *La Gaceta literaria ibérica: americana: internacional* publishes an article by Dalí in December entitled "Artistic Film, Anti-Artistic Film," dedicated to Buñuel, who serves as the magazine's foreign-film correspondent while he is in Paris.

On December 7, Dalí receives a letter from Pierre Loeb, who praises the artist's work and encourages him to send photographs of paintings for his consideration.

1928 On February 29, Dalí publishes the first part of his article "The New Limits of Painting" in *L'Amic de les arts*. The second part is published on April 30, 1928, and the final and third part appears on May 31, 1928. Dalí's text addresses the work of Jean Arp and Yves Tanguy and incorporates various ideas on surrealism expressed by André Breton.

Dalí, Sebastià Gasch, and Lluís Montanyà publish the *Anti-Artistic Manifesto* in March. Printed on colored paper, the manifesto is nicknamed *Manifest Groc* (Yellow manifesto). The three contributors express outrage at the current intellectual and artistic climate in Catalonia.

On May 13, Dalí, Josep Carbonell, and J. V. Foix lecture at the Sitges Atenue on current artistic and literary trends.

On May 21, Dalí takes part in a series of lectures at the Casino Menestral in Figueres that accompany an exhibition to which the artist has contributed nine works.

Lorca publishes *Gypsy Ballads* at the end of July, a collection of poetry that is received with critical acclaim. In a letter to the poet Dalí responds less enthusiastically, stating that the work is traditional and conservative. He later expands on his views in an article entitled "Reality and Surreality," published in *La Gaceta literaria*, on October 15 of the same year.

In August, Dalí sends *Dialogue on the Beach* and *Big Thumb, Beach, Moon, and Decaying Bird* to the Barcelona Autumn Salon, held at Joan Maragall's Sala Parés. Because of its overtly sexual theme, Maragall insists that Dalí withdraw *Dialogue on the Beach.*

1929 Luis Buñuel travels to Figueres in January to work on a film project with Dalí. They name it *Un Chien andalou*, and the editor of *La Gaceta literaria*, Ernest Giménez Caballero, publishes an article about the film on February 1.

Dalí, Pepín Bello, Sebastià Gasch, Buñuel, and J. V. Foix contribute to the final "Surrealist" issue of *L'Amic de les arts*, which appears in mid-March.

Five of Dalí's paintings are included in Madrid's "Exhibition of Painting and Sculpture by Spaniards Residing in Paris," organized by the Society for Courses and Lectures at the Residencia de Estudiantes.

Buñuel begins shooting *Un Chien andalou* on April 2 at the Billancourt film studios outside Paris. Dalí travels to Paris to assist with the filming, and stays for about two months, living in a hotel on the Rue Vivienne. During this time, Miró introduces Dalí to many notable

figures living in Paris, including the Belgian art dealer Camille Goemans. The dealer has recently opened his Galerie Goemans at 49, Rue de Seine, with an exhibition of works by Picasso, Arp, Ernst, and Magritte. On May 14, Goemans and Dalí sign a contract ensuring that all of the artist's paintings will be handled by the dealer in return for a monthly stipend of 1,000 francs.

The premiere of *Un Chien andalou* takes place on June 6 at the Studio des Ursulines.

Dalí returns to Cadaqués for the summer, where he finishes *The First Days of Spring* and paints *The Lugubrious Game*. At the beginning of August, René Magritte and his wife come to Cadaqués, along with Camille Goemans and his girlfriend, Yvonne Bernard. Paul Eluard, his wife, Gala, and their daughter, Cécile, arrive several days later. Dalí develops an infatuation for Gala, and the couple spend much time together. Dalí's father is outraged by his son's behavior with a married woman.

In Paris, *Un Chien andalou* opens commercially at Jean Mauclaire's Studio 28. The film is shown October 1– December 23, and has its first screening in Barcelona on October 24.

Dalí celebrates a one-man exhibition at the Galerie Goemans (November 20– December 5). The catalogue to the show lists eleven works, all but two from 1929. Before the show opens, Charles de Noailles buys *The Lugubrious Game*, and André Breton purchases *The Accommodations of Desire*.

While the exhibition opens in Paris, Dalí and Gala travel to Spain, first to Barcelona and then to Sitges. At the end of November Dalí returns to Figueres, and Gala goes back to Paris. Buñuel journeys to Figueres to begin working with Dalí on a new film project.

Dalí and Gala, circa 1930.

On December 15, the last issue of *La Révolution surréaliste* is published. It includes Breton's *Second Surrealist Manifesto*, reproductions of Dalí's *The* *Accommodations of Desire* and *Illumined Pleasures,* and the screenplay for *Un Chien andalou.* Dalí and Buñuel officially declare themselves surrealists.

1930 On January 11, Dalí and Gala travel to the Hôtel du Château at Carry-le-Rouet, near Marseille, where they stay until March.

In late February, Charles de Noailles offers to assume the role played by Camille Goemans, whose gallery is about to go out of business. Dalí asks de Noailles for 20,000 francs to help him establish a new home in Cadaqués, which he is granted in exchange for a painting from Dalí's forthcoming works. At the same time, Buñuel begins shooting *La Bête andalouse*, as *L'Age d'or*, his new film, was originally titled.

On March 22, Dalí delivers a lecture at the Ateneu Barcelonès entitled "The Moral Position of Surrealism." After the lecture, Dalí and Gala travel to Cadaqués for a brief visit before returning to Paris at the end of March.

On March 28, an exhibition is inaugurated at the temporarily reopened Galerie Goemans with works by Arp, Braque, Duchamp, Ernst, Gris, Miró, Magritte, Man Ray, Picabia, Picasso, Tanguy, and Dalí, who shows *The First Days of Spring*.

Dalí and Gala travel to Torremolinos, a small coastal fishing village near Málaga. They stay for five weeks while the artist works on a new multiple-image painting, *The Invisible Man*. The painting is not completed until 1932.

In early June, Dalí creates the frontispiece for the book publication of Breton's *Second Manifesto of Surrealism*.

On June 30, the final version of *L'Age d'or* is screened in Charles and Marie-Laure de Noailles' private cinema.

In July the first issue of *Le Surréalisme au service de la révolution* is published, containing a surrealist "Declaration" composed by Breton and signed by

various artists and writers. Dalí's "The Rotten Donkey," three film stills from *L'Age d'or*, and two reproductions of the artist's *Invisible Man* (still unfinished) are included.

The de Noailles arrange for a private screening of *L'Age d'or* on October 22. By the end of the year, the film is subject to reviews by almost every Parisian newspaper and journal, many of them negative. On December 5, the Paris police chief censors the film, and on December 10, it is banned. The surrealists publish a response in a four-page pamphlet entitled "L'Affaire de *L'Age d'or*."

On December 15, Dalí's book *The Visible Woman* is published by Editions Surréalistes. The book contains four texts, including "The Rotten Donkey," "The Sanitary Goat," "The Great Masturbator," and "Love." After the artist's father is shown a copy of *The Visible Woman*, he draws up a new will in which he disinherits his son.

1931 Dalí celebrates an exhibition of sixteen works at the gallery of his new dealer, Pierre Colle, which runs June 3–15. New York art dealer Julien Levy sees Dalí's work and buys *The Persistence of Memory*. Levy takes the painting back to America, where it is shown at the Wadsworth Atheneum in Hartford, Connecticut, in November. Levy soon buys *Illumined Pleasures* from Paul Eluard, and *The Accommodations of Desire* from André Breton.

On September 18, Dalí and René Crevel present a lecture on the connection between surrealism and Communism at a meeting of the Workers and Peasants Front, a non-Stalinist Communist group.

Dalí publishes an article entitled "Surrealist Objects" in the December

issue (no. 3) of *Le Surréalisme au service de la révolution*. His variations of "objects" include *Symbolically Functioning Objects* (automatic origin), *Transubstantiated Objects* (affective origin), *Objects for Hurling* (dream origin), *Enveloped Objects* (daytime fantasies), *Machine Objects* (experimental fantasies), and *Mould Objects* (hypnagogic origin).

In December, Dalí publishes his poem *L'Amour et la mémoire* (Love and memory). At the same time, the fourth issue of *Le Surréalisme au service de la révolution* appears, in which the artist includes another text, entitled "Rêverie," that is sharply criticized by the French Communist Party, with which Breton is allied.

1932 Dalí's second exhibition at Pierre Colle's gallery opens on May 26 and runs through June 17. The catalogue lists twenty-seven works, and the introduction is written by Paul Eluard.

Surrealists in Belgrade publish an inquiry on desire, with contributions by Dalí, Eluard, Breton, and Crevel.

On July 15, Gala and Paul Eluard divorce, and Dalí and Gala move into a studio at 7, Rue Gauguet. At the same time, Dalí publishes *Babaouo*, a film script and ballet with autobiographical references. During the summer, Réne Crevel introduces Dalí and Gala to Caresse and Harry Crosby, wealthy American socialites living in Paris. Caresse Crosby encourages Dalí to exhibit his work in New York.

At the end of July, Dalí and Gala depart for their home in Port Lligat and are visited by Réne Crevel, Breton, and Valentine Hugo.

A third exhibition of Dalí's works is held at Pierre Colle's gallery November 22–24. The French-American writer

Julien Green and his sister Anne are introduced to the artist on the last day of the show, and their long-lasting friendship begins with the inauguration of an accord known as the Zodiac, according to which twelve parties agree to provide financial support to Dalí in exchange for a painting of their choice on one month of the year, chosen at random.

1933 At the end of January, Dalí signs a contract with Albert Skira in which he is commissioned to produce forty engravings illustrating a deluxe edition of the Comte de Lautréamont's *Songs of Maldoror*.

The sixth and last edition of *Le Surréalisme au service de la révolution* (May 15) includes an advertisement for *A Paranoiac-Critical Interpretation of the Obsessive Image in Millet's "Angelus,"* an essay that Dalí intends to publish imminently but that does not appear until 1963. The essay's prologue, entitled "New General Considerations on the Mechanism of the Paranoiac Phenomenon from the Surrealist Point of View," is published in the first issue of Skira's *Minotaure*, and its content reveals Dalí's regard for the ideas expressed in Jacques Lacan's 1932 doctoral thesis, *De la Psychose paranoïaque dans ses rapports avec la personnalité*.

A surrealist group show is held at Pierre Colle's gallery June 7–18. Twenty-two artists participate in the exhibition. Dalí is represented by eight works, including two surrealist objects.

Dalí's fourth and final exhibition is held at Pierre Colle's gallery June 19–29. Twenty-two paintings, ten drawings, and two objects are included in the show.

In mid-September, Man Ray travels to Catalonia to photograph Cap Creus and Barcelona's art nouveau architecture.

These photos will illustrate a forthcoming article by Dalí in *Minotaure* entitled "On the Terrifying and Edible Beauty of Art Nouveau Architecture."

Dalí celebrates his first exhibition in New York at Julien Levy's gallery November 21–December 8. Twenty-six works are exhibited, and the show is a critical success.

In Barcelona, Dalí's work is shown at the Galeria d'Art Catalònia in an exhibition that runs December 8–21.

1934 In January, as a result of Dalí's espousal of academic painting and his controversial declarations concerning the advance of Fascism in Europe, André Breton demands that he declare his allegiance to the cause of the proletarian revolution.

Dalí and Gala are married in Paris on January 30. Yves Tanguy and André Gaston (an artist and a neighbor of Dalí) are witnesses.

On February 2, Dalí participates in the fiftieth-anniversary exhibition of the Salon des Indépendants at the Grand Palais in defiance of his agreement with the surrealists not to participate in bourgeois exhibitions. As a result of his actions, Breton and other members of the surrealist group sign a resolution banning Dalí from the movement. The decision is reversed at a meeting held in Breton's apartment, when a contrite and somewhat disingenuous Dalí convinces the group to excuse his behavior.

Dalí goes to Brussels to attend Albert Skira's exhibition on *Minotaure* (May 12–June 3). An exhibition in London at the Zwemmer Gallery entitled "Borés, Beaudin, Dalí" runs May 14–June 3. Dalí and Gala travel to London to see the show and stay with Edward James, a friend of Charles and Marie-Laure de

Noailles. James is a well-known art collector and writer.

On June 13, Skira's edition of *The Songs of Maldoror* is published. Dalí's forty-two engravings are exhibited, along with thirty related drawings, at the Galerie des Quatre Chemins in Paris.

June 20–July 13, Dalí celebrates an exhibition at the Jacques Bonjean Gallery in Paris. Forty-seven paintings and drawings, two sculptures, four surrealist "objects," and several illustrations for *The Songs of Maldoror* are on view.

Dalí's first solo exhibition in London opens at the Zwemmer Gallery on October 24 and runs through November 10. Sixteen paintings, twenty drawings, and plates for *The Songs of Maldoror* are included.

On November 7, Dalí and Gala depart for New York on the *Champlain*, and arrive one week later. The *New York Times* and other newspapers announce Dalí's arrival and include short references to his upcoming show at the Julien Levy Gallery, which opens on November 21 and runs through December 10. Twenty-two works are listed in the catalogue, of which twelve are sold, one purchased by the Museum of Modern Art and two bought by the Wadsworth Atheneum in Hartford, Connecticut.

1935 In early January, Dalí gives a lecture at the Museum of Modern Art in New York entitled "Surrealist Paintings and Paranoiac Images."

A bon-voyage costume party is held on January 18 for Dalí and Gala to which the guests come as their favorite recurrent dream. The following morning the Dalís depart for Europe on the *Ile de France*.

Dalí seeks reconcilation with his father in March, and Dalí i Cusí accordingly changes his will to stipulate that his son receive one-fourth of his estate.

Conquest of the Irrational, Dalí's newest essay, is published in French and English on July 20 in the form of a booklet.

At the end of September, Dalí and Lorca meet in Barcelona, and Gala is introduced to the poet for the first time.

1936 At the Charles Ratton Gallery in Paris, the "Surrealist Exhibition of Objects" is held May 22–29. Dalí's *Aphrodisiac Dinner Jacket* is featured.

June 11–July 4, the "International Surrealist Exhibition" is held at the New Burlington Galleries in London. Dalí shows three paintings, an engraving, several drawings, and *Aphrodisiac Dinner Jacket.*

On June 20, Edward James works out a contract with Dalí in which all works produced between July 1, 1936, and July 1, 1938, will be the property of the collector. Under this agreement, Dalí is to receive monthly payments of £200 from James. The final contract is signed by all parties on December 21, after an amendment postpones the beginning of the exchange period to June 1, 1937.

In late June through early July, Dalí has a solo exhibition at Alex, Reid, and Lefevre's Gallery in London. Twenty-nine paintings and eighteen drawings are included.

On July 1, dressed in a diving suit, Dalí gives a lecture in Burlington Gardens entitled "Authentic Paranoiac Fantasies."

In September, Dalí learns that Lorca has been executed by Fascists in Granada.

The exhibition "Fantastic Art, Dada, and Surrealism" opens at the Museum of Modern Art, New York, on December 9 and runs through January 17, 1937. Six paintings and two drawings by Dalí are included in the show.

Bonwit Teller commissions surrealist artists to design window displays in early December. Dalí's window attracts large crowds with its theme "She Was a Surrealist Woman, She Was Like a Figure in a Dream."

On December 14, a photograph of the artist taken by Man Ray appears on the cover of *Time* magazine. On December 10, Dalí's solo exhibition opens at Julien Levy's gallery.

1937 Dalí and Gala travel to Hollywood at the end of January. They visit Harpo Marx, to whom Dalí had sent a barbed-wire harp for Christmas.

In March, Dalí and Gala return to Europe and spend time at the Arlberg-Wintersporthotel in Zürs.

Dalí finishes his "paranoiac" poem "The Myth of Narcissus" in mid-June. Editions Surréalistes publishes the work that summer along with a color reproduction of Dalí's painting *Metamorphosis of Narcissus.*

July 6–30, Dalí exhibits the works he has made for Edward James during the prior month at the Renou et Colle Gallery in Paris.

Opposing the agreement among the surrealists to refrain from participating in bourgeois exhibitions, Dalí sends eight paintings to a show entitled "Origins and Development of Independent International Art," held at the Jeu de Paume July 30–October 31.

Dalí with Harpo Marx, February 1937.

After traveling to Austria, Hungary, and Italy, and then to Edward James's villa in Rapallo, Dalí and Gala return to Paris in October and move to an apartment at 88, Rue de l'Université.

1938 On January 17, a surrealist group exhibition opens at the Galerie des Beaux Arts, in Paris. Dalí's *Rainy Night Taxi* is placed in the lobby.

On July 19, Dalí visits Freud, who is living in exile in London.

In autumn, Dalí begins to work with Léonide Massine on the ballet *Tristan Fou*, later renamed *Bacchanale*.

1939 Dalí travels to New York in February. Bonwit Teller commissions the artist to create two window displays for its spring fabric collections. When Dalí's designs are altered without his consent, he accidentally breaks through the store's glass window after attempting to change the display. The artist is arrested and receives a suspended sentence for disorderly conduct. Two days later, on March 21, Dalí's exhibition at Julien Levy's gallery opens. Twenty-one paintings, five drawings, and several "objects" are included.

In April, Dalí receives a commission to design the surrealist pavilion for the Amusement Area of the New York World's Fair. Due to ongoing disagreements between organizers and investors, Dalí's design is altered without his approval. Dalí and Gala leave New York on June 6 before the start of the fair. Before departing, Dalí writes an essay on artistic freedom entitled "Declaration of the Independence of the Imagination and the Rights of Man to His Own Madness," which is dropped from a plane over New York City.

In the May issue of *Minotaure*, Breton publishes "The Latest Tendencies in Surrealist Painting," in which he publicly denounces Dalí for expressing racist views. As a result, Dalí is expelled from the surrealist movement.

Dalí and Gala travel to a spa in the French Pyrenees during the summer, where he works on the Ballet Russe de Monte-Carlo production of *Bacchanale*, scheduled to open in Covent Garden, London, in mid-September. With Hitler's invasion of Poland on September 1, the premiere of the ballet is moved to New York. Dalí and Gala briefly return to Paris, after which they leave for Arcachon, near Bordeaux and the Spanish border.

1940 After the Germans occupy Paris on June 14, Dalí travels to Figueres to see his family, while Gala heads to Lisbon to make arrangements for their trip to New York. The couple arrive in New York on August 16. Shortly thereafter they travel to Virginia, where they stay with Caresse Crosby at Hampton Manor, near the town of Bowling Green. Anaïs Nin and Henry Miller are also guests at the estate.

After traveling to Washington, D.C., Taos, and Hollywood, Dalí and Gala return once again to Hampton Manor, where the artist works on his memoirs, *The Secret Life*.

1941 Dalí's sixth exhibition at Julien Levy's gallery is held April 22–May 20. Nineteen paintings are included. The show travels to other cities in the United States after its New York run, including Chicago, San Francisco, and Los Angeles.

Dalí and Gala spend the summer in Pebble Beach, California, and Dalí works in a studio in nearby Carmel. They organize an event called "Night in a Surrealist Forest," based on Caresse Crosby's 1935 "Bal Onirique," which is intended to raise funds for exiled European artists. Celebrities attend the evening's affair, which further advances Dalí's fame in California.

On November 18, a joint retrospective of works by Miró and Dalí opens at the Museum of Modern Art in New York. Forty-two paintings, sixteen drawings, and Dalí's cover design for the *Second Surrealist Manifesto* are exhibited. A monographic catalogue by James Thrall Soby accompanies the show. The exhibition subsequently travels to eight venues around the United States.

1942 In September, Dalí, currently living with Gala in Los Angeles, begins a publicity campaign to promote *The Secret Life*, which is published in New York and London.

1943 Reynolds and Eleanor Morse buy Dalí's *Daddy Longlegs of the Evening—Hope!* on March 21, and *The Archaeological Reminiscence of Millet's "Angelus"* in early April. They arrange for an interview with the artist, and soon afterward become patrons of Dalí, assuming the role played by Edward James.

On April 14, an exhibition of portraits by Dalí opens at the Knoedler Gallery in New York. Portraits of individuals from the upper strata of New York society are exhibited, including one of Princess Gourielli, also known as Helena Rubinstein, who subsequently commissions Dalí to paint three frescoes for the dining room of her apartment.

In mid-autumn, Dalí and Gala travel to Franconia, New Hampshire. They stay at the Marquis de Cuevas's estate, where Dalí begins to work on a novel entitled *Hidden Faces*. The book is published in April 1944.

In the next months, Elsa Schiaparelli commissions Dalí to publicize her line of perfumes called Shocking Radiance. Dalí works on advertisements for Bryans

Hosiery and designs a set of ties for the McCurrach Organization. While working on other advertising campaigns, Dalí continues to execute book illustrations and set and costume designs for theatrical productions.

1945 In September, Dalí begins work with Alfred Hitchcock, who has commissioned the artist to design the nightmare sequences for his new film, *Spellbound.*

"Recent Paintings by Salvador Dalí" opens at the Bignou Gallery in New York on November 20 and runs through December 29. Eleven works are included in the show, and Dalí publishes a broad-sheet entitled *Dali News,* which is meant to parody the *New York Daily News.*

1946 On January 15, Dalí travels to Hollywood to begin work with Walt Disney on a film called *Destino.* Only one sequence of the film is shot as Disney changes his mind about the project.

In December, Dalí's father retires from his position as *notaría* in Figueres.

1947 Dalí celebrates a solo exhibition at the Bignou Gallery, held November 25–January 3, 1948. Fifteen works are included. The artist prepares the second issue of *Dali News* to accompany the show. The issue proclaims the artist's return to classicism and includes the first chapter of his forthcoming technical treatise, *50 Secrets of Magic Craftsmanship.*

1948 On July 29, after eight years in America, Dalí and Gala arrive in Figueres.

The couple travel to Cadaqués, where they move in temporarily with Dalí's father, stepmother, and sister.

1949 Dalí is commissioned to design the sets and costumes for three productions: Zorilla's *Don Juan Tenorio* in Madrid, which opens on November 1; Strauss's *Salome* in London, which premieres on November 11; and Shakespeare's *As You Like It,* which begins its run on November 26 in Rome. Dalí and Gala travel to Rome for the premiere of the play and to meet with Pope Pius XII.

Dalí and Gala depart for New York at the end of November.

In December, Dalí's sister, Ana María, publishes her book *Salvador Dalí Seen by His Sister,* with an introduction by the artist's father.

1950 In January, Dalí's responds to Ana María's work with anger, accusing his sister of confecting false accounts of his life.

On January 30, Dalí's father authors a new will in which Ana María is designated his sole heir. Dalí receives the legally stipulated amount of 60,000 pesetas.

Vogue magazine publishes an article in its May issue entitled "To Spain, Guided by Dalí," containing the artist's recommendations for touring around his homeland.

In the spring, Dalí and Gala return to Port Lligat. Several months later, on September 21, Dalí's father dies of prostate cancer. Dalí does not attend the funeral or burial.

On October 19, Dalí delivers a lecture at the Ateneu Barcelonès entitled "Why I Was Sacrilegious, Why I Am a Mystic."

November 27–January 10, 1951, the Carstairs Gallery in New York exhibits Dalí's second version of *The Madonna of Port Lligat.*

Dalí with Reynolds and Eleanor Morse, Knoedler Gallery, New York, April 14, 1943.

1951 Dalí publishes his "Mystical Manifesto" in April. The text appears in French and Latin and maps out the artist's method of "paranoiac-critical mysticism."

On November 11, Dalí gives a lecture entitled "Picasso and I" at the María Guerrero theater in Madrid.

In London, the Alex, Reid, and Lefevre Gallery holds an exhibition in December, displaying the second version of Dalí's *Madonna of Port Lligat* and *The Christ of St. John of the Cross.* The latter work is purchased by the Glascow Art Gallery and generates considerable controversy.

1952 Dalí gives lectures in America on his new theory of "nuclear mysticism."

Paul Eluard dies at the age of fifty-six and is buried in the Cimetière du Père Lachaise in Paris. Neither Gala nor Dalí attends the funeral.

In December, Dalí shows six paintings at the Carstairs Gallery in New York.

1954 Dalí begins work on a three-act play entitled *Erotic-Mystical Delirium*, later renamed *Martyr: Lyrical Tragedy in Three Acts.* Although Dalí works on it for over two decades, it remains unfinished.

In May, Dalí travels to Rome for his exhibition at the Palazzo Pallavicini, where he shows 24 paintings, 17 drawings, and 101 watercolor illustrations for Dante's *Divine Comedy.*

Dalí works on a film project with French photographer Robert Descharnes called *The Prodigious History of the Lacemaker and the Rhinoceros.* Several scenes are shot between 1954 and 1961, but the project is never completed.

1955 Dalí meets Nanita Kalaschnikoff at a New York society ball in February, and the two become good friends.

In May, Dalí is commissioned to do a portrait of Laurence Olivier during the filming of *Richard III.* After finishing the painting, Dalí meets Peter Moore, a high-level British military officer who works in Italy as head of London Films International, an organization that provides a front for espionage activities in Europe. Moore arranges for Dalí to have his second meeting with the pope.

In the summer, Dalí hires stage painter Isador Bea to assist him on the large-scale painting *The Last Supper.* Bea has recently completed a commission based on a small work by Dalí, which the artist greatly admired. An agreement is made, and Bea continues to work for Dalí for the next thirty years.

Dalí lectures on December 17 at the Sorbonne, Paris, on "Phenomenological Aspects of the Paranoiac-Critical Method."

1956 In November, Dalí and Gala travel to New York. One of the major collectors of French impressionist art, Chester Dale, buys Dalí's *The Last Supper* and donates it to the National Gallery of Art in Washington, D.C.

1958 Dalí and Gala renew their marriage vows in a religious ceremony on August 8. The Catholic rite is celebrated in Sant Martí Vell, near Girona, Spain.

In December the Carstairs Gallery holds an exhibition of Dalí's works. The catalogue contains the artist's "Anti-Matter Manifesto," in which he declares that his work with the unconscious is now finished.

1959 Dalí and Gala meet with Pope John XXIII on May 2, during which time Dalí tells the pontiff of his new commission to design a cathedral in the Arizona desert.

Chateau Madrid, New York, 1954. From left: A. Reynolds Morse, Gala, Dalí, Eleanor Morse.

At the end of the year, Dalí presents his Ovocipède, a transparent, bubble-shaped automotive device, in Paris, with Josephine Baker, Martine Carol, and others in attendance.

1960 Early in the year, Dalí hires Peter Moore as his business manager. Moore is responsible for generating sales of Dalí-related merchandise, for which he receives a 10 percent commission.

In February, French and Company's New York gallery shows *The Discovery of America by Christopher Columbus*, a work commissioned by Huntington Hartford in 1957 for his Gallery of Modern Art in New York City.

In May, Joseph Fôret's edition of *The Divine Comedy* is published. The book contains wood engravings of Dalí's watercolor illustrations, which are shown at the Palais Galliera.

Dalí and Gala execute joint wills in November in which they designate each other as sole heir. All paintings, drawings, and other artworks are bequeathed to the Prado.

Dalí convinces Duchamp to include his *Sistine Madonna* (or, *Ear with Madonna*) in the International Surrealist Exhibition, held November 28–January 14 at the D'Arcy Galleries in New York. The exhibition co-organizers, Breton, Edouard Aguer, and José Pierre, are angered by Duchamp's decision and write the text "We Don't EAR It That Way" in protest.

1961 In May, the mayor of Figueres requests that Dalí donate paintings to the Empordà Museum. Dalí instead requests that an entire museum be constructed in his honor, to which he will donate his art. On August 12, a bullfight is held to celebrate the agreement, and a ceremony and reception are held in front of the

Teatro Principal, the future site of the new museum.

Dalí travels to Venice on August 22 to attend the premieres of the operetta *The Spanish Lady and the Roman Cavalier* and the ballet *Gala*, for which he, with the assistance of Isador Bea, designs the scenery.

1962 Robert Descharnes's book *Dalí de Gala* is published in the autumn, containing color reproductions of selected paintings by Dalí, the artist's commentaries, and a selection of photographs. Dalí and Gala approve of the book, and Marie-Laure de Noailles hosts a party to celebrate its publication.

Dalí paints *The Battle of Tetuán* in homage to Mariano Fortuny's unfinished work of the same title. The two paintings are exhibited side by side on October 15 at the Sala Tinell in Barcelona. Huntington Hartford purchases Dalí's painting after the show.

1963 Dalí's new interest in DNA is featured in his painting *Galacidalacidesoxiribnucleicacid*, subtitled *Homage to Crick and Watson*. The painting is shown at the Knoedler Gallery in New York November 26–December 16, along with nine additional works. The New England Merchants National Bank of Boston purchases the painting for $150,000.

Dalí receives a commission to produce one hundred illustrations for the Bible. During the same time, he begins a series of watercolor illustrations for *The Arabian Nights*.

1964 On April 13, the Galerie Charpentier holds a large retrospective of surrealism, organized by Patrick Waldberg. *The Lugubrious Game* is included in the exhibition.

Dalí's autobiographical book *Diary of a Genius* is published in the late spring.

Wedding portrait of Salvador and Gala Dalí, 1958.

1965 Amanda Lear and Dalí meet in Paris. Lear, formerly Alain Tap, becomes part of Dalí's circle of friends, and in 1984, after advancing from model to singer and performer, she authors a book entitled *Le Dalí d'Amanda*.

Dalí celebrates a major retrospective exhibition at Huntington Hartford's Gallery of Modern Art December 18–February 28, 1966. Included are 170 paintings, 59 drawings, gouaches, and watercolors, 10 prints, and 18 collages, in addition to "objects" and sculptures.

1968 In March, the French writer Louis Pauwels publishes *The Passions According to Dalí*, a book of Dalí's monologues recorded and edited by the author during the summers of 1966 and 1967.

Following student riots in Paris, Dalí writes "My Cultural Revolution" on May 18, and, with the help of Pierre Argillet, quickly distributes his tract to protesters.

1969 Dalí begins work on *The Hallucinogenic Toreador*. Over the next fifteen months, his progress is recorded by the writer Luís Romero, the photographer Melitón Casals, and Reynolds Morse, who purchases the picture before it is finished. Six years later, Romero publishes *Todo Dalí en un rostro*, his account of the evolution of the painting.

1970 On October 13, work begins on the construction of Dalí's museum in Figueres. During this time, Enric Sabater covers the activities of Dalí and his friends in the newspaper *Los Sitios*, and also begins to work with Dalí and Gala as their business administrator.

1971 Dalí designs the December issue of French *Vogue*, which he dedicates to Gala.

Reynolds Morse opens the Salvador Dalí Museum in Cleveland, Ohio, featuring his considerable collection of work by the artist.

1972 At the Knoedler Gallery in New York, Dalí exhibits three new paintings demonstrating his work with holograms.

Dalí works on an "opera-poem" entitled *Être Dieu*. The Catalan writer Manuel Vázquez Montalbán produces the libretto, and composer Igor Wakhévitch writes the music. The final recording does not occur until 1974.

1974 Enric Sabater takes over all of Peter Moore's responsibilities as Dalí's business administrator.

In April, André Parinaud's book *Comment on devient Dalí* is published in Paris, and released in English with the title *The Unspeakable Confessions of Salvador Dalí*.

On September 28, the Teatre-Museu Dalí Public Services Foundation is officially

Dalí, photographed in Venice, August 21, 1961.

opened. The ceremony takes place in the Town Hall of Figueres, at which time Dalí is presented with the Gold Medal of the city. Sometime in the months prior to the event, Dalí and Gala change their wills to stipulate that the new museum in Figueres and not the Prado will be the recipient of all artworks belonging to the estate of the couple upon their deaths.

1975 In response to General Franco's execution of five members of the Basque organization ETA, Dalí issues a fairly neutral, if not supportive, press statement. As a result, Dalí is the recipient of death threats and decides to leave the country. He and Gala go to Geneva, accompanied by Enric Sabater and Amanda Lear.

1976 In February, a bomb is discovered underneath Dalí's usual chair at the Via Veneto Restaurant in Barcelona while the artist is in New York.

In May, Michael Ward Stout, Dalí's new lawyer, helps establish a joint company for the artist, Sabater, and Sabater's wife, called Dasa Ediciones. Stout also assists in managing negotiations during an IRS investigation into Dalí and Gala's financial affairs.

In June, Dalí undergoes a prostate operation without complications.

During the summer, the Musée Goya in Castres, France, holds an exhibition of Dalí's eighty drypoint etchings based on Goya's *Caprichos*.

1977 Sabater arranges residency in Monaco for Dalí and Gala as a tax shelter.

1978 Dalí is elected a member of L'Académie des Beaux-Arts of the Institut de France.

1979 Dalí gives a lecture at L'Académie des Beaux-Arts entitled "Gala, Velázquez, and the Golden Fleece," in which he

discusses such topics as mathematics, DNA, the American artist Richard Estes, and academic painting.

On June 15, the Figueres town council votes to reinstate the original name of the "Plaça Gala–Salvador Dalí," located in front of the Theater Museum.

Three films are produced by Spanish Television in honor of Dalí's seventy-fifth birthday. The programs are structured around interviews given by the artist to Paloma Chamorro.

December 18–April 1980, a retrospective exhibition of Dalí's work is held at

the Centre Georges Pompidou, Paris. The show includes 120 paintings, 200 drawings, and more than 2,000 documents. More than a million visitors attend the show. The Dalí retrospective travels to the Tate Gallery in London.

1980 Dalí's physical condition begins to deteriorate, and he is taken to Barcelona to consult with doctors.

Dalí and Gala draw up new joint wills on December 12. All artworks are to be divided evenly between the Spanish State and the Catalan regional government upon their deaths.

Dalí in the future Teatre-Museu Salvador Dalí, Figueres, circa 1970–72.

On December 30, Enric Sabater relinquishes his position as Dalí's business adviser and secretary. His responsibilities are taken over by Robert Descharnes.

1981 Dalí and Gala return to Port Lligat on July 6. The President of the Generalitat de Catalunya, Jordi Pujol, visits Dalí. King Juan Carlos and Queen Sofía of Spain visit the artist on August 15.

1982 King Juan Carlos presents Dalí with the Grand Cross of the Order of Charles III, the State's highest award.

In March, the Salvador Dalí Museum in St. Petersburg, Florida, opens.

On March 20, Dalí receives the Gold Medal of the Catalan Government, the highest honor given in Catalonia.

After a long period of deteriorating health, Gala dies in Port Lligat on the morning of June 10. She is buried on June 11 in Púbol. According to Gala's most recent will, her paintings are split equally between the Spanish State and the Catalan regional government. Dalí moves into the castle he purchased for Gala at Púbol.

On July 20, King Juan Carlos designates Dalí Marquis of Púbol.

The Spanish Government buys *Little Ashes* and *Harlequin* for one hundred million pesetas, which allows Dalí to pay medical bills and run his estate in Púbol.

On September 20, Dalí signs a new will, in which the Spanish nation is to receive his entire estate. Neither the Catalan regional government nor the Teatre-Museu in Figueres is included in the revised will.

1983 April 15–May 29, the Museo Español de Arte Contemporáneo in Madrid holds a retrospective of Dalí's work entitled " 400 Works by Salvador Dalí, 1914–1983."

The exhibition is attended by 250,000 visitors before traveling to Barcelona.

Dalí finishes his last painting, *The Swallow's Tail*, in May, with the likely assistance of Isador Bea.

Luís Buñuel dies in Mexico on July 29.

On October 31, Dalí dictates his essay "The Most Important Discovery of My Paranoiac-Critical Method: Perpignan Station" to his friend and assistant Antoni Pitchot.

On December 23, the Teatre-Museu in Figueres is linked to a supporting foundation, thereby establishing the Fundació Gala–Salvador Dalí in Figueres.

1984 The Fundació Gala–Salvador Dalí is officially established on March 27, with King Juan Carlos and Queen Sofía as honorary patrons.

On the morning of August 30, a fire breaks out in Dalí's bedroom in Púbol, caused by a short circuit in a call bell. Dalí suffers first- and second-degree burns on his leg, and is taken to the Pilar Clinic in Figueres for treatment. On September 7, he undergoes a skin-graft operation, and on the same day, authorities begin an investigation into the circumstances of the fire. Dalí remains in the clinic until October 17. Following the fire, Dalí moves into the Torre Galatea in the Teatre-Museu in Figueres.

1985 Dalí sets up a new company, called Demart Pro Arte BV, to handle copyright issues, and appoints Robert Descharnes its managing director.

1986 On June 13, Dalí signs a contract authorizing Demart Pro Arte BV to control his copyright, and thus his royalties, until May 11, 2004. In 1995, the agreement is nullified, and control of

Dalí's copyright is relinquished to the Fundacío Gala–Salvador Dalí.

1988 Dalí is admitted to Figueres Hospital on November 27. After various complications and the threat of infection, the artist is transferred to the Quirón Clinic in Barcelona.

On December 5, King Juan Carlos visits Dalí in the clinic. The artist's condition improves enough for him to return to Púbol on December 14.

1989 Dalí makes several trips back and forth from the hospital to his home until January 18, when he is readmitted with complications from pneumonia and a serious heart condition.

On January 20, Dalí is given his last rites. The next day, a press conference is held by the Figueres mayor, during which time the attending parties discuss Dalí's expressed wish to be buried in the Teatre-Museu.

Dalí dies on Monday, January 23, at 10:15 A.M. The cause of death is determined as cardiorespiratory failure. Following a public viewing by some fifteen thousand visitors January 25–26, Dalí is buried in the crypt of the Teatre-Museu. As stipulated in his will, the artist's remaining property is bequeathed to the Spanish State. His work is subsequently dispersed to institutions in Madrid, Barcelona, and Figueres.

* Information for this chronology is based on the following sources: *Salvador Dalí Retrospective: 1920-1980*, exh. cat., Musée National d'Art Moderne, Centre Georges Pompidou, Paris, 1979; Dawn Ades, *Dalí* (London: Thames and Hudson, 1982); Montserrat Aguer and Fèlix Fanés, "Illustrated Biography," in *Salvador Dalí: The Early Years*, exh. cat., South Bank Centre, London, 1994; and Ian Gibson, *The Shameful Life of Salvador Dalí* (London: Faber and Faber, 1997).

List of Exhibitions

The following does not represent a complete list of individual and group exhibitions in which Dalí participated. The exhibitions cited are limited to those in which works currently in the Salvador Dalí Museum collection were exhibited. Long-term loans to other museums are not cited. The exhibition history for individual paintings in the catalogue is given only for those works that can be securely identified. A question mark following an exhibition citation indicates a degree of doubt.

BARCELONA 1922

Galeries Dalmau, "Associació Catalana d'Estudiants. Exposició Col.lectiva," January 1922.

BARCELONA 1925

Galeries Dalmau, "Exposició S. Dalí," November 14–27, 1925.

MADRID 1925

Palacio de Exposiciones del Buen Retiro, "Exposición de la Sociedad de Artistas Ibéricos," May 28–August 1925.

BARCELONA 1926A

Sala Parés, "Saló de Tardor," October 1926.

BARCELONA 1926B

Galeries Dalmau, "Exposició S. Dalí," December 31, 1926–January 14, 1927.

BARCELONA 1928

Sala Parés, "Saló de Tardor," October 6–28, 1928.

FIGUERES 1928

Casino Menestral Figuerense, "Exposición Provincial de Bellas Artes," May 1928.

PITTSBURGH 1928

"Twenty-Seventh International Exhibition of Paintings,"October 18–December 9, 1928.

MADRID 1929

Salón del Jardín Botánico, "Exposición de Pinturas y Esculturas de Españoles Residentes en París," March 20–25, 1929.

PARIS 1929

Galerie Goemans, "Dalí," November 20–December 5, 1929.

ZURICH 1929

Kunsthaus, "Abstrakte und Surrealistiche Malerei und Plastik," October 6–November 3, 1929.

PARIS 1930

Galerie Goemans, "La Peinture au défi: Exposition des Collages," March 28–April 12, 1930.

HARTFORD 1931

Wadsworth Atheneum, "Newer Super Realism," November 16–December 7, 1931.

PARIS 1931

Pierre Colle Gallery, "Exposition Salvador Dalí," June 3–15, 1931.

PARIS 1932

Pierre Colle Gallery, "Exposition Salvador Dalí," May 26–June 17, 1932.

CHICAGO 1933

Chicago World's Fair Art Exhibition, 1933.

NEW YORK 1933A

The Museum of Modern Art, "Modern European Art," October 4–25, 1933.

NEW YORK 1933B

Julien Levy Gallery, "Exhibition of Paintings by Salvador Dalí," November 21–December 8, 1933.

PARIS 1933A

Pierre Colle Gallery, "Exposition Surréaliste," June 7–18, 1933.

PARIS 1933B

Pierre Colle Gallery, "Exposition Salvador Dalí," June 19–29, 1933.

LONDON 1934

Zwemmer Gallery, "Salvador Dalí: Catalogue of an Exhibition of Paintings, Drawings and Etchings at the Zwemmer Gallery," October 24–November 10, 1934.

NEW YORK 1934

Julien Levy Gallery, "Dalí," November 21–December 10, 1934.

PARIS 1934

Galerie Jacques Bonjean, "Dalí," June 20–July 13, 1934.

PITTSBURGH 1935

Carnegie Institute, "The 1935 International Exhibition of Paintings," October 17–December 8, 1935.

LONDON 1936

Alex, Reid, and Lefevre Gallery, "Salvador Dalí," June–July 1936.

NEW YORK 1936A

The Museum of Modern Art, "Fantastic Art, Dada, Surrealism," December 9, 1936–January 17, 1937.

NEW YORK 1936B

Julien Levy Gallery, "Dalí," December 10, 1936–January 9, 1937.

PARIS 1938

Galerie Beaux-Arts, "Exposition Internationale du Surréalisme," January–February 1938.

AMSTERDAM 1938

Galerie Robert, "Exposition Internationale du Surréalisme," Spring 1938.

NEW YORK 1939

Julien Levy Gallery, "Salvador Dalí," March 21–April 17, 1939.

PARIS 1939

René Huyghe, "French Painting: The Contemporaries," 1939.

SAN FRANCISCO 1939

Golden Gate International Exhibition, "Contemporary Art of 79 Countries: The International Business Machines Corporation Collection, Exhibited in Its Gallery of Science and Art in the Palace of Electricity and Communication at the Golden Gate International Exhibition, San Francisco, California," 1939.

CHICAGO 1941

The Arts Club of Chicago, "Salvador Dalí," May 23–June 14, 1941.

LOS ANGELES 1941

Dalzell Hatfield Galleries, Ambassador Hotel, "Salvador Dalí," September 10–October 5, 1941.

NEW YORK 1941A

The Museum of Modern Art, "Salvador Dalí," November 18, 1941–January 11, 1942.

NEW YORK 1941B

Julien Levy Gallery, "Salvador Dalí," April 22–May 20, 1941.

BOSTON 1943

The Institute of Modern Art, "Europe in America," March 27–April 24, 1943.

NEW YORK 1943A

Art of This Century, "Art of This Century: 15 Early Paintings, 15 Late Paintings," March 13–April 10, 1943.

NEW YORK 1943B

Knoedler Gallery, "Dalí," April 14–May 5, 1943.

DAYTON 1944

Dayton Art Museum, "Religious Art Today," April 11–June 1, 1944.

NEW YORK 1944

Art of This Century, "First Exhibition in America of Art of This Century," April 1944.

DAYTON 1945

Dayton Art Institute, "The Little Show: The Modern Room," March 2–31, 1945.

BOSTON 1945

Plotkin Brothers, "Art Panorama: United Modern Art in Boston," January 22–February 24, 1945.

NEW YORK 1945A

Bignou Gallery, "Exhibition of Modern Paintings," January 8–27, 1945.

NEW YORK 1945B

Bignou Gallery, "Dalí (Fortis Imaginatio Generat Casum)/ Recent Paintings by Salvador Dalí," November 20–December 29, 1945.

NEW YORK 1946

Bignou Gallery, "A Selection of Contemporary Paintings," February 4–March 9, 1946.

BOSTON 1946

The Institute of Modern Art, "Four Spaniards: Dalí, Gris, Miró, Picasso," January 24–March 3, 1946.

CLEVELAND 1947

The Cleveland Museum of Art, "Salvador Dalí: An Exhibition," October 8–November 9, 1947.

INDIANAPOLIS 1947

John Herran Art Museum, "Contemporary American Paintings: 68th Annual Exhibition," December 28, 1947–February 1, 1948.

NEW YORK 1947

Bignou Gallery, "New Paintings by Salvador Dalí," November 25, 1947–January 3, 1948.

PITTSBURGH 1947

Carnegie Institute, "Painting in the United States," October 9–December 7, 1947.

PITTSBURGH 1949

Carnegie Institute, "Painting in the United States," October 13–December 11, 1949.

NEW YORK 1950A

Delius Gallery, "Exhibition: 20 Paintings, Old and New, From Duccio to Dalí," May 2–27, 1950.

NEW YORK 1950B

Sidney Janis Gallery, "Challenge and Defy," September 1950.

LONDON 1951

Alex, Reid, and Lefevre Gallery, "Dalí," December 1951.

NEW YORK 1952

Carstairs Gallery, [untitled], December 1952–January 1953.

SANTA BARBARA 1953

Santa Barbara Museum of Art, "Fiesta Exhibition: Picasso, Gris, Miró, Dalí," August 4–13, 1953.

ROME 1954

Sale dell'Aurora Pallavicini, "Mostra de Quadri, Disegni ed Oreficerie di Salvador Dalí," 1954.

KNOKKE LE ZOUTE 1956

"IXe Festival Belge D'Eté," July 1–September 10, 1956.

SOUTHAMPTON, LONG ISLAND 1958

The Parrish Art Museum, "Dalí—2nd Collection of Jewels Sacre Coeur de Jesus Paintings—Sketches," August 1–21, 1958.

NEW YORK 1958

Sidney Janis Gallery, X Years of Janis: 10th Anniversary Exhibition—The Sidney Janis Gallery, New York, New York," September 29–November 1, 1958.

NEW YORK 1960A

Finch College Art Gallery and Museum, "Loan Exhibition of Selected Paintings, Drawings and Water Colors of Salvador Dalí," May 23–June 18, 1960.

NEW YORK 1960B

D'Arcy Galleries, "International Surrealist Exhibition: Surrealist Intrusion in the Enchanters' Domain," November 28, 1960–January 14, 1961.

MADRID 1962

Casón del Buen Retiro, "Exposición de Pintura Catalana. Desde la Prehistoria hasta nuestros dias," 1962.

NEW YORK 1963

Knoedler Gallery, "Salvador Dalí," November 26–December 16, 1963.

NEW YORK 1964

The Gallery of Modern Art, "Paintings from the Huntington Hartford Collection in the Gallery of Modern Art," 1964.

NEW YORK 1965

The Gallery of Modern Art (including the Huntington Hartford Collection), "Salvador Dalí: 1910–1965," December 18, 1965–February 28, 1966.

SAN DIEGO 1969

Fine Arts Gallery of San Diego and Putnam Foundation, Timken Gallery, California, [untitled], January 2–March 4, 1969.

NEW YORK 1970

Knoedler Gallery, "Dalí: Paintings and Drawings, 1965–1970," March 10–April 4, 1970.

NEW YORK 1972

Sidney Janis Gallery, "Exhibition of Works of Art of Colossal Scale by 20th-Century Artists," March 9–April 1, 1972.

NEW YORK 1973

Sidney Janis Gallery, "25 Years of Janis Part I—From Picasso to Dubuffet: From Brancusi to Giacometti," October 2–November 3, 1973.

ST. PETERSBURG 1982

The Salvador Dalí Museum, "Homage to Gala," July 13–September 12, 1982.

BARCELONA 1983

Museo Español de Arte Contemporáneo, Barcelona, Palau Reial de Pedralbes, "400 Obres de Salvador Dalí del 1914 al 1983," 1983–84.

STUTTGART 1989

Staatsgaleire, "Salvador Dalí 1904–1989," May 13–23, 1989. Subsequently traveled to Zürich, Kunsthaus, August 18–October 22, 1989.

FIGUERES 1993

Teatre-Museu Dalí, "Exposició Salvador Dalí: el pa," May 23, 1993– [?].

LONDON 1994

Hayward Gallery, "Salvador Dalí: The Early Years," March 3–May 30, 1994. Also shown in New York, The Metropolitan Museum of Art, June 28–September 18, 1994; Madrid, Museo Nacional de Arte Reina Sofía, October 14, 1994–January 16, 1995; Barcelona, Palau Robert, February–April 1995.

MADRID 1995

Museo Nacional Centro de Arte Reina Sofía, "Exposició del Salón de los Artistas Ibéricos," September 25, 1995–January 22, 1996.

PARIS 1995

Musée National d'Art Moderne, Centre Georges Pompidou, "Féminimasculin: Le sexe de l'art," October 24, 1995–February 12, 1996.

ATLANTA 1996

Michael C. Carlos Museum, Emory University, "From Gaudí to Tàpies: Catalan Masters of the 20th Century," April 27–June 2, 1996. Subsequently traveled to Quebec, Quebec City Museum, June 17–July 10, 1996; St. Petersburg, The Salvador Dalí Museum, July 27–September 22, 1996; San Antonio, San Antonio Museum of Art, October 12–December 11, 1996; Tacoma, Tacoma Art Museum, January 19–March 20, 1997.

BARCELONA 1996

Fundació Caixa de Catalunya (La Pedrera), "Dalí and Architecture," June 27–August 27, 1996.

FORT LAUDERDALE 1997

Fort Lauderdale Museum, "Treasures from the Salvador Dalí Museum," January 25–April 6, 1997.

NEW YORK 1997A

The Museum of Modern Art, "Objects of Desire: The Modern Still-Life," May 12–August 26, 1997. Subsequently traveled to London, Hayward Gallery, October 9, 1997–January 4, 1998.

NEW YORK 1997B

The Solomon R. Guggenheim Museum, "Art/Fashion," March 12–June 6, 1997.

LIVERPOOL 1998

The Tate Gallery, "Salvador Dalí: A Mythology," October 30, 1998–January 31, 1999. Subsequently traveled to St. Petersburg, The Salvador Dalí Museum, March 5–May 24, 1999.

PITTSBURGH 1998

The Andy Warhol Museum, "Dalí," June 20–September 20, 1998.

RIO DE JANEIRO 1998

Museu Nacional de Belas Artes, "Dalí Monumental," March 23–May 20, 1998; Subsequently traveled to São Paolo, Museu de Arte de São Paolo, June 8–August 1, 1998.

BILBAO 1999

Museo de Bellas Artes de Bilbao, "The Spanish Still-Life: Zurbarán to Picasso," November 15, 1999–March 20, 2000.

FIGUERES 1999

Fundació Gala–Salvador Dalí, 25th
Anniversary Exhibition, November
15, 1999–March 15, 2000.

NEW YORK 1999

Equitable Art Gallery, "Dreams
1900–2000: Science, Art and the
Unconscious Mind," November 4,
1999–February 26, 2000.
Subsequently traveled to Vienna,
Historiches Museum der Stadt Vien,
March 22–June 25, 2000;
Binghampton, Binghampton
University Art Museum, July 28–
September 22, 2000; and Paris,
Passage de Retz, November 22,
2000–January 12, 2001.

SHINJUKU (TOKYO) 1999

Mitsukoshi Museum of Art,
"Treasures from the Dalí Museum,"
June 12–August 22, 1999.
Subsequently traveled to Fukuoka,
Fukuoka Asian Art Museum,
August 28–October 24, 1999.

TALLAHASSEE 1999

Museum of Art, "Florida: State of the
Arts," January 23–April 11, 1999.

HARTFORD 2000

Wadsworth Atheneum, "Salvador
Dalí: Optical Illusions," January 13,
2000–March 26, 2000. Subsequently
traveled to Washington, Hirshorn
Museum and Sculpture Garden,
April 20–June 25, 2000; and
Edinburgh, Scottish National
Gallery of Modern Art, June 23–
October 1, 2000.

abjection
 analysis of, 80
 in Dalí's work, 47, 49
Accommodations of Desire, 55
Adam (Michelangelo), 140
Ades, Dawn, 55, 56 n. 5, 75
 on castration complex, 68 n. 2
Adoration of the Magi (Leonardo), 104
"Aerodynamic Apparitions of 'Being-
 Objects' " (Dalí), conception of
 space discussed in, 96
aesthetic objectives of Dalí, 36,
 41–42, 55, 98 n. 4
afternoon outing, described
 by Dalí, 4
Alice's Adventures in Wonderland
 (Carroll), 101 n. 1
The Ambassadors (Holbein), 83
anamorphic imagery in Holbein's
 Ambassadors, 83
anamorphosis, 83
"An Anatomy" (Picasso), 99
The Angel of Port Lligat, 133–134
Angelus (Millet)
 basket image in, 88 n. 4
 Dalí's interpretation of, 87–88
 Dalí's paintings based on, 86–88,
 88 n. 1, 89–90, 93
Angelus imagery in Dalí's paintings,
 75, 81, 83 n. 1, 117, 157, 158.
 See also Angelus (Millet): Dalí's
 paintings based on
The Angelus of Gala, 88 n. 1
Anglada-Camarasa, Hermen, 3
Anteneu Barcelonès lectures, 136
Anthology of Black Humour
 (Breton), 134
Anthropomorphic Beach (fragment),
 50–51
Anthropomorphic Echo, 110–111
"Anti-Matter Manifesto" (Dalí),
 145
Aphrodisiac Dinner Jacket, xiii, 106
Apotheosis of Homer, 131

Apparatus and Hand, 40–42, 79
*Apparition of Face and Fruit Dish on a
 Beach*, 118, 123
Aragon, Louis, on Dalí's use of
 collage, x, 56
*Archaeological Reminiscence of Millet's
 "Angelus,"* 88 n. 1, 89–90
The Architectonic "Angelus" of Millet,
 88 n. 1
Arcimboldo, Giuseppe, 148
Arouet, François-Marie. *See* Voltaire
Arp, Jean, 55, 56
 influence on Dalí's work, 43,
 51, 52
art nouveau architecture, Dalí's
 interest in, 58
The Art of Painting (Vermeer), 111
Associació Catalana d'Estudiants
 exhibit (1922), 18
Atavism at Twilight, 88 n. 1
*Atmospheric Skull Sodomizing a Grand
 Piano*, 93, 94–95
Au Bord de la Mer, 64–66, 73
*Automatic Beginning of a Portrait of
 Gala (Unfinished)*, 78
Autumn Cannibalism, 121 n. 2
Autumn Salon, Sala Parés (1928), 49
Autumn Sonata, 129, 131
avant-garde art, Dalí and, 21, 23, 26
*Average Atmospherocephalic Bureaucrat
 in the Act of Milking a Cranial
 Harp*, 82–83
The Average Bureaucrat, 62–63, 93

Babaouo, 126
ballet, Dalí's involvement with, 115,
 126, 127
The Basket of Bread, 36–37, 73
Bataille, Georges, 44–45 n. 1, 55,
 56 n. 5, 71, 99
The Bather, 42–44, 51
bather paintings, Dalí's, 42–45
Battle of Tetuán, 154 n. 2
Bea, Isador, xiv, 147, 153

Beatrice, 150–151
Beigneuse, 44–45, 51
beings and objects, relations of,
 96–98
Belle Saison (Ernst), 52
Bello, José (Pepín), 26, 41, 52
Benedito y Vives, Manuel,
 influence on Dalí's
 work, 17
Benjamin, Walter, on André
 Breton, 96
Beyond the Pleasure Principle
 (Freud), 68
bicyclist imagery in Dalí's work,
 126–127
Boccioni, Umberto, 26
Boecklin, Arnold, 70
Bonwit Teller, xi
"Book of Putrefaction." *See El Libro
 de los putrefactos*
Bosquet, Alain, 157
Bouquet (L'Important c'est la rose),
 26–27
Bowles, Paul, 126, 127
Bracelli, 105
Bramante, Donato, 135
Braque, Georges, 29
bread as subject in Dalí paintings, 36,
 73, 75
breasts as objects of Dalí's "first
 crime," 80
Breton, André, xii, xiii, 55, 56 n. 5,
 61, 62, 66 n. 2, 115, 121
 censorship of Dalí, x–xi, 117,
 118, 134
 Walter Benjamin's description
 of, 96
The Broken Bridge and the Dream,
 128, 131
Brueghel, Jan, 145
Buñuel, Luís, 26, 75
 Un Chien andalou, 49, 52, 54–56
bureaucrat imagery in Dalí's work,
 62–63, 82–83

Cadaqués, 20–21
Cadaqués
 depicted, 1–9, 12–13, 16, 18–21
 described, 1–2, 4
cadavre exquis, 93 n. 1
Camí de Granollers (Martí i Alsina),
 106 n. 1
Cannibalism of Objects, 75
Cap Creus
 depicted, 18–19
 described, 2
Capgras, J., 88 n. 9
Carrà, Carlo, influence on Dalí's
 work, 23, 29, 39
Carroll, Lewis, 101 n. 1
castration complex, 66
 Dalí's work and, 67, 68 n. 2, 85
Catalan Bread, 36, 72–73
Catalan culture, Dalí and, 49, 51
Catalina (Dalí's aunt), 25
Catholicism, Dalí's return to, xiv, 134
"Ceci n'est pas une pipe" inscription,
 significance of, 104. *See also
 Wind and the Song/Ceci n'est pas
 une pipe*
Cenecitas/Little Ashes, 40
Cézanne, Paul, 2
 influence on Dalí's work, 23, 26
Chair in Open-Air Painting, protest
 regarding, 30
Chamberlain, Neville, 117
Chanel, Coco, 106, 115
*A Chemist Lifting with Extreme
 Precaution the Cuticle of a Grand
 Piano*, 106 n. 1
Chirico, Giorgio de, influence on Dalí's
 work, 39, 40, 55, 62, 64, 100
Christ of St. John of the Cross, 134, 147
classical motifs in Dalí's postwar
 work, 131
collage elements
 Dalí's use of, 55, 56, 56 n. 6
 painters' use of, 96
Columbus, Christopher, 147

"Con el Sol" (Dalí), 71
Conquest of the Irrational (Dalí), 108, 135
 aesthetic objectives discussed in, 55
Constantine the Great, 142
Corpus Hypercubus (Crucifixion), 140
Couple with Their Heads Full of Clouds, 88 n. 1
Crane, Hart, 121
Crevel, René, 121
Crick, Francis, 154
Cristo de Vallès, 154
Crosby, Caresse, xi, 121
crutches imagery in Dalí's work, 79–80
cubism
 Dalí and, 26, 29, 39
 relation to physics, 141–142
cultural provocateur, Dalí's role as, 15, 30–31, 55–56

Daddy Longlegs of the Evening—Hope!, 120–121, 126
Dalí, Ana María, 11, 33
 depicted, 22–23, 34–35, 38–39
 relationship with Dalí, 23
Dalí, Gala, 23, 41, 60, 61, 121, 151, 158
 as child-woman, 66, 75
 Dalí's first encounter with, 77–78
 depicted, 77–78, 122–123
 depicted as spiritual being, xiv, 134, 142, 147, 153
 early years of, 77
 as incarnation of Galuchka, 77–78, 80
 in *L'Amour et la mémoire*, 66
 as a sphinx, 81
 symbolic roles of, 66, 68 n. 1, 134, 142
Dalí, Salvador
 aesthetic objectives of, 36, 41–42, 55, 98 n. 4
 and commercialism, x–xiv
 cultivated persona of, 15, 41
 as cultural provocateur, 15, 30–31, 55–56
 "first crime" of, 80

intrauterine "memories" of, 71
as new man, 126
Oedipal drama of, 23, 60, 62, 66
relationship with his sister, 23
shaved head of, 62, 66, 75
Dalí i Cusí, Salvador, 1
 banishment of Dalí, 23, 60, 62, 66
 Catalina and, 25
 referred to in Dalí's paintings, 62
Dalí i Cusí, Salvador Galo Anselmo, Dalí's mythic account of, 157
Dali News, x, xi
Dalmau, Josep, exhibit of *Dialogue on the Beach*, 49
Dante, 151
David (Michelangelo), 140
Degas, Edgar, 12
de Kooning, Willem, 145
Delusions and Dreams in Jensen's Gradiva (Freud), 78 n. 6
Departure: Homage to the Fox Newsreel, 41
Derain, André, 29
Descharnes, Robert, 140
desire, located within the painting, 104
Desnos, Robert, 56 n. 5
Devulina, Helena Diakanoff. *See* Dalí, Gala
Dialogue on the Beach/Unsatisfied Desires, controversy regarding, 49
Dionysus Spitting the Complete Image of Cadaqués on the Tip of the Tongue of a Three-Storied Gaudinian Woman, 148–149
Disappearing Bust of Voltaire, 123–124
The Discovery of America by Christopher Columbus, 146–147
The Disintegration of the Persistence of Memory, 136–137
Dit Gros etc. (Big Thumb, Beach, Moon and Decaying Bird), 48–49
Diurnal Illusion: The Shadow of a Grand Piano Approaches, 66 n. 3
The Divine Comedy (Dante), 151
Documents journal (Bataille), 45, 71, 99
Domènech, Anselm, 12, 21, 34
Domènech i Ferrés, Felipa, 25

Dalí's Oedipal drama and, 23, 60, 62, 66
double images, in Dalí's work, 105, 123, 158
drawing, relation to painting, 12
The Dream, 60 n. 1, 62 n. 2
dream, love, annihilation, relationships among, 68–69
"Dream of Venus" pavilion, xi, xii
The Dream Places a Hand on a Man's Shoulder, 106 n. 1
Ducasse, Isidore (Comte de Lautréamont), 93, 99
Dullita, 80
Dullita Rediviva, 80
Dutch art
 Dalí's passion for, 34, 37 n. 2
 Vermeer and, 91

The Ecumenical Council, 151, 152–153
egg imagery in Dalí's work, 71
egg volume, contrasted with pearl volume, 91
Eglevesky, André, 126
El Libro de los putrefactos (Book of Putrefaction), 41, 47, 66 n. 1, 93, 127
Eluard, Gala. *See* Dalí, Gala
Eluard, Paul, 42, 55, 66 n. 2, 77, 101 n. 1
Enchanted Beach with Three Fluid Graces, 104, 112–113, 117
Encina, Juan de la, 29
The Endless Enigma, xii, 118
The Enigma of Hitler, 117
The Enigma of William Tell, x, 99, 117
Enlightenment reason attacked in Dalí's paintings, 123
Equestrian Portrait of Príncipe Baltasar Carlos (Velázquez), 145
Ernst, Max, 44, 56, 96, 115
 influence on Dalí's work, 40, 47, 51, 52, 55, 56 n. 6, 93
eroticism in Dalí's paintings, 33–34, 39, 140. *See also* sexuality
Eucharistic Still Life (Nature Morte Evangélique), 36, 135–136
Eucumenical Council, 142

Exposició d'Art Français (1917), 2
Exposición de la Sociedad de Artistas Ibéricos (1925), 29, 31
Exposición Internacional de Bellas Artes e Industrias Artísticas (1907), 2
Eyck, Jan van, 36

Fantasies Diurnes, 75–76
fashion design, Dalí and, 106
fauve painting, Dalí's use of, 11
fecal imagery in Dalí's work, 61
Femme Couchée, 38–39
Fernández, Juan Núñez, 30
Figueres Instituto, 30
Figures surréalistes, 99
finger/phallus imagery, 42–43, 51
Finkelstein, Haim, 61, 68 n. 1
 on *Apparatus and Hand*, 41
"first crime" of Dalí, 80
The First Days of Spring, x, 47, 54–56, 60 n. 1, 131
First Portrait of Gala, 78
fish/grasshopper anecdote, 85
flood of the Rio Llobregat, painting commemorating, 154
flowers as women's hair/heads, in Dalí's work, 106 n. 1
Foix, Josep-Vincenç, 88 n. 2, 115
The Font, 59–60, 62 n. 2, 102 n. 2
foods, symbolism of, 62–63
Foucault, Michel, 104
Fountain of Milk Spreading Itself Uselessly on Three Shoes, 130–131
Freud, Sigmund, 55, 56 n. 3, 60 n. 3, 68, 78 n. 6
 analogy of his mind and snails, 63 n. 1
 castration complex and, 66, 68 n. 2, 85
 interpretation of Medusa, 59
 paranoiac painting and, 104
Freudianism, Dalí's interest in, 42–43, 56 n. 3
Freudian symbolism, in Dalí's work, 41, 55, 60–62, 66–68
frottage technique, 44, 47

Gala and the "Angelus" of Millet Preceding the Imminent Arrival of the Conic Anamorphoses, 88 n. 1

Galacidalacidesoxiribunucleicacid (Homage to Crick and Watson), 154–155

Galeries Dalmau, exhibitions, 23, 38

Galuchka, Gala as incarnation of, 77–78, 80

García Lorca, Federico, 26, 34, 44 n. 4, 158
 El Libro de los putrefactos (Book of Putrefaction) of, 41, 47
 purported sexual interest in Dalí, 41, 95

Garfias, Pedro, 26

Gasch, Sebastià, 21, 36, 51, 115
 reviews of Dalí's work, 38–39, 55–56

Gaudí, Antoni, 58

gender differentiation theme in Dalí's work, 73, 85

geometrical structure in Dalí's paintings, 135–136, 141–142, 147, 153

The Geometry of Art and Life (Ghyka), 142, 147

Geopoliticus Child Watching the Birth of the New Man, 125–126, 131

The Ghost of Vermeer of Delft Which Can Be Used as a Table, 90–91

Ghyka, Matila, 142, 147, 153

Giacometti, Alberto, 99

Gibson, Ian, 41, 60, 78, 95, 121

Giménez Caballero, Ernesto, 58 n. 3

Girl's Back, 34–35

Girl with Curls, 33–34

Gleizes, Albert, 135–136

Goemans, Camille, 55

Golden Section, Dalí's adaptation of, 135–136

Gradiva, 34, 78

The Grand Paranoiac, 104

grasshopper child theme in Dalí's work, 85, 87, 91

grasshopper/fish anecdote, 85

The Great Masturbator, 55

Great Masturbator imagery in Dalí's work, 57, 68, 75, 121

Grindel, Eugène. *See* Eluard, Paul

Gris, Juan, influence on Dalí's work, 26, 29, 158

Gropius, Walter, 58

Guillard, Georges Pierre-Théophile, 87

guilt theme in Dalí's work, 57, 59–60, 66

Guimard, Hector, 58

The Hallucinogenic Toreador, 158–159

Halsman, Philippe, 126 n. 2

Hamen y León, Juan van der, 36

Hartford, Huntington, 147

Heisenberg, Werner Karl, 136, 141

Helena, Saint, 142, 153

Heraclitus, 136

Herrera, Juan de, 135

Hitler, Adolf, Dalí's fascination with, x, 117

Holbein, Hans, 83

homosexuality, Dalí and, 41, 95

Honey Is Sweeter Than Blood (The Birth of Venus), 40

Hort del Llané, Cadaqués, 4

Houdon, Jean-Antoine, 123

I, Inspector of Drains (Giménez Caballero), 58 n. 3

Illumined Pleasures, 55, 126

Imperial Monument to the ChildWoman, 88 n. 1, 99

Imperial Violets, 117

impressionism, 5
 in Catalonia, 2, 21
 Dalí and, 2, 21, 25

infantile regression theme in Dalí's work, 73

Ingres, Jean-Auguste-Dominique, 26, 34, 39

insurgency, Dalí and, 15

Interpretation of Dreams (Freud), 55, 56 n. 3

intrauterine "memories" of Dalí, 71

The Invisible Man, 36, 74–75

The Javanese Mannequin, 98–99

Jeanneret, Charles-Edouard (Le Corbusier), 29, 41, 58

Jensen, Wilhelm, 78 n. 6

Jiménez, Juan Ramón, 52

John XXIII, Pope, 153

jump rope/hoop imagery in Dalí's work, 100, 101 n. 1

Kristeva, Julia, 80, 102

L'Amic de les arts journal
 Dalí reviewed in, 38–39
 Dalí's explanation of his art in, 41–42

L'Amour et la mémoire (Dalí), 78
 Gala described in, 66

"L'Ane pourri" (Dalí), 87
 art nouveau architecture discussed in, 58

L'Esprit nouveau journal, 21

L'Histoire de l'oeil (Bataille), 71

L'Immaculée conception (Breton and Eluard), 66 n. 2

Lacan, Jacques, paranoiac delirium and, 87, 88 n. 9, 108–109

Lacemaker (Vermeer), 34

La Femme 100 têtes (Ernst), 96

La femme visible (Dalí), relationships among dream, love, annihilation discussed in, 68–69

La Main (Les Remords de conscience), 60–62, 131

Landscape of Port Lligat, 132–133, 134

Landscape with Telephones on a Plate, 117

Landscape with Young Girl Jumping Rope, 101 n. 1

The Lane to Port Lligat with View of Cap Creus, 18–19, 21

Las Meninas (Velázquez), 145

The Last Supper, 36

Lautréamont, Comte de. *See* Ducasse, Isidore

Lawrence, D. H., 121

Le Calme blanc, 102 n. 1

Le Corbusier. *See* Jeanneret, Charles-Edouard

Leda Atomica, 151

Leg Composition, xiv

Léger, Fernand, 115

Le Mythe tragique de l' "Angelus" de Millet (Dalí), 157

Leonardo da Vinci, 60 n. 3
 influence on Dalí's work, 104
 paranoiac painting and, 104

"Leonardo da Vinci and a Memory of His Childhood" (Freud), 42

Les Chants de Maldoror (Ducasse), 93, 99

"Les Idées lumineuses" (Dalí), Vermeer discussed in, 91

"Les Mots et les images" (Magritte), 109

". . . The Liberation of the Fingers . . ." (Dalí)
 finger/phallus associations discussed in, 42–43
 fish/grasshopper anecdote recounted in, 85

Loeb, Pierre, 44 n. 2

Lomas, David, 93, 102

LopLop, Superior of Birds, 47

Lorca, Federico García. *See* García Lorca, Federico

Los Sentidos Corporales, La Vista y el Olfato (Brueghel), 145

Ludwig II (king of Bavaria), 115

The Lugubrious Game, 45 n. 1, 55, 61

The Madonna of Port Lligat, 134, 151

Magnasco, Alessandro, 106 n. 2

Magritte, René, 56
 "Ceci n'est pas une pipe" painting of, 104, 148
 influence on Dalí's work, 55, 64, 66 n. 2, 75, 109

Manet, Edouard, 12

Manifest Groc (Yellow manifesto) (Dalí, Gasch, Montanyà), 51

The Man with the Head of Blue Hortensias, 105–106, 113

Maragall, Joan, controversy
 regarding *Dialogue on the
 Beach*, 49
Marist Brothers' School, 2, 110
Martí i Alsina, Ramón, 21
 purported influence on Dalí's
 work, 105, 106 n. 1
Marx, Harpo, xii
Marx Brothers, 126
Mason, Rainer Michael, 99 n. 1
Massine, Léonide, 115
Masson, André, influence on Dalí's
 work, 43, 148
masturbation. *See* onanism
Matisse, Henri, 11
Meditation on the Harp, 86–88
Medusa, Freud's interpretation of, 59
Melancholy, Atomic, Uranic Idyll, 131
Melancholy and Mystery of a Street
 (Chirico), 100
memory, relation of visuality to,
 110–111
Memory of the Child-Woman, 66–68
Metamorphosis of Narcissus, 102 n. 4
metaphysical painting, Italian, 23
Metzinger, Jean, 135–136
Michelangelo, influence on Dalí's
 work, 140, 142, 153
Mies van der Rohe, Ludwig, 58
Millet, Jean-François. *See also Angelus*
 (Millet)
 influence on Dalí's work, 75, 81,
 83 n. 1, 117, 158
Mir, Joaquim, influence on Dalí's
 work, 3, 6
Miró, Joan, 44 n. 2, 55, 56, 96,
 99, 115
 Dalí's admiration of, 43–44
 influence on Dalí's work, 47, 51
 "Spanish Dancers" series of, 44
Mistress and Maid (Vermeer), 109
modern art, Dalí and, 2–3
modernist tradition, Dalí's attack on,
 xiii, 131, 135
Mondrian, Piet, ix
Monet, Claude, 6
Montanyà, Lluis, 51
Montes, Eugenio, 26

Morandi, Giorgio, 23, 29
Moreno Villa, José, 29, 37 n. 2
Morphological Echo, 100–101, 108–109
Morphologies (Man Ray), 106
Morse, A. Reynolds, 51, 62 n. 1, 105
Moses (Michelangelo), 142, 153
motifs, Dalí's recurring use of,
 126–127
Mount Paní
 depicted, 1, 16
 described, 1–2
multiple images. *See also* double
 images, in Dalí's work
 in Dalí's paintings,
 103–104, 118
*Myself at the Age of Ten When I
 Was the Grasshopper Child*,
 84–85
"Mystical Manifesto" (Dalí), 135
 Picasso extolled in, 148
 science and religion aligned
 in, 136
mystical painting, Dalí and, 135–136,
 148, 153

Nativity of a New World, 126 n. 2
*Naturaleza Muerta, Invitación al
 Sueno*, 41
Naturaleza muerta al claro de luna, 41
*Nature Morte Vivante (Still Life — Fast
 Moving)*, 141–142
Nazism, Dalí's fascination with, 117
Necrophiliac Springtime, 106 n. 1
neoclassicism, Dalí and, 38–39
"The New Colors of Spectral
 Sex-Appeal" (Dalí), 94
 phantom forms discussed in,
 65–66
"The New Limits of Painting"
 (Dalí), on surrealism, 44
new man, Dalí as, 126
New York World's Fair, xi
Nonell, Isidre, 31
Noon (Barracks Port Lligat),
 138, 140
Nostalgic Echo, 101 n. 1
Noucentisme, 21
Nuits Partagées (Eluard), 101 n. 1

objectivity, Dalí and, 36, 41
objects and beings, relations of,
 96–98
Ocell . . . Peix, 46–47
Oedipal drama
 Dalí's, 23, 60, 62, 66
 expressed in Dalí's work, 60–62,
 62–63, 66
 the sphinx and, 81
Oeufs sur le Plat sans le Plat, 70–71
*Old Age, Adolescence, Infancy
 (The Three Ages)*,
 118–119, 158
Olive Trees, 18
onanism
 Dalí and, 41
 expressed in Dalí's work, 42–43,
 57–58, 60–62
Ozenfant, Amédée, 29, 41

painting, relation of drawing to, 12
paranoiac-critical activity, Dalí's
 theory of, xiv, 87–88, 108–109
paranoiac-critical method, means
 of testing desire hypothesis,
 104
paranoiac delirium
 evidenced in Dalí's work, 109
 Lacan's theories of, 87, 88 n. 9,
 108–109
Paranonia, 103–104, 113, 158
Parinaud, André, 2
paternal retribution theme in Dalí's
 work, 57, 59–60, 66, 67
pearl volume, contrasted with egg
 volume, 91
Peinture series (Miró), 96
Pensées (Ingres), 39
Perpignan Railway Station, 88 n. 1
The Persistence of Memory, 43, 73, 136
persona, Dalí's cultivated, 15, 41
Person Throwing a Stone at a Bird
 (Miró), 47
Peseur de perles (Vermeer), 91
phallus/finger imagery, 42–43, 51
phantom forms, discussed by Dalí,
 65–66
The Phenomenon of Ecstasy, 62 n. 4

photography, objectivity of, 36
physics
 influence on Dalí's work, 136,
 141–142, 145
 relation to cubism, 141–142
piano imagery in Dalí's work,
 65, 66 n. 1, 93, 94, 106,
 126, 127
Picabia, Francis, 60
Picasso, Pablo, 34, 115, 145
 Dalí's putative collaboration
 with, 99
 extolled by Dalí, 148
 influence on Dalí's work, 23, 29,
 38, 39, 43, 51, 52, 148
Pitchot, Pepito, 2
Pitchot, Ramón, influence on Dalí, 2
*Pittura scultura futuriste (Dinamismo
 plastico)*, 26
Pius XII, Pope, 134
Planck, Max, 145
Platero y Yo (Jiménez), 52
*Playa Port Alguer from Riba d'En
 Pitchot*, 6–7
*Poetry of America — The Cosmic
 Athletes*, 126 n. 2
political/social content in Dalí's
 work, 117, 121
Porcel, Baltasar, 99 n. 1
Port Alguer, 6. *See also* Portdogué
Portdogué. *See also* Port Alguer
 depicted, 8–9, 16
Portdogué, Cadaqués, 8
*Portdogué and Mount Paní from
 Ayuntamiento*, 16
Port Lligat
 depicted, 132–133, 143
 described by Dalí, 133, 134
Port of Cadaqués (Night), 5
Portrait of Gala, 34
*Portrait of Infanta Marguerita of
 Austria* (Velázquez), 145
Portrait of My Dead Brother, 88 n. 1,
 156–157
Portrait of My Sister, 22–23
Portrait of Sebastiàn de Mora
 (Velázquez), 145
Portrait of the Duke of Olivares

(Velázquez), 145

Portrait of the Vicomtesse Marie-Laure de Noailles, 106 n. 1

primal scene, 66. *See also* castration complex

The Prodigious History of the Lacemaker and the Rhinoceros (film), 140

The Profanation of the Host, 57–58

psychoanalytic theory. *See* Freud, Sigmund; Freudianism; Freudian symbolism

Puignau, Emilio, 136

Punta es Baluard from Riba d'En Pitchot, Cadaqués, 2–3

putrefaction
 in Dalí's work, 47
 rotting donkey image and, 52
 vs. sentimentality, 41, 52

Puzzle of Autumn, 101–102

Pythagoras, 136

Quevedo y Villegas, Francisco Gómez de, 145

The Ram (Vache Spectrale), 52–53

Raphael, 15

Ray, Man, xi, xiii, 106

Real Academia de San Fernando, Dalí's protest at, 30–31

religion
 aligned with science in Dalí's work, 136, 154
 Dalí's return to, 134, 135, 142

Renoir, Pierre-Auguste, 2, 12, 25

repetition in Dalí's work, 100, 102, 118

Residencia de Estudiantes, 26

Retrospective Bust of a Woman, 75

reviews of Dalí's work, 18, 38–39, 55–56

Riba d'En Pitchot, 6

Romero, Luís, 158

Roncalli, Angelo Giuseppi Cardinal, 153

rotting donkey image in Dalí's work, 52

Rubin, William, 82–83

The Sacred Heart: Sometimes I spit for PLEASURE on the portrait of my mother, 60, 66

Sainte Vièrge (Picabia), 60

Saint Helena of Port Lligat, 142–143

Sala Parés show (1928), 49

Saltor, Octavi, 5, 18

Salvador Dalí Seen by His Sister (Ana María Dalí), 23

Sánchez, Eugenio, 42, 85

Santos i Torroella, Rafael, 41, 95

"Sant Sebastià" (Dalí), 41, 49

Schiaparelli, Elsa, xii, xiii, 106, 115

science, aligned with religion in Dalí's work, 136, 154

Seated Monk, 30–31

Second World War, allegorized by Dalí, 126

The Secret Life of Salvador Dalí (Dalí), 11, 23, 55, 118, 157
 Dalí as new man allegory in, 126
 Dalí's visual persona described in, 15
 first encounter with Gala described in, 77–78
 Freud's mind discussed in, 63 n. 1
 fried eggs associations discussed in, 71
 introduction to impressionism recounted in, 2
 limp pocket watch imagery discussed in, 73
 Port Lligat described in, 133, 134
 symbolism of foods discussed in, 62–63
 use of crutches imagery discussed in, 79–80
 vision of Dalí's student days described in, 110

Self-Portrait, 10–11

Self-Portrait (Figueres), 14–15

self-portraiture, Dalí's, 11, 15

Sentimental Colloquy (ballet), 126, 127

Sentimental Colloquy (Dali painting), 126–127

sentimentality, vs. putrefaction, 41, 52

Sérieux, P., 88 n. 9

A Seventeenth-Century Demonological Neurosis (Freud), 68 n. 2

sexuality. *See also* eroticism
 in Dalí's work, 42–43, 44, 55
 sexual perversion in Dalí's work, 47, 49

Shades of Night Descending, 64–66, 73, 93

shaved head, Dalí's, 62, 66, 75

simulacra
 art nouveau architecture and, 58
 Dalí's definition of, 58

Skira, Albert, 99

Skull with Its Lyric Appendage Leaning on a Night Table Which Should Have the Exact Temperature of a Cardinal Bird's Nest, 92–93

Slave Market with the Disappearing Bust of Voltaire, 122–123, 158

Sleeping Woman, Horse, and Lion, 104

snails, symbolic significance of, 62–63, 63 n. 1

social/political content in Dalí's work, 117, 121

soft and hard matter
 Dalí's theories of, 62–63
 theme in Dalí's work, 73, 93, 106

Soft Construction with Boiled Beans — Premonition of Civil War, 121 n. 2

Soler (Frederich) monument, in Dalí's work, 62 n. 2

solo exhibitions, Dalí's, 38, 96

Sololla, Joaquín, 30

space, conception of, 96

The Specter of Sex-Appeal, 99, 158

The Spectral Cow, 52

sphinx, the Oedipal drama and, 81

spoon imagery in Dalí's work, 68, 70 n. 2

St. Peter's in Rome (Explosion of Mystical Faith in the Midst of a Cathedral), 153 n. 1

Still Life (Pulpo y Scorpa), 17–18

Still Life (Fish with Red Bowl), 23–24

Still Life (Sandia), 28–29

still-life genre, Dalí and, 17, 23

The Stinking Ass, 52

"The Story of the Linden-Blossom Picking and the Crutch" (Dalí), Dalí's "first crime" described in, 80

student days, Dalí's memory/vision of, 110

studio, Dalí's description of his, 11

Studio Scene, 30–31

Study of a Nude, 31–32

subjectivity, the coming into being of, 80

subject/object relations, 96–98

The Sublime Moment, 117

Suburbs of a Paranoic-Critical Town: Afternoon on the Outskirts of European History, 101 n. 1

Suez, 68–70

Sugar Sphinx, 81, 88 n. 1

sun imagery in Dalí's work, 71

surrealism. *See also* surrealist movement
 Dalí on, xi, 44, 58
 Dalí's allegiance to, xi, 55
 Dalí's early relation to, 40, 42, 47

Surrealist Architecture, 70 n. 2

Surrealist Gondola Above Burning Bicycles, 126

surrealist movement. *See also* surrealism
 Dalí's deteriorating relationship with, x, 117, 118

Surrealist Object, Gauge of Instantaneous Memory, 73

Surrealist Poster, 95–96

Surrender of Breda (Velázquez), 147, 157

Tanguy, Yves, influence on Dalí's work, 40, 42 n. 2, 43, 64

Teilhard de Chardin, Pierre, 154

telephone imagery in Dalí's work, 117

Telephone in a Dish with Three Grilled Sardines at the End of September, 101 n. 1, 116–117

Tell, William. *See* William Tell theme

"Terrifying and Edible Beauty of Art Nouveau Architecture"

(Dalí), 58

Three Young Surrealist Women Holding in Their Arms the Skins of an Orchestra, 106–107

Tieta, Portrait of My Aunt, Cadaqués, 25

Time magazine, xi, 106

Toulouse-Lautrec, Henri de, 3

The Tragic Myth of Millet's "Angelus" (Dalí), xiii
 "appearance" of *Angelus* to Dalí recounted in, 87
 development of themes of, 88 n. 2
 fantasy of sculptural figures recounted in, 90

transsubstantiation, metaphor of, 58

Tristan Fou (ballet), 106, 115, 131

Tristan Fou (Dalí painting), 114–115

Trois Baigneuses, II (Picasso), 99 n. 1

Tush, Peter, 56 n. 6

Two Adolescents, 139–140

Two Children Are Threatened by a Nightengale (Ernst), 93

ultraísmo movement, 26 n. 1

Un Chien andalou (film), 49, 52, 54–55, 66 n. 1, 93, 127

The Unspeakable Confessions of Salvador Dalí (Dalí), 132
 Dalí's deceased brother described in, 157

Untitled (Persistence of Fair Weather), 79–80

Untitled—Scene with Marine Allegory, 131

Valori plastici journal, 21

Vázquez-Díaz, Daniel, 30

Velázquez de Silva, Diego Rodríguez
 Dalí's interpretation of, 145
 influence on Dalí's work, xiv, 145, 147, 157

Velázquez Painting the Infanta Marguerita with the Lights and Shadows of His Own Glory, 144–145

Venus de Milo, image of, 158

Venus de Milo of the Drawers, 158

Verlaine, Paul, 126, 127

Vermeer, Johannes
 Dalí's admiration of, ix, 34, 36, 37 n. 2
 Dalí's description of, 91
 influence on Dalí's work, 109, 111
 represented in Dalí painting, 90–91

View of Cadaqués from Playa Poal, 12–13

View of Cadaqués with Shadow of Mount Paní, 1–2

View of Portdogué (Port Alguer), Cadaqués, 9

Vilaseca, David, 78
 analysis of Dalí's "first crime" narrative, 80

visuality, relation of memory to, 110–111

Vitruvius, 136

Vogue magazine, 101 n. 1, 106

Voltaire, depicted, 122–124, 158

watch imagery in Dalí's work, 73

Watson, James, 154

The Weaning of Furniture-Nutrition, 96–98, 158

"Why I Was Sacrilegious, Why I Am a Mystic" (Dalí lecture), 136

William Tell, 67

William Tell and Gradiva, 67

William Tell theme in Dalí's work, 67–68, 75, 83 n. 1, 117

Wind and the Song/Ceci n'est pas une pipe (Magritte), 104, 148

Woman at the Window in Figueres, 100

Woman with the Head of Roses, 106 n. 1

The Wood of Gadgets, 40

world war
 Dalí's allegory of, 121
 Dalí's preoccupation with, 117

Zoas, Christos, 147

Zurbarán, Francisco de, influence on Dalí's work, 36, 136